THE

Da VINCI WOMEN

THE

Da VINCI WOMEN

The UNTOLD FEMINIST
POWER *of* LEONARDO'S ART

KIA VAHLAND

BLACK DOG
& LEVENTHAL
PUBLISHERS
NEW YORK

Black Dog & Leventhal Publishers
Hachette Book Group
1290 Avenue of the Americas
New York, NY 10104

www.hachettebookgroup.com
www.blackdogandleventhal.com

Originally published in 2019 by Insel Verlag in Germany

First U.S. Edition: February 2020

Black Dog & Leventhal Publishers is an imprint of Perseus Books, LLC, a subsidiary of
Hachette Book Group, Inc. The Black Dog & Leventhal Publishers name and logo are
trademarks of Hachette Book Group, Inc.

The publisher is not responsible for websites (or their content) that are not owned by the
publisher.

The Hachette Speakers Bureau provides a wide range of authors for speaking events.
To find out more, go to www.HachetteSpeakersBureau.com or call (866) 376-6591.

Additional copyright/credits information is on page 288.

LCCN: 2019950345
ISBNs: 978-0-7624-9643-3 (hardcover), 978-0-7624-9642-6 (ebook)

Printed in the United States of America

LSC-C

10 9 8 7 6 5 4 3 2 1

CONTENTS

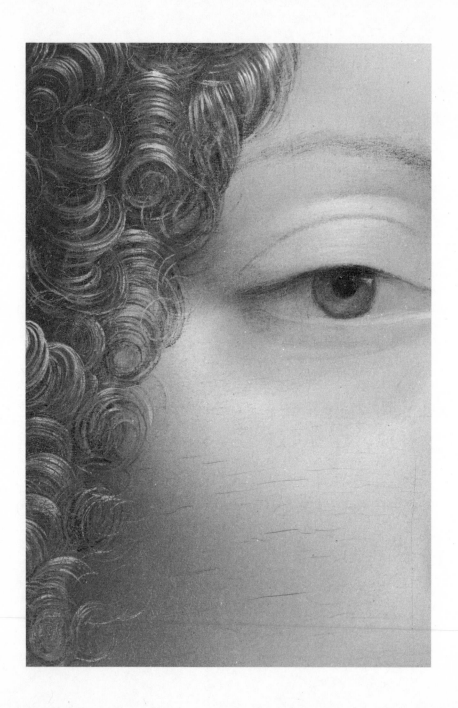

PREFACE

PAINTING IS FEMININE, or at least it is in the case of Leonardo da Vinci. From his early Madonnas (Plates 1 and 2) to the late *Virgin and Child with Saint Anne* (Plate 23), from the first portrait he painted, *Ginevra de' Benci* (Plate 9), to the *Mona Lisa* (Plate 28), the main figures in Leonardo's paintings are women. Only two men are featured as protagonists in the surviving panel paintings that are definitely by Leonardo. One is *Saint Jerome* (Plate 14), the unfinished picture of an old man praying in the desert as he struggles to renounce worldly temptations. The other is the *John the Baptist* (Plate 29), which Leonardo painted at the end of his life, where the youthful subject is both self-assured and sensual. We would have to include all the disciples in the fresco of the *Last Supper* (Plate 19) and all the figures of the baby Jesus in the images of the Madonna in order to reach anywhere near a balance between the sexes. Even Joseph did not manage to appear in Leonardo's paintings of the Holy Family; instead, the artist usually assigns his place to Saint Anne, the mother of Mary (Plates 22 and 23). Painted portraits of kings, popes, or princes are lacking altogether, as far as we know; he left us only a sketch for one portrait of a ruler, which also shows a woman: Isabella d'Este, the marchioness of Mantua (Plate 20).

Leonardo da Vinci did more for the visibility of women than any other painter. In the twentieth and twenty-first centuries he has been perceived in a different way, however, as a technical pioneer who anticipated the inventions of the modern era with his drawings of flying machines, weapons systems, and lifting devices. Yet this is too one-sided. Leonardo enjoyed designing all kinds of machines on paper, but they were hardly ever built. If these feats of engineering had been the most important thing in his life, he would have been a failure.

Leonardo's machines make up only a small part of his vast body of drawings. He worked extensively on human anatomy, geological history, and the growth of plants, and constantly returned to his great passion, the movement of winds and water. He drew in order to understand the world, and he sought to understand the world in order to paint it. For him, painting was the greatest of all the sciences and the defining medium of his age. At the easel, man becomes a creator and can feel his kinship with Mother Nature, the great creator. If Leonardo sometimes struggled in the studio, adding brushstrokes very slowly one by one, it was because he was thinking so deeply about what he wanted to paint and how to depict it. He was a philosophical painter, as his amazed contemporaries remarked, a man who worked because he was interested in understanding things and because he had something he wanted to tell people.[1]

The knowledge at the center of Leonardo's painting is the knowledge of women. Even in antiquity the painting of a beautiful woman was evidence of a painter's skill. Her power to seduce was also his. Leonardo once gleefully recounted how viewers rapturously kissed the women in his paintings.[2] Up until his time, young ladies in Italian portraits were depicted only in chaste profile. Leonardo was the first to turn his female figures to face the viewer, allowing an intimate dialogue between them. Leonardo's women have a soul and a strong will; they move in space and time; they are beings in their own right in an age when women had no rights. Leonardo's *belle donne* have what the poet Petrarch once found lacking in portraits of women: "voce ed intellecto," voice and intellect.[3] Together with his female models, the artist revealed the independent, self-assured woman, and in his works she became man's equal.

Leonardo da Vinci was not a feminist; this concept simply did not exist around 1500. He did not fight for equal legal and social rights for women, because there were no such struggles in Renaissance times. However, there was a lively debate about whether women thought in the same way as men, and whether or not they could love. As can be understood from Baldassare Castiglione's *Book of the Courtier*, this was the subject of discussion between the enemies and supporters of women.[4] Some men with a humanist education despised women and thought of them as objects, while others respected and admired them. In his writings, drawings, and paintings, Leonardo da Vinci positioned himself on the side of women, so his art developed a feminist power centuries before the emancipation of women. For him, women's ability to feel, think, and make decisions was beyond question. He therefore warned men that

they should not be inconsiderate in their attitude toward sex, because women must be able to feel desire during the sexual act so that the child they deliver will be understanding, intelligent, lively, and lovable.[5] For Leonardo, women's ability to give birth was an act of creation. They were creators, and in his opinion, painters are also creators, because they produce something new in their art. That is also why he felt so close to women.

By allying himself with women, Leonardo also emancipated art. It was no longer a wish machine for clients but had an intangible life of its own. His Mary is at peace with herself, not subject to an annunciatory angel, and his paintings were not subject to the wishes of his patrons. Leonardo kept the paintings that really meant something to him in his home until the end of his life. These included the *Mona Lisa* and the *Virgin and Child with Saint Anne*. Both works combine the feminine with the history of nature and the earth, which the artist displayed in background landscapes. In Leonardo's opinion, an individual woman can stand for the whole of nature, because she shares with nature the gift of giving life. This ability to keep making a fresh start enables the human race constantly to redesign its existence. The bird lover, hill walker, and vegetarian treats uncontrollable nature, with its seas and cliffs, its animals and plants, with deep respect, and Leonardo demanded the same from the viewers of his art.

So the idea that Leonardo's drawings of armored vehicles and plans for diverting rivers mean that he wanted to subjugate the world is erroneous. Yes, he went to war and accompanied the butcher Cesare Borgia on a campaign of conquest. However, he quite openly condemned what he saw. He referred to war as *pazzia bestialissima*, a most bestial madness, and used it in his cartoon for a painting of the Battle of Anghiari, which concerned the hopelessness of violent conflicts.[6]

The distorted image of Leonardo as a "techie" and the ideal model of a virile man goes back to a Leonardo exhibition in Milan, in 1939, at the start of World War II. The Italian dictator Benito Mussolini, who declared himself to be the "greatest living Italian," wanted this exhibition to celebrate the "greatest Italian of the past."[7] Models of Leonardo's machines that were never built in his lifetime were exhibited for the first time, and his deeply humanistic nude drawing of the *Vitruvian Man* (Ill. 21) in a circle and a square was now said to represent the technophile man of the future, who has almost become a machine himself.

The image of Leonardo as the unrelenting rationalist continued to have an effect after the end of the fascist period. In the late twentieth century it was still influencing the pioneers of the computer industry, who discovered Leonardo's designs when they were on the lookout for a forebear, and subsequently claimed him as their own, although no longer the warrior but Leonardo the engineer and technical visionary (this was probably the reason why, in 1994, Bill Gates bought Leonardo's scientific manuscript, the Codex Leicester).[8] A gap still remained. Leonardo's women, for whose presence on the stage of art and natural history the artist had done so much, were ignored and overlooked. And one more thing has fallen by the wayside: the realization that, in his old age, Leonardo reinvented the male image, creating figures that were just as sensual, self-willed, and close to nature as his women.

The year 2019 marked the five hundredth anniversary of Leonardo da Vinci's death. It is time to look back without prejudice, examine his paintings and drawings, read his texts, and listen to him and the contemporary witnesses who knew him personally.

This biography of the artist does that through detailed study of the sources. As well as Leonardo's artistic works, there are analyses of his writings on art and nature, unpublished in his lifetime, and his diary-like notes on everyday life. There are also letters and statements from contemporaries, legal documents, tax and court records, and other papers. This wide range of evidence enables us to make a critical examination of later judgments, such as those of the art writer Giorgio Vasari. (Information on the sources, with the original Italian and Latin quotations, as well as references to the status of art history and historical research, can be found in the notes at the end of the book.) In addition to Leonardo's life and works and the art of his time, the book deals with the sociohistorical and political circumstances during the period when this exceptional artist was active. For instance, the first chapter is about Leonardo's early Madonnas and also the role of mothers and their infants in the Renaissance, while the fourth chapter shows, on the one hand, how love was celebrated in Florence in richly symbolic spectacles and, on the other hand, how men who loved men were persecuted.

Leonardo da Vinci was the illegitimate son of a notary and a simple peasant woman. In consequence, he was denied a higher education. As a young man

he was once accused of sodomy—homosexual activities. His origins and his desires made him an outsider in society. However, this appears to have proven fortunate. Instead of living in a patriarchal family structure, he lived with his pupils and lovers in a home and work community. He put orthodox opinions to the test. He went his own way, took nothing for granted, drew and painted, researched and wrote whatever came into his head. As a result, he was able to empathize with his figures, both female and male, and also to follow the birth and death of nature. This is not a story of a virile male genius and female victims; it is about a vibrant, creative collaboration. The artist's enormous inner freedom, his boundless imagination, and his ability to project himself into the minds of others constitute the universality of Leonardo's creative work.

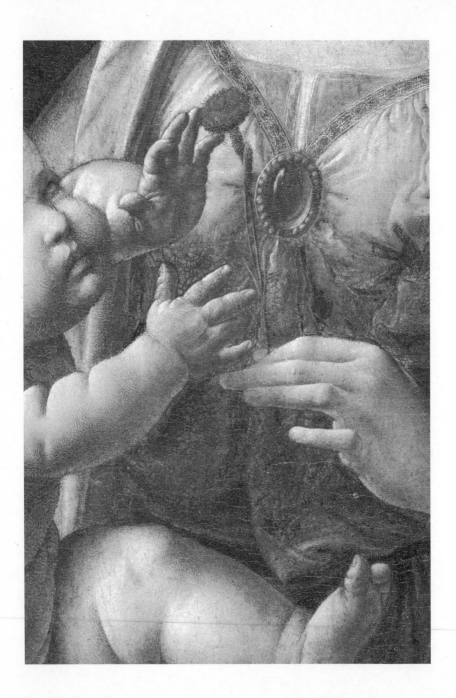

I

CHILDHOOD

HE IS THRIVING. He is well fed, alert, and loved. The surprisingly large infant is sitting naked on a comfortable velvet cushion. His mother has such a firm, secure grasp on his back that her fingertips leave an impression in his baby fat (Plate 1).[1] No harm can come to him—or so it seems. His left leg is kicking out, as if he wanted to try his strength against an imaginary opponent. But there is nobody there, just the two of them in their dark, almost cave-like, palazzo with round-arched windows that reveal the view of a shimmering blue mountain landscape. Warm light falls on the plump body of the infant, emphasizing his muscular torso and almost hairless head, but more particularly it sculpts the bright face of the young mother and the low neckline of her dress. She is beautiful, with reserved, still-girlish features, a small mouth, and lowered eyelids under high, fair brows. And she has made herself look beautiful. It must have taken hours to braid her hair like this with not a single strand falling over her forehead and carefully controlled blond ringlets tumbling out on either side of her cheeks from under a narrow veil, framing her angelic face. Her deep blue robe is fastened with a transparent, shimmering rock crystal, and below its trimming of gold-embroidered braid, it gathers in wrinkles over her small breasts, which the infant is presumably still suckling.

However, unlike the child, the mother is fully clothed. Under her mantle she wears a high-fastening red gown with gathered sleeves, and she has a patterned silk shawl draped around her shoulders and back and hanging down to her lap. The many lengths of fabric seem slightly antiquated, as if the late

fifteenth-century wearer were longing to be back in the ancient world. However, this is of no interest to the little boy. She is his mother and she is there for him. He is happy to join in the game she is proposing. She has the stem of a carnation in her left hand, holding it where he can see it. He stretches out both hands, concentrating and trying to grasp the red flower, without touching it immediately. It seems as if he knows what he is doing; as if he is determined to look at the carnation—his destiny—and take possession of it. He is much too serious for his age. How could it be otherwise? His name is Jesus Christ, and he will not outlive his mother but will die for humankind in less than thirty-three years, before the eyes of the people, crucified with nails that are almost as large and long as the stalk of this carnation. The blood-red flower tells of the love of God, his father, which will eventually lead to the Passion of the son, who is Mary's only child. Yet, despite everything, the young mother in the painting shows no fear. She is enjoying her intimacy with the vigorous boy, her own beauty, and the peace of the palace. This moment belongs to her and her baby.

But not entirely. However much Leonardo da Vinci imagined himself in the position of his protagonists when painting this little work from Florence, he was also thinking of the people who would look at this painting, both in his own day and at any time in the future. One of the first was Giuliano de' Medici, the younger, somewhat impetuous brother of Lorenzo de' Medici, the ruler of Florence. Their family emblem was five red balls and one blue ball on a shield; the inconspicuous glass balls dangling from the boy's cushion may be a reminder of these. Also, the modern window arches in the painting are similar to those of Giuliano's Palazzo Medici. In the bottom right of the painting is a delicate vase of flowers—a symbol of Mary's purity—that particularly appealed to Leonardo's biographer, the sixteenth-century Renaissance painter and writer Giorgio Vasari. He reported that the painting had come into the possession of Pope Clement VII, an illegitimate son of Giuliano de' Medici, who had probably ordered it directly from the artist. A commission from the Medici might explain Leonardo's extravagance: the gold, the fine layers of paint, and the care he took.[2]

This image of the Madonna is one of the first paintings known to be from Leonardo da Vinci's own hand. At the time of its creation around 1475, the artist was a young man in his early twenties with long, curly hair and was already a full member of the Florentine painters' guild. He was still living and working at his master's studio, either out of loyalty or because he was not receiving enough commissions on his own account in a city teeming with art and artists.

Leonardo's master, Andrea del Verrocchio, ran a flourishing workshop in the Via Ghibellina, just a short walk away from the city hall, the Palazzo Vecchio. The district was bustling with craftsmen and traders offering their services in the narrow streets. Artists usually worked in a large windowless room on the street; the door would stand open, inviting passersby to look in. For cooking and sleeping, the artists' families and apprentices would withdraw to the back rooms or the upper floor.

Andrea came from a family of brickmakers, and for him art meant a rise in social status. Before devoting himself first to sculpture and then to painting, he trained as a goldsmith. He was so grateful to an elderly master of this craft that he adopted his surname of Verrocchio. By the time Leonardo arrived, the rich and powerful were regular visitors to Verrocchio's workshop. Andrea, Leonardo, and the other assistants could turn their hand to anything. They carved in wood and stone, cast bronzes, made armor, painted, and supplied decorations for banquets, theater scenery, and complete interior furnishings for noble palaces. For important commissions Andrea collaborated with masters who joined with him, including the young Sandro Botticelli, who would soon become famous.

The Medici and other noble lords were regular customers of the workshop. In the Via Ghibellina, a bagful of gold could buy you everything you might need for a stylish life and death, from traditional birth plates to marriage chests and gravestones. The only art Verrocchio would not touch was fresco painting, the specialty of Andrea's rivals, the Pollaiuolo brothers, who were smarter than the sculptor in this area.

Images of the Madonna on poplar wood were part of Andrea del Verrocchio's standard repertoire, but none of those emanating from his workshop was as refined as the young Leonardo's *Madonna of the Carnation*. His model was probably the same girl who sat for Verrocchio, or at least he adopted the latter's ideal of beauty of a feminine young woman seen face-on, with her hair artistically braided. Like all Andrea's pupils, Leonardo had spent years copying his master's drawings of female heads in pencil and ink on paper or with metal styli on cheap wood (see also Ill. 35).[3]

Yet despite all the elegantly proportioned girlishness, despite all the desire for harmony, Leonardo's Madonna is different. Her emotions are restrained; she is strikingly pensive, yet she knows precisely what she wants when she gives the boy the carnation. The painting is not a mere snapshot; it illustrates a whole story, an interaction between two beings who are intimately connected yet have independent feelings.

In parts of the painting the artist experimented with oil paints, which dry very slowly, unlike classic tempera pigments bound with egg yolk. This makes it possible to apply a further layer of color on the wet paint, so that the shades merge into one another. This small painting was highly experimental as, although the Florentines already knew about oil paints and occasionally used them, the technique there was nowhere near as well developed as in Flanders.

Leonardo was delighted with the natural effect of paints bound with oil. In this painting of the Madonna, one of the techniques he developed was the art of gentle transitions between light and dark. However, he was not yet certain how much oil he needed to use when mixing the paints. His master, Verrocchio, could not tell him, as he had only just begun painting himself and preferred to keep to the long-established Florentine technique of tempera painting. As a result, Leonardo chose the wrong mixture, and the Madonna soon developed deep furrows that still make the surface of the painting look rough today.[4]

Leonardo used this soft shadow play to place mother and son in the here and now of the palazzo, freeing them from the sense of remoteness that often envelops older images of the Madonna. They are enclosed in a dark, protective space, yet it is not in any way a prison, as it reveals a view of the distant brightness of God-given mountain peaks, of a kind rarely found in Tuscany, but probably plentiful in the artist's imagination. Distance and nearness are interdependent, in the same way as light and shade, life and death, nature and art. Leonardo was a young man, not yet worldly wise, but with a conception of the world as a whole that is reflected in the ordinary individual.

Leonardo later wrote, "A good painter is to paint two main things, namely, man and the intention of man's soul."[5] However, "man" in this context is definitely not always male as far as Leonardo is concerned. Quite the opposite. In the 1470s and 1480s it was mothers on whom he first tested out his fundamental conviction that the emotions of the soul and the spirit are expressed in the movements of the body.

With a few strokes of the pen, the artist committed to paper a youthful mother walking along with her braided hair fluttering as she goes. She has to use her upper body to counterbalance the weight of the sturdy infant in her arms. The child has spotted something on the road in front of them and is looking and pointing down at it. The mother does not want to dampen the child's curiosity, but she has her

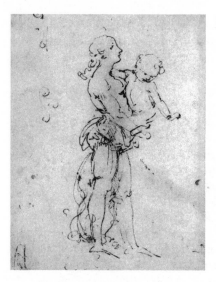

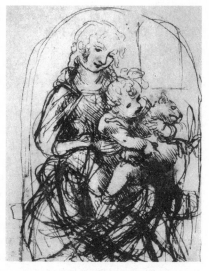

Illustration 1. Leonardo da Vinci, *Study of a Young Woman with a Child*, British Museum, London

Illustration 2. Leonardo da Vinci, *Study for the Virgin and Child with a Cat*, British Museum, London

own purpose in mind and counteracts gravity as kindly as she can.[6] A child wants to move and must do so; it may be small, but it has a mind of its own (Ill. 1).

In the Renaissance period and for a long time after that, babies were bound so tightly in swaddling bands that they could no longer move their arms and legs. That was evidently not to Leonardo's taste. He advised painters to take an affectionate look at the clumsiness of small children: They should paint "[l]ittle children, with lively and contorted movements when sitting, and, when standing still, in shy and timid attitudes."[7] He was fascinated by unbound boys discovering the world from the safety of their mothers' arms.

In another drawing, the world is a domestic cat, not dangerous, but not easy to control (Ill. 2).[8] A boy is trying to hold on to it, but the cat has no intention of being a plaything and has half escaped from his unwelcome curiosity. His smiling mother holds both of them on her lap, which is shaded by strong hatching. She does not intervene; the child must experience things for himself

and discover that the world does not always do what one wants. From his mild gaze, it seems that the boy has now realized that he must be as patient with the self-willed cat as his mother is with him.

Only those who experience love can love others. This was not considered a matter of course in Renaissance times. Lively debates about whether women were capable of loving at all were still raging in the sixteenth century. The tendency was to say that they were not. They could only coolly refuse or humbly accept; the full range of emotions was reserved for men. However, as well as the few eloquent female writers who raised their voices later in the High Renaissance, there were always male humanists who contradicted the prevalent view and considered that women were capable of loving.[9]

In painting there was at least one feminine feeling that could not be questioned: motherly love, which was extolled in an image of the Madonna on the wall of almost every home. Besides its religious meaning, this most beloved of all subjects also had an educational purpose. Boys should model themselves on the boy Jesus and the young John the Baptist, take pleasure in them and emulate them. Girls should learn from Mary's chastity and bear in mind her future role as a mother, which was a woman's true purpose in the world of Renaissance thought. Brides were given Jesus dolls at their wedding, in order to practice motherhood.[10]

In many paintings (and not only in Leonardo's milieu) the baby Jesus is suckling at his mother's breast.[11] Both priests and humanists avowed that breastfeeding established the bond between mother and child. It was said that the father left his mark on the body and mind of his offspring through his seed, whereas the mother's contribution was to nourish the child, first in her womb and then, after giving birth, with her milk. According to the beliefs of the time, this was produced from the menstrual blood that had collected in her body during pregnancy; even Leonardo continued to accept this medieval misinformation for a time.

However, the joint responsibility of parents for the child remained largely theoretical. In practice, the role of the mother counted for very little, whereas the father's contribution was everything in a society where male succession was absolute and women had no rights over their children. The fine words about the "tender emotions" of the Mother of God while breastfeeding and her "delight" at feeding her son (according to a thirteenth-century preacher) went unheeded.[12]

The majority of prosperous Florentine women did not breastfeed at all. Instead, their husbands made agreements with the spouses of the wet nurses

who took over this task. Fathers were concerned that their wives' milk might be polluted by having sex and, above all, by a new pregnancy. They wished however to become fathers again soon, as having several children increased their chances of having future heirs. It was important for men's social status to have many legitimate offspring, whereas an intimate mother–child relationship in early years seemed to many of them to be of secondary importance. The rich fathers expected the parents of poorer families to abstain from sexual intercourse and inform them immediately if the wet nurse got pregnant again, which would result in the termination of the agreement.[13]

In the fifteenth century the custom of handing babies over to a wet nurse soon after they were born, contrary to all good advice, was followed not only by the very rich but also, according to their account books, by lawyers, artists, merchants, and doctors. The only question was what kind of wet nurse they could afford—whether she would live in the family home, as was usual in rich families, or elsewhere, and whether she had just recently given birth (which was considered an advantage) or whether it was a long time previously. The economic pressure on the families of the wet nurses was so great that many of them entrusted their own newborns to an even poorer wet nurse or gave them away to the Foundling Hospital in Florence that was opened in 1445. A merchant's wife from Prato who arranged wet nurses for the newborns of wealthy families cruelly boasted that she had forced a woman to promise to become wet nurse to a strange child on the very night that her own baby had died.[14]

Many children died in the care of these substitute mothers. In order to prevent this, the biological parents provided them with lucky charms in the form of crosses, holy medals, or wolf's teeth set in silver. However, especially when the wet nurse lived some distance away, the father and mother were soon out of contact and no longer had any control. It was easier for the nobility, who had their children nursed at home. Many of them could afford to buy female slaves as domestic servants. These were Tartar, Bulgarian, Russian, Mongolian, or Greek women who were kidnapped and sold in seafaring cities. Many of the men of the house subjected these women to brutal sexual exploitation, sent the children they had together to the orphanage, and then demanded that the slaves should breastfeed the legitimate offspring in the home. In the end, the scholarly idea that a woman's milk determined the character of a child counted for almost nothing. In practice, the wet nurses did not have to be free women or of Christian upbringing; it was enough if they were fair-skinned, like the slaves from the east.[15]

The idea that it could be otherwise, that breastfeeding was close to a mother's heart and important for the child's development, was professed by Renaissance philosophers such as Leon Battista Alberti, and later Erasmus of Rotterdam and Michel de Montaigne, who were looking back to Plutarch and other writers from classical antiquity. However, it was mainly artists who made the Florentines aware of how intimate mother love could be through their images of the Madonna. Their beautiful paintings portrayed not the reality but the Florentines' unacknowledged longing for maternal care in addition to paternal power. In the guise of religion they brought long-suppressed knowledge into the home and explained the emotional value of social bonds, which could not be measured in terms of money.

Soon it was the artists themselves who spread the gospel of mother's milk. In the sixteenth century, when Giorgio Vasari described the lives of the great Renaissance artists, he also looked for explanations for their talent in their early childhood. In Vasari's opinion, Raphael's father was a painter "of no great excellence." What had been good for the young man's character was not his father's ability but the special parental care he received. Raphael's father had wisely decided that the boy should be suckled by his mother, so that "in his tender years he should have his character formed in the house of his parents, rather than learn less gentle or even boorish ways and habits in the houses of peasants or common people."[16] According to this principle, a baby sucks in nobleness of heart with its mother's milk.

Michelangelo Buonarroti, who was suckled by a wet nurse, also glorified breastfeeding. The sculptor had a love–hate relationship with his biological father, who attempted to beat his desired profession out of him during his boyhood. Michelangelo traced the fact that he nevertheless became an artist back to the good influence of his wet nurse, who was married to a country stonemason. He owed his talent in dealing with marble to the parents with whom he was put out to nurse, wrote Vasari, quoting Michelangelo: "I also sucked in with my nurse's milk the chisels and hammer with which I make my figures."[17]

What about Leonardo da Vinci? He was fascinated by early childhood development. Especially as a young man, but also later, he worked intensively on painting and drawing Madonnas (Plate 2).[18] The harmonious bond between mother and child is evident, and so is the way in which the actions of Leonardo's baby Jesus show that he nevertheless has a mind of his own. He is not a tool of a higher power; he is a small human being, and she is a larger one. Leonardo was also preoccupied with his own childhood. All his life he

remembered details: the hilly landscape, a particular bird, the women's clothing. It sometimes seems as though he were taking a nostalgic look back at his own past in his painting, as if the subject of the Madonna and Child awakened memories of a lost paradise of early childhood.

When Leonardo was born late in the evening of April 15, 1452, in the small Tuscan town of Vinci, home to a mere 400 people, it was a day of great joy for his family, but also of great shame, as his parents were not married. His mother, Caterina, was an orphan from Vinci who had been left to fend for herself with a very small brother and with no dowry to enable her to marry like other teenage girls. She came from a line of small-scale farmers, and her family owned a minor landholding that, after their parents' death, had been inherited by her two-year-old brother and was very rundown. Apart from a distant cousin and his wife, Caterina had no other living relatives when, at the age of fifteen, she became involved with Leonardo's father, Piero da Vinci.[19] He was in his mid-twenties, the eldest son of a respected family of notaries whose heraldic animal was a winged lion. In Vinci, the place from which they had taken their name, the family belonged to the wealthy top 4 percent who owned relatively large estates. Piero was already working as a notary in Florence, which earned him the honorary title of Ser Piero. The family was held together by Leonardo's grandfather Antonio, a prosperous country gentleman who enjoyed the rural peace and quiet in Vinci and liked to spend his leisure hours playing board games.

As the patriarch, Antonio made the important decisions, and it was he who arranged for his newborn grandson to be baptized in Vinci on the day after he was born. Ten respected ladies and gentlemen from the town were asked to be godparents. The firstborn of his son Piero was not to be abandoned to his fate with his single, penniless mother or grow up in the orphanage. Antonio and his wife, Lucia, took care of him personally, so the boy would not upset the plans of his father, Piero, who was due to marry Albiera, the sixteen-year-old daughter of a notary, in the same year. Caterina was also cared for. Evidently, Antonio provided her with a dowry and arranged a marriage with a young lime-burner, whose family owned some land in Campo Zeppi, a hamlet near Vinci. The two families remained in occasional contact for decades. Leonardo's stepfather, the lime-burner, later made himself available to Ser Piero to witness the signing of his contracts, and in return the notary arranged the marriage contract for one of the couple's daughters.

Maybe this arrangement spared Leonardo the customary separation from the mother immediately after birth. Maybe Caterina suckled the boy herself, as mother and wet nurse at the same time. Piero had no reason to relieve the girl of the strain of breastfeeding, as he would have done in the case of a wife befitting his own rank. It is possible that Leonardo was allowed to remain with Caterina at least until her marriage the following year; Caterina could have been a regular visitor at his grandfather's house or even taken the baby home with her from time to time. It was not until two years after Leonardo's birth that she got pregnant again and gave birth to a daughter.

At any rate, as a five-year-old, the boy was living in the well-furnished home of his paternal grandparents. This can be seen from their tax declaration. Meanwhile Caterina's husband's tax documents say that, although the couple were producing some wheat and wine, they were generally living in modest circumstances, with what were soon to be five legitimate children.

Leonardo had certainly not lost sight of his mother in the little town of Vinci, but their contact did not remain as close as it had probably been at the start. The boy grew up without his biological mother.[20]

Much later, when Leonardo was already over forty and running his own workshop, he suddenly recorded in his documents the arrival of a Caterina in his household. His mother had just been widowed at that time. Two years later Leonardo soberly noted the costs of this Caterina's modest funeral: He bought three pounds of candle wax, as well as a bier with a canopy and a bell; a cross had to be erected, and gravediggers, priests, and choirboys paid. As so often in his notes, Leonardo avoids personal comments here, so there is no proof of what was very likely the case, that it was his mother, Caterina, who spent her last years in the house of her firstborn.[21]

Maybe the painter acted out of sympathy and family feeling, but perhaps he also wanted to make up for what he had once lost: an everyday mother–son relationship.

An illegitimate birth was a stigma in Renaissance Italy.[22] Families were the smallest and most important units of society; they—and, within them, the fathers—made the decisions about education and the choice of career and partner. Anyone who was born illegitimate never really belonged. Anything that such a child received was a favor. There were fathers who treated their illegitimate

children as servants, especially when the mothers were slaves or maidservants. Others, like Ser Piero, took care of their natural sons (though not usually daughters), because they saw them as a reserve, in case they had no surviving legitimate sons. This "insurance" was worth the cost of an education, though as a rule it was less than for legitimate sons.

When the natural children reached adulthood, they had no claim on their families. While it was not easy for a father to disinherit his legitimate descendants, illegitimate offspring had to be explicitly included in his will, and even then it was likely that legal arguments with other relatives would arise after his death. That is what happened in the da Vinci family. In his third and fourth marriages the father sired another fifteen children, by which time Leonardo had long since reached adulthood. Ser Piero had nine sons who were legitimate heirs, so his firstborn came away empty-handed—and despite the fact that his favorite uncle, Francesco, who had died childless, had bequeathed all his possessions to his oldest nephew, Leonardo spent many years in legal battles with his half brothers over this inheritance.[23]

Anyone who was born illegitimate in and around Florence had to make his own way in life and work hard to acquire the social recognition that might make people forget his low status. However, this fate was not unusual. In Florence it was customary for the daughters of middle-class and noble families to marry young, whereas men did not marry until ten or twenty years later. That gave them a long time in which to sire many illegitimate children with lower-class women.

Leonardo was relatively fortunate; besides his grandparents, he was also aided by his first stepmother, Albiera.[24] At first, when he was his father's only descendant, he grew up in the shelter of the family's large country house with its vegetable garden and view of the castle of Vinci. His father, Ser Piero, spent much of his time in Florence; his business flourished, and he moved into city apartments in increasingly prestigious locations and began wearing reddish-violet cloaks like a nobleman. He probably saw his son quite rarely. However, Ser Piero's brother Francesco, who was only fifteen years older than Leonardo, lived in the neighboring house to Leonardo's grandfather and enjoyed spending time with the boy.

Whether it was because he lived in the country or because he was not a legitimate, overprotected child, Leonardo enjoyed considerable freedom in Vinci. He drew a great deal, especially with his left hand. He was also able to wander freely

through the countryside and romp about with dogs and cats, and he probably learned to ride. He had all the time in the world to contemplate clouds, hunt birds, and catch lizards and other creatures. He was interested in everything. Gazing in wonder, he absorbed country life, examined an oil mill, studied the flow of water, and watched the women weaving willow baskets—the occupation that gave the place its name, as Vinci comes not from *vincere*, the Latin verb meaning to conquer, but from the Old Italian word *vinco*, meaning willow.

Being an only child, Leonardo probably did many things on his own initiative. He later wrote that one must be open to nothing but nature in order to understand it properly. For him it was a matter of understanding why things are as they are. As an adult he would always carry a notebook with him in order to record his everyday observations. He would muse over the flight of birds and whether machines were capable of replacing muscle power. He devoted himself to the question of why dogs sniff each other's backsides (Leonardo thought it was because that was where they could smell how well fed the other animal was).[25] He tried to read clouds and understand the laws of water. He liked to say that nature was his teacher, and, using his extraordinary gift for observation, he filled his imagination with as much as others learned from long years of study.

What else was left for him to do? As a boy, he went to school, wrote, did sums, and read a few modern texts. However, he did not learn classical Latin, because after the secondary school where pupils were prepared for commercial professions, his father took him out of education. Evidently, it seemed to him that the higher-level classical education, which was a requirement for study and a legal career, was too much of a good thing, especially as it was a prerequisite for legitimate offspring in order for them to become notaries.[26] His son was to take up a skilled trade and quickly make his own way in the world. Ser Piero turned to the versatile workshop manager Andrea del Verrocchio, who was a good customer of his. Verrocchio thought that the fourteen-year-old had talent and took him on. Thus, in around 1466, Leonardo began his working life in the best studio in the city.[27]

Although this was evidently also Leonardo's own choice, as he drew a great deal and enjoyed doing so, the lack of academic education gnawed away at him for many years. Much later he taught himself Latin and assembled and read a considerable library, but he still had a feeling of being flawed, the second-class son of a notary.

Years later, when he had long since achieved some success in life, he suspected that "arrogant" men who had studied at university despised him, because he had learned no ancient languages at school. So he went on the offensive. He wrote

that he was proud of being an "inventor," a man who believed only what he had seen with his own eyes, the "straightforward experience" of the "true teacher." By contrast, well-read people seemed to him to be "puffed-up and pompous"; "they begrudge me my own work." They "should be criticized because they invent nothing themselves but glorify and repeat the works of others." Equally contemptible were "people who crave only material wealth and pleasures and know nothing of the desire for knowledge, the food and the true riches of the soul." His secret was to behave like a poor man who is the last to go to the market and takes what others have left—namely, what can be seen and grasped in the hands.[28]

Stubborn and certain of victory, sometimes downright arrogant, Leonardo trod his own unique path. Had he been a legitimate firstborn son, this would not have been possible for him. Without the "shame" of origins unbefitting his station in life, Leonardo would probably not have devoted his life to his studies of nature, his inventions, and his art, or struggled to make a reputation for himself from them, but would have striven only to uphold the reputation of his family. His unconventional individualism may have been a compromise solution, but it was a solution all the same. Yet Leonardo's particular path also brought with it a certain isolation. As a young man, he learned the rules of conversation. He appeared adaptable in company, likeable, amusing, and courteous when necessary, but he did not reveal what was in his heart. His surviving notebooks amount to 5,300 pages, but if he expressed his feelings and his private thoughts, they were encoded in general words of wisdom. These sometimes sound sad. "Experience has shown that those who trust nobody are never betrayed." And "The passion of the mind drives away lust." Or: "As soon as you are alone, you are your own man, and when you have a companion, half of you belongs to yourself, and even less in proportion to the tactlessness of his behavior."[29]

As a writer, Leonardo da Vinci remains cool and impersonal, hard on himself and on others. As a person, he placed his trust in only a few people, mostly pupils he was close to. However, as a draftsman and painter he was full of empathy, an artist who pursued the spiritual in its finest ramifications. His understanding was centered on two things: nature and women. From today's perspective, this bond may not necessarily appear any more apparent than that of human beings and nature in general, but, in Leonardo's eyes, nature was a female force and women had a wondrous power that interested him throughout his life: the gift of giving life.

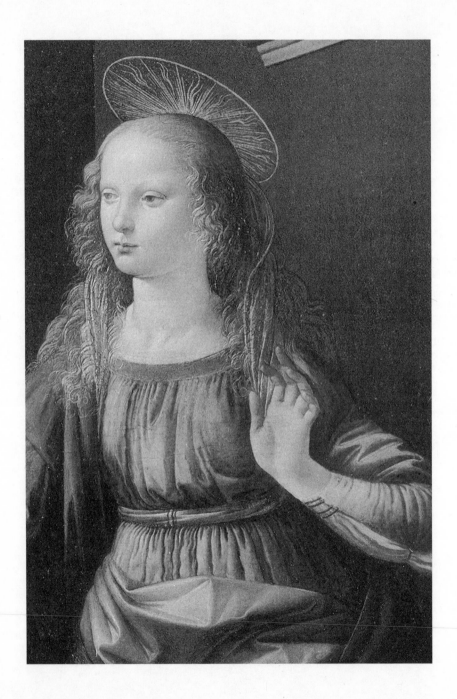

II

BOYHOOD IN THE COUNTRY

FLORENCE DURING THE Renaissance was not green and airy; it was crowded and noisy. Oxcarts, mules, and passersby pushed their way through narrow, foul-smelling streets, which were as dark as tunnels, because many of the householders had added oriel windows to the upper floors. Buildings were going up everywhere. Workmen pulled down old, cramped dwellings and carted in building materials for palaces until these became a scarce commodity. Many of these new houses were as big as castles. One could lose one's way for hours in their suites of brightly painted rooms. During the fifteenth century rich Florentines grew even richer, while the poor became even poorer.[1] Wealthy families also cut themselves off from the city. Where their palazzi would once have opened on to the city with a loggia, they now looked inward over magnificent interior courtyards where social events took place.

Although only around 2,000 of a population of some 50,000 were wealthy, and few were extremely rich, they vied with one another in displays of magnificence. Their clothes were as elegant and colorful as their freshly decorated family chapels. Their estates were filled with portraits, statues, gold and silver jewelry, wall hangings, fine furniture, precious books, and manuscripts. There was plenty of money about, and in contrast to the preceding centuries, it was no longer considered shameful to spend it in a way that all could see, instead of practicing pious modesty.

The city's currency, the florin, was linked to the value of gold and worth a fixed amount throughout Italy. The city was home to dozens of banks whose

influence affected the European financial system. They enabled people to cash checks, obtain loans, and exchange currencies. Tuscan investors put their money into ships' cargoes or bought shares in companies trading all over Europe. Money no longer had to be made from agriculture or production; now it could also be increased through speculation. Given the right conditions, citizens with a decent inheritance or noblemen could amass the kind of wealth that had previously been possible only for sovereigns and high dignitaries of the Church.

Florence was a center not only for finance but also for textiles. Fabric production flourished on the banks of the Arno. There were more than eighty Florentine workshops making silks and brocades and hundreds of businesses close to the river, all working at full speed. Dyers, tanners, wool-carders, weavers, sewers, and furriers supplied goods for export. Royal courts in Italy, the Low Countries, and England ordered cloth and furs from the city, and in the great markets in the center of the city locals and travelers could buy anything from kid gloves to silk scarves from Baghdad.[2]

The artists in Florence had their hands full. They had long since stopped working only to order and were also producing for the open market. Gone were the days when painters and sculptors were undervalued artisans, whose names nobody noticed. The price of a painting was determined by size, subject, and material, and now also by the fame of the master and whether it was painted by his own hand or left to his assistants to complete. Successful painters' workshops comprised large teams. Nowhere else was the six-year apprenticeship as comprehensive as in Florence, but nowhere else was it as hard to make a breakthrough as a trained artist, as there were some forty artists' and fifty sculptors' workshops all competing with one another.

Apprentices began with unskilled tasks that taught them the basics of painting. They would spend all day grinding pigments on polished stones, mixing binders, and stirring up the pale priming mixture of size and plaster or lime. They also continually copied drawings from their teachers' sketchbooks before they were allowed to pick up a brush themselves and lay paint on plaster or wooden panels, following the preliminary sketches of their masters.

The young Leonardo also practiced painting watercolor drapery studies from clay figures he had made himself and wrapped in cloths soaked in plaster. He probably also learned bronze casting and carving, and he drew as much as he could. He was enthralled by the work and wanted to learn, understand, and try everything.

His father, Ser Piero, was pleased that the boy was getting on so well in Verrocchio's workshop and liked to make use of his newly acquired skills. Leonardo's biographer Giorgio Vasari said he had been told that one of the peasants from Vinci asked Piero for a favor. He had carved a shield from an old fig tree, and it now needed to be painted. The notary, who was always pleased to receive gifts of fish and birds caught by the peasant, took the crudely carved piece of wood to Florence and gave it to Leonardo, without mentioning the peasant, and asked the budding artist whether he could come up with an idea as a favor to his family.[3]

The son was always pleased to be of service to his father. He would have done anything in order to be recognized. He made a special effort with the shield, smoothing it with the help of a turner friend of his, then painting it carefully with a layer of plaster. Next, he pondered on what would be the highest expression of art and what would amaze Ser Piero. He could have painted something beautiful and pleasant, a harmonious subject. However, his relationship with his constantly absent father was evidently too tense, and he preferred to make a lasting impression on him by giving him a real fright.

According to Vasari, Leonardo collected monstrosities or things whose value he appreciated, whatever others might have thought of them. He kept two species of lizard locked in a room, as well as crickets, snakes, butterflies and moths, grasshoppers, and bats. He killed the creatures, cut them up and reassembled them, which seems not to have been something he would normally have done. The result was a hideous monster, apparently a beast spitting poison and breathing smoke, which he then painted on the shield. Shields decorated with the severed head of the mythical Medusa, whose gaze was said to have the power to turn her enemies to stone, were popular at the time. They conveyed a message about the power of images, and that was also the point Vasari was making.

However, Ser Piero did not contact his son again about the shield; evidently it was not that important to him. Leonardo grew impatient and asked his father to come and fetch it. Eventually, the notary knocked on the door of the workshop. Leonardo asked him to wait for a moment, darkened a small room, and placed the shield in the single ray of light. His father came in and was horrified. For a moment he really believed he was facing a monster. That was precisely the effect that artists had been boasting about ever since ancient times, claiming that the public believed in the art they produced and confused it with reality, so the work must be as real as the reality. Still according to Vasari, the son dutifully told his father that he had only shocked him in order to show him the quality of the

work, saying, "This work serves the end for which it was made; take it, then, and carry it away, since this is the effect that it meant to produce."[4]

Then Leonardo's father was proud of him and praised him. He took the embellished shield away and sold it secretly for a hundred ducats to a Florentine merchant, who allegedly sold it shortly afterward to the ruler of Milan for three times that amount. Ser Piero gave the peasant a new shield painted with a simple, pierced heart, a cheap, commonplace piece from the market.

This story is so similar to other well-known anecdotes about artists that it is quite possible, even probable, that Vasari simply made it up.[5] What is more, Leonardo had been dead for decades by the time he published the first edition of the artist's vita, in 1550. Nevertheless, as in fairytales, two motifs of Leonardo's life are compressed in this episode. One is disappointed love for his father, who gave him little in the way of money or affection and thought only of his own interests. This is coupled with a youthful mixture of curiosity, imagination, and energy that recognized no taboos. Leonardo wanted to employ all his powers to create something new.

Fortunately, Andrea del Verrocchio took more interest in Leonardo than Ser Piero did. The unmarried master was so inspired by the keen youngster that he probably asked him to pose for him. Shortly after Leonardo's arrival in Florence, Verrocchio created a statue of David, the figure with which Florence, as a medium-sized power, most liked to identify (Plate 3). The people of the city wanted to be like the youth in the Bible who triumphed over the giant Goliath—not paralyzed with fear but ambitious, curious, energetic, and innocent. In fourteenth-century Florence, David had ceased to be depicted as a bearded king and become the youthful challenger of Goliath. Verrocchio created his sculpture for the powerful Medici family, who sold the work a few years later to the city government of Florence to adorn the city hall, the Palazzo Vecchio. Verrocchio's gleaming bronze *David*, with its thin face framed in curls, has very individual features. It is easy to imagine that Leonardo, who was around fourteen years old in the mid-1460s, was that kind of promising, self-assured youth. Enter a slender, somewhat conceited lad in a close-fitting doublet, with his hand resting proudly on his hip, gazing mischievously out far above the wrinkled face of the severed head of his old enemy. His sword is held loosely in his right hand. Goliath's maltreated head at David's feet has no supporting function for the bronze and is merely a casually discarded trophy.[6]

Apart from bronze, Verrocchio mainly worked in silver, gold, marble, terra-cotta, and wood, all with great success. Shortly before Leonardo joined him, he had also begun to paint. He found it less inspiring than sculpture, but the market for paintings was growing, and this gave Leonardo the opportunity to become such a skilled assistant that it was not long before his master would entrust whole sections of paintings to him. When Leonardo was in his early twenties, Andrea assigned him the figure of the kneeling angel in a *Baptism of Christ* (Plate 5).[7] It was probably also during Leonardo's apprenticeship that Verrocchio once competed with his rivals, the Pollaiuolo brothers. They had painted the young Tobias who, in an incident in the Book of Tobit, is sent to collect a debt for his blind father and is accompanied on his journey by the Archangel Raphael. He advises Tobias to treat his father's eyes with the insides of a fish. Verrocchio also painted this story, and he showed what a trained sculptor could do as a painter. His two figures are more dynamic and three-dimensional than those of the Pollaiuolo brothers; Tobias and Raphael appear to be talking animatedly as they walk (Plate 4), though the landscape appears much more schematic than that of his competitors. Verrocchio was not a painter of nature.

It's possible that Verrocchio lost interest when the small painting was almost finished, or maybe he wanted to offer his favorite pupil a real challenge. Either way, it looks very much as if he eventually allowed Leonardo to paint Tobias's fish and his little dog,[8] as these two creatures have nothing in common with other animals painted at that time. The highly gifted painter knew exactly what an injured fish looks like; his work was obviously based not on examples of other paintings but on what he had observed at the fish market. There is blood flowing from under the bright, shiny scales, its mouth is open as if gasping for air, and its eyes glisten in desperation. It is only a fish, just a food animal in contemporary eyes, but the artist shows sympathy with the dying creature.

In contrast to the suffering fish, the little terrier is enjoying itself. It is trotting briskly along beside the angel with its velvety ears flapping in the breeze, and the silky curls of its white coat look freshly washed. The dog seems almost transparent, yet it catches the eye in the otherwise serious painting.

This is the work of a youthful animal lover who, as a child, wandered through the open countryside around Vinci with his eyes open. To Leonardo, the city

must have seemed like a cage by comparison. He sometimes visited a market in Florence and was so enchanted by the birds that were on sale that he bought some and released them. That story comes from Vasari, but it is true that Leonardo sympathized with birds.[9] He studied their flight and dreamed of developing his engineering skills so far that people would also be able to fly. And once, decades later—though this was probably no more than a figment of his adult imagination—he said that his earliest childhood memory was of an encounter with a red kite that opened his mouth in the cradle with its tail feathers.[10] Birds were more than mere animals for Leonardo; they were his alter ego.

At some point Leonardo decided to stop eating meat. His vegetarianism appeared rather odd in the eyes of his contemporaries, but it fits well with the view of the world and self-image of an artist who probably had a closer bond with nature than any other in the Renaissance. Leonardo's entire understanding of art is based on his deep respect for divine *natura*. Nature is the yardstick and model for his painting, yet in each of his works he seeks to outdo her once more. He later wrote, "The painter strives and competes with nature," and warns that "If you condemn painting, which is the only imitator of all visible works of nature, you will certainly despise a subtle invention which brings philosophy and subtle speculation to the consideration of the nature of all forms—seas and plains, trees, animals, plants and flowers—which are surrounded by shade and light." Painting, at least successful painting, is "born of nature—or, to speak more correctly, we will say it is the grandchild of nature; for all visible things are produced by nature, and these her children have given birth to painting. Hence we may justly call it the grandchild of nature and related to God."[11]

Leonardo leaves us in no doubt about whom he feels indebted to: nature considered as female power, and God in person. In his view, only women come as close to creation as painters because, just as artists give life onto panel and canvas, women can do so through pregnancy and childbirth. Leonardo's affinity with the feminine may be highly emotional and have its roots in his childhood, but it also has a theoretical basis.[12] He is on the side of the women in his paintings, because in his eyes he and they are both closely related to God and have similar gifts and opportunities.

Nature and women came together at an early stage in Leonardo's painting. Shortly after he was accepted into the Florentine painters' guild in 1472, he

painted a picture of a woman in the setting of a beautiful garden (Plate 6).[13] In the background of the painting is a shimmering mountain landscape, so pale that the mountaintops are almost indistinguishable from the sky. It is as if Leonardo wanted to prove to himself and everyone else that it is possible to paint air and light. The artist's brush enables the viewer to experience the supernatural. The woman is receiving

Illustration 3. Leonardo da Vinci, *Study of the Flood*, Royal Library, Windsor

a visit from an angel, a boyish figure with feathered wings like those of a real bird, whose hair curls as vigorously as the wind and waves in Leonardo's later drawings (Ill. 3).[14]

The archangel tells Mary that she will conceive the son of God. Gabriel approaches to a respectful distance and kneels down on the flower-strewn grass, which seems to bend in the breeze created by his flight. Then he extends a hand in greeting. In his left hand, he holds a lily, the symbol of maidenly purity and incidentally also a symbol of the city of Florence.

Mary is a delicate young woman with smooth skin, yet she reacts like an experienced lady. Her right hand keeps her place in the book she has been reading. Her little finger is crooked, as is often the case in paintings from Verrocchio's workshop. Her body, swathed in long robes, is turned away, but her brightly lit face is turned to look directly at the angel. She calmly raises her left hand in a gesture that might mean: Just a moment, let me think about what you are saying. However, she could also be returning the angel's greeting and signaling her calm consent to the event. Precisely because of this ambiguity, Mary's pose appears both spontaneous and commanding. This Mother of God is the mistress of the situation.

Not everything about the figure is correct in terms of perspective and anatomy. One of her arms seems too long, and we do not know from what viewpoint

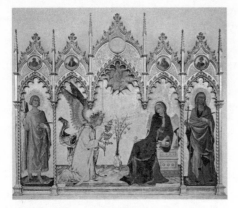

Illustration 4. Simone Martini and Lippo Memmi, *Annunciation*, Uffizi, Florence

we should be looking at her lectern. The proportions of the dark trees behind the garden wall are also not quite right. Maybe the original intention was that the picture should be viewed from the bottom right, which would make it appear more coherent. However, such beginner's problems do not stand in the way of Leonardo's concept. Mary and the landscape are lit by divine light, which replaces the dove of the Holy Spirit or the clumsily written text on older pictures of the Annunciation. Nature speaks for itself, and this Mary is clever enough to know what she is doing. She is no passive tool of an abstract plan of salvation; she is well read and supports God's purpose on her own initiative. Her ability to conceive is inseparably bound up with the Word becoming flesh and thus with the human capacity to understand and act.

Leonardo took women seriously, especially at a point when they were making a vital decision. In his unusual view of Mary, the young painter broke with convention. In theory, images of the Annunciation follow a specific course. According to theologians, Mary goes through five stages in the encounter with the angel. First she is shocked, then she deliberates, before she asks whether she needs to get involved with a man in order to conceive. Eventually, when it is explained to her that she will remain a virgin, she humbly agrees and finally appears in a happy, blessed state.[15] Many artists depict an uncertain woman in the first phase, *conturbatio*; others prefer *humiliatio*, consent, and paint Mary with her head bowed. Only Leonardo allowed his protagonist to improvise. There is no doubting her evident will and her power to decide. The humbly approaching angel is the supplicant, not Mary.

In this painting, Leonardo clearly took a different view from colleagues, whose angels issue commands and intimidate Mary. These stern images of the Annunciation played an important part in disciplining the female population.

For instance, in the fifteenth century, the Tuscan preacher San Bernardino praised the Annunciation scene painted by Simone Martini and Lippo Memmi in 1333, which was then in the Cathedral of Siena (Ill. 4).[16] In his opinion, this Mary was so modest, as she listened humbly, almost fearfully, to the angel, that she dared not look directly at the bearer of the divine message, even though he was not a man but merely an angel—and his advice was "Take this as your model, young ladies!"[17]

Leonardo did not agree with San Bernardino. In his writings the artist once mocked traditional depictions of the Angel Gabriel as a domineering figure: "I saw some days ago a picture of an angel making the Annunciation, who seemed to be chasing Our Lady out of the room, with movements which displayed the kind of offensiveness one might show to a hated enemy, and Our Lady seemed as if she was going to throw herself in despair out of the window." This criticism is followed by a warning to painters not to fall into similar errors.[18]

Leonardo himself did not drive women to despair, and he was not interested in their subjugation. He needed Mary and other women, and they needed him, because he offered them role models they could never have imagined.

Leonardo's *Annunciation* (Plate 6) was probably painted before the *Madonna* in Munich's Alte Pinakothek (Plate 1). The two works are linked by having a particularly calm Virgin Mary seated in front of an imaginary mountain landscape, shimmering in a heavenly glow. The whole world is displayed on the horizon even in Leonardo's early paintings, enfolding the women, who, according to the conventions of the age, were supposed to stay indoors, preferably with the windows closed. The archbishop of Florence Antonino Pierozzi later canonized as a saint, once warned women in a book of etiquette that "It displeases me when you stand at the window to see who is passing by."[19] A wife should not stand around in the square whispering in doorways; she was only allowed to leave her home in order to go to church, and then only when accompanied. Even the humanist, author, and architect Leon Battista Alberti warned men not to allow their wives to go outside; outdoor spaces were the sole preserve of men. In fact, this often led to accidents, when bored women attempting to catch a glimpse of what was going on in the street fell out of windows. This can be seen from tax declarations at that time, in which the male heads of families listed all the members of the household and had to

declare the reason why people who had appeared on the list in previous years were no longer shown.[20]

In defiance of such restrictions, Leonardo threw the windows and doors wide open to his Madonnas, giving them and viewers access to new horizons. Similarly, there is an opening in the terrace wall in the early picture of the Annunciation. The mother-to-be could walk out into the world and explore the park, the harbor, and the mountains. Mary and other women are related to God, but above all they are the accomplices of an artist who shows how well the small human being and the vast cosmos fit together.

Later in his life, Leonardo rather immodestly put into words the reason why he invited the wide world into his paintings. In writings that were unpublished in his lifetime, he wrote: "The divinity which is the science of painting transmutes the painter's mind into a resemblance of the divine mind." He continued: "With free power it reasons concerning the generation of the . . . various animals, plants, fruits, landscapes, fields, landslides in the mountains, places fearful and frightful, which bring terror to those who view them; and also pleasant places, soft and delightful with flowery meadows in various colors swaying in the gentle breeze."[21] An artist must see everything, paint everything, work creatively—and celebrate *natura*.

The young Leonardo was in his element when drawing and painting and equally pleased to be working with Andrea del Verrocchio, but evidently there were still days when he was discontented with city life. His thoughts often returned to Vinci, to the wide hills, the forest and the rivers, the sky, and the solitude. Later, in a fable, he warned against leaving "a life of solitary contemplation [. . .] to live in cities among people full of infinite evil."[22] He believed that seclusion was essential in order to understand anything, to find peace, to observe, and to think. He despised painters who did not involve themselves with nature, and he went home to the countryside at every suitable opportunity.

It is not certain whether the twenty-one-year-old Leonardo really wandered through snow in the area around Vinci on the Marian feast day of August 5, 1473. In any event, he claims to have done so in the inscription on a drawing that, like much of the young master's early work, is somewhat unusual (Plate 7).[23] It shows an open landscape, of a kind that not even the Pollaiuolo brothers, who were famous for the panoramic views in the background of their pictures, had hitherto successfully depicted. With deft strokes of his pen, Leonardo sketched

a view of a valley bathed in sunlight. On the left in the background is a small castle on a hill, though it is inconspicuous compared with the grandeur of the mountains. The whole picture is filled with growth and change. Bushes roll over the hillside, a waterfall plunges down from above, treetops thrust upward into the bright sky. Everything is in motion. Close and distant views alternate in a way that in reality would scarcely be possible from a single standpoint.

There is no vantage point near Vinci from which this landscape can be seen in this way, though details of the picture can actually still be found there. For instance, from a few hills it is possible to see Monsummano, a strangely isolated, cone-shaped mountain, as it appears in the background of the landscape sketch, and also below the angel's wing in the landscape of the *Annunciation* (Plate 6). This mountain is only a few hours' walk from Vinci, and if, as a young man, Leonardo sometimes walked from the home of his father's family to that of his mother Caterina, who lived in nearby Campo Zeppi, he would have been able to make out Monsummano in the distance from his path.

Leonardo possibly put his perfect landscape together in the workshop in August 1473, working from memories, drawings, and various observations. At that point, he could not have known that with this sketch he was preparing the way for the new genre of the autonomous landscape, as in his time the landscape element in art was always the means to an end. It was there to show the story in the foreground to advantage, not for its own sake, and Leonardo did not question this concept at all in his paintings. However, he differed from his contemporaries in not reducing nature to its utility value or using it purely decoratively. He believed that landscape has a life of its own that is ungovernable by man and it should be gazed at in admiration and explored with respect.

In his treatise on painting, Leonardo wrote that depictions of landscape should awaken memories of real places where people had once found pleasure. Looking at such a picture could trigger a great many emotions. The viewer would suddenly find himself back in a flowering meadow or see himself strolling with his beloved in the shade of a tree—assuming, of course, that he had often escaped from his cramped city dwelling and regularly gone walking through mountains and valleys in order to enjoy "the natural beauty of the world."[24]

Leonardo strongly recommended this to people living in cities. It almost seems as if he felt a little sorry for the busy, pale Florentines in their dark, stinking streets, like the songbirds in the market that he released from their cages. It was his task to teach them to fly.

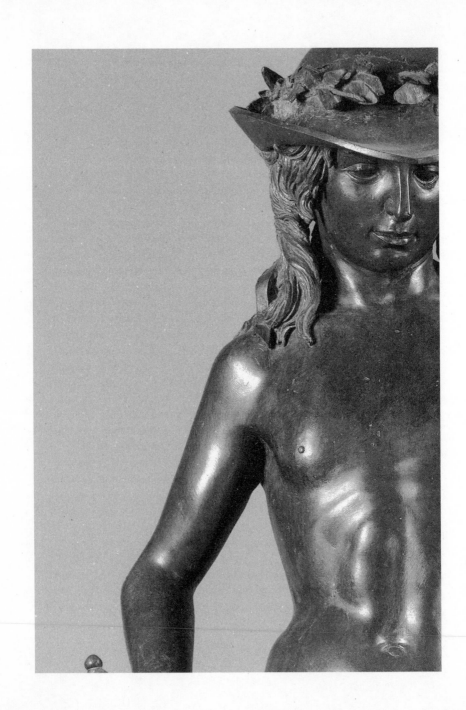

III

A CITY OF IMAGES

FLORENCE WAS ALREADY a legend in its own time when the young Leonardo arrived there in the mid-1460s. It was the city of the sculptor Donatello, the painter Masaccio, the theoretician Leon Battista Alberti, and the architect Filippo Brunelleschi. Without these men of the new European age, Verrocchio could not have created his lively, realistic figures in such a natural way, and without them, Leonardo da Vinci would never have thought of observing, depicting, and celebrating nature and women so intently.

In the field of art the Renaissance began with a magical illusion, forty years before Leonardo's birth. It was probably in 1412 that a man in his mid-thirties stood in front of the entrance to Florence Cathedral gazing at the baptistery opposite, a small but splendid octagonal building in green and white marble. In his hand he held a rail, about the length of an arm, with two wooden boards mounted on it. The front one measured just 12 inches by 12 inches (30 by 30 cm) and had a small hole bored through it. Holding this instrument, he stopped passerby and invited them to participate in a scientific experiment.

He might have been taken for a trickster, if he had not been well known in the city as the goldsmith and building consultant Filippo Brunelleschi. He asked his test subjects to close one eye and look through the little hole with the other and then tell him what they could see. "The baptistery," they replied, but it was not so. They saw only an image of the baptistery. Brunelleschi had deceived them with a new invention: central perspective, which was as yet unknown in

this form. He had made the vanishing lines of his painted baptistery come closer together in the distance, thus recreating the effect of natural vision. The painting now suggested spatial depth.

Evidently, Brunelleschi had painted a mirror image of the baptistery in correct perspective on the back of the wooden board that the subjects looked through. The opposite board was surfaced with a mirror and showed the reflection of the passing clouds as well as the painted baptistery, thus creating a moving image.[1]

The optical illusion, or trompe l'oeil, was perfect because it was totally unexpected. Although the painters of antiquity were aware of various techniques of perspective and foreshortening, the knowledge of how to suggest three-dimensionality had been lost during the Middle Ages.[2] Because Brunelleschi based his ideas on his own perception and feelings, complemented by his scientific knowledge, he was able to harmonize the image on the retina with the painting, the internal and external images.

Many of his contemporaries—scholars, artists, educated noblemen—thought in the same way as he did. They placed man at the center and wanted his needs, feelings, and ideas to find expression in art and society. They sought a science that would impartially investigate the human body and the natural world and engage in practical observation. Science and art should match life.

Pictures painted using central perspective follow geometrical rules. The painter determines a vanishing point (where Brunelleschi placed the small hole in his painted board). In preliminary sketches he draws fine guidelines starting from this point and places the objects he wants to depict in between them. Then he could make the vanishing lines for any house or any wedding chest come closer together in the distance, creating an impression of spatiality. This technique alone makes it possible to understand the picture as a window that opens onto the world and also invites the whole world into the painting—something that became important for Leonardo.

Central perspective soon caught on in the early fifteenth century. Many artists were longing for a radical new start. Their work was now to be obedient to higher laws; they measured, calculated, and experimented. Paintings were to convey the true impression of the viewer; seeing should lead to understanding. Philosophy and the natural sciences moved into the workshops, and artists felt responsible for perceiving, reproducing, and surpassing nature—a responsibility Leonardo would later take on to the most radical degree.

They found their models for this position in classical antiquity. Philosophers such as Aristotle and Plato were equally passionate about science and the theory of art; Greek and Roman sculptors designed their works with the human body in mind. Learned Italians had been examining what remained of the ancient world—the marble statues, Greek and Latin manuscripts, painted vases, and ruined buildings—since the fourteenth century. They devoted themselves to ancient texts, many of which had been forgotten but had been preserved by Arab scholars in the Near East and were now making their way back along the trade routes to central and southern Europe. This research gathered momentum in 1453, the year after Leonardo's birth, when the Turks conquered Constantinople and the scholars who had been living there fled to Italy with their precious scrolls.

Italy was particularly open to new stimuli because, unlike the lands north of the Alps, the intellectual life of its nimble mercantile societies was not centered solely on theology. As early as the thirteenth century, students at the universities of Padua and Bologna were taught law and the humanities as well as medicine. In around 1416 a treatise by the architect Vitruvius dating from the first century BC was found in a library. It caused a great stir among the *studiosi* because Vitruvius made a connection between architecture and human proportions. For instance, some 1450 years before the Renaissance, Vitruvius had proposed the idea that a column was successful only if it related to the regular proportions of the human body.[3]

Man is the measure of all things. Intellectuals soon came to agree with this sentiment, which later became so important for Leonardo's work. The men and women of the Renaissance translated inspiration from antiquity into the present. They rescued statues, studied the crumbling ruins, and scraped the moss off ruined triumphal arches and reliefs, in order to use them in their own buildings. They immersed themselves in the Greek and Roman myths and painted their gods in contemporary dress.

The knowledge of the ancients served as a starting point for the humanists to follow their own path. This revolution in thought and vision stopped at nothing, not even religion. The pioneers of the new age were probably no less religious than their predecessors in the Middle Ages, but they did not feel subjected to God, since it was He who had given men godlike gifts. For instance, in around 1452, the philosopher Giannozzo Manetti wrote in his treatise *On the Dignity of Man* that God the Father had created man as a perfect work of art, so

nothing more was required. This was also a celebration of the capabilities of God's creations: "Ours are the pictures, ours the sculptures, ours are the arts and sciences, ours is wisdom."[4]

The humility of the Middle Ages, when Saint Augustine's teaching that a creature cannot itself be a creator held sway, seems to have been forgotten. In the fifteenth century, the art theorist Leon Battista Alberti noted instead that the masters of modern painting felt "almost like a second god."[5] This already hinted at the arrogance of Leonardo, who would come to consider himself indebted to the unconventional thinker Alberti, who was also an illegitimate son. And even consider himself to be a painting "Lord and God."[6]

Art, literature, and philosophy may have dreamed of a new harmony, but south of the Alps the reality was less harmonious. The country was disunited, marked by wars and feuds. Although areas of northern and central Italy had long been part of the Holy Roman Empire, in these regions the emperor could not guarantee peace and justice. Even the Church had lost something of its authority. Clerics were living lives of luxury and vice, and the papacy was only one power among many.

Power relationships in Italy were fragile and complicated during the early Renaissance. In many cities there were feuds between families and clans who barricaded themselves in their fortress-like towers. Deception, murder, and war had become natural ways for city rulers and princes to gain power and expand their territory. Little by little, five principal powers came to determine the fate of Italy: the ecclesiastical state surrounding Rome, which was gradually regaining strength; the prosperous trading power of Venice; Florence, which considered itself a republic; the Duchy of Milan; and the Kingdom of Naples in the south. It was an age of self-destruction and constant danger of war, so this was another reason why artists and intellectuals yearned for something different. They wanted man to be the image of God: just, virtuous, and well formed.

When Brunelleschi, the highly educated son of a notary, investigated the habitual workings of the eye, he was already familiar with the works of the exceptional artists of the late Middle Ages. Around 1300 the painter Giotto had set the stage for the appearance of the individual. Giotto wanted his paintings to bring stories to life before the eyes of the viewer as if in a theater, unlike many of his colleagues, who preferred to concentrate on the glorification of

Illustration 5. Giotto, *Descent from the Cross*, Cappella degli Scrovegni, Padua

Christianity. They liked to choose golden backgrounds in order to elevate saints and Madonnas into a celestial sphere, free from human sin.

Giotto's revolutionary way of depicting scenes was preceded by a revolution in thought. Most medieval scholars believed that a beam of fire emanated from the eye and thus took hold of the world. This had already been refuted around the turn of the first millennium by a Muslim mathematician from present-day Iraq. Using ancient writings as evidence, Abu Ali al-Hasan ibn al-Haytham, known as Alhazen, stated that, on the contrary, objects and living beings emitted rays that were concentrated in the lens of the eye. His treatise was not translated into Latin until the thirteenth century, when it was studied in monasteries and universities, and most eagerly in central and northern Italy.[7]

The new science of optics knew that things existed in the outside world and emitted rays, even when nobody was looking at them. This stimulated Giotto to replace the solemn mental introspection of old religious painting with accurate

observation of people and objects in space. Giotto's new man is firmly rooted in this world. For instance, although his Mary Magdalene's dress still falls in severe Gothic folds and her golden halo meets the conventions of the traditional depiction of saints, the way in which she turns toward the crucified Christ and strokes his nailed feet makes it a physical action (Ill. 5).[8]

Giotto acknowledges that his men and women have emotions and allows them to appear in rooms of a size consistent with real houses. Although the artist was not yet acquainted with the rules of central perspective, he made his lines come closer together in the distance, thus approaching an early attempt at three-dimensionality. In order for people to believe that a figure breathes, speaks, thinks, and loves, it must physically take up space and have depth. In Giotto's painting, physical presence and emotional expression are already inseparably linked. He thus created the preconditions for the work of Leonardo da Vinci, who would later make us feel as if his painted figures, especially those of women, were sentient, human beings facing us in space and time.

In the late Middle Ages it was the poets who first understood how to bring an artistic creation to life, and they continued to inspire painters into the Renaissance. In his early verses, the Florentine poet Dante Alighieri, whom Giotto may have known personally, praised the beautiful Beatrice and promised that one day he would say something about her that had not yet been said of any mortal woman. Shortly before his own death, the poet kept his promise. In his *Divine Comedy*, completed in 1321, it is Beatrice who guides the first-person narrator through Paradise.

Petrarch was more emotional in his poems about the unattainable young woman Laura, who is said to have broken his heart with a single glance on Good Friday 1327, a few years after Dante's death. This was probably the first time in Christian Western Europe that an author had written so personally about his emotions of pain, loneliness, passion, and unrequited love. He invests his *Canzoniere* with numerous allusions to classical mythology and history. Even the name Laura reminds him of *l'aureo*, golden, of *l'aura*, the aura or the breeze, and, most of all, of *lauro*, the laurel tree, whose leaves once adorned the Caesars. In 1341 he had himself crowned with laurels on the Capitoline Hill in Rome, as if he wanted to say that the rulers of a future age would be the intellectuals who dared to speak of themselves and the ancient world in one breath.[9]

Precisely because Laura does not return his desire (and, as a woman, she could not do so outside marriage), Petrarch was able to translate his vulnerability into literature and create an epoch-making work that was still being imitated in Leonardo's time and recited at convivial court banquets. Petrarch's *Canzoniere* to Laura was probably the most popular literary work of the Renaissance; it was widely available in a handy pocket edition and read equally by both men and women. Courtiers took it with them on their travels, noble young ladies received it as a gift, successful gentlemen added particularly beautiful editions to their libraries, and sophisticated courtesans learned the verses by heart in order to attract customers.[10]

The slim volume was also such a great success because love was having such a hard time in the fifteenth century. Arranged marriages and prostitution were considered acceptable, while real-life romantic love was socially despised. Anyone who threw caution to the winds and followed their heart risked shame and honor killing. Free love was too inconsistent with the ideal of feminine chastity and family structures that were centered on maintaining status and procreation. However, in the centuries after Dante, Giotto, and Petrarch, people had already learned to say "I" and explore the state of their souls in words and pictures. The suppressed longing for romantic affection migrated into painting and literature and became a subject of casual conversation among members of polite society. Petrarch became one of the most important sources of inspiration for the art of Leonardo and his contemporaries—it is impossible to imagine the Italian Renaissance without him.[11]

Brunelleschi had one advantage over Giotto and the two poets: He was not isolated. Innovative powers were congregating in Florence. In the early fifteenth century the city was a place where neither ecclesiastical nor secular authorities inhibited the spirit. Although artists were obliged to become members of the guild and had to observe its rules—for example, they were not allowed to paint on any imported leather, only on local buffalo and cowhide—they were still independent entrepreneurs and could choose which commissions to accept, so no one could curb their desire for aesthetic experimentation. In fact, the opposite was true: The merchants with international business activities were eager for new trends, and unusual innovations found customers more quickly here than anywhere else.[12]

Brunelleschi had artist friends who shared his curiosity—Donatello, for instance.[13] The latter probably started experimenting with vanishing lines in 1416, in a stone relief of *Saint George and the Dragon*. In it, Saint George is spearing the monster while the princess watches against a background of elegant foreshortened arcades. Shortly after the turn of the century, Donatello had accompanied Brunelleschi on his journey to Rome and evidently studied ancient sculptures there. Soon after that, he started placing the figures in large sculptures freely in space, which had been unusual in the Middle Ages. Sculpture was emerging from its niche and was no longer found only in institutions such as churches and rulers' palaces but had become an end in itself.

In around 1445 Donatello glorified the new consciousness of the human body in a bronze statue of David (which Verrocchio would later apply to his own figure of David during the time of Leonardo's apprenticeship) (Plate 8). This was the first life-size nude statue since classical antiquity.[14] Donatello already understood that the subject had political relevance: Just as the biblical hero overcame the giant Goliath using reason rather than strength, the Florentine Republic would also withstand powerful enemies. However, Donatello depicted David not as a victor but as a coltish, conceited youth. His bent wrist is placed coquettishly on his narrow waist. The Old Testament hero had become a harbinger of masculine beauty, a young man as elegant and self-confident as the city of Florence.

Masaccio, who was also a friend of Brunelleschi but around twenty years his junior, painted pictures whose radiant colors announced the new vitality of art, its claim to resemble and go beyond reality. For him, the real and the ideal of beauty belonged together, something that would later also seem natural to Leonardo. To show reality as it is was not sufficient for either of them; it was important to improve on it as well. In Masaccio's fresco on a side wall of the church of Santa Maria Novella in Florence, Mary, John, and the two donors stand in grave silence by the dying Christ. In the background, instead of the usual landscape, there is an imaginary structure. Behind the cross Masaccio painted a precisely calculated barrel vault, foreshortened after the manner of Brunelleschi.

The painter makes only one exception to the perspectival setting in which the figures appear: God the Father in superhuman size spreads his arms above the cross. By contrast, his son appears particularly small and vulnerable in front of the monumental architecture. With his emaciated body and lowered eyes, he

is a man suffering torture. In a cycle of biblical scenes for the Brancacci Chapel in Florence, Masaccio also depicts a freezing child waiting to be baptized, Eve sobbing after the expulsion from Paradise, and an infant with a naked behind clinging to its mother's neck. Where earlier artists still had set ways of depicting biblical figures, painters like Masaccio now gave them strong feelings and a visible personality, even in sacred art.

Stimulated by this striving for character and beauty, in 1434 the architect Leon Battista Alberti began formulating the first comprehensive theories of Renaissance art. He had kept a close eye on Brunelleschi's experiments with perspective, Donatello's new images of the body, and Masaccio's humane painting. It must have become clear to him how much the friends had influenced one another, and he recognized the common factors in the different disciplines. As a result, he was able to explain the laws vision scientifically. He talked of "rays" leading in a pyramid shape from the object to the painter's eye. According to Alberti, a level section through the imaginary "pyramid of vision" would produce an image in exact perspective. The polymath Alberti also drew up rules for architecture. Just like painting and sculpture, and in line with the ideas of Vitruvius, architecture should be based on human proportions. In addition, all three arts should learn from the ancients, their images of man and the orders of their columns.[15]

Brunelleschi, meanwhile, was in a state of euphoria. Everything seemed possible to him now. The Florentines had been building their cathedral for over a hundred years—Giotto had been in charge of the construction work at one time—and the shell of the building was more or less finished. However, the most difficult task still remained: Someone had to be found who could erect a dome over the opening in the roof, which was almost 144 feet (44 m) in diameter. Brunelleschi felt it was his mission to find a solution. Instead of consulting the textbooks, he looked at his notes from his stay in Rome. The vast dome of the Pantheon, completed in AD 125, had survived for centuries. Brunelleschi believed that one of its secrets lay in its lightness. Rocks such as the tufa and pumice used by the Romans weighed relatively little, so it should also be possible to use the lightweight red bricks of Florence. The bricks would support one another, as long as they were wedged together skillfully enough, meaning that no expensive supporting structure would be necessary, as the bricks would keep one another in place. With this apparently crazy proposal, Filippo Brunelleschi

Illustration 6. Dome of Florence Cathedral

won the competition to build the dome in 1420. The Florentines awarded their most important building contract to a theoretician with a passion for ancient ruins.[16]

Their courage was rewarded. Brunelleschi did not merely imitate the Pantheon; using precise calculations, he constructed an astonishingly stable double-shell dome more than 116 feet (35 m) high (Ill. 6). It was completed in 1436 and since then its deep-red presence has soared above the rooftops of Florence. In Leonardo's day, travelers would already have recognized from afar what the city stood for: science and the awareness of form. Or, as Vasari put it, Brunelleschi challenged the heavens.[17]

However, there was something missing: a globe with a cross on the very top of the dome. When Leonardo arrived in the city twenty years after Brunelleschi's death, the dome still lacked an ornament. There were now fewer famous men working in the city. Donatello had died during this time, in 1466. By then, Masaccio had already been dead for twenty-eight years. The aged Alberti, whom Leonardo admired, was still living but often away on his travels. Leonardo's master, Andrea del Verrocchio, was the man of the moment.

In 1468 the cathedral masons' guild commissioned the sculptor to make the ball and cross and set them in place. With a diameter of 8 feet (2.5 m), the ball made considerable logistical demands on the workshop. Three years later, in the early summer, when Leonardo had reached the age of nineteen, the ball was ready. Working at a height of over 330 feet (100 m), Verrocchio's workmen mounted the ball on top of the lantern, accompanied by the blaring trumpets of musicians who had climbed up with them (Ill. 6). Lastly, the cross was put in place. The cranes, cables, and pulley systems used to hoist the giant ball made a lasting impression on Leonardo, and decades later he still remembered this feat of engineering.

Now the silhouette of the cathedral was no longer merely imposing—it shone out over the city in the evening light, dazzling new arrivals. To many Florentines, it seemed that the golden age was within their grasp. This was largely due to a contemporary of Leonardo, Lorenzo de' Medici. Just three years older than the artist, he set the tone in the Florentine state when Leonardo was living there. He had weak eyes and a reedy voice, and his features were too angular, but that did not dampen his self-confidence. The well-educated, vigorous young man presented an image of a hedonistic lover of all things beautiful. He was surrounded by an aura of luxury as soon as he set foot in the street, often accompanied by a group of learned friends outdoing one another in quick-witted jokes and suggestive innuendos.[18] Lorenzo knew all about pleasure and about how to please. Half of Florence enjoyed his favors, whether financial or social.

The republic was governed from the Palazzo della Signoria, the city hall, by a nine-man board that changed every two months. One of the members of this government was chosen as the gonfaloniere, the head of state. Membership of the Signoria was decided by lot. The names of all eligible men were written on slips of paper and placed in a bag, shaken up, and picked out at random. In theory, this ensured fairness, but in practice it was not quite so much a matter of chance which of the better families in the city held sway.[19]

The Medici family had been extremely successful in financial affairs since the twelfth century. Cosimo de' Medici, Lorenzo's grandfather, was particularly shrewd in the way he dealt with other people's money. Credit from his bank cost vast sums, while investments brought a comparatively modest interest of 8 percent. The bank was subject to a great deal of risk owing to the international transportation of money by mule caravan and galley, in which the Medici had shares. Their profits were so high that Cosimo was eventually able to lend the Florentine Republic the money it needed for its military campaigns in the surrounding area. Even the pope got into debt with the Medici. By around 1430, Cosimo was by far the richest man in Tuscany.

Slowly but surely, Cosimo de' Medici had made the Florentines dependent on him. With apparent generosity he supported monasteries, saved medium-sized businesses from bankruptcy, and helped his friends by paying for their daughters' dowries and their sons' educations. This close-knit network soon resulted in the Signoria being favorably disposed toward the Medici, despite its changing membership, to the extent that, in the end, it also introduced

Medici-friendly election committees. Although these did not actually manip-
ulate the drawing of lots, as early as 1434 they ensured that the names of
Cosimo's critics were never put into the bag again. This incensed many other
rich merchants, but anyone who rebelled against the new policy was forced to
pay extremely highly taxes. The Medici immediately had around a hundred
opponents exiled from the republic, and the secret police now took their orders
from Cosimo. It was no longer possible to go against his will, which made him
the secret ruler of the republic.

His grandson Lorenzo, who, after an interlude during the time of his father,
Piero, was now head of the Medici family, also thought of himself in this way.
He could rely on the surviving network of supporters and on his friendship with
the duke of Milan, who lived on credit from the Medici and would support him
with troops in the event of a civil war. However, this power structure was fragile;
Lorenzo and his younger brother, Giuliano, were not dukes, and not even of
noble descent. Everyone knew this, but nobody was supposed to notice.

Only art could help. Lorenzo knew that and invested in creating an image.
After the death of his father, Piero, in 1469, he engaged Andrea del Verrocchio
to create the lavish monument for his father and one of his uncles in the church
of San Lorenzo. Verrocchio had already created the bronze *David* for the
Medici, for which Leonardo may have been the model (Plate 3). Now he became
the bankers' furnisher and interior designer; the workshop supplied everything
necessary to produce a prestigious image—anything from theater scenery
to armor to interior decor. Even Leonardo's self-assured little *Madonna of the
Carnation* (Plate 1) was created for the family. It is possible that, as reported by an
early source,[20] the painter occasionally visited Lorenzo's sculpture garden near
San Marco, where the young Michelangelo later also trained his eye by studying
the Medici family's antique statues.

In fact, Lorenzo did not spend nearly as much money on culture as his
father and grandfather had, but supported artists and writers personally instead.
Most importantly, he required those around him to do the same. In order to
keep pace with others in the metropolis of good taste, anyone who was anyone
had to invest in painting, architecture, sculpture, literature, furnishings, music,
and fashion.

Young Leonardo was living in the city at a good time. With a wealth of
ideas, curiosity, and elegance, a person who did not receive everything by right
of birth could also make something of himself. Scientific and mathematical

ways of thinking had become established. Experiments were now desired rather than frowned on. Central perspective, Brunelleschi's great achievement, was taken for granted, and for Leonardo it opened up his field of vision as a window on the world.

As in the early *Madonna of the Carnation* (Plate 1) and the *Annunciation* (Plate 6), he made use of this to strive upward toward the mountaintops and allow his gaze to wander ever further through creation. However, the artistic heritage of Giotto, Donatello, and Masaccio ensured that he never lost sight of people. Also, the much-read works of Dante and Petrarch may have prevented the Florentines around him from thinking only of numbers and material values and neglecting the affairs of the heart.

Leonardo's contemporaries had absorbed the ideas of the older generation of poets, architects, and artists; under Lorenzo's rule, at the same time everyone was adjusting to the new. The time was ripe for the second wave of the Renaissance.

Leonardo was also able to keep up in respect to his appearance.[21] According to early biographers, when the country boy came to the city he liked to dress in expensive fabrics of the kind he had seen his father wearing, only more extravagant. At some time later he owned linen shirts, satin cloaks in carmine and purple, fur-lined robes, fashionable leather boots, and a pink cape that reached only to his knees. He took great care of his long curls, which hung down to his chest, and rubbed his hands with sweet-scented rosewater. He dressed not for the position he had but for the status he wanted. In the Florence of Lorenzo the Magnificent there was no harm in being foppish.

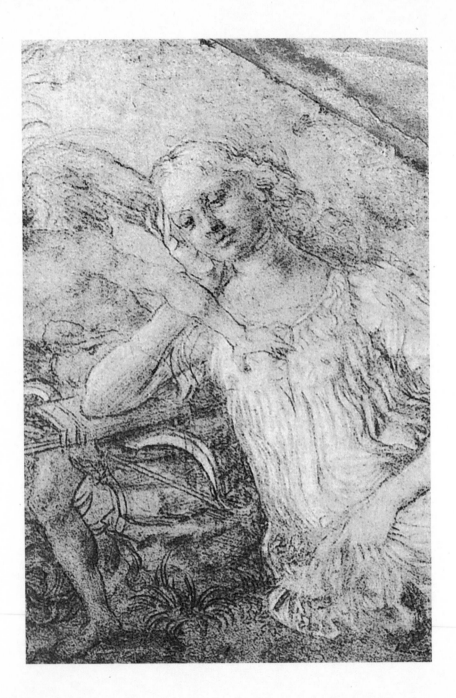

IV

GAMES OF LOVE

ON FEBRUARY 7, 1469, Leonardo was probably winding his way through the narrow alleys leading to the open square in front of the church of Santa Croce, near the Arno. On that day the sixteen-year-old would have chosen his wardrobe with particular care, as Lorenzo de' Medici had issued an invitation to a sparkling feast with jousting, such as Leonardo had never experienced before. This was not a celebration of victory, or a religious event, or even a wedding, but a celebration of love.

Lorenzo de' Medici suspected that he would soon be taking over from his seriously ill father as *maestro di bottega*, as head of the company or head of state, depending on one's point of view. It was time to present himself to the people. And, despite being only twenty, he would have to get married as quickly as possible in order to ensure the continuation of the family line. It would be strategically sensible to marry a girl from Rome, as the Medici were dependent on having good connections in the Eternal City. So his mother journeyed to Rome and meticulously surveyed the Roman nobility, inspected young ladies, checked their origins, fortunes, conduct, and looks, and finally decided to recommend the nineteen-year-old Clarice Orsini—although in her letters home she grumbled that the candidate was quite skinny and that, despite her pretty, round face, she had slightly drooping cheeks and, what was more, she did not hold her head up as high as the Medici women.[1]

Lorenzo agreed to the choice but had no desire to travel to Rome in February to seal the contract. He had something more important to do. On

this very day he wanted to hold his celebration in the Piazza Santa Croce, not for the wedding, not for Clarice, but for his great love. Her name was Lucrezia Donati. In his eyes she was very beautiful, and three years before she had given him a bunch of violets. That was more than a man could expect. Lorenzo promised Lucrezia the tournament at Santa Croce.[2]

As a foretaste, he had already organized a carnival ball in the hall of the church of Santa Maria Novella, which gave him the opportunity to wear a dark, pearl-embroidered robe and dress all his friends in matching colors.[3] Lorenzo could not have expressed his admiration of Lucrezia more publicly. Everyone should see and hear what kind of young man this Lorenzo was: passionate, educated, resolute, seductive, good-looking—and sensitive.

Poems written by Lorenzo in the style of Petrarch were circulating in the city. It was also convenient for him that the Latin form of Lorenzo is Laurentius, which would remind people of *laurus*, meaning laurel. Like Petrarch, he saw himself as the god Apollo pursuing the nymph Daphne, who constantly rejected him and was transformed into a laurel tree so that she could escape him. For him, the woman who "held his heart in her hands" was *luce*, light, a beautiful, unattainable goddess Diana, whom he would have dearly loved to pursue into the forest.[4] He acted as though Ovid, Petrarch, and the other classical poets had scattered the evergreen laurel leaves so that they would now crown the head of Lorenzo de' Medici.

Lorenzo's poet friends gave him the key words for this literary game. The first-person narrator could openly give proof of his energy and his humanistic sensitivity, without running the risk of having to enter into a real relationship. Even Lucrezia's new husband seems to have been certain from the start that it would not come to an affair. He was a merchant, whose forefathers—and consequently he, too—had been exiled from Florence by Lorenzo's grandfather, and therefore lived outside the city. He was also frequently away on business. Lucrezia probably married him only because her father lacked the money to pay the high dowry needed in order for her to marry a respected Florentine.[5]

In Florence Lorenzo's vows of love came at the right time for everyone involved. The young Medici could make his mark as a man who wanted some-thing without having to struggle with a rival in the city. Lucrezia was the talk of the town; she was invited to high-society banquets and gatherings that would otherwise have been closed to her. Her husband hoped that his wife's contacts would enable his family to get back into favor with the Medici. And everyone else had something to talk about. Courtly love, poetry, feasting, and declarations

of love confirmed the Florentine's hedonistic, cultivated self-image. Only Lorenzo's Roman bride, Clarice, required a particular outcome from all the hurly-burly. She prayed steadfastly that her bridegroom would win the tournament without being injured and even considered fasting for that purpose.

On February 7, 1469, Lorenzo attached Lucrezia's long since withered violets to his helmet, though this was the only modest thing about his appearance. Two professional jousters rode into the Piazza Santa Croce at the head of his train. The duke of Milan and the king of Naples had sent them as a symbol of their support for the prospective ruler of Florence. The king of France had sent a warhorse clad in thick leather, which came snorting along farther back in Lorenzo's train. According to eyewitnesses, there were also twelve young men from Florentine families that had been Medici supporters for many years. They wore dark red hats ornamented with pearls, precious stones, and golden feathers. Their horses were arrayed in dark red and white.[6]

Drumbeats resounded through the square; the audience fell silent. Then a particularly richly caparisoned horse trotted past, but ridden only by one of Lorenzo's servants, who presented the latter's silver helmet. It bore the image of a woman carrying a laurel wreath and a lance in her hands. Petrarch had probably not intended his verses to be so martial, but on this day Venus and Mars, and the arts of love and war, apparently met in a carefree manner.

Andrea del Verrocchio and his workers had made the decoration for the helmet and also designed the standard carried by a page at the head of Lorenzo's train.[7] Below the French motto *le temps revient*—time returns—on the white taffeta of the banner was a woman in a dress of blue and gold flowers holding a half-made laurel wreath. She was also grasping the single green branch of a laurel tree, signifying Lorenzo, the scion of the Medici. Verrocchio and his workers had evidently thought their way into the world of Petrarch for the tournament, not realizing that the future head of state had no intention of ever paying the bills for this expenditure.[8]

Gradually, the onlookers around the edge of the Piazza Santa Croce became impatient. Ornately caparisoned warhorses were all well and good, but where was the lovelorn young man who wanted to lead the city to fame and fortune?

Then he arrived, sweeping past high on his white horse, a gift from the king of Naples. The pearls decorating the saddle matched the robe of the man

on whom their hopes were centered. Both were embroidered with laurel sprigs and roses, and his breastplate was emblazoned with a red precious stone. Like his escort, he wore a dark-red hat with golden feathers. His cheering supporters shouted "Palle, palle," an allusion to the balls on the Medici coat of arms. It is not known how many of them were in debt to the family of bankers.[9]

The victor of the day was fixed the moment Lorenzo appeared in the square. The jury judged neither his skill in combat nor his art of love; they were assessing their own future. Florence was to be like this young god.

Lorenzo was not skilled in jousting. During the combat he had to change horses three times. Once he was tossed clattering to the ground with all his ornate trappings. Looking back, he would admit that his part in the contest was not exactly a strong performance.[10] It was of no significance; he was of course awarded the first prize, and as for Lucrezia, she was only peripheral. For a while after he was married Lorenzo would continue to honor her in his poems, and they would both carry on with their lives as normal.

Leonardo, the horse connoisseur, probably stood gaping in astonishment at the edge of the tournament. It was a celebration of love, but more important than the beloved was the lover who was extolling himself. An entire city succumbed to his youthful love, and to the love of gold, fashion, art, and elegance. Florence was the city that felt better represented by David than by Hercules. It was enraptured by courage, spontaneity, the desire for a good life, and perhaps even by the arrogance a very young man can embody. This young man was now Lorenzo. The Medici were not only the masters of money and beauty, they were also playing with people's collective desires—which were by no means preoccupied only with young women.

At this time, Donatello's bronze *David* stood on a marble column in the interior courtyard of the vast Palazzo Medici, the highly modern, castle-like family residence close to the cathedral (Plate 8).[11] Entering the courtyard from the visitors' side, one encountered the outrageously naked youth from the front. Casually— and somewhat posily for a fighter—he presses his boot into the face of Goliath's severed head lying on the ground. His flawless body gleams delightfully, yet the overlong sword in his hand makes it clear that this adolescent is not to be trifled with. Anyone entering here, be he a prince, a messenger, a business partner, or merely the gardener, would be aware that the rule of the Medici would be as

fresh and attractive as it was quick-witted and assertive.[12] The clan would also, if necessary, use force to defend the interests of the republic.[13]

Donatello's statue, created during the lifetime of Lorenzo's grandfather, Cosimo de' Medici, suited the Lorenzo worship of the house. This continued on the upper floor, in the magnificent private chapel where, seven years before Lorenzo's Santa Croce tournament, the Florentine painter Benozzo Gozzoli had completed his wall frescoes (Ill. 7). These depict the Magi and their retinue riding through a serene Tuscan landscape. The youngest of the Magi, who appears to be little more than a child, is particularly captivating. Dressed in a gold-embroidered doublet, he sits enthroned on his white horse, whose harness is emblazoned with the Medici symbols. His serious yet confident gaze scans the onlookers. The young king has the features of Lorenzo de' Medici, which at that time were still soft.

Illustration 7. Benozzo Gozzoli, *Lorenzo de' Medici on Horseback*, Palazzo Medici Riccardi, Florence (detail)

His father and grandfather, who were still living at the time the frescoes were created, allowed the boy to take precedence. The cult of youth practiced by the house of Medici was planned far in advance. But Florence would not have been Florence if so much beauty and so much platonic love had not after all proved dangerous. The Palazzo Medici also had a private side, a small flower garden at the back of the palace. Anyone approaching the building from here would have seen the courtyard with Donatello's statue of David from the back (Plate 8). His naked back now appears androgynous. The rounded sweep of his hips catches the eye, as does the wavy hair cascading down between his shoulder

blades. Then there is also the ornament on Goliath's helmet, a very long, broad plume. It touches David's right leg, climbing unambiguously up the inside, snuggling ever higher up the naked thigh, as if this Goliath had yearned in vain for something other than a mere victory in battle.[14]

No one, neither the head of the house nor the artist, needed to explain what was going on here. It cannot be overlooked, not least because Donatello's *David* is not actually completely naked. He has stylish, close-fitting boots and, above all, a very fashionable hat, trimmed with leaves. Such hats did not exist in biblical times; this was the type of headgear worn by the young men of Florence. Many Florentines who were no longer in the first flush of youth, successful men in their twenties and thirties, loved to steal the hats of the boys in the street. Evidently, that was their way of paying a compliment and saying—or rather demanding—I want to sleep with you. These crude jokes did not always end in mutual agreement. In 1469, the year of Lorenzo's tournament, a fifteen-year-old accused a member of the distinguished Rucellai family, saying that the patrician had stolen his hat one evening and shouted, "I will not give it back to you until you do me a service." He had then pulled the boy into an alley, raped him, thrown the hat on the ground, and gone away.[15]

The enemy of tyranny, the young David in the Medici courtyard, kept his hat on his head. The game ended well for him, but not for the older man at his feet. Visual temptation was followed by punishment, and this time the radiant winner was the beautiful, androgynous, and above all self-reliant youth.

The homosocial nuances of the Medici politics of symbolism and power can hardly have escaped the young Leonardo da Vinci. At this point, the Medici already owned a second bronze *David*, also a symbolic figure of opposition to tyranny. This boy is not naked, but he is just as bold and hopeful as his namesake in the palace courtyard, and also unambiguously modeled from life. On Leonardo, if appearances are to be believed. It was the bronze for which Leonardo was probably the model shortly after his arrival at Verrocchio's workshop (Plate 3).

Sexual relationships between men were punishable in the Florence of the Medici and regularly prosecuted. Everyone was required to report suspects anonymously; there were special letterboxes for this purpose all over the city. The cases were examined by the *ufficiali di notte*—the officers of the night. They were supposed to be controlling *l'amore masculino*, but their conduct and

documents often made love between men visible to the public for the first time and turned it into a subject of conversation.[16]

In the churches of Florence in the early fifteenth century, the theologian Bernardino of Siena stirred up hatred against sodomy, which, in his opinion, would lead to the extinction of the Tuscans. These sinners should all be burned. In the language of the times, sodomy meant various forms of sexual behavior that were not for the purpose of procreation. In the eyes of the people of the Renaissance it was a moral offense against the divine order, but not an innate tendency or some kind of disease. Bernardino mainly had his sights on men who made advances to adolescents. He reproached mothers for mollycoddling their sons and dressing them too attractively, for instance in tight-fitting breeches that revealed bare skin at the top of the thighs. He warned fathers not to allow youngsters out into the streets alone and to check their purses regularly to see if they had accepted gifts from sodomites. In particular, he criticized parents who hoped to gain advantages for themselves from their sons' intimacy with distinguished men. However, in Bernardino's eyes, the greatest dangers lay in men who were still sleeping with men after reaching the usual age of marriage—that is in their late twenties or early thirties.[17]

Homosexual desire was still both banned and widespread in Florence when Leonardo was living in the city between the 1460s and 1480s. Men from all tiers of society had sex with younger males—workshop owners as much as shoemakers and hairdressers, merchants as much as humanists. These contacts were among the few—certainly not legal yet widely accepted—forms of erotic togetherness in an age when men married late and for financial reasons and young women were locked away to preserve their chastity. Certainly, many men, including Leonardo, never married, but for most of them homosexual experiences remained an episode of their youth and early adulthood.

For a great many Florentines sodomy was a part of growing up and becoming a man, so much so that north of the Alps the term *florenzen* ("doing it like the Florentines") was a synonym for the male homosexual act. The people of the time did not distinguish between homosexual and heterosexual orientation, but between active and passive roles in the game of love. In Florence it was considered ridiculous, even as a betrayal of manhood, to continue assuming the passive position beyond the age of adolescence, so few grown men would have been with partners of the same age.[18] So the patriarchal and hierarchical order of the sexes continued to be symbolically

preserved, even where no women were present. It was male youths between puberty and adulthood, who were not yet able to defend themselves, who temporarily took on their allegedly passive status and were often described like women as graceful, gentle, and attractive.[19] Their contemporaries were unaware that the burgeoning sexuality of young people, male and female, was worth protecting.

Between 1432 and 1502 the Officers of the Night systematically prosecuted sodomites. Over these seventy years 17,000 men fell under suspicion but only 3,000 of them were convicted. Punishments ranged from fines and whipping in the pillory or the stocks to imprisonment and exile; on rare occasions men were executed.[20]

At times the controllers had their sights on a large part of the male population of the city, although much of the information received by the Officers of the Night was probably invented. An anonymous accusation could be used to create problems for a competitor or a detested neighbor. Even if most of the proceedings were abandoned, a charge meant a summons, possibly associated with detention and the fear of being found guilty.

When Lorenzo de' Medici came to power in 1469, many people hoped for leniency. After all, some of the friends in his *brigata*—his clique—were well-known sodomites. His court poets vied with one another in coarse jokes, and in the writings of his favorite humanist, Angelo Poliziano, a student of Homer and later tutor to Lorenzo's children, masculine love was soon transfigured in the Neoplatonic sense—although Poliziano was not altogether Platonic with regard to refraining from it in practice.[21]

However, Lorenzo had no intention of confirming rumors about the carefree hedonism of the Medici. Possibly he wanted to demonstrate that, despite his youth, he was ready to take drastic action. The number of convictions rose rapidly after he took power late in 1469. During the first five years of Lorenzo's unofficial rule, 535 men were punished. The figures began to fall only in the 1480s, when his regime was securely established.

In 1476 almost eighty men were convicted of sodomy in Florence.[22] At this time an accusation could lead to serious trouble. Leonardo, now aged twenty-four, would come to realize this. He was in constant danger, as at some point during his years as an apprentice and journeyman with Andrea del Verrocchio he must have discovered how much he desired men.

It is not known whether this discovery caused problems for him as a young man. Later he evidently enjoyed his way of loving without any great feelings of guilt. By then he was constantly employing new, good-looking boys in his workshop; they drew caricatures of penises and sketched coarse and unambiguous cartoons. And the drawings produced by Leonard's circle also include one of a girlish-looking, long-haired youth, possibly an angel, with an erection (Ill. 40).[23] Fear of damnation does not appear to have been the dominant feeling in Leonardo's workshop.

In 1563, decades after Leonardo's death, in his *Book of Dreams* the painter and art writer Giovanni Paolo Lomazzo imagined an interview between the antique sculptor Phidias and the Renaissance man da Vinci. When Lomazzo's Leonardo says that he had particularly loved one of his employees, Phidias asks, "Did you perhaps play the game from behind with him that the Florentines are so fond of?" Lomazzo had Leonardo answer: "Many times! Remember that he was a very beautiful youth, and especially when he was fifteen." In reply to the following question of whether he was not ashamed to say that, Leonardo retorts: "No. Why should I be ashamed? There is nothing more praiseworthy between deserving men." Lomazzo's Leonardo considered *l'amore masculino* to be an act of friendship, on a par with philosophy, precisely because this form of love does not serve the purpose of procreation but stands for nothing but itself.[24]

In a second dialogue in the same book, Lomazzo has Leonardo meeting the historian, doctor, and bishop Paolo Giovio, who was around thirty years younger than the artist. The fictional Leonardo tells him about a fantasy. He had admired a girl named Drusilla, who would not yield to him. Then, in a forest, Leonardo had eaten a fruit that had made his beard fall out and his body had turned into that of a woman. He then imagined being able to consort with Drusilla as a woman, who in turn would be able to change sex to become a man. The fictional Leonardo's astonished interlocutor replied, "Love is the cause of all such fancies."[25]

So Leonardo already had something of a reputation by the early modern period. However, Lomazzo did not see him as the usual kind of sodomite, an adult who has intercourse with young boys. He was alluding to something that was considered much more outrageous at the time, because it called into question the heroic and virile image of man—Leonardo's penchant for the androgynous, the ability to see himself in the position of both sexes, and to imagine both female and male characteristics as part of himself.[26]

In fact, it seems that Leonardo was not particularly bothered by what people thought about his inclinations. There is much evidence to show that he lived his homosexual life with more enjoyment and less concern than, say, Michelangelo, a Platonist, who largely avoided physical intercourse out of fear of its effect on his ability to work.

On April 9, 1476, the Officers of the Night found an anonymous letter in one of their boxes in the Santa Croce district. A copy of this has been preserved in the Florentine Archives. The author denounced Jacopo Saltarelli, a seventeen-year-old goldsmith's apprentice from the neighborhood. The boy liked to dress in black and was ready to fulfill indecent desires. "He has performed such services for several dozen people." The writer mentioned four of them by name: the goldsmith Bartolomeo di Pasquino, the tailor Bacchino, the friend of the Medici Lionardo Tornabuoni, and "Lionardi di Ser Piero da Vinci, living in the house of Verrocchio."[27]

Leonardo was then charged. It was not the first time Saltarelli had fallen into the clutches of the Officers of the Night; a man had previously reported himself for having had intercourse with the young goldsmith.[28] Leonardo must have been afraid that Saltarelli would confess under interrogation or that other men from the neighborhood would confirm the accusations—in which case he would soon become one of the many men convicted that year. He might have to beg his miserly father to pay the fine, or he might be thrown into prison or expelled from the city. His career might be over before it had really begun.

Leonardo had to wait in fear for two months. He might have spent a night in detention during the enquiry. However, it was probably useful for him that there was a close friend of the Medici among the accused. Lorenzo's mother, Lucrezia Tornabuoni, came from the same family as this man, and his influential relatives may have forced the Officers of the Night to be lenient. Either way, on June 7 the guardians of public morals recorded that the accused would remain at liberty until further notice but must be prepared to appear in court. This did not happen, and the affair fizzled out. Everyday life in Verrocchio's workshop continued as before, and apparently no one in his circle took the accusation against Leonardo amiss. He had escaped with a scare.

Leonardo was undeterred. Shortly afterward he called another man *amantissimo*—most beloved—in a note that is now barely legible. A little later, a

youth by the name of Paolo de Leonardo de Vinci was expelled from the city. The name indicates that this was one of Leonardo's assistants, as by then the artist had become a guild member and was allowed to train his own apprentices, for whom it was then customary to be called after their master. The boy ended up in Bologna, where he was imprisoned for six months because of his previous "depraved" life. He then worked as an intarsia lapidary and somehow in February 1479 a letter of recommendation from the mayor of Bologna was sent to Lorenzo de' Medici, asking if he could lift the ban on the craftsman, as he was now living a respectable life and wished to return to his home city.[29]

All this looks as though, after surviving that earlier accusation with little effort, Leonardo surrounded himself with young, even very young, men who struck people in Florence as immoral. He lived as and with whom he pleased and could thus not have distanced himself further from his father's ideal of manhood. After his affair with Leonardo's mother, Ser Piero contracted a series of marriages, always concerned with siring as many heirs as possible as the ultimate proof of successful manhood.

Once, however, almost twenty years after his experience with the Officers of the Night, Leonardo's anxiety rose again. Possibly in connection with his depictions of Christ, he wrote: "When I made a Christ-child you put me in prison, and now if I show Him grown up you will do something worse to me."[30] Then he crossed the sentence out. It is not known precisely which pictures and events Leonardo was referring to in this complaint. Possibly he was depressed by how negatively love between grown men was judged; maybe he feared that, if he was considered to be a sodomite because of his art, something "even worse" would be done to him than what had happened back then in Florence, when he had been accused only of having a penchant for boys. The sentence is now almost illegible; it might also mean: "When I did well, as a boy you used to put me in prison. Now if I do it being grown up, you will do worse to me." One way or the other, the danger of being socially destroyed evidently still preyed on his mind decades after the accusation of sodomy. And, for Leonardo, almost nothing was as unpleasant as the thought that he might lose his freedom, that he, the country lad, could be caged like one of the birds in the market.[31]

As was the case with his illegitimate origins, his vegetarianism, and a love of animals and nature that was unusual for the time, Leonardo's private life was

Illustration 8. Leonardo da Vinci, *The Sexual Act in Vertical Section*, Royal Collection, Windsor

also out of line, but he would make the best of his position as a minor player in the game of status and influence. He was thus able to observe things from a distance; he did not have to believe what others said but could feel, think, and learn according to his own standards and for that very reason he could create something new. He would succeed in painting women as no artist has done before or since. He met the women he painted, possibly with astonishment and curiosity, but certainly with a respect that was unusual in his day. In 1427 the inflammatory preacher Bernardino of Siena had implied that sodomites hated women and did not believe in equality between women and men—which seems strange in an age that did not consider women to be equal counterparts to men, but rather as inferior versions of them.[32] Misogynistic sayings were also commonplace in Lorenzo de' Medici's Florence. The Medici family's publicly exhibited admiration of women could topple over at any time into its opposite, contempt for women. For instance, the advice of Lorenzo's personal philosopher, the Neoplatonist Marsilio Ficino, was that women should be treated like chamber pots and locked away after use.[33]

This kind of disparagement and objectification of women was absolutely foreign to Leonardo. He was interested in heterosexual intercourse out of curiosity and from both perspectives. He drew the organs in anatomical section (Ill. 8), and the female genitalia also in close-up.[34] Maybe he had experimented with sexual relations with women. In 1509 a former courtesan may have stayed with him for a short time and acted as his model; whether she was also his lover on

occasion remains unknown.[35] However, Leonardo liked to expatiate on the act between woman and man. In awe and wonder, he writes on a sheet of paper: "The sexual act and the members employed are so repulsive." The only explanation he could find for the fact that men and women nevertheless got together and the human race did not die out was that the faces and emotions of those engaged in procreation have something beautiful about them.[36]

Leonardo started from a firm assumption that sexual intercourse must be mutually desired and that desire and inclination are essential to the act of love between man and woman. Thus he wrote that "the man who has intercourse aggressively and uneasily will produce children who are irritable and untrustworthy; but if the intercourse is done with great love and desire on both sides, then the child will be of great intellect, and witty, lively and lovable."[37] In this view, the woman must feel she is loved and understood; she herself must desire in order to be able to love her children in the way that Leonardo's early Madonnas do. Love, like art, is universal. In Leonardo's case, the ability to project oneself into the minds of others is not a question of gender.

This was not a matter of course. To be sure, the Italian societies of the Renaissance were almost obsessed with talking and thinking about love. The early modern individual discovered and celebrated himself in this discourse—but in reality it continually came up against social and economic boundaries. Prostitution and forced marriages were widespread. Romantic love had a hard time of it in real life. Status and money counted for more than grand feelings.[38]

However, none knew better than the Medici that in public—in art, theater, literature, performances, and pictures—love unfolds as a great celebration, outshining all sorrows. They orchestrated the romantic longings of their age for their own political interests.

In the early 1470s Lorenzo, the secret ruler, succeeded in negotiating a balanced relationship with all the relevant powers in Italy. The city prospered, but there was still a risk of being deprived of power by other wealthy families who begrudged the Medici their leading role and were only waiting for an opportunity. In order to display their supremacy for all to see, in 1475 the family planned another tournament in the Piazza Santa Croce. It was prompted by the alliance that Lorenzo had forged with Venice and Milan in order to protect the city from the southern Italian powers. This time the

Illustration 9. Andrea del Verrocchio and Leonardo da Vinci, *Sketch for a Tournament Banner*, Uffizi, Florence

tournament was organized by Lorenzo's younger brother, Giuliano, and he made every effort to ensure that the event was just as bombastic as Lorenzo's celebration six years previous.[39]

At this point in time Leonardo da Vinci was the best painter in Andrea del Verrocchio's workshop. Together with the master he designed a triangular banner for the tourney. His sketch for this is preserved in the Uffizi (Ill. 9).[40] A *bella donna*, probably a nymph, slumbers half sitting in the open air, with her long bare legs stretched out. Her unbound hair falls in ringlets to her shoulders, tickling her neck. Her soft features are similar to those of other female heads from Verrocchio's workshop. She could be the relaxed sister of Leonardo's early Madonna in Munich's Alte Pinakothek (Plate 1).[41]

This woman is certainly no stranger to worldly pleasures. She is dressed only in an undergarment, which is wrapped in loose folds around her smooth body. It is so thin that her delicate breasts can be seen through the fabric. Cupid watches the sleeping nymph. The winged youth, no longer a small child, becomes curious and daring. He rushes up to her, pulls an arrow from his quiver, grasping her between her breasts with his other hand to unfasten her garment even further. However, she rests her elbow on the quiver and remains undisturbed.

It is not known for certain whether this unusual reclining female figure was designed by Verrocchio or Leonardo. The audacious Cupid shows clear similarities with other figures by Leonardo, including the anatomical distortions that are reminiscent of da Vinci's slightly clumsy Mary in the Uffizi *Annunciation* (Plate 6). Then there is the vegetation. The roots, leaves, and reeds do not reach up toward the sky in the orderly fashion that was familiar to contemporaries from the paintings of Verrocchio's rival Antonio Pollaiuolo.[42] In the sketch for the banner, the greenery stretches out in all directions, forms eddies, and explodes

in an organic ecstasy, even wilder than was the case in the garden of the Uffizi *Annunciation*. This can only be by Leonardo. Once again, the boy from Vinci trusted the powers of nature, and once again he was strong enough to have no desire to tame them. Energetic movement became one of his leit-motifs. Be it hair, waves, winds, or leaves spreading out their shoots and curls, throughout his life as a draftsman and painter he would continue to take pleasure in the growth of nature (Ill. 10).[43]

In da Vinci's mind, where nature is, women are not far away.[44] The nymph whose image on the banner waved in the breeze at the tournament in the Piazza Santa Croce appears amazingly

Illustration 10. Leonardo da Vinci, *Star of Bethlehem*, Royal Collection, Windsor

casual. Love could also be like this, not subject to any probably unavoidable laws of purity but only to its own desires. Sensuality sleeps and does not allow a little god to annoy her. But when she wakes, that will be a different matter. The image of the nymph is a promise that is fulfilled only in fantasies.

Leonardo and his master were taking something of a risk with this, as the official story behind the tournament was different. Once again, it was not about private happiness but about the prestige of the republic in general and the reputation of the Medici brothers in particular.[45] Negotiations were in progress for Giuliano de' Medici, a squarely built man with a pudding-basin haircut, to marry various women from other Italian states, depending on the political climate. Sometimes he was supposed to wed a Venetian bride in order to support the new alliance with Venice. Then his brother Lorenzo would start wondering whether it would not be better to have Giuliano make a career in the church, which would make things easier for the Medici in Rome. Lorenzo was no more interested in the fact that the sport-loving Giuliano was not sufficiently well

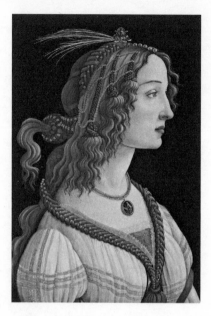

Illustration 11. Sandro Botticelli, *Simonetta Vespucci*, Städel Museum Frankfurt

educated to become a priest than in his aversion to celibacy.

However, on January 29, 1475, Giuliano made his big appearance. This day and this pageantry belonged to him. Although the duke of Milan had refused to send his jousters as escorts, the twenty-one-year-old scion of the Medici knew how to show himself off. He entered the Piazza Santa Croce with seventy foot soldiers in his train, as well as trumpeters, other wind players, and drummers. He and his horse glittered in the sun, both strewn with jewels, precious stones, and pearls. An eyewitness estimated Giuliano's jewelry at the fantastic value of over 100,000 ducats.[46]

The official "queen of the tournament" was, as six years before, Lorenzo's admired Lucrezia Donati. Continuity was also needed. However, Giuliano also wanted to play the great lover himself. As "queen of beauty" he chose his favorite, Simonetta Vespucci, a twenty-three-year-old Genoese lady who was living in Florence and was married to a Medici supporter. Leonardo's rival Sandro Botticelli painted her looking like an enraptured, antique idol, with her thick blond braids and her hair artistically bound with pearls.[47]

Leonardo disliked Botticelli, who was about eight years older and occasionally also collaborated with Verrocchio. He found Botticelli's way of painting too artificial and unworldly. He even criticized his rival in his writings.[48] Botticelli's idealized, ethereal female figures must have very much displeased Leonardo, the admirer of natural beauty.

Botticelli imagined Simonetta chastely. In a portrait he even showed her well-rounded body in a stomacher that peeps out under her white chemise (Ill. 11).[49] This would have suited the official way of reading the 1475 tournament. Angelo

Poliziano, Lorenzo's court poet, invented a prehistory for the event based on Neoplatonism.[50] Love does not stand for itself, it is the servant of honor. In Poliziano's verses Giuliano, who believed himself to be impervious to Eros, is struck by Cupid's dart and burns with love for the beautiful Simonetta. However, she remains chaste. Giuliano dreams that she is wearing the armor of Minerva, the goddess of wisdom and of war. She ties Cupid to an olive tree, plucks out his feathers, and breaks his arrows. In Poliziano's script, Simonetta/Minerva teaches her admirer Giuliano to sublimate his desire and strive for fame instead of fulfillment through love. She encourages him to enter the tournament in full armor in her sight. That is why most of the banners at the event show Simonetta as able to defend herself in addition to as a respectable beauty. Botticelli also designed a tournament banner for Giuliano, showing Minerva in full armor.[51]

Giuliano was therefore only allowed to love from a distance in order to be the victor close at hand—times had grown strict and the shimmering eros of the previous years had given place to Neoplatonist ethics. In this atmosphere of ambition and self-denial the happy nymph on Leonardo and Verrocchio's banner must have been striking. Her message is quite different, telling of playful love and the realm of possibilities promised by a *bella donna* relaxing among the reeds. Once again, Leonardo set his own criteria, and Verrocchio allowed him to do so.

Predictably, Giuliano won the tournament in the Piazza Santa Croce. It was to be the high point of his public life. Two years later, on Easter Sunday 1478, the Medici family's opponents made an attempt to overthrow them. During Mass in Florence Cathedral, henchmen of the Pazzi banking family succeeded in stabbing Giuliano in the back. He died, whereas Lorenzo, though wounded, was able to reach safety in the sacristy with the aid of his court poet Poliziano. One by one the conspirators were caught and publicly hanged. Leonardo went to the scene and drew one of the condemned men dangling from the rope. Sandro Botticelli, who had meanwhile become Lorenzo's favorite artist, painted the official pictures of the hanged men.[52]

In name, Florence was still a republic. The mood in the city was bleak; in a climate fearful of further attacks, Lorenzo's rule became more and more repressive. The time of great celebrations and magnificent ceremonies of love appeared to be over. Yet a longing for romantic togetherness and poetry still remained, not only in the writings of the Ancients but in contemporary life as well.

V

The First Key Work:
THE MOUNTAIN TIGRESS

"I BEG FOR MERCY and I am a wild tiger."[1] This is how the woman whose eyes Leonardo da Vinci looked more deeply into than anyone had done before expressed herself in a line of verse. The young Leonardo found his model and muse in the Florentine lady Ginevra de' Benci (Plate 9).[2] She was the first of the women who made him famous, and he made her famous too, though that was merely a side effect. For both of them it was about something more than that—the desire that what counted should not be the pose but the essence of a beautiful person, because she is what she is. After the meeting of Leonardo and the wild tiger, Western painting was no longer the same. Togetherness moved into art, the need to be close to another person, to sense another's—possibly contradictory—feelings and thoughts, as if they were the air they breathed. The image Leonardo created of the young Ginevra de' Benci was the first ever psychological portrait in Italy, the start of a new kind of art that was both living and touching.

Little is known about the beginning of their acquaintance. Ginevra's brother, Giovanni de' Benci, was one of Leonardo's few friends in Florence. When the artist later left the city, he left a world map, books, precious stones, and his tools with Benci.[3] He probably got to know the Benci siblings through his father, Ser

Piero, as their father, Amerigo, was one of his long-standing clients. The Benci family was one of the city's most influential families. Ginevra's grandfather had run the banking business for Cosimo de' Medici, the ancestor of the family in power. Amerigo de' Benci also worked for the Medici bank and collected Greek and Roman manuscripts.[4]

His children, Ginevra and Giovanni, grew up in a grand palazzo close to the Arno, in the present-day Via de' Benci. Their family had for generations supported Le Murate convent in the center of Florence, where there was a cell reserved as a retreat for the Benci women. Ginevra was educated by the Benedictine nuns. She was eager for knowledge, and in Le Murate she was taught mathematics and music and also learned Latin.[5]

In 1474, when Ginevra was sixteen, the entrepreneur Luigi Niccolini asked for her hand in marriage. His wool-weaving business was not doing very well, but he was a supporter of the Medici and had political influence in the city. A few years later he was even appointed *gonfaloniere di giustizia*, the highest office in the republic.[6] Ginevra's father was already dead when Luigi asked for her hand. Her brother Giovanni probably married them. Her generous dowry of 1,400 florins halted the bridegroom's economic decline for a while, but six years later he bemoaned his miserable financial situation in his tax statement. He also declared that his wife, who had remained childless, was sick and receiving expensive medical treatment.

However, Ginevra recovered and lived a long life. When Luigi Niccolini died in 1505, his brothers were unable to repay the forty-seven-year-old widow her dowry as provided in his will. Ginevra returned to Le Murate convent; as a secular inhabitant she was not banned from leaving.[7] She evidently liked the contemplative atmosphere. When she died in 1520 or 1521, aged over sixty, she was buried in the convent. As was customary when Florentine women were laid to rest in Le Murate, she was buried in a nun's habit.[8]

From the convent to marriage and back to the convent might well be the usual story of a wealthy woman of the Italian Renaissance. A woman's life behind walls was the rule rather than the exception. According to the books of etiquette, a young lady should lower her eyes when walking through the streets to church. Only her husband and close male relatives were allowed to catch her eye. After all, the eyes were the windows of the soul, and their sparkle could kindle the flame of love.[9]

An average woman of good family would be painted once in her life, on the occasion of her wedding (Ill. 12).[10] For her portrait, she would wear her

best dress, which would be made of silk and fine wool and lavishly embroidered. The sleeves would be firmly and chastely attached at the shoulders and cover her undergarment, as respectable women should have neither loose ribbons nor loose morals. She would put on the jewelry that her husband had given her on the morning after the wedding: a necklace, a brooch for her shoulders, and a clasp for her hair.[11]

Maidservants would plait her hair in artistic little braids, weaving in chains of pearls so that no tresses would escape, and no strands would wave in the breeze. A woman of this class would be only discreetly made up, although that would be a matter of indifference, as the artist would smooth out her face anyway. Possibly he would immediately take a pretty girl of a lower class as a model for the head or employ a reusable template, so that the bride would not even have to stand for long in front of the easel or the sketch block. The end result would be an artificial creation, a woman whose dress appeared more individual than her face.

Illustration 12. Piero del Pollaiuolo, *Profile Portrait of an Unknown Woman*, Gemäldegalerie Berlin

Newly married Florentine women looked out of their frames in severe profile without smiling; that was the convention. After all, the wooden panels would be shown to others and would say something about the fortune of the husband and his family and the chastity of the lady of the house. No unauthorized person was allowed to look into the lady's eyes or into her heart; the modest side view of the face was intended to prevent this.

If Ginevra's fate had been the same as that of her contemporaries, her name would have been forgotten at some stage and she would have joined the ranks of the countless unknown beauties of the Florentine Renaissance whose bridal portraits all look so suspiciously similar. It is possible that a wedding portrait of Ginevra de' Benci was commissioned by her husband from one of

the city's other artists, but it is not known which of the many idealized *belle donne* whose profiles now hang in museums could be Ginevra.

However, this story is not about feminine invisibility and masculine claims to ownership. It is about a woman who wanted to express herself and was able to do so, and an artist who had apparently been waiting for a challenge of this kind. No bride in her best dress or successful man in a high position would have been suitable for what Leonardo clearly had in mind—to create a work in which the interior and exterior of a person would be balanced in a new way. It seemed that only Ginevra, the charming, eloquent poetess who called herself the wild tiger, a mountain tigress, was on the same plane as Leonardo.

The powerful yet paradoxical line *Chieggio merzede e sono alpestro tygre*, "I beg for mercy and I am a wild tiger," is the only surviving fragment of Ginevra's literary work that can be attributed to her with certainty. It seems as if the author feels she must apologize for her powers, which appear to have been unbecoming in a woman. The sentence was found in a letter sent by a lute player from Rome on August 12, 1490, to Ginevra in Florence.[12] At this point Ginevra was thirty-three years old and not yet widowed. She had already made a name for herself as a poet. People could boast of being acquainted with her, as this musician did.

In the letter the lutenist recounts how, on the previous evening, he was dining in a shady loggia in the company of a number of respected Roman women, including a daughter of the pope. The conversation turned to the question of what makes women lovable. He began a hymn of praise to Ginevra de' Benci and her poetic art. In his opinion, besides beauty and chastity, a woman was distinguished by her intellectual capacities. The Roman ladies became curious and asked where they could read something by this splendid Tuscan lady. Unfortunately, the lutenist could recite only the first line of the tiger poem from memory, and he repeated it in the letter. Because he was traveling at the time, he did not have his copy of the whole text on hand, so he wrote to the author asking her to send him the complete sestina—a particularly sophisticated verse form—to Rome, so that he could satisfy the curiosity of the Roman ladies. Her reply has not survived, so the remainder of the poem is now unknown.

In her own day, Ginevra's talent was the talk of the town in Florence, but she would be forgotten by the next generation. The writer Cristoforo Landino, a regular guest in the Medici palace, was enraptured by Ginevra's "masculine

virtue in a feminine breast and the memorable power of her talent." This moved him more than her "golden hair" and her "dark eyes."[13] In the 1470s there were very few women poets in Italy. It was not until sixty years later that the Roman writer Vittoria Colonna, Michelangelo's spiritual mentor, became the first woman to make a breakthrough with her poetic works. Full of admiration, people also said of her that a man had been lost in a woman of such virtuosity.[14]

When Ginevra spoke of herself as a wild tiger, Colonna was not even born. As a female poet, the Florentine lady was a new kind of figure on the stage of Italian society. Apart from Sappho in ancient Greece, she had very few predecessors.[15] No model could have better suited Leonardo da Vinci, for whom surprise was always preferable to repetition.

Illustration 13. Petrus Christus, *Portrait of a Woman*, Gemäldegalerie, Berlin

Only, how could one paint a wild tiger? Dangerous or endangered, or both at once? Would it even be possible to capture her appearance on a wood panel, or would she immediately flee back into the rocky heights of her soul that only she seemed able to scale? How would it feel to observe her for longer than was considered proper and to grasp a piece of what remained hidden from others?

Leonardo da Vinci must have known the richly detailed paintings of Flemish artists. Florentine merchants traveling north of the Alps had acquired painted wood panels, which could then be seen in the city's palazzi. The Medici brothers also owned works of art from north of the Alps. In Lorenzo de' Medici's study there was a small portrait of a woman by Petrus Christus, who spent his old age in Bruges (Ill. 13).[16] This follower of Jan van Eyck was not afraid of the serious gaze

Illustration 14. Sandro Botticelli, *Portrait of a Lady Known as Smeralda Brandini*, Victoria and Albert Museum, London

of the wealthy young wife he was portraying. Unsmiling, she is turned three-quarter-face to the viewer, looking at him out of the corners of her eyes. Her hair is invisible under her stiff cap, whose dark voile bands her chin and cheekbones. The woman, who can be seen only in bust-length, appears to be standing only a yard away from the viewer in the paneled room, but her face radiates a sense of expectant distance. In this less-than-life-size painting, Petrus Christus also tells us something about painting itself. Yes, she can approach the viewer, offering him a physical presence, but no, he may not touch her, as she lives in her own world behind the frame, and this world is not ours.

This young woman from the north evidently bewitched Leonardo da Vinci in the mid-1470s. He must have thought to himself that it would be possible to abandon the usual profile view of women in Florence, without immediately giving rise to moral doubts. The side view said too little about a person; it was inhibiting, because it prevented dialogue. In order to be on an equal footing with the viewer, if not actually superior to him, the painted figure must be able to return his gaze. God had given people eyes so that they could understand the world, so they should be used, not hidden. "Oh eye, you stand supreme above all the other creations of God!" exclaimed Leonardo. "It is the window of the human body, through which it sees its way and enjoys the beauty of the world; it is thanks to the eye that the soul is content with its human prison."[17]

At the same time, or slightly later, Leonardo's favorite rival, Sandro Botticelli, also attempted to raise awareness of a woman and free her from the profile view. He found a solution that indeed showed the face of a Florentine

lady from the front but shocked no one (Ill. 14).[18] She is looking out of the window of her palazzo, which she has just opened with her right hand. Her left hand rests on her rounded belly. She is expecting a child. Her expression gives no clue as to what this means to her. Botticelli's depiction of the mother-to-be is as idealized as his other stylized *belle donne*. Like Leonardo, in the 1470s, Botticelli probably knew Andrea del Verrocchio's most recent creation, the marble bust of a young curly-haired woman with her hands held protectively in front of her body, clasping a bunch of primroses to her heart. The stone woman is beautiful, but her pupil-less gaze remains impersonal (Plate 11).[19]

Leonardo had his mind on greater things. Small departures from the usual format were not enough for him; he wanted to play by his own rules. That was the only way in which, together with his model, he could create something completely new.

Leonardo may have met Ginevra in the early 1470s in one of the expensively furnished rooms of the Palazzo Benci and begun by drawing her. Her rounded, evenly proportioned face with its high forehead was turned toward him, but Leonardo became aware of something else, which would be seen in the finished painting. No smile, no desire to reveal herself completely to the artist. The young woman gazes out at life from warm brown eyes, while looking into herself at the same time. It looks as if she must be constantly seeking a balance between the outside world and her inner world, in order not to lose herself in either. The delicate, rosy-cheeked, girlish face is surrounded by an aura of melancholy. It is the melancholy of a thinker.

Leonardo was only five years older than Ginevra, and the longer he looked at her, the more strongly he might have felt an affinity of spirit with the sensitive, pensive young woman. Clearly, he must have imagined how he could capture her aura, her blend of resolution and fragility, and how he could portray her irresistible beauty without betraying her restrained individuality. Physical and mental energy must match one another in the portrait, of that he was convinced. He wrote that a painted figure should express "the passion of its soul"; only then would it be successful.[20] The portrait of Ginevra de' Benci was the first in which he put this idea into practice.

He worked hard. Although it was only a small portrait, he drew a cartoon, a full-scale preparatory sketch.[21] He pricked out the lines of the drawing with a pin,

Illustration 15. Infrared reflectograph of the right eye of Leonardo da Vinci's *Ginevra de' Benci*, National Gallery of Art, Washington, DC

so that he could use charcoal or some other dark powder to transfer the face onto the prepared poplar wood panel and then connect the dots.

He prepared the eyes with particular care; they would be the center of his composition (Ill. 15). Fine lines indicate the lids and the tear ducts. Then he started on the underpainting and was not immediately satisfied. It was not easy to capture Ginevra's restrained gaze. He had to rework the iris of the left eye, closer to the center, to make the figure really look in the direction of the viewer, even though she was not looking at him.[22]

In the painting, Leonardo lit Ginevra's pale complexion, as well as the dark-blond curls, carefully oiled and arranged at the sides of her face. They hint at his later dynamic studies of wind and waves (Ill. 29). The hair at the back of her head is loosely held in place by an undecorated scarf. This seems outrageously simple compared with the headgear usually on display in portraits of Florentine women. Leonardo even kept her dress as simple as if we were looking at the daughter of a craftsman rather than the child of one of the richest families in the city. Ginevra is wearing a *gamurra*, a brownish woolen dress, laced across the breast, of the kind worn by women in the home when no strangers would see them.[23] The neckline of her almost transparent shift is decorated only by a narrow gold-patterned border. A dark shawl falls down over her shoulders. The lavish, attached oversleeves, a feature that often appeared in the foreground of earlier female portraits, are lacking. For Leonardo and his model, it was not about status symbols but about inner values that for one moment become clearly visible on the outside.

Leonardo revolutionized the image of the woman in yet another respect. He carried Ginevra away from the closed room of feminine restriction and placed her in the middle of a landscape. It is not certain whether he could also have copied this idea from Flemish models. Maybe he was thinking of his own

beautiful, free Marys (or possibly the sequence of pictures runs the other way and he painted Ginevra first, and she inspired his later images of the Virgin). In the *Madonna of the Carnation* (Plate 1), the Virgin feels the warm mountain sun on the back of her neck; the angel tells the young Mary of the *Annunciation* (Plate 6) of her pregnancy on an open terrace. Leonardo's women need light and air; they are children of God, relations of nature, and their full femininity develops only in the fresh air—at least in the view of the artist, who can only imagine the microcosm and macrocosm, the human being and the universe, together.[24]

Leonardo's *Ginevra* is set in an early-morning lakeside landscape. There are bushes reflected in the water; the nearby trees seem to overtop the church towers of civilization on the horizon. In many parts of the background of the painting Leonardo became a little overconfident. Oil painting was still new to him, and he became bored with applying the paint only with a brush. Usually, he set great store by not making himself and his workshop dirty when working; after all, he wanted to look as elegant as a nobleman at all times, not dusty like a baker.[25] Yet now he boldly picked up the sticky, oily smelling paste and pressed it onto the prepared wood with just his fingers and the ball of his thumb. Mostly Leonardo is a left-hander, but here he used only his right to spread the paint. This was not a deliberate act of creation and thought; it was pure enjoyment of the immediate brightness of the greasy pap on the prepared wood. His handprints can still be made out on the portrait of Ginevra.[26]

However natural the landscape may appear, Ginevra is not exposed to it. Her upper body and head are framed by a well-armed plant. A thick, spiny juniper bush stretches up toward the sky. Once it was a shimmering dark green and every needle could be picked out. Over the course of centuries it has gradually darkened into a gloomy, opaque mass, against which Ginevra's pale face now stands out in stark contrast. Originally person and bush formed an organic whole. Lower parts of the panel were cut away after Leonardo's death, resulting in the loss of the figure's upper abdomen and hands. If, as suggested by a comparison with one of Leonardo's studies of hands, Ginevra once held a twig, possibly of juniper, pressed against her body, the relationship between woman and plant would have been even closer than it appears today (Ill. 16).[27]

Why juniper? Why not laurel, the evergreen bush once praised by Petrarch that crowned emperors and poets? No, laurel belonged to the great writers,

Illustration 17. Leonardo da Vinci, *Study of a Woman's Hands*, Royal Collection, Windsor

giving them and their art undying fame.[28] But in the picture two different people were entering into a pact: Ginevra de' Benci, a woman who had stepped out of her traditional role, because she wanted to write poetry herself and not merely be celebrated in verse like Petrarch's Laura. A personality in her own right and her own name, as made clear in her portrait. The name Ginevra comes from *ginepro*, the Italian word for juniper. Her ally in this was Leonardo da Vinci, who wanted to establish painting as a new leading science and felt only scorn for the poet princes who still set the tone of fashion. The artist once wrote mockingly that many people thought laurel tasted "good with sausages and roasted thrushes." That was probably why Petrarch liked it so much. Everything else was mere prattling.[29]

However, irony was not enough for Leonardo. A self-taught man with no higher education, he enjoyed exercising his sharp tongue on the criticism of scholars, and he wanted more. He wanted to create a serious alternative to Petrarch's ethereal and slightly unreal Laura. He was helped in this by the young poet Ginevra, who lived a life of her own, thus defying the men who were obsessed with their self-appointed authority in interpretation. Ginevra's prickly obstinacy, her presence, seemed almost rebellious, and that was precisely what Leonardo obviously admired in her.

Leonardo's refusal to pay homage to the legendary Petrarch and indeed his resistance to the poet are all the more noteworthy since this portrait would not have been painted without the initiative of one of Petrarch's admirers. It is unlikely

that Ginevra and Leonardo would have met if it had not been brought about by, of all people, a humanist with a good knowledge of literature, namely Bernardo Bembo, the Venetian ambassador to Florence. He had evidently commissioned the portrait of Ginevra from Leonardo da Vinci; a slightly modified form of his personal emblem can be seen on the back of the painting (Plate 10).[30] Bembo admired Ginevra as his platonic beloved, in the way that Petrarch paid homage to Laura, Lorenzo de' Medici to Lucrezia Donati, and his brother Giuliano to Simonetta Vespucci.[31]

Illustration 16. Hans Memling, *Portrait (Bernardo Bembo?)*, Royal Museum of Fine Arts, Antwerp

Bembo, the brown-haired Venetian with the sharp features and the slight cleft in his chin, had studied law and philosophy in Padua (Ill. 17).[32] Born in 1433, he belonged to a generation of the nobility for whom education and diplomacy, poetry and statecraft, went hand in hand. He was one of the puppet masters of the Venetian Republic, which was financially strong but still relatively small, even with its hinterland. In order to survive it had to rely on making arrangements with the great powers of Europe. Many envied Venice's trading power, its political sovereignty, and also its elegance. However reluctant the Venetians were to allow interference in their affairs, they were very mindful of the need to find and retain new political partners. Bernardo was particularly successful at this. He had already represented his home state in Castile and at the Burgundian court, where he had negotiated a complicated alliance pact. As an educated man, he knew how to invoke a sense of common values, the Greek and Roman heritage, the writings of the ancients, and the noble modern age that was now dawning. He was also frequently on the move as a cultural ambassador, and he knew how to beguile his audience with humor

and good rhetoric, stylish clothing, and a manner that was both pleasant and persistent. And, wherever he was, he liked to absorb intellectual inspiration. He once traveled as far as Avignon in order to trace the spirit of Petrarch in the southern French city and believed he had discovered an image of the poet's beloved Laura in a church fresco.[33]

In November 1474 Lorenzo de' Medici succeeded in forming a triple alliance with Milan and Venice to counter the central Italian expansionist policy of Pope Sixtus IV. Two months later Bernardo Bembo closed the water gate of his Venetian *casa*, took one last breath of the damp winter air over the Grand Canal, and left the city. With his wife, a lady of noble family, and their two small children, Pietro and Carlo, he set off for Florence. He arrived just in time to witness Giuliano de' Medici's appearance at the *giostra*, the tournament. Bernardo stood in the crowd in the Piazza Santa Croce and was amazed by what he saw. The young Leonardo da Vinci, whom Bembo commissioned to paint Ginevra's portrait a short while later, was probably also among the spectators.

Bernardo Bembo was not particularly impressed by the splendor, the grandeur, and the vast amount of money; Venice was used to finer clothes and more stunning appearances than these bejeweled horse cloths and helmets. However, the Venetian was bewildered by the contributions of the artists. What were these tournament flags and banners in the Medici procession all about? Why was the little Cupid bound and looking at the ground in embarrassment? Why was this terrible goddess Minerva brandishing her lance above the head of the frightened boy? How were such complicated images to be interpreted? Bembo was nonplussed.[34] All his knowledge was of no help to him when faced with the somewhat puritanical Neoplatonist private mythology staged for the Medici by Sandro Botticelli and his colleagues. (Bembo did not comment on Leonardo and Verrocchio's counter-project, the banner with the beautiful recumbent nymph, possibly because her more liberal sensuality was self-explanatory [Ill. 9]). In search of clarification, Bembo turned to the thinkers in the Medici circle who had put this program of victory and honor into the artists' heads. He received the answer in writing from an adherent of Ficino: The bound Cupid and the warlike Minerva would be explained in different ways by different people. The wonderful thing about modern art was that it allowed different interpretations: "The most beautiful of all painted pictures is of this kind."[35]

The "most beautiful of all painted pictures"? Bembo may have thought that this had not yet been achieved, and he took up the challenge. The

admiration of women that so obsessed the Florentines also appealed to him as a keen reader of the works of Dante and Petrarch. That did not mean that he was becoming a strict Platonist.[36] There was no need for so much self-castigation, for a Cupid with his feathers plucked, and for lances and armor.

Bembo did not approach his stay in Florence in a combative spirit; his inclination was not for war but for understanding between states. And how better to celebrate the flirtation between the two republics than if the Venetian ambassador and friend of Lorenzo de' Medici were to be openly bewitched by a dignified, beautiful, and chaste Florentine woman from one of the best families, and honor her with the gift of poems and a portrait? Bembo would not show off like the Florentine heads of state, but prance with typical northern Italian *sprezzatura*—affecting an appearance of simplicity.[37] The Venetian would show the Tuscans who were so proud of their literature how it should be done—living poetry.

Bernardo may have met Ginevra one day at one of the banquets in the Medici palace. Or maybe he was looking at ancient manuscripts in the Benci palace, or his new philosopher friends told him about the poetess, who was fourteen years younger than he; after all, Ginevra's father was a patron of the Platonist Marsilio Ficino. Bernardo Bembo recognized that Ginevra de' Benci was the perfect choice. She not only excelled the ladies admired by the Medici brothers, Lucrezia Donati and Simonetta Vespucci, she even outdid Petrarch's Laura. She was not only enchanting—she could not only be gazed at, worshipped, and celebrated in poetry, she could also be heard. Petrarch created world literature in the form of a monologue. How much more sophisticated would the Platonic game of love appear, how much greater would a man's reputation be, if he enabled his Laura to speak? Answers could be expected from a woman as well read and talented as Ginevra de' Benci. The exchange of thoughts and emotions that had been denied to Petrarch suddenly appeared on the horizon as a real possibility.

Bernardo paid court to the young, married Ginevra, declared himself in love, and made it absolutely clear that his intentions were honorable and he was not looking for a mistress (he already had one) and that neither his nor Ginevra's marriage was in danger. He was allowed to continue his attention and was even celebrated for his passion. Thanks to the Medici brothers' theatricals, the ritual of the love of Laura had afforded the people of Florence years of practice. Although they were obsessed by women's chastity (and therefore constantly

calling it into question), nobody was outraged when a foreign ambassador celebrated his love for the young wife of a politician and it became the talk of the town. As with the flirtations of the Medici, this time there was no sign that the lady's husband, Luigi Niccolini, was annoyed by this literary game.

It was, after all, an honor to be chosen by Bernardo Bembo. At least, that was what was loudly proclaimed by the poets of the Medici circle, who soon gathered around the Venetian humanist. Bernardo invited them to a banquet, discussed the immortality of the soul with them, and read their compositions. They reciprocated with paeans of praise about Ginevra and Bernardo. "He saw her, and the flame penetrated his innermost being. And a fearful trembling ran through his hard bones."[38] Ginevra felt happy, added the author, the poet Cristoforo Landino, because, dear Bernardo Bembo, "you are young in years, there is power in your good looking body and you skillfully combine jesting with dignity."[39] There followed a list of the honors and services gained by the statesman and his family and praise for his cosmopolitanism, elegance, intelligence, and charm. "Now Ginevra is lightly moved by these things (for she does not bear a hard stone in her human breast), now she is eager to be made a symbol of eternal love."[40] Not only that; according to the author, she would like nothing better than to change her name and become a "Bemba" herself.

This no longer sounds like Petrarch, who had once been confronted with an apparently unyielding heart and forced to come to terms with it. Times had changed. Now, with a little bit of luck, love would be reciprocated.

"No other young woman in the entire city is considered more beautiful and no other is thought greater in her chastity. So, who could deservedly criticize your love?" wrote Alessandro Braccesi in justification of his friend Bembo, surprising him with a gift of flowers. He had observed Ginevra picking violets and pressing them to her bosom. When she saw Braccesi, she had deliberately dropped the bunch and walked away, at which he had picked it up and had it delivered to Bembo.[41]

As a fourteenth-century woman, it would have been hard for Laura to allow such teasing, but her admirer, Petrarch, was the first to allow his heart to give free rein to such emotional outbursts. In unattainable love, one could find his way to his expressive, emotional, and intellectual self. In the late fifteenth century, however, the Petrarchan admiration of women and the complaints against apparently hard-hearted females sounded like nothing more than endless repetitions.[42] It was time to go a step further.

Landino said of Ginevra: "Why did the concise and happy language of Petrarch not encounter such a goddess at the right time? For she outshines Laura in her beauty, goodness, restraint and her noble morals."[43] However, the new Laura differed most of all from the old one in that she had the ability to express herself. That is why Landino not only praised the "power of her talent" but also preached that "Every lover / who is overcome by beauty alone / is stumbling over slippery ground with uncertain steps. / But if anyone loves a superior mind, a keen / intelligence and a heart filled with different virtues, / then he will follow beauty."[44] And his friend Braccesi imagined how this woman with her keen intelligence and excellent heart would weep when Bernardo finally had to return to Venice. She would beg "all the gods above that a difficult road might slow him down." She would even wish for "contrary winds and heavy storms" to delay his departure. The contemporary Laura was able to feel, to think, and to act.[45]

What did Ginevra de' Benci think of all this? Was there anything in all that gossip? Did she really return Bernardo's affected passion in her heart? Or did it annoy her to be thus glorified and be the object of so much attention, not only from an admirer but also from his followers? Did she enjoy the attention that was unusual for a woman, or did she find it frightening? And what about Bernardo? Was he only showing off, basking in the sunshine of a new, more perfect Laura, or did he really like and respect the young woman for her whole personality?

In the State Archive of Florence there are sheets of curved script that were not found until 2016, when a researcher discovered them in an envelope containing texts from the milieu of Bernardo Bembo.[46] They evidently originate from the time of Bembo's second stay in Florence in 1479 and 1480. In the midst of the pile of unsorted duplicates and notes was a copy made by an unknown contemporary of an exchange of poems that does not sound at all like the praises of Bembo's poet friends. The verses were not in Latin but in *volgare*, the new Italian—the language of love lyrics, in which Petrarch had also written. The characters are an admirer addressing himself to his lady friend, and a Ginevra, who answers him in two poems. There is a lot of evidence in favor of the idea that these are copies of sonnets from the love letters of the Platonic couple of Bembo and Benci. If that is correct, then more of Ginevra de' Benci's writings than the previously known single line of verse have survived after all.

The voice of the mountain tigress was heard—and she knew what she wanted.

The man in the poem praises "my juniper," meaning Ginevra, who is said to be even more beautiful than Helen, as described by Homer in his verses. The evergreen plant has a scent but it also has natural defenses; the woman combines *durezza*, hardness, with *gentilezza*, kindness. He wishes for the latter from "my queen." He does not ask for anything dishonorable, he says. A modest glance or a small exchange of words would be enough to give him hope. Such a favor would be balm for his weak soul, since "Without you, any joy would be a great war for me." And, more urgently, "Madonna, if comfort from you does not come soon you will find me dead and I will be free from pain."[47]

On the one hand, this is reminiscent of Petrarch—the pain of the man and the supposed harshness of the woman. On the other hand, this author seems to be allowed to expect more from the lady he admires than Petrarch, whose contact with Laura was restricted to a single glance in the church in Avignon.

Ginevra replied, and she did so as a woman, without a literary example of the kind available to Bernardo as a man in the "I" of Petrarch's lyrics. She alone was responsible for her attitude to him. In the first poem, she appears approachable. "I know very well that it is true that you honor me," she begins. His verses give her great pleasure, "because our love is chaste and dignified."[48] He is in Jupiter's favor and knows how to preserve a woman's dignity. It pleases her when he calls her name so often, because "It is a higher power and it is reason that allows me to love you."[49]

So she loved him too, and she believed that he was thinking of *her*, and not just his own fame. What she particularly liked about him was his respect for her boundaries, and, to be on the safe side, as if she wanted to make sure that he did not forget this, she emphasized it several times. On the one hand, she shifted responsibility for her love onto a higher power, bringing Jupiter into play. On the other hand, her mind also decided in favor of this love, and she was in no doubt that she had a mind of her own. She appears to have been unimpressed by the thinkers of her time who considered women incapable of either loving or thinking.

Bernardo could count himself lucky; he sought for Laura and found a tigress.

However, that also meant living with a contradiction. In the second poem she takes the mournful admirer to her bosom. "What, my lord, is the use of so much lamenting?" she asks, confronting her admirer with her objection. "Your great misery affords me no joy." It had to be said; after all, it had been

assumed since Petrarch that the sorrow of the rejected lovers suited the Laura figures. "If you are in pain, I am in torment," she says; "this will not end without effort." And then, "The love in my breast will never die but the tears and the pain are of little value." She does not consider death worth striving for, so "let us think of the common good." Once again, it was up to her to be the voice of reason.[50]

This exchange of poems seems more delicate and intimate than the vapid praises of Bernardo's poet friends. It may have been intended to be read also, though not mainly, in the semi-public environment of the Florentine salons. Here are two people talking to each other instead of about one another, and also talking a little to themselves. Longing shimmers through the lines, happiness flickers up. Anger may be expressed, anxieties seek comfort. Talking results in interaction with one another and with their own souls.

Possibly the couple's verses were inspired by Leonardo's portrait; possibly they were created at the same time or even before it. However, one thing is clear: Only an unconventional mind like Leonardo's could do justice to such intimacy and paint Bernardo's beloved Ginevra as she was, in the midst of her literary game. Bernardo Bembo seems to have suspected this when he chose Leonardo. To show a woman in a painting as an individual to be admired, instead of the conventional dream woman withdrawn from life, required the boldness of a figure on the edge of society and the conviction that reality was more interesting than the world of ideas and ideals.[51]

Petrarch also had a picture of his Laura that he praised, saying that Simone Martini had been in heaven when he painted it. Two sonnets in his *Canzoniere* are devoted to this painting, which has not survived. Petrarch was enchanted by the painting and said he could see Laura in person before him. Then he became deeply disappointed, as he wanted to be able at last to speak to the object of his admiration, to get everything from the artwork that the real lady denied him. It seemed as if the beauty could hear him, but the picture did not respond; it lacked what Petrarch longed for, *voce ed intellecto*, voice and intellect.[52]

The reproach still echoed a hundred years after Petrarch's death: Artists act as though they could create life, but their silent pictures cannot think, listen, or speak. From this point of view, painting is deception, whereas literature claims to be true.

Illustration 18. Leonardo da Vinci, Infrared reflectograph of the motto on the back of *Ginevra de' Benci*, National Gallery of Art, Washington, DC

This bothered Leonardo da Vinci more than other painters. In his mid-twenties he was very sensitive to disparagements, and this was one. But it was also a challenge. He accepted Bernardo Bembo's commission, and it subsequently seemed that he was pleased to do so for that very reason.[53]

Leonardo was probably also at Bernardo Bembo's service when the latter had an idea for the back of the picture. First, Bembo had his motto, *Virtu[s et] Honor*, "Virtue [and] Honor," painted there (Ill. 18). His emblem consisted of a palm branch and a laurel twig forming a circle around the words. The palm stood for virtue and the laurel for honor. Bernardo would later decorate some of his books and manuscripts with it, and as mayor of the Venetian city of Ravenna, he subsequently had no reservations about having this personal mark put on Dante's grave, which he was having restored for symbolic political reasons. The ambassador of culture never missed an opportunity to put himself forward.[54]

However, at this point, it was not about him, or only secondarily. It was about Ginevra, a wife and poet, who wanted to be respected. A mark of possession, such as her admirer's motto on the reverse of her portrait, seemed inappropriate. Someone, possibly Leonardo or a member of the Benci family, probably pointed out to Bernardo that he would be misappropriating the portrait, and even more the person portrayed, if he monopolized the picture in this way. For whatever reason, the motto was altered and overpainted, not in oils but in old-fashioned tempera (Plate 10). The palm branch and laurel twig still formed a circle, but in the middle there was now a juniper twig, the emblem of Ginevra, and the inscription on the surrounding banderole, which now read:

Virtutem forma decorat, Beauty adorns virtue.[55] This no longer sounded much like Bernardo, but much more like the motto of an educated woman.[56]

Depicting a beautiful soul in a beautiful person with the addition of a fine intelligence coincided with Leonardo's ambitions. He cared little about creating a monument to Bembo and his Petrarch cult, especially not on the front of the panel. It is a statement, not just about a beautiful, intelligent woman, but about the beauty and intelligence of painting itself. Since antiquity, the image of a woman has been considered the standard for perfection in art. Leonardo was spurred on by a twofold ambition: He wanted to drive painting, the science of the human being, into life, and he wanted to topple the poets from the throne of their sense of superiority. He was motivated by this rivalry with the literati and fought throughout his life to have painting rather than literature recognized as the leading medium of the age.

In his notebooks Leonardo later unleashed his full fury against poets. Could a poet create words? Maybe, but a painter could express something that was impossible to capture in words. For Leonardo, what the poet produced was nothing but a "tissue of lies," "a figment of the imagination."[57] The poet would have to take a body apart in order to describe it. He would arrange the parts of the body one after the other, limb by limb, in the text. By contrast, the painter, like nature, could display an entire person in a single moment. In Leonardo's opinion, his work of art would have "divine harmony . . . which can enthrall the viewer to such a degree that he loses its freedom."[58]

And what is the proof? It is images of beautiful, lovable women. Leonardo told the story of how the king of Hungary, Matthias Corvinus, received a painter and a poet, both of whom had praised the woman he loved. The king pushed the poet's work aside, unread. He wanted something to look at and grasp, not something to listen to.[59] By contrast, he touched the picture and happily held it before his eyes.[60] In Leonardo's eyes this was proof of how real and seductive the painting of a beautiful woman is.

And that is not all. Leonardo maintained that his customers caressed his paintings of women and spoke to them. A good many brought images of saints back to his workshop so that he could remove the halo, making it less awkward to kiss and talk to the lady in the picture. On the other hand, who would want to kiss a poem? The power of painting was so great that it could make the viewer fall in love not only with the picture of a living woman but also with a freely created female figure.[61]

In Leonardo's opinion, it was beautiful women who gave painters power over the viewer, "so that he lost his freedom." When this viewer was also a writer and humanist like Bernardo Bembo, the painter's triumph must have been especially great.[62] And after all, according to his poet friends, did not Bernardo want it this way himself and appear to enjoy his devotion to Ginevra, who was for him "both a goddess and a gift from the gods"?[63] Leonardo gave his desirable figure a life of her own, in a way that neither the poets nor any other painter had hitherto believed possible.

The woman in this painting is nobody's servant. She is surrounded by her own plant, the prickly juniper. She does not hide away but reveals herself to the viewer. He is given a brief insight into her melancholy contemplation, yet she does not allow him to see into the uttermost depths of the landscape of her soul.

Leonardo loved mystery, and he also conferred it on his Ginevra, the woman who, as Petrarch once demanded, possessed *voce et intellecto*, voice and intellect, to a greater extent than almost any previous figure in a secular painting. With her distinctive round face, her curls, and her pale, finely veined complexion, she appeared almost alive, even to her early admirers.[64] Yet she would never yield completely to any man or woman of her day or later centuries. This *bella donna* lives in her own world behind the frame; she seduces and binds the viewer in alluring togetherness, but she will never yield to him. She is his adored counterpart, not the fairy who grants all his wishes.

Leonardo had learned from the mountain tigress. The sovereignty of the beautiful, intelligent, nature-loving poet brought him to his greatest invention: painting as a self-assured and self-determined art. Ginevra's inner and outer beauty led to the beauty of a new, unconventional kind of painting. This combination benefited both art and women.

"If you want to go your own way, do not be born a woman."[65] Thus wrote Lorenzo de' Medici's sister Nannina in a letter to her mother in 1479, after losing an argument with her husband. How resigned this sentence sounds. In composing it, Nannina de' Medici was drawing attention to the injustice of gender hierarchy for once. In this sentence is the germ of a claim that, in theory, things could be different and that being a woman should not necessarily exclude following one's own path. Against all the conventions of their age, in their painting Leonardo da Vinci and Ginevra de' Benci hastened the arrival of this utopia,

encouraged by the Platonic game of love between the young poetess and the humanist Bembo, in which Ginevra raised her voice and displayed her intellect. As a result, the improbable happened. The mountain tigress showed the world her face and her intelligence. And, at the same time, the artist who painted her gave his first secular portrait so much heart and soul that art was never the same again. The emancipation of women would not come for another five hundred years, but the emancipation of art happened at that moment.

VI

THE FRIEND OF MARY

LEONARDO WAS NOT yet the leading artist in the city of Florence. That was the ubiquitous Sandro Botticelli, who painted modern and mythological subjects without causing too much offense to contemporary taste. Also, Leonardo's works were rarely to be seen in public. His *Madonna of the Carnation* (Plate 1) was in the private possession of the Medici, and the portrait of Ginevra (Plate 9) evidently remained in the possession of the Benci family after Bernardo Bembo's return to Venice. Leonardo's groundbreaking *Annunciation* (Ill. 8) and the *Baptism of Christ* (Plate 5), his early piece produced in collaboration with Verrocchio, hung in the monastic churches outside the city.[1]

Nevertheless, word of Leonardo's talent was gradually spreading. Lorenzo di Credi, a young painter who respected and copied Leonardo, was now living and working in Verrocchio's workshop. However, it is clear that he did not really understand Leonardo's new ideas. For instance, he copied Leonardo's *Annunciation* in a predella for an altarpiece (Ill. 19),[2] but his Mary is ill at ease. Her head is shyly bowed, and she does not venture to look at the angel. Leonardo's proud women were so unusual that even an admirer such as Lorenzo di Credi chose not to copy their upright posture, instead returning instinctively to the traditional pattern of feminine humility.

Yet Leonardo was obviously pleased to have found a kind of pupil in the younger man. He willingly let him sketch the figures for an altarpiece in the neighboring city of Pistoia. Lorenzo was also a blessing for Verrocchio as, unlike

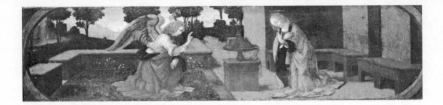

Illustration 19. Lorenzo di Credi, *Annunciation*, predella, Louvre, Paris (detail)

Leonardo who was always bubbling over with new ideas, he was a reliable worker and finished what he had begun.

Leonardo sensed that, in order to be able to do what he wanted, he needed his freedom. Despite all his liking for his long-standing supporter Verrocchio, the time was ripe for him to have a workshop of his own.[3]

In January 1478 Leonardo was twenty-five years old and had become independent. His first major commission came from the Florentine city government. He was to paint an altarpiece dedicated to Saint Bernard for the city hall, the Palazzo della Signoria, and would receive an advance payment for doing so.[4]

However, Leonardo was not as good a businessman as his father. Efficiency and punctuality were not his strong points. He considered painting to be the supreme science, which meant that he set himself incredibly high standards. Speed and pragmatism were out of the question for him. In his biography of Leonardo, Vasari later expressed the opinion that the artist was a hindrance to himself, because he constantly tried to "seek out excellence upon excellence, and perfection upon perfection." And a poet friend once asked the artist straight out in a sonnet, "Leonardo, why so troubled?"[5]

Possibly Leonardo did not know the answer himself. He kept putting things off, became distracted, and allowed his thoughts to wander aimlessly. Life was so short, and there was so much he still wanted to know and try out. He was simply incapable of concentrating on one thing at a time, and it went against the grain for him to take the expectations of others more seriously than his own. The altarpiece for the city hall was never completed; possibly it was never even begun. In the end he lost the commission to a competitor.[6]

Illustration 20. Leonardo da Vinci, Designs for a catapult (above) and a war machine with sixteen crossbows (below), Biblioteca Ambrosiana, Milan

Leonardo preferred to think of things that were not or could not be paid for. He often fastened his notebook to his belt and roamed the streets observing different types of people. Who looked angry? Who looked indifferent? What did a cheerful or an anxious face look like? At some stage, perhaps at this time, he developed a method of preparing templates of faces in his notebook so that, when he was out in the street, all he had to do was quickly pencil in the special features in order to recall everything later.[7]

Mostly Leonardo was busy drawing, because, as can be seen from his deft touch, it was so much quicker for him than painting. He invented machines on paper that would make life easier or protect him from the dangers of the world, if they were ever constructed. Being rather slightly built, he would have liked to possess superhuman powers. Ideas would achieve what muscle power could not. For instance, with the right technology, he believed it would be possible to use winches and screws to raise the baptistery of Florence Cathedral and place it on steps to protect it from the flooding of the Arno. And what else might be possible with water power? There might be even better mills and machines so that people could harness nature's energy to help them, instead of being at the mercy of her whims. Leonardo's first design for a flying machine, based on the model of bird flight, was also created at this time.

If a person understood nature, nothing could stand in his path. No prison could hold him. Were he ever to be incarcerated for a longer period, which Leonardo seems to have feared ever since the accusation of sodomy, he would be able to free himself with his device for breaking through armor plating: One of his drawings demonstrates how pincers could be fixed to a bolt, in order to burst a secure prison door open from the inside.[8]

Leonardo would not harm a sparrow. He defended the right of bees to live, suffered with every beast of burden, and hated to see young goats being slaughtered. Hen's eggs made him think of the unhatched chicks, and cheese reminded him of the milk that really belonged to the calves. He could even empathize with walnut trees, because people beat them with sticks to shake the fruits from the branches.[9] Yet among the contradictions in his personality was this: The more destructive an engine of war, the more it fascinated him. In his later drawings he imagined armored vehicles, catapults, automatic weapons, submarines, all kinds of engines of war (Ill. 20).[10]

This was a warlike age, and Leonardo seems to have been worried by the prospect of losing his life (or his freedom) at an early age. He relished the idea of

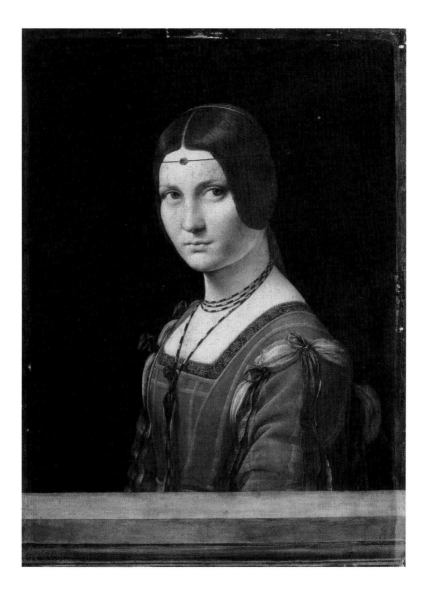

PLATE 18: Leonardo da Vinci, *Portrait of an Unknown Lady (La Belle Ferronnière)*, Louvre, Paris (63 × 45 cm / 24.8 × 17.7 in)

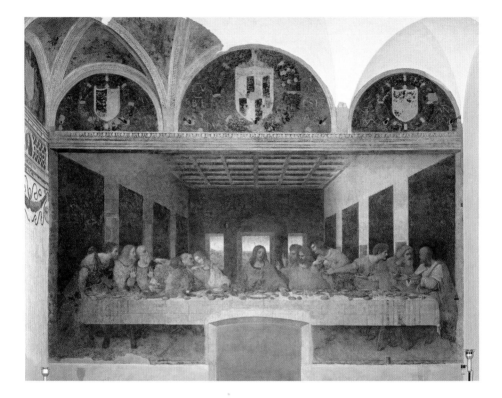

PLATE 19: Leonardo da Vinci, *Last Supper*, Santa Maria delle Grazie, Milan
(460 × 880 cm / 181.1 × 346.4 in)

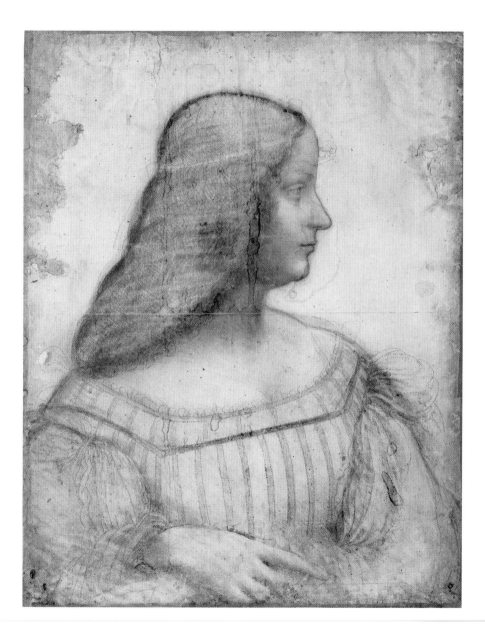

PLATE 20: Leonardo da Vinci, *Profile Portrait of a Woman* (Isabella d'Este?), Louvre, Paris
(63 × 46 cm / 24.8 × 18.1 in)

PLATE 21: Titian, *Isabella d'Este (Isabella in Black)*, Kunsthistorisches Museum, Vienna
(102.4 × 64.7 cm / 40.3 × 25.5 in)

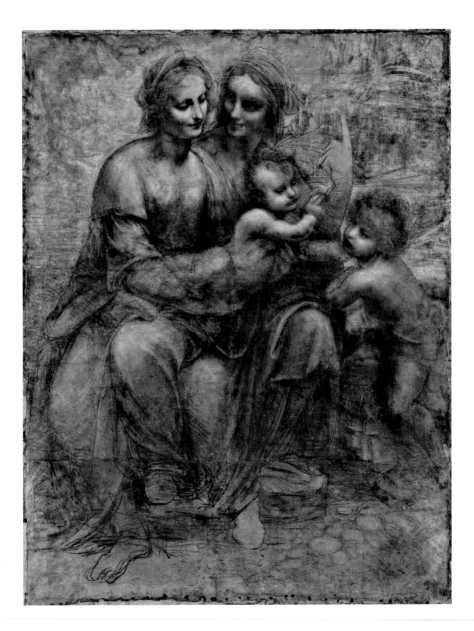

PLATE 22: Leonardo da Vinci, *Burlington House Cartoon (The Virgin and Child with St. Anne and St. John the Baptist)*, National Gallery, London (141.5 × 106.5 cm / 55.7 × 41.9 in)

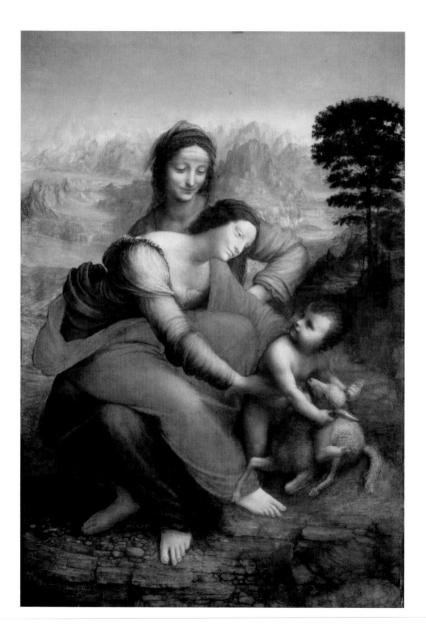

PLATE 23: Leonardo da Vinci, *The Virgin and Child with Saint Anne*, Louvre, Paris
(168.5 × 130 cm / 66.3 × 51.2 in)

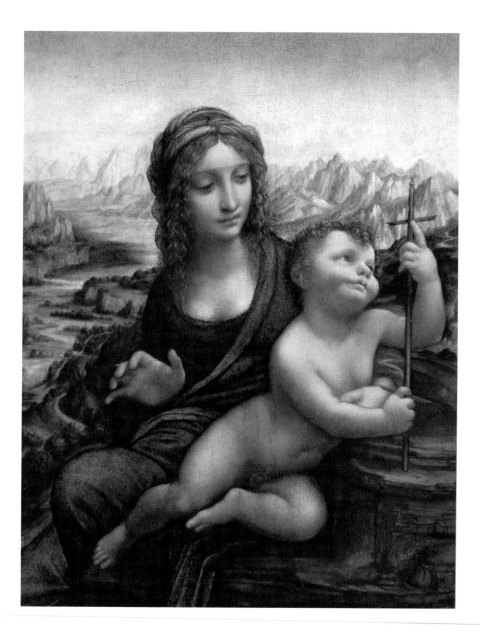

PLATE 24: Giacomo Salaì or unknown artist, *Madonna of the Spindle*, private collection, New York (50.2 × 36.4 cm / 19.7 × 14.3 in)

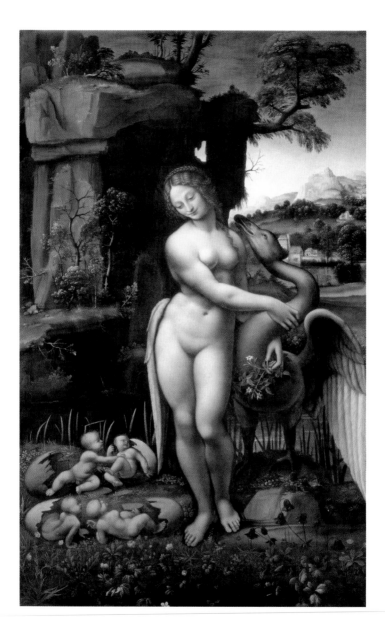

PLATE 25: Successor of Leonardo, *Leda and the Swan*, Uffizi, Florence
(130 × 78 cm / 51.1 × 30.7 in)

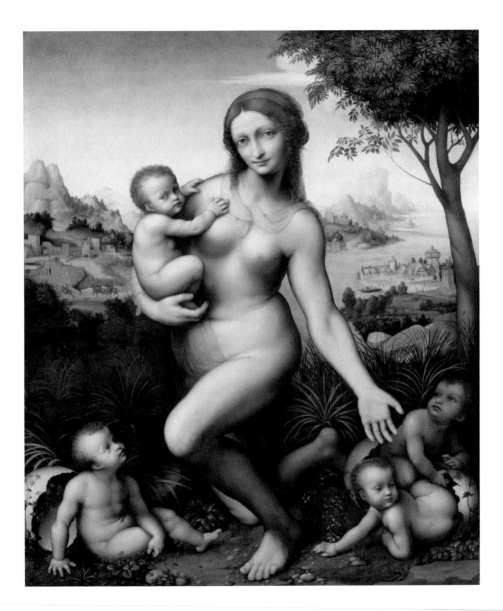

PLATE 26: Giampietrino, *Leda and Her Children*, Gemäldegalerie Alter Meister, Kassel
(128 × 105.5 cm / 50.4 × 41.5 in)

PLATE 27: Workshop of Leonardo da Vinci, Copy of the *Mona Lisa/Gioconda*, Museo del Prado, Madrid (76.3 × 57 cm / 30 × 22.4 in)

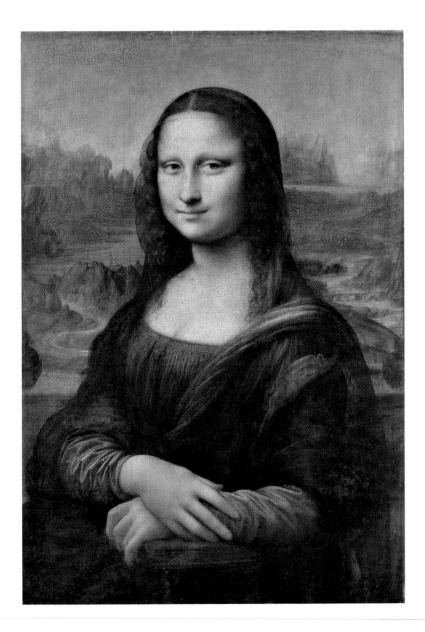

PLATE 28: Leonardo da Vinci, *Mona Lisa/Gioconda*, Louvre, Paris
(77 × 53 cm / 30.3 × 20.8 in)

PLATE 29: Leonardo da Vinci, *John the Baptist*, Louvre, Paris (69 × 57 cm / 27.1 × 22.4 in)

PLATE 30: Workshop of Leonardo, *John the Baptist with Attributes of Bacchus*, Louvre, Paris
(177 × 115 cm / 69.7 × 42.3 in)

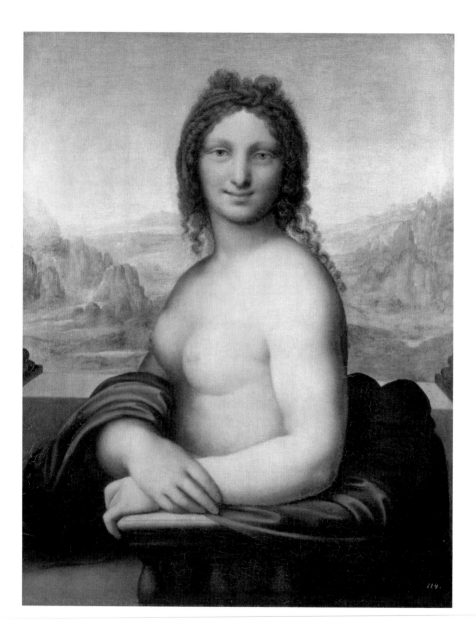

PLATE 31: Circle of Leonardo da Vinci, *Monna Vanna/Nude Woman*, Hermitage, St. Petersburg (86.5 × 66.5 cm / 34 × 26.2 in)

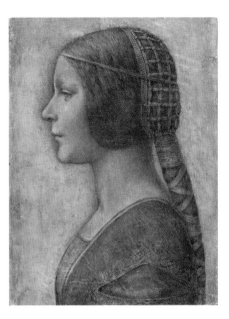

PLATE 32: Unknown artist, *Bella Principessa*, private collection (33 cm × 23.9 cm / 13 × 9.4 in)

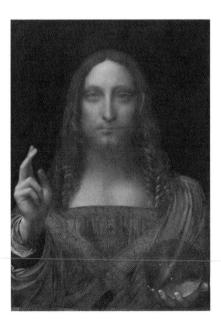

PLATE 33: Follower of Leonardo da Vinci (?), *Christ as Salvator Mundi*, private collection 45.4 × 65.6 cm / 17.8 × 25.8 in)

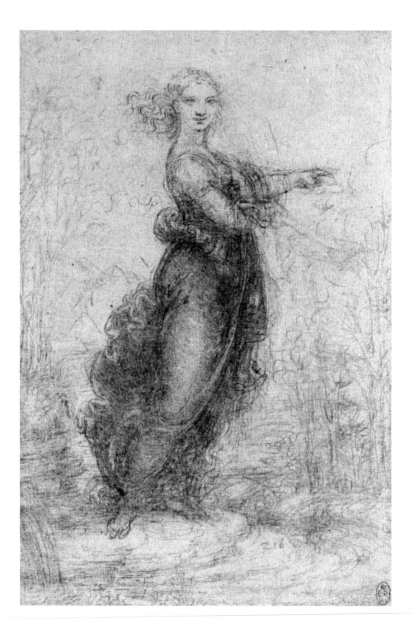

PLATE 34: Leonardo da Vinci, *Woman Standing in a Landscape*, Royal Collection, Windsor
(210 × 135 cm / 82.7 × 53.1 in)

being superior to others, not just intellectually and aesthetically, but also in terms of physical force, thanks to his miracle weapons that could apparently render a person invulnerable.[11] He might have felt an immense need for protection, which may have resulted from his experiences of having to fight for everything as an illegitimate son and unmarried man. As such, Leonardo did not assume that the right of the powerful would be on his side. He lacked the carefree attitude of the privileged. Scenarios of disasters large and small constantly forced their way into his mind, and he apparently liked the idea of using technical knowledge to make up for loss of control and inferiority. He toyed with the idea of becoming a military adviser, among other potential careers.

Leonardo did not indulge in such fancies only when alone in his room. He soon made the acquaintance of a like-minded person: Tommaso di Giovanni Masini, known as Zoroastro. Ten years younger than Leonardo, the eccentric Zoroastro was part scientist, part visionary, and a gifted metalworker. Like Leonardo, he wore no leather and was a vegetarian. From that time on, Zoroastro lived among the artist's entourage, serving him by grinding his pigments and probably advising him in matters concerning the natural world, metallurgy, and chemistry.

An eyewitness later described Zoroastro's laboratory thus: "In the middle of the room there is a large table cluttered with pots and flasks of all sorts, and paste and clay and Greek pitch and cinnabar, and the teeth of hanged men, and roots. There is a plinth made of sulfur polished up on a lathe, and on this stands a vessel of yellow amber, empty except for a snake with four legs, which we take for a miracle." The walls were said to be painted with grotesque faces and strange creatures, such as an ape teaching a group of rats.[12]

This report may be disconcerting in its desire to sensationalize, but Leonardo must have been interested by the notion that Zoroastro was someone who "looked into the darkness of nature," as it later said on his gravestone.[13] Although Leonardo was so fond of nice scents that he rubbed his hands with lavender flowers, his curiosity and his love of extremes were even greater than his dandyism. In his notes there is even a recipe entitled "deadly smoke," which, according to the author, contains sulfur and arsenic. As an antidote he advised rosewater. He also recommended boiling a tortoise, mixing the broth with a tarantula and the foam from the mouth of a rabid dog, and adding a little powdered verdigris or poisoned lime, if one should happen to want to fire a missile at

enemy ships.[14] Leonardo distrusted magic and alchemy, partly because the belief that it was possible to make gold was too contradictory to his rationalist way of thinking. But that did not mean that he was not willing to experiment with any conceivable ingredients if he considered that doing so would suit his purpose.

When Leonardo painted now, it was with the same existential zeal as that of Zoroastro pottering around in his laboratory. No sooner had he acquired his own workshop and thus escaped from society's norms than he unleashed his restless spirit on the composition of paintings. New figures kept coming into his mind—animals, humans, a seething mass of interactions, as well as landscapes, houses, wind, and weather. Anything imaginable could be painted, and if everything did not fit on to the surface of the painting at the same time, he layered the figures on top of one another, killed off one newly painted creature in favor of another, corrected arms, hands, and facial expressions, and started again from the beginning.

Later a euphoric Leonardo noted: "If the painter wishes to see beauties that charm him, it lies in his power to create them, and if he wishes to see monstrosities that are frightful, ridiculous, or truly pitiable, he can do so as a Lord and God."[15]

However, being Lord and God was more of a burden than a blessing. There were always decisions to be made; everything could be better than it was. Creating the world was one thing; optimizing it, as Leonardo did in his workshop, was another. The Lord and God of painting was drowning in the sea of his own ideas.

This made Leonardo's clients despair. It was not as if they were queuing up outside the door of his workshop. On the contrary, business was soon going so badly that Ser Piero evidently felt obliged to act as the agent for his son. The notary was working for the Augustinian monastery of San Donato a Scopeto, just outside the city gates. He could thus have learned that the father of one of the monks had bequeathed a property to the monastery, which meant that the monks could now afford a new altarpiece. However, Ser Piero would surely not have drawn up the contract that was subsequently awarded to Leonardo, as it was on terms detrimental to the artist. The fact that the artist accepted this document despite his father's involvement shows the precariousness of his situation in 1481.

Leonardo undertook to complete the painting within twenty-four months, and thirty months at the latest (Plate 12).[16] For this he would receive one-third of the inherited property, though he would not be permitted to sell it or make any

other use of it until further notice, as the monastery reserved a right of reacquisition. However, Leonardo had to take over the costs of the property and pay a large dowry for a relative of the testator. He also had to pay for the paints, the gold, and everything else he needed for painting his picture.[17]

The contract became too expensive for Leonardo, who was now in his late twenties, and soon even the monks noticed how overstretched he was by the agreement. A slightly later additional document to the contract records that the Augustinians lent him money for the dowry and ended up advancing him for the paints for the altarpiece that he could not afford.

Despite the harsh conditions, Leonardo threw himself into the work. He was to paint an Adoration of the Magi, the Three Wise Men from the East paying homage to the Christ child. This subject would please the Augustinians, but it was not enough for Leonardo. If he could paint a Virgin and Child, the whole world would pay homage to them.

So he placed one of his beautiful, calm Madonnas at the center of a multifarious group of figures. She seems to pay little heed to the hustle and bustle around her; all her attention is on her little son. He lies in the crook of her arm, with one hand raised in a kind of blessing and the other examining what gifts are being presented. No one approaches the pair too closely, neither the three kneeling kings in the foreground nor the crowd of people around them. Even Joseph, probably positioned discreetly behind Mary's shoulder, hangs back. Throughout his life, Leonardo could never bring himself to grant this earthly substitute father a leading role, as he considered the union of mother and child to be too sacred.

Leonardo laid down the outlines of the Madonna and her son and a few shadows, but he did not complete them, as he was much too busy adding more and more new ideas to the wall-sized panel to correct them and start again. He created many more figures than he could finally use; they even included an elephant.[18]

Leonardo was particularly attracted by the contrast between young and old. Youngsters jostle their way between the aged. In their thoughtless eagerness to see, their extravagant gestures set the picture in motion. There are horses present and a joust is starting up in the background. Trees sprout from an ancient ruin. As if he wanted to put the emphasis on new life, Leonardo went straight for the green paint, instead of first sketching in the foliage in earth tones as he had done with most of the figures. He even dabbed a little blue lapis lazuli into the sky.[19]

The contract stated that, if the artist did not complete the painting, the Augustinian monks could keep the unfinished picture and have it overpainted. But Leonardo himself stopped working on it even before he had laid in all the shadows or painted in the final colors, and before deciding which of his many creatures should survive and which should be discarded.

The Augustinians did not claim the unfinished work for themselves; instead, they later commissioned another artist to start afresh on a second panel. Possibly they considered Leonardo's extravagant image unsalvageable and the cheap wood he had used as impossible to recycle. Or maybe they came to an agreement with its creator, who did not want to lose his work. His pictures were his children; he would not abandon them. Leonardo kept the large panel and stored it at the house of his friend Giovanni de' Benci, the brother of Ginevra.[20]

The artist had a new plan. He would leave Florence. On September 28, 1481, he received a delivery of red wine from the monastery cellars. That was the last surviving sign of his life in the city.

After all, why should he stay? In Tuscany, Leonardo had nothing left to lose and nothing to gain. His friend and master, Andrea del Verrocchio, had set off for Venice, where he was to cast a large equestrian statue for the Senate of the Venetian Republic. While working on this commission he eventually died in Venice, far from home, in 1488. Leonardo's congenial client, the cultural diplomat Bernardo Bembo, had also left for northern Italy.

What of Lorenzo de' Medici, the splendid lord of lords? It would have been unrealistic to go on believing that he would ever fully appreciate Leonardo's talent. After the murder of his brother Giuliano, the de facto head of state had plenty to occupy him in trying to appease Pope Sixtus IV, who hated the Medici and had excommunicated the Florentines. The latent threat of war with Rome was averted only when Turkish troops invaded Apulia in the summer of 1480 and the southern Italians were forced to rely on galleys from Florence.

In February 1481 Lorenzo finally came to an agreement with the pope. Art was also to be part of the new peace pact between Florence and Rome. Lorenzo dispatched his best painters to the Eternal City to decorate the holy of holies, the new Sistine Chapel in the Vatican. Of course, he sent his favorite, Sandro Botticelli, but he also sent Domenico Ghirlandaio and the insignificant Cosimo Rosselli. The contracts were signed in October. Leonardo da Vinci was not invited.

The artist remained in Florence, drinking the wine from the monastery, and was past caring. He wanted a patron, someone to support him and enthuse over his experiments and visions. What Leonardo needed was a head of state who wanted to create an image and would put this in his hands without making great demands on him—someone who would trust him precisely because he was different from others.

That was not unrealistic. Leonardo must have heard what a good life, for instance, his colleague Andrea Mantegna was leading at the court of Mantua. Princes had been employing court painters for some time.[21] In the contest of might and influence between the regional powers, aesthetics was a trump card. Works of art made both rivals and subordinates aware of prosperity, generosity, a desire for peace, and a certain drive for self-assertion; they misled people into assuming that their owner was also beautiful, pious, and pure of heart. However, a court artist was not paid for propaganda alone; his master also wanted to display his carefree situation, as if he were saying, "Look at me, I can afford to pay someone to think, invent, draw, and paint." The court artist was part interlocutor, part entertainer, part style adviser, as well as an upmarket court jester, but always a humanistic ornament, a proof of modernity and sophistication.

Instead of waiting for a ruler to summon him, the thirty-year-old Leonardo chose one for himself: Ludovico Sforza of Milan, known as Il Moro, the dark one, because of his complexion and his second name of Mauro. He was the ideal candidate. The heavily built ruler with the thick neck and narrow eyes was sufficiently rich and influential to support an artist in the grand manner; he ruled over a big city that was visited by many travelers. He was also in dire need of improving his reputation. His grandfather had seized power as the leader of the dukedom's mercenary army. Ludovico was not even his legitimate successor; that was Ludovico's young nephew, a fact that Il Moro went to dramatic lengths to keep hidden.

At this point, the ruler of Lombardy was possibly not even aware of how much he needed an artist and researcher, but it was certainly clear to him that he needed cannons. In his exuberance, the would-be duke also quarreled with powerful rivals, true to his family name, which his grandfather had derived from the battle cry "Sforza!"—Attack!

While he was apparently still in Florence, Leonardo honed his letter of application, and for once he did not use mirror writing. As a precaution, he represented himself as a military engineer; perhaps that would be particularly

well received. He did not mention the fact that he had no practical military experience. In the draft letter, he offered to reveal his "secrets" to his "illustrious master," claiming to be able to construct weapons, mobile bridges, catapults, armored vehicles, fighting ships, and all kinds of machines for attack and defense. He knew how to blow up castles, divert water from a besieged town, build secret passages, envelop an enemy in smoke, and triumph in naval battles. And, then almost as an afterthought, he mentioned that his painting was worth looking at. If the duke would employ him, he would also receive a large bronze horse from Leonardo, in honor of his father, Francesco Sforza.[22]

After that Leonardo made a list of the works he wanted to take with him to Milan. They included two images of the Virgin, one of which was probably the one that later became known as the *Benois Madonna*, the painting of a pretty young mother with a large baby (Plate 2). The subject of the important, free woman was still very close to his heart; it seems as though he needed the Mother of God to accompany him. To these he added drawings of flowers and studies of the heads of a duke and a "gypsy girl." He also took a precious stone with him.

And if the early biographers were correct, there was something else in Leonardo's baggage: a silver lyre, a stringed instrument in the shape of a horse's head that he had made himself. He was a musician as well as an artist, and this was a talent that might qualify an elegant gentleman like him for entry to courts.[23] He could even take part in duets, as there was a sixteen-year-old with considerable musical talent by the name of Atalante di Manetto Migliorotti circling around him. Atalante would later become a successful opera singer and instrument maker. Leonardo had taken the boy into his heart. His packing list for Milan also mentions a portrait of "Atalante looking up." Perhaps Leonardo, or one of his pupils, has painted him with big brown eyes and pretty ringlets arranged like Ginevra's, but falling unbound to his shoulders, like a mane—rather like the portrait of a musician that has come down to us from his workshop (Plate 13).[24]

The charming Atalante accompanied Leonardo on the journey north, and they were almost certainly joined by Zoroastro, the talented metalworker and chemist.[25] After traveling for a good week, the trio arrived in Milan. The population was around 125,000, which was greater than that of other large European cities. Life centered around the moated red fortress of the ruler who, with the goodwill of the upper classes, had pushed his way into the position after his

brother's murder. For all its economic success, Milan had little of the splendid variety of Florence, with its brightly colored markets and its elegant, swanking merchants, and Milan's sixty or so visual artists could only dream of the international fame of their Tuscan colleagues.[26] These were prime conditions for a knowledgeable and extravagant newcomer.

This did not mean that Leonardo could simply go to Il Moro, serenade him, and hand in his letter of application for a post as military engineer. There were no shortcuts to the top in Milan, either, especially as Sforza started a war with Venice in 1483, the year after Leonardo's arrival, and expenditure on armaments rose to over 70 percent of the state budget.[27] Leonardo may have actually managed to play the lyre at a court reception, but it would be years before he won the trust of the ruler, who was the same age as he was. It is also questionable whether his letter was of any help; possibly he never actually sent it.

First of all, Leonardo had to find his way around as a foreigner. That should not have been too difficult for him; after all, nothing had simply fallen into his lap in Florence. He knew how to make glib conversation, and the Tuscan dialect was considered refined in Milan. Leonardo may have tried to join up with the Florentine community, which was composed of merchants, exiled opponents of the Medici, and those humanists who found the Neoplatonist cult of fame and honor of the circle of the philosopher Marsilio Ficino ridiculous. Most of all, however, he needed a workshop of his own. The de Predis family of artists, who occasionally worked for the Sforzas, were kind enough to take him in. Leonardo then lived in the southwestern part of the inner city, almost certainly with Atalante and Zoroastro.

Leonardo had arrived, and things started to happen. Where, if not here, protected by the walls of Milan, would he overcome his creative block with painting and follow brooding with action? And what better way could there be to celebrate a new start than together with a beautiful, good, and intelligent woman. Leonardo would also dedicate his next painting to the Madonna (Plate 15).[28] He did not want to impute any vanity to the Mother of God. But how could it be otherwise, he must have thought, than that she would guide the hand and thoughts of her master painter, and be delighted by his ideas and his enthusiasm, which celebrated equally both her beauty and the beauty of art? "The Deity loves such a painting and loves those who revere it," he once proudly

commented on the subject of sacred painting.[29] He also wrote that pictures move people, he was certain of that; after all, they could also pray and believe at home. But because art had a special power to reveal what was holy, they left their comfortable beds and even undertook arduous pilgrimages.

Leonardo thought of himself as a scientist but, deep down, he was, of course, also a believer. And he could refuse the Madonna nothing she desired, not even when it once again landed on his table in the form of a harsh contract.

The Franciscan Confraternity of the Immaculate Conception needed a painting for its new, richly decorated altar in San Francesco Grande, the second largest church in Milan after the cathedral. The order was dedicated to the doctrine of the Immaculate Conception. Its adherents were convinced that not only had Mary been a virgin when Jesus was conceived, but she had also been without mortal sin from the first moment of her existence, as it had always been God's plan that there would one day be a Mother of God who would give birth to the Savior, and he had therefore absolved Mary of human sin from the very start. Other theologians considered this to be impossible because Mary was the child of human parents. They believed that God had purified her after she was conceived in her mother's womb and thus freed her from sin. The then pope, Sixtus IV, was a Franciscan and tended toward the doctrine of the Immaculate Conception, although he had not yet declared it to be dogma.

As the idea was still the subject of dispute, there was as yet no established convention for how to paint an "immaculate" Mary. So did that imply complete artistic freedom? Not entirely. The Franciscans gave Leonardo and his business partners, the brothers Ambrogio and Evangelista de Predis, instructions for the altar. The contract, dated April 25, 1483, required "gold brocade and ultramarine blue" for the Virgin's mantle, her dress was to be painted in "red lacquer and oil," and the lining of the dress in "gold brocade and green in oil." God the Father was also to have a robe of gold and costly ultramarine. The artists were obliged to buy the gold from the confraternity at a fixed price.

The painting was to look expensive, regardless of the recommendations of the art theorist Leon Battista Alberti, who had advised against excessive use of gold in painting a century before.[30] The design of the frame and the side panels was also part of the contract. These were to be the task of the de Predis brothers; "magister Leonardus de Vincii florentinus," as he is called in the contract, was responsible for the central panel.

Christians had recently begun to celebrate the Feast of the Immaculate Conception of Mary on December 8. This had been ordained by Sixtus IV. The altarpiece was to be completed in time for the celebrations in the following year. However, the confraternity paid the fees only in small installments, so once again the artists had to carry out the work in advance of payment.

Leonardo probably had little desire to be told how he should clothe his Mary, immaculate or otherwise—and even less desire to have her accompanied on the middle panel by exactly two prophets and a visible God the Father, as prescribed in the contract.[31] He had already exhausted himself in his *Adoration of the Magi* (Plate 12) and been forced to realize that having a large number of figures in a picture quickly overwhelmed the composition. Now he had the opposite in mind. This time it would not be the whole world but one small boy who would pay homage to his beautiful, intelligent lady. The young John the Baptist would represent humankind. He would show his respect for Jesus and be caressed by Mary for doing so.

On the other hand, there was one idea in the contract that Leonardo was pleased to accept—the figure of the Virgin would be placed in a mountain landscape. His Florentine *Annunciation* (Plate 6) and the *Madonna of the Carnation* (Plate 1) were set against a backdrop of high mountains, and that had seemed strange and new at the time. But now Leonardo at last had the opportunity to bring woman and nature together on a big stage.

It was now possible and permissible for Leonardo to yield to the attractive force that wild nature exerted on him. However, he was endowed with self-control; he channeled this force into his creative work, into thought, drawing, painting, and writing. The artist asserted that he once visited a cave and felt torn between fear and happiness. He wrote this up in what was for him a relatively emotional description: "[O]ften bending first one way and then the other, to see whether I could discover anything inside, and this being forbidden by the deep darkness within, and after having remained there some time, two contrary emotions arose in me, fear and desire—fear of the threatening dark cavern, desire to see whether there were any marvelous thing within it."[32] He was more familiar with the dangers of nature than city folk. One could be swallowed up out in the wilds, so great was the power of mountains and lakes, caves and ravines. They led an ungovernable life of their own. According to Leonardo, this could be captured only by exploring it respectfully in search of the *miracolosa cosa*, the miraculous. Anyone who walked this path over roots and boulders would appreciate the divine by learning to understand it.

However, there is one problem with understanding; one can also misunderstand. Leonardo may have made fun of unworldly scholars, but he was not so arrogant as to ignore their supposed words of wisdom completely. He simply wanted to test them out in practice through observation of nature, drawing, and painting. For this purpose he adopted late medieval doctrines on geology and the history of the earth.[33] These theories considered that clouds, rain, and glaciers had a limited effect on the volume of water in the mountains. Rather, they tended to assume that there were gigantic veins running through the body of the earth, in which the water forced its way up to the mountain peaks, where it was discharged into rivers and lakes. Leonardo was fascinated by this, because it defied the force of gravity. He thought about it and came up with an explanation for this considerable logical problem: nose bleeds.[34]

After all, human beings also have a circulatory system, and the body pumps the blood from the heart up to the head. If a vein in the nose bursts, the fluid runs down from it like a mountain stream. That is how Leonardo imagined the functioning of the earth, and this represented one of his fundamental convictions: Human beings and the world function according to similar principles and are constructed in almost the same way.

Years later he wrote down these thoughts: "By the ancients man has been called the world in miniature; and certainly this name is well bestowed, because, inasmuch as man is composed of earth, water, air and fire, his body resembles that of the earth; and as man has in him bones the supports and framework of his flesh, the world has its rocks the supports of the earth; as man has in him a pool of blood in which the lungs rise and fall in breathing, so the body of the earth has its ocean tide which likewise rises and falls every six hours, as if the world breathed; as in that pool of blood veins have their origin, which ramify all over the human body, so likewise the ocean sea fills the body of the earth with infinite springs of water."[35]

The painting for the Milan confraternity gave Leonardo his first opportunity to put the supposed geological connections that he believed in into practice in his art. It also enabled him to defeat Sandro Botticelli and his theory of art and banish them from the field. Ten years later, the insult that his adroit and successful fellow artist had flung at him in Florence probably still rankled. Leonardo remembered exactly how Botticelli had mocked him for the trouble he took over his accurately observed landscapes. "Just as our Botticelli said that such study was of no use, because merely throwing a sponge soaked in a variety

of colors at a wall, there would be left on the wall a stain in which could be seen a beautiful landscape."[36]

Leonardo, the boy from Vinci, wanted to go one better and gain more precise knowledge, so in his new painting, under a wide-open sky, he piled up the rocks, the bones of the earth, on top of one another in a daring formation. No caves resulted, but instead a protective frame embracing John the Baptist, Mary, Jesus, and an angel. A deep chasm opens up before them at the front edge of the painting, yet the Christ child sits enthroned above it with no fear of heights. This might be a place where the water that had built up into an imposing mountain lake behind the rock formation once cascaded down. The stony ground is still fertile, and there are pretty flowers sprouting from the cracks in the stone.

So, despite its dark colors, the landscape does not seem sinister, merely remote from civilization. Children of God who trust their creator cannot be frightened by such direct contact with the body of the earth, not even Mary, who appears to feel at home in this barren waste that is so close to the heavens. She too can provide the kind of protection offered by the high rocks behind her. She is young, with delicate girlish features, framed by dark-blond ringlets falling freely to her collarbone. Leonardo did not send a carefully groomed lady covered in gold paint on a mountain walk but a genuine child of nature. Yet Mary's hands are those of a strong matron. Her left hand is as large and flexible as if she too were a painter, like her creator. It protects the baby Jesus as he sits cross-legged at the edge of the slope under the roof of her long fingers. But before viewers become too absorbed in the relationship between mother and son, the pointing hand of the angel cuts across their thoughts. The angel twinkles at us from the corner of his eyes and shows us a face of androgynous beauty.

The angel's outstretched forefinger steers our gaze toward the praying figure of John receiving Jesus' blessing. John is kneeling gravely before his playmate, yet he is not in any way a small adult but a chubby-cheeked boy with baby down on his head. Mary's flowing mantle almost enfolds John, and her strong right hand grasps him by the neck and shoulder, as if she wanted to make up for the wings that humans do not have.

People stroke babies between the shoulders to calm them, and adults also relax when gently touched on this part of the back, which they can hardly reach with their own hands. The Virgin, secure in the rocky surroundings of God's creation, provides John, and all believers with him, with her care, cloaking their human defenselessness. The immaculate element in this young mother is

her remarkable closeness to nature and God and the natural skill with which she guides the children through the wilderness. She is a woman through and through, and a mediator between heaven and earth.

The painting was in fact as good as finished by the end of 1484, in accordance with the contract.[37] Leonardo rarely worked as fast as that. He had had a good run.

And he had a goal: an appointment with Ludovico Sforza, known as Il Moro. The beautiful, nature-loving Virgin did indeed catch the attention of the would-be duke. The work appears to have awakened his desire—more so than all the fantastic machines that Leonardo designed in his sketchbooks, and more than his boasting about what a mighty military engineer he was, when he was really an artist.

Although Il Moro may have been unscrupulous, he was clever enough to know what he did and did not need. And a painter whose art climbed to the roof of the world in order to come closer to Our Lady would appeal to Sforza's taste—all the more so if he also came from avant-garde Florence. This painting, which later became known as the *Virgin of the Rocks*, was something completely new. It reached for the stars with its claim to understand and explain the world, it combined the feminine with the divine and the natural, and it was also a bewitching sensual pleasure. How humane, how deeply religious, how clever and modern it would make its owner appear.

However, the work had been commissioned by the Milan confraternity, whose ranks included many of the city's dignitaries. It belonged in the church of San Francesco Grande. The very idea of removing a specially commissioned sacred work from a church in order to adorn a private collection would surely have seemed like sacrilege to Sforza's contemporaries. Art was to serve God, not the highest bidder. But Il Moro wanted the picture.

This was only possible through a conspiracy in which Leonardo and his partner Ambrogio de Predis played a major part. They complained about the delayed payments from the confraternity, demanded a higher bonus, and picked a quarrel about their costs not being covered. They threatened that there were other people interested in the work, so they were by no means dependent on the churchmen's willingness to cooperate. Hypocritically, they turned to Il Moro, begging him to mediate, and arguing polemically that the friars were ill-informed and would be like blind men talking about color.[38]

In the end the painting of the Virgin probably passed into Sforza's possession; he may have bequeathed the piece to the future emperor Maximilian, a Habsburg who married Ludovico's niece Bianca Maria in 1493. At any rate, the painting did not remain in the possession of the brothers. And Leonardo and the de Predises' workshop received a second commission. They were to paint the same subject again, this time really for the Confraternity of the Immaculate Conception, who thus had to be patient for a considerably longer time and to accept that Leonardo would have much more assistance from colleagues in his workshop than he did for the first version, which was by his own hand (Plate 16).[39]

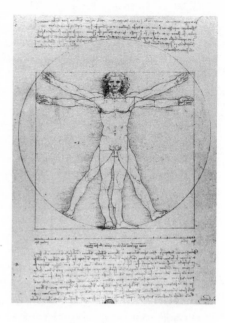

Illustration 21. Leonardo da Vinci, *Vitruvian Man*, Galleria dell'Accademia, Venice

The second version is less delicate and less innovative. John the Baptist now carries a cross so that he can be recognized by everybody. This time the artists did not scrimp on the expensive ultramarine, which, as requested, floods the Virgin's mantle and the mountain lake. This time there are halos, another concession to traditional representation. Everything is slightly clearer—for instance, the flowers that are to be understood as symbols of Mary. The angel no longer points with his finger, and he does not look quite so coquettishly at the viewers, who should be immersed in the subject of the painting, not flirting with unusual heavenly figures. The baby Jesus is no longer quite as cute; his natural childishness is now of less interest than his authority as the future savior.

Yet this second version has its own charm. Leonardo and his comrade-in-arms Ambrogio de Predis no longer wanted merely to come closer to nature; they were also trying to improve on nature, sharpen its outlines, and force it to yield up a striking clarity that mountains, skies, and waters do not actually have.

Leonardo had nothing against an experiment of this kind, but his heart was no longer in the picture. After he had signed the contract for the first version, almost a quarter of a century was to pass before he felt obliged to completely finish the second *Virgin of the Rocks*.[40]

Once again, Leonardo had so many other ideas, so many plans, and so many questions about himself and the world. He absolutely had to take skulls apart in order to understand how the inner workings of the human microcosm functioned. He also wanted to find the seat of the soul, or at least the *sensus communis*—the sense in which all the other senses converge. He was also interested in "What sneezing is. What yawning is, and epilepsy, cramp, paralysis, shivering with cold, and sweat."[41]

Years later, in the anatomy schools for doctors, Leonardo would dissect the still-warm bodies of criminals, draw their sinews, muscles, and entrails, and be proud of how he managed to control the nausea that overcame him and the fear of spending whole nights alone with the dead. His curiosity was stronger than his revulsion and even than his desire for cleanliness; he was driven by a compelling need, which filled his contemporaries with a mixture of admiration and disgust.[42]

In Milan, Leonardo now also measured his living models from head to toe. He wanted to know whether the Roman writer on architecture Vitruvius was correct when he said that a man would fit equally into a square and a circle. (He was not, as Leonardo's drawing of *Vitruvian Man* from around 1490 shows. In one, the center of the man is level with the navel, but in the other it is level with the genitals, and in addition, the person must stretch his limbs differently in the circle and the square, both widthways and longways [Ill. 21]).[43] However, that was not enough; as both researcher and artist, he felt the need to find out more about the macrocosm as well. Like an astonished child, he was interested in everything: the movement of the winds and tides, thunderstorms, or an eclipse of the sun.

Leonardo not only wanted to understand the world, he also wanted to improve it. When plague broke out in Milan in 1485, the thirty-three-year-old hid himself in his workshop and tested out Zoroastro's secret recipes, even though he suspected that these would not prevent anything in the long run. So he designed a healthier, less stinking city on two levels: pedestrians would

stroll on the upper level, while oxcarts would drive below. He thought open spiral staircases would be more practical than dark stairways, in which people urinated. Even the toilets could be improved by proper ventilation. In addition, it would be good if people learned to fly and could flap out of each other's way, instead of bumping into one another in overcrowded Milan.[44] Leonardo's architectural projects and other visions remained on paper.

When Il Moro continued to employ him, Leonardo had time to think and fantasize about whatever came into his head. He was, of course, in service. He built expensive stage sets for theatrical performances or entertained the court with word games and picture puzzles. And he made a gigantic clay model for the bronze horse he had promised his new master as a memorial to his father. As this work required a good deal of space, Sforza let him have a large, old palace adjacent to the Piazza del Duomo with a view of the mountains, which must have delighted a man who hailed from hilly Vinci. At least once in the early 1490s Leonardo went walking in the Alps, searching for bear tracks, climbing rocks on all fours, or abandoning himself completely to his beloved wilderness.

Leonardo would never complete the bronze memorial for the Sforzas. This was probably partly to do with the fact that a rearing horse of the kind the artist had in mind would be almost impossible to cast, even with the help of such a gifted metalworker as Zoroastro. Leonardo thought faster than he worked, and, aside from his painting, he regularly overestimated his manual skill.

Il Moro himself probably did not believe he would ever see the equestrian statue made by Leonardo's hand.[45] And he clearly did not think of having his employees construct all the apparatus of war that Leonardo dreamed of. A more suitable use for his court genius occurred to him. Ludovico had the artist do what he was best at—paint a beautiful, intelligent, and self-assured woman. He could not have given himself, Leonardo, and posterity a greater gift.

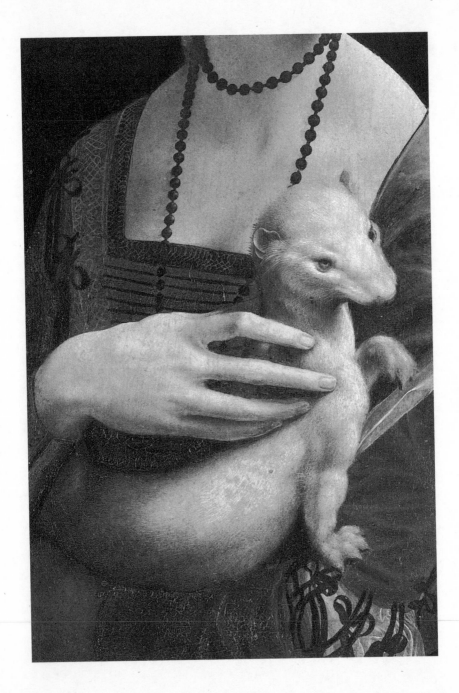

VII

The Second Key Work:
BEAUTY AND THE BEAST

WHAT ANIMAL HUNTED the mice in the nooks and crannies of Leonardo's old palace on the Piazza del Duomo in Milan? Maybe the artist kept a weasel for this purpose. These little predators are agile, fast, and brutal. The widest part of their body is their pointed head, so a weasel can get through anywhere it can get its head through. Members of the mustelid family—which include common weasels, ferrets, and stoats—have been used for hunting mice or kept as pets since ancient times. Rich ladies wore their furs as stoles and fastened them to their girdles with gold chains. The skull of the dead animal was replaced with a golden, jewel-encrusted head. The trophy huntresses looked as though they were wearing domesticated predatory animals wrapped around their bodies. This luxury fashion became so widely popular that a law was passed in Milan in the late fifteenth century under which only dignitaries were permitted to wear the better classes of fur.[1] However, few people took any notice of such bans on dress.

Leonardo's paintings may even have encouraged this women's fashion. In Milan he was very preoccupied with these creatures. The mustelid family includes the stoat, whose fur, with the exception of the tip of its tail, turns white in winter, when it is known as ermine. The Italians, who were only familiar with the common brown weasel in their immediate surroundings, were fascinated by the pale fur. They credited the ermine with a purity and modesty that was not really

Illustration 22. Leonardo da Vinci, *The Ermine as a Symbol of Purity*, Fitzwilliam Museum, Cambridge

appropriate to a predator. Passing on an idea that had been widespread since the time of the Roman naturalist Pliny the Elder, Leonardo noted that a stoat would rather be caught than get dirty. He also admired the great strength, flexibility, and resolution of the weasel family, some of which could even kill snakes.[2] No animal other than the ermine would be better suited for his plan to introduce energetic movement into painting and thus set art itself in motion.

At the court of Ludovico Sforza, Leonardo probably saw both live and dead stoats that had been imported from Russia by fur traders. He drew a stoat at its moment of decision: Should it flee into the open countryside, where its feet would get muddy, or should it yield to the stick-wielding hunter behind it (Ill. 22)?[3] The look in the eyes of the slender creature makes an impression on the ungainly man who is after its pale fur. The stoat is physically inferior but morally superior to the hunter.

Similarly, according to the beliefs of the time, a very young woman could be superior to a powerful man because she appeared not to compromise herself in the games of power and money. A mistress had much less say than a ruler, but that did not mean that she had to surrender herself completely to an influential lover. She was a little like a court artist in that respect; she could not be replaced, because she was unique—and possibly equally stubborn.[4]

In the late 1480s Ludovico Sforza asked Leonardo to paint a portrait of his new mistress, the young Cecilia Gallerani. The artist set to work enthusiastically (Plate 17).[5] A painting of a mistress meant that he would not be restricted by any conventions. There would be no precious stones, no obligation to paint her in profile, as in a bridal portrait. Of course, Cecilia would have to appear as a respectable woman, but all the same her success lay in her powers of seduction, and that suited Leonardo's desires very well. He wanted painting to be perceived as the most seductive of the arts, more intelligent, sensual, charming, and true to life than poetry, music, or sculpture.[6] In order to achieve this, he wanted to make his figures animated and give them a soul. It must look as though they could twist and turn their bodies as naturally and nimbly as a weasel, and bite back at the world outside the frame surrounding them.

Cecilia Gallerani was the perfect partner for this ambitious plan. The slender sixteen-year-old with big brown eyes, a high forehead, and a small mouth was the daughter of a Milan tax official who came from a family of Sienese merchants. Her mother was descended from a family of lawyers and theologians, and her brother, a respected Franciscan friar in Milan, was among the advocates of the doctrine of Mary's Immaculate Conception.

Cecilia's father died in 1480, when she was seven years old. He had divided his inheritance between his six sons, who were to pay the dowries of the two daughters. Cecilia was promised to a much older man. The wedding was to be celebrated on her twelfth birthday, which was the lowest age for a bride according to ecclesiastical law. Despite this haste, and probably at the insistence of her mother, Cecilia received a good education and even learned Latin.

Possibly her brothers were not willing to pay the whole of her dowry. For whatever reason, Cecilia was still unmarried at the age of fourteen. And then something unusual happened: In June 1487 she dissolved the legally concluded contract with her betrothed. The bride was almost at the altar and then walked away.[7]

This could not have been done on a whim. Evidently Il Moro, who was still unmarried in his mid-thirties, was already pulling the strings in the background at this point. He wanted the first version of Leonardo's *Virgin of the Rocks* (Plate 15), and he probably got it. He wanted this young woman, and he succeeded in that as well.

Being the mistress of an absolute ruler meant a rise in social status. Such a relationship was based on a kind of bargaining. The man would get a companion, and thus the chance of having an illegitimate son in reserve, in case he later had problems with legitimate heirs. Nevertheless, he would require the consent of the girl's family, if he wished to avoid gossip, accusations of dishonorable conduct, and acts of vengeance. He would also reward the young lady and her relatives with privileges, gifts, entry into a better class of society—advantages that were dependent not on a contract but on the patronage and benevolence of the ruler. When Cecilia's eldest brother committed a murder, Il Moro urged the victim's family to make peace with the perpetrator. Other male relatives were granted ecclesiastical sinecures, and family estates that had earlier been confiscated were restored to them without complications. Even though her father was dead, Cecilia had no material wants after becoming Sforza's favorite, although this did not mean that the uncouth and unscrupulous Ludovico was necessarily to her taste. It was probably more a matter of resigning herself to her fate than returning Ludovico's feelings.[8]

Leonardo himself was the son of a woman in financial need who became involved with a more prosperous man. He was probably still in contact with his biological mother, as he apparently later brought the recently widowed Caterina to Milan in 1493, where she lived with him in his palazzo in the Piazza del Duomo until her death.[9] He had no reason to disapprove of the mistress of his patron, Il Moro. On the contrary, he liked and admired Cecilia, who was aged about sixteen when he was to paint her in around 1489, the same age as Caterina was when she was pregnant with Leonardo.

Ludovico Sforza was carried away by his affair. He felt as if he were on an equal footing with Lorenzo de' Medici, whose adoration of women had Florence under his spell. The fact that this was a matter of a platonic, poetic love and unfulfilled desire in the spirit of Petrarch was not taken so literally by an old campaigner like Sforza. In 1487 he informed Lorenzo de' Medici via the Florentine ambassador in Milan that he was "in love again" and therefore had his mind set on "many lovely and worthy things." So he would hold lavish

carnival celebrations in his villas and order his court poets to write sonnets as Lorenzo had done before.

In his reply, Lorenzo congratulated Sforza on his young love, continuing complacently that he hoped she would help to refine Sforza's mind. Then he added the warning that passion was not only sweet, it could also torment the soul, attaching two plangent verses by Petrarch as evidence. He was obviously repelled by the unscrupulous way Il Moro made use of the Petrarchan platonic game of love cultivated by the Medici brothers for his own erotic pleasure.[10]

Leonardo may have had his own thoughts about this when he was commissioned to paint Cecilia's portrait, probably two or three years later. His relationship with the would-be duke of Milan was of a pragmatic nature. He was not among Ludovico's followers, as his chief loyalty was to his research and his art, not the personal and political interests of his master. Nevertheless, Il Moro's commissions and marks of favor ensured the painter a good livelihood (although he once complained bitterly to his patron when he was not paid). And in between all the contracts for festive decor and other ephemera, this was at last a promising job—painting the portrait of a desirable woman, in the way that had been an expected part of the ritual of love ever since Petrarch had had a portrait of his Laura painted by Simone Martini. For Leonardo, such a traditional task must have been a matter of professional honor. The posthumous fame of his art was at stake.

However, unlike Petrarch's Laura, Cecilia had a lover who was not content to gaze lovingly at a likeness and express himself in tender laments. Il Moro wanted to possess his beloved completely. Leonardo was faced with the question of where to place the coarse Ludovico in the painting of this young beauty.

The artist had an idea that was both wicked and good. Ludovico Sforza had recently been admitted to the Order of the Ermine, a chivalric order created by the king of Naples. Members received a gold chain with a representation of an ermine. The motto of the order was *Malo mori quam foedari* (Better death than dishonor),[11] and it is the same motto that Leonardo proclaims in his drawings and writings. So what could be more obvious than to transform Ludovico into an ermine? In his painting Leonardo would make the great man into his mistress's pet, and since a comparison with a creature that had such firm principles would be considered complimentary, Ludovico could have no possible objection.

At the same time, the ermine, which Leonardo would paint rather larger than life, could also refer to the Gallerani family, as the ancient Greek word for animals of the weasel family was *galēē*.[12] So the ermine also symbolized Cecilia—Leonardo could never resist a pun—and there was no doubting her virtue and power.

Lastly, there was a third possible way of interpreting the ermine that Leonardo would place in Cecilia's arms in her portrait. The animal being delicately cradled by the young woman suggests a baby, especially if Ludovico was hoping to have a son with Cecilia, who was more than twenty years his junior. (She was probably not yet pregnant at the time the portrait was painted.)

So the ermine was very suitable, not least because there was a widely held belief that stoats and other weasels could be helpful before and during pregnancy, thus they were often depicted on the crockery that women were given for the birth. People said that if a woman caught sight of a weasel while giving birth, she would have an easier time of it.[13] The Italian word for weasel is *donnola*, which is reminiscent of *donna*, lady. In Italy, this creature stood for the natural, life-giving womanhood that Leonardo admired.

There were good mythological reasons for the *donnola* to be considered as the protector of pregnant women. The Roman poet Ovid told the story of how the clever maidservant Galanthis was transformed into a weasel by Juno, because she had helped with the birth of Hercules by telling a lie. This angered Juno, whose husband, Jupiter, had betrayed her with Hercules' mother, Alcmene. As a weasel, Galanthis was allowed to keep her red-blond hair, her intelligence, and her agility. Ovid added one more thing: "Because by her lying lips she'd assisted Alcmene in labour, she breeds her young through her mouth and haunts my [Alcmene's] house as she used to."[14]

The idea that weasels gave birth through the mouth persisted. Aristotle endeavored to explain that these mammals brought their young into the world via the uterus and merely transported them in their mouths, but his ideas were not generally accepted. On the contrary, from antiquity through to the Renaissance, the story persisted that the weasel gave birth through the mouth, and that this was preceded by an immaculate conception—through the animal's ear. The word was made flesh, so the weasel must also be a kindred spirit of Mary.[15]

Leonardo certainly did not believe this superstition, at least not in the literal sense. He considered the ermine more as a vigorous, agile, symbolic creature

that became even more interesting when it was enticed out of the world of mythology and apparently brought to life in every detail with paint and brushes.

Leonardo was interested in conception, pregnancy, and birth. In his drawings, he imagined how human embryos would look in the womb (Ill. 23), explored the bloodstreams of men and women, and reconstructed coitus in anatomical cross section (Ill. 8). At first he was guided by the generally recognized ideas of Aristotle, according to which only the man's semen left its mark on the body, mind, and soul of a child. In Aristotle's eyes, body and mind generally corresponded to the male principle, while what he considered to be the inferior material—all that was earthy and organic—followed the female principle.[16]

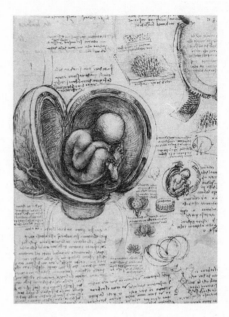

Illustration 23. Leonardo da Vinci, *Fetus*, Royal Collection, Windsor

However, in the course of his studies, Leonardo would depart further and further from these simplistic opposites. He was too much in awe of nature's creative power to subject it completely to human thought processes. He was impressed by the ceaseless growth of plants, the freedom of birds, and the speed of waterfalls, and he believed that Mother Nature was a great creator who never made mistakes. That was the reason why he did not like to paint flowers, mountains, or the sea in a way that was as far removed from their natural models as, for example, those of his fellow artist Botticelli.[17]

During his years in Milan, Leonardo came across the writings of the ancient Greek physician Galen, whose version of the differences between the sexes was not quite as simple as Aristotle's. Although according to the ideas of Galen and his later interpreters, woman is an inferior version of man, she is

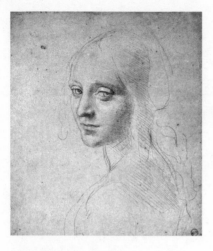

Illustration 24. Leonardo da Vinci, *Study of a Girl's Head*, Biblioteca Reale, Turin

not merely the vessel for his semen. On the contrary, in Galen's opinion, both parents have a share in creating a child. Years later Leonardo would conclude from his observation of mixed-race couples and their babies that the male and female "seeds" are equally responsible for the form and nature of a new human being. Then he also started to think about the formative influence of the mother's soul on the soul of the unborn child.[18]

Leonardo's art was often ahead of his thought and that of his contemporaries. What he later put into words had often long been lying dormant in his painting.[19] This was true of the portrait of Cecilia Gallerani. In the late 1480s Leonardo's ever-increasing respect for active, creative, and uncontrollable womanhood was already making its way into this work.

In Leonardo's eyes, Cecilia was not only beautiful and fertile, she was also headstrong and dangerous. He was convinced that it was possible for the portrait of a captivating woman not only to depict love but also to inflame complete strangers. Just as Laura was emotionally dangerous for the unfortunate Petrarch, a visual depiction of a painted figure can cause the viewer to lose himself in contemplation of her, as though she were flesh and blood and not merely created from pigments and oil.[20] Cecilia's dynamic nature, her vital energy, her supple body, and all her beauty, independence, and intelligence would help Leonardo to give painting a lively, seductive, and dangerous appeal.

Leonardo pondered on how he could show this. There was no question of portraying her in profile; this traditional format would be too rigid and chaste. But the absorbed inwardness with which Ginevra de' Benci, whom Bernardo Bembo admired with such delicacy, turned her gaze toward the viewer would also be out

of place here (Plate 9). This love affair was different and more substantial; it was not a matter of a sentimental connection between two poets but an exchange, disguised as deep feelings, in the context of an imbalance of power.

Leonardo was convinced that people's "passions of the soul" were reflected in the shape and movements of their bodies.[21] On his sketch block he tried out the effects of a woman inclining her face to the left or right, upward or downward.[22] On another occasion he had already drawn a girl looking over her shoulder (Ill. 24).[23] He investigated how far the body and head could be turned in opposite directions, and how much movement the spinal column could support. He made a pen and ink sketch of another considerable seductress, Mary Magdalene, in two versions (Ill. 25).[24] In one she looks irritatingly straight at the viewer, as if he were her savior; in the other she faces to the side, looking out of the frame, as though Christ were standing beside the picture.

Illustration 25. Leonardo da Vinci, *Study for Mary Magdalene*, Courtauld Gallery, London

In the oil painting of Cecilia, Leonardo finally decided to show her looking out of the frame (Plate 17). She has just advanced from the back to the front edge of the picture, and her upper body is still in motion, whereas her head and her wide-open eyes are turned to the side in three-quarter profile.

The youthful Cecilia is dressed fashionably, but not luxuriously, in the Spanish style; in her arms she holds her alter ego—a short-haired, muscular, and surprisingly large ermine. The position of the animal reinforces the axis around which its mistress is turning. The heads of the woman and the ermine are positioned one above the other and brightly lit. The viewer cannot help comparing the two pairs of dark eyes and the human nose with the animal's snout, expecting to see the thin ears of the animal repeated on the

woman who holds it, only to be disappointed on seeing that her ears are hidden by her dark, smoothly combed hair.

The two lively and dangerous figures are not only similar in physiognomy, they also act as one. Their attention is concentrated on someone facing them beyond the right edge of the frame. The ermine holds up his paw to this person, possibly Il Moro, as if to have his hand kissed. This creates an optical extension to the extremely long, nimble finger with which Cecilia is gently stroking the creature. She must be aware of the ermine's throbbing pulse, and the ermine must feel the beating of her heart. They are one heart and one soul, two agile beings, strong enough to defend themselves, that must be won over because they cannot be tamed.

Leonardo had great respect for the well-educated young woman who posed for him when she was just sixteen. Later, he would begin a letter to her with the words "My lady Cecilia. My most deeply loved goddess . . ." She caused a sensation among the humanists, courtiers, and travelers at the court of Milan. An eyewitness wrote that the "noblest and finest minds to be found in Milan" vied for her company. She was a *virtuosa*, a shining light of the Italian language, he said.[25]

Cecilia did indeed take pleasure in writing poetry. Sadly, there is not a single surviving line of her verse that could provide information about her view of life at Sforza's court. However, written evidence from her hand has been preserved. In a noteworthy letter of 1498, Cecilia expressed her view of the "incomparable" Leonardo.[26] By that time, she had reached the age of twenty-five and was now the owner of Leonardo's portrait. Ludovico had given it to her when he abandoned her.

During his liaison with the middle-class Cecilia, Ludovico had become engaged to Beatrice d'Este, a wealthy daughter of the duke of Ferrara, although he had kept delaying the marriage because of Cecilia. However, in the end there was a grandiose wedding, and the couple moved into the Sforza's gloomy castle in Milan, where the heavily pregnant Cecilia, whom Ludovico had accompanied everywhere for so long, and who was almost the same age as Beatrice, was living. Now, however, Ludovico vulgarly boasted that the pregnant woman was too fat, and he would not sleep with her again until she had borne him a son.[27]

The ménage à trois was not a success. When Beatrice found out that her husband had given his mistress the same dress that he had given her, she had had enough of it. Shortly before giving birth on May 3, 1491, to a boy named Cesare, Cecilia was forced to move out, along with her unborn baby and Leonardo's portrait. Ludovico left the boy and Cecilia a big estate and arranged her marriage to a Milanese nobleman.

When a messenger on horseback visited Cecilia in late April 1498, she was living with her new family in a luxuriously furnished palace close to the castle and was surrounded in her salon by humanists, poets, and artists. Ludovico had handed over the house to his firstborn, Cesare. His wife, Beatrice d'Este, had died in the spring, giving birth to their third son. Ludovico was carrying on a relationship with one of Beatrice's ladies-in-waiting, who was already pregnant by him when her mistress died.[28] By this time Leonardo was already a famous artist; word had traveled around Italy about the original thinker and gifted painter employed by Il Moro in Milan.

The letter that Cecilia Gallerani received from the messenger on that spring day in 1498 was from Beatrice's sister, Isabella d'Este. No man could teach this impressive lady about anything. She could beat them all in her own field—prestige. Isabella, the wife of the marchese of Mantua, was the most important art collector and connoisseur in Italy, if not in Europe. She had taste, contacts, and an unshakeable determination not to let anything escape her. The prospect of being shown a special work made her forget all her scruples. So she saw no reason not to beguile the rival of her recently deceased sister with a charming letter, because she wanted to see, touch, and be close to the portrait of the lady with the ermine.

Isabella asked whether Cecilia could send her the portrait for which she had sat for Leonardo so that she could inspect it. She currently had a painting by the Venetian Giovanni Bellini in her home, and she would like to compare this and other pictures with a genuine work by Leonardo. And she would also have the pleasure of admiring the appearance of Cecilia Gallerani.[29]

Just three days later, Cecilia replied—politely, modestly, and honestly—and consented, "but I would send it more willingly if it looked more like me." Isabella was not to think that this was Master Leonardo's fault; he was incomparable, the best in his profession. Only he had painted this portrait of her at such an "imperfect age." "[My] face has since changed completely, so that if you put the portrait and me side by side, no one would think it was me represented there."[30]

In retrospect, Cecilia felt she had been immature, probably too young for her relationship with Il Moro. Maybe she was also ashamed of the aggressive energy conveyed by her portrait. Since then she had borne several children and become a nobleman's wife; she was no longer a young girl trying her strength in the interactions between weasels and men. And she showed no inclination to self-deception: She was well aware of how idealized portraits were at that time, even those painted by Leonardo.[31]

One more thing comes out of her letter: an echo of Leonardo's hubris. He liked to stress that his paintings of beautiful women would live longer than the women themselves. People grew old and died, but, according to Leonardo, that was not true of his paintings. "How many paintings have preserved the image of a divine beauty, whose natural model was soon destroyed by time or death, and consequently, how much greater is the value of the artist's work than the work of nature, his teacher?"[32]

Cecilia must have known the verses that Ludovico Sforza had once ordered from Bernardo Bellincioni, his court poet. Bellincioni had worked for Lorenzo de' Medici; he was schooled in Petrarchan love and knew that poems were an essential accompaniment to the portrait of a desired lady. After all, Petrarch's adulatory and melancholy sonnets on Simone Martini's portrait of Laura were legendary. Even Leonardo, who had argued intensely against Petrarch in Florence, must have welcomed the fact that his fellow countryman Bellincioni had celebrated Cecilia's portrait in verse. But what of Cecilia herself? She liked the poet. After the birth of her son Cesare, Bellincioni visited her and gloated: "I [. . .] am her favorite, and I swear to God we had such fun with Signor Cesare, who is nice and fat, I mean fat."[33]

Like Cecilia in her letter to Isabella, Bellincioni also noticed a difference between the portrait and its model. Leonardo and Mother Nature were in competition. *Natura* was jealous of Cecilia's shining eyes in the portrait. However, she should not have been angry, but grateful to Leonardo and Ludovico. After all, the portrait did honor to *natura* and earned her fame throughout the future, because Cecilia would live forever in the painting and be admired for her beauty. In his sonnet on Cecilia's portrait, Bellincioni wrote: "Anyone who sees her like this, even when she is no longer living, will say: this is enough for us now to be able to understand nature and art."[34]

Leonardo would probably not have agreed with the rest of Bellincioni's verse, which suggests that his painting looks as though Cecilia listens but does not speak.[35] Here the court poet was imitating Petrarch, who had summed up his dissatisfaction with Simone Martini's portrait of Laura in the words "If only she could answer me!"[36]

However, Leonardo's Cecilia and her ermine react to the lover, who must be imagined as the invisible man beside the picture frame. They are moving toward him, looking at him, lurking ready to spring at him, offering him fingertips and paws. And they are as open to his addresses as the weasels who were said to conceive their young through their ears. The two energetic, closely linked figures in the painting not only accept but also give; they promise excitement, exchanges, and a new generation. Petrarch wanted *voce ed intellecto*, voice and intellect, from the painting of his beloved. Being so alert and educated, Cecilia could also have listened, answered, and contradicted, if this would have been something Ludovico valued.

Ludovico probably did not care about that. He was not a humanist like Bernardo Bembo, who fought for the genuine affection of an articulate woman. But Leonardo knew what he had in his model. At some future time, very few people would know the name of Il Moro, but Leonardo, Cecilia, and her ermine would remain in people's memory as the three who gave painting bite, movement, seductive power, and a soul.

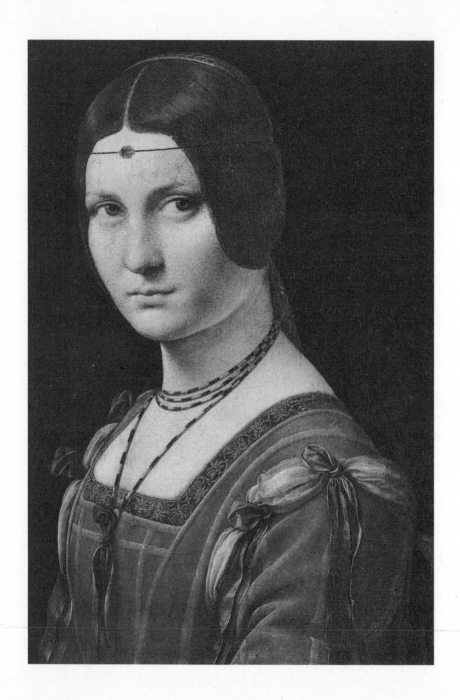

VIII

BELLIGERENCE AND SENSUALITY

LEONARDO FELT AT ease in Milan. He was the most respected painter in the city and a welcome guest everywhere. He had begun to collect like-minded people around him in the large old palace in the Piazza del Duomo. The metalworker Zoroastro was still among them, serving Leonardo as an assistant engineer and paint mixer. Together with a few colleagues, Ambrogio de Predis, Leonardo's collaborator on the *Virgin of the Rocks*, completed some of the paintings that Leonardo had lost interest in but which had been sketched in his style and under his guidance. Only Atalante, the beautiful young musician from Florence, was pursuing a career elsewhere: In 1490 the marchioness of Mantua, Isabella d'Este, engaged him for the title role in Angelo Poliziano's new Italian opera *Orfeo*.

However, the next curly-haired boy was already waiting in the wings. On July 22, 1490, Leonardo welcomed Giacomo di Pietro Caprotti, the ten-year-old son of a middle-class family from the vicinity of Monza. No one in the circle needed to remember his name, as by his second day Leonardo had already nicknamed the new apprentice Salaì, a word borrowed from Arabic meaning "little devil" or "demon."

Salaì lived up to his name. To begin with, Leonardo wanted to have stylish shirts, breeches, and a doublet tailor-made for him, and put the money for it aside in a purse in readiness. Salaì stole it but denied having done so. The next day Leonardo took him to a dinner at the house of an architect friend. The boy devoured everything that was edible, broke three pitchers, and spilled the wine.

He could not be left unsupervised even at home. One of the workshop employees owned a silverpoint pen, a special piece—until Salaì purloined it and hid it in a chest. He showed no remorse—quite the contrary. The next colleague who briefly put his silverpoint stylus on the drawing block and left the room also had it stolen by Salaì.

Leonardo had to keep apologizing to people for the nuisance created by the little devil. He had just designed costumes for a tournament, including for the main attraction of animal-like "savages." The participants came for a fitting, took off their shirts, breeches, and belts, slipped into the furry costumes, and put on long false beards. Everyone was fascinated by the gruesome effect. But then Salaì seized the chance to rummage through the clothes that one of the men had taken off when no one was looking and help himself to a man's purse. On another occasion, when a guest gave Leonardo a special piece of Turkish leather from which to have a pair of boots made for himself, Salaì sold it to a cobbler, bought a nice piece of aniseed cake with the proceeds, and immediately devoured it.[1]

"Thief, liar, pig-headed brat, greedy-guts," scolded Leonardo, and started to keep a meticulous account of the boy's misdeeds. He also made a note of the things he bought for Salaì and was forced to admit to himself that they were extravagant. Leonardo, now in his late thirties, could not resist dressing his attractive apprentice and errand boy in fine fabrics. In the first year of his stay in the workshop Salaì was given numerous pairs of shoes and a wardrobe better than that of many a courtier—jerkins, belts, shirts, breeches, a cloak, and a lined robe.[2]

Leonardo, who was somewhat thrifty by nature, might tell himself that the expenditure was worthwhile, because Salaì also acted as a model for him. The lad personified exactly the type of curly-haired, energetic, androgynous boy that the artist most liked to draw and paint, maybe because he recognized himself in the boy.

He seems to have suspected this himself, and in any case he often warned colleagues that every artist paints himself. If a person is ugly, he will also paint ugly faces if he does not take care. "[A]nd it is the same with any part that may be good or poor in yourself; it will be shown in some degree in your figures."[3]

And, one might add, the same applied to someone as attractive and well-groomed as the long-haired Leonardo, who loved and painted alluring, curly-haired beauties. Anyone who was as self-willed as he was and cared so little for the rules would be attracted to those who did what they wanted to.

So Salaì was allowed to remain in the workshop, although, or precisely because, Leonardo did not succeed in making him behave respectably and moderately. The boy grew toward adulthood, became more and more attractive, and was given increasingly expensive clothing by his master. When Salaì was seventeen, Leonardo bought him four ells of silver fabric for a cloak, green velvet for the lining, and braid for trimming. At 15 lire and 4 soldi, the silver fabric alone was so expensive that a family of four could have bought enough bread for a year, as well as sixty bottles of local wine. Once again, Leonardo was forced to add to his notes, "Salaì stole the money," probably referring to the change. All the same, he later handed the boy three gold ducats to have embroidered pink breeches made for himself.[4]

At this point, the two of them had long been a couple, and not altogether in secret. Morals were loose in Milan, and Leonardo was now among those who were so highly respected that almost anything they did was forgiven. Vasari emphasizes how much Leonardo enjoyed the "grace and beauty" of the younger man, and his colleague Lomazzo was even more specific when, in his imaginary dialogue, he asked the dead Leonardo whether he had slept with his favorite pupil, Salaì. The fictitious Leonardo confirmed that he had, and said that Salaì had been particularly beautiful at the age of fifteen (the age at which girls were considered marriageable).[5] Crudely drawn cartoons about anal sex with the name Salaì written on them have also survived from Leonardo's workshop. Nothing was hushed up in Leonardo's circle; the group surrounding him seems to have had much less to fear than Leonardo did during his youth in Florence.

Salaì may have joined in from inclination, or possibly because the relationship with a highly regarded artist brought him a privileged life and also supported his family. For example, Leonardo later paid Salaì's sister's dowry and provided lodging for his father. Evidence in favor of love is the fact that Salaì would remain with Leonardo until the end of the latter's life. After that, he married a lady who was much richer than he.[6] For Salaì, as for most people at the time—both men and women—sexuality and the struggle for economic success, emotional health, and financial dependence were almost inseparable.

What of Leonardo? Like everyone else, on closer inspection, he had weak points. For all the permissiveness in his palazzo on the Piazza del Duomo in Milan, the artist may have had moments when he found lust a burden, or at

least asked himself what the complete renunciation of worldly things might feel like. Probably a few years before he took the little devil into his home, he was preoccupied with Saint Jerome (Plate 14).[7] He was impressed by how the old man struggled in the wilderness against his desires and how he subjugated his body in order to keep his soul pure. He pondered on what goes on inside a man who beats his own breast with a stone and what the body of a starving, half-naked man who denies himself everything must look like.

The sight is terrifying and not worth striving for—at least, that seems to be what is going through the lion's mind as it watches Jerome in torment in the desert. In Leonardo's painting of Saint Jerome, the animal roars with horror and sympathy; it is the saint's friend, rather than his enemy. The artist was familiar with living lions from Florence, where they were kept in a cage in the city center and occasionally set loose to chase horses or lambs in great spectacles in the Piazza della Signoria. Their agility, their power, and their brutality fascinated Leonardo. He once drew a picture puzzle of a lion surrounded by flames with a table standing next to it, showing his identification with the big cat in a play on words. Underneath, it says *leonardesco*, Leonardo-like—a word made up of *leone* for the lion, *ardere*, to burn, and *desco*, table.[8]

The lion in the painting of Saint Jerome remained unfinished; Leonardo laid in the animal he thought of as his symbol with no more than a few firm brushstrokes and then devoted himself to the old man. He was particularly interested in the man's head. It was the period when Leonardo was fascinated by human anatomy. In around 1490 he drew his *Vitruvian Man* (Ill. 21), investigated the skulls of dead men, and deliberated on the exact position of the seat of the soul, or at least of the common sense that he believed to unite all the other senses. Jerome's face is contorted with pain, his eyes are sunk deep in their sockets, and lines of care are engraved on his forehead. The saint has his shoulder and the crook of his neck turned toward the viewer, as if he wanted to appear particularly vulnerable to the onlooker—and to God. The tendons, bones, and muscles that bind together head and body, mind and material existence, are protruding. It was customary for Saint Jerome to be depicted with a beard, but Leonardo made him clean-shaven; as an artist, he was interested in the details of the construction of the body that appear on the surface at the moment of greatest tension.

The picture is preserved in earth tones. As with the *Adoration of the Magi* (Plate 12), the colors have been applied in only a few places. The background

is one of Leonardo's ethereal, bluish mountain-and-sky landscapes; this too remains unfinished. In the background he also sketched a Renaissance church of the kind he knew from Florence and would have liked to build himself in northern Italy. However, this was no more than a trimming. Leonardo's subject was the torment of a man struggling with himself, yet always intimately connected to divine nature, represented by the stony landscape around him and his faithful but skeptical friend *leone*.

Leonardo knew all about self-torment—from his early youth he had been haunted by doubts about the process of artistic creation. Paintings remained unfinished, and this one was no exception. Yet these moods of thoughtful hesitation did not lead him into isolation and self-destruction. He understood how to live his professional and private life as well as he was allowed to.

He could consider himself fortunate to be living in Milan, in the shadow of an autocratic ruler who, though despotic, offered him protection. While Leonardo dressed the adolescent Salaì in pink, green, and silver and encased himself in tight-fitting breeches and rose-colored cloaks, things were happening thick and fast in Florence. The city on the Arno was now the European capital of art, fashion, and diverse lifestyles. But in the 1490s the Florentines, of all people, were becoming totally preoccupied by imaginary enemies, and the people most affected by this hysteria were the artists, sodomites, and beautiful women.

The tempo in Florence had recently been set by the Dominican friar and self-styled prophet Savonarola, who preached extreme asceticism. The Florentines must renounce trumperies, splendor, and even the sensual arts and love poetry, and become models of virtue, because they were a chosen people, superior to all others.[9] Among the growing crowd of ardent supporters of this doctrine of purity was an army of boys who were stirred up in Savonarola's monastery of San Marco. They paraded in the thousands through the streets of Florence, dressed in white habits and chanting hymns of praise to the Lord. In their role as Savonarola's guardians of virtue they snatched golden combs from women's hair, destroyed the chessboards of people playing in the streets, forced their way into houses, and ordered mirrors, perfumes, wigs, toys, and the books of Dante and Petrarch to be thrown out.

Everything was now under suspicion: the long hair and tight, bright-colored breeches of the boys; the bodices and cosmetics of the women; dances; horse

races; the wine in the taverns; and the pictures of *belle donne* in the palaces—and, of course, love between men. The preacher of repentance threatened the sodomites. If they were caught once, they were put in the stocks. The second time, they were publicly branded on the forehead with the arms of the city as a mark of shame. The third time they would be burned at the stake.

Jewelry, luxury articles, musical instruments, paintings, and books went up in flames in two "bonfires of the vanities" in the Piazza della Signoria in the heart of the city. The Florentines willingly cast their best objects into the flames, or watched the children doing so. These were not good times for aesthetes. The artists became uncertain. Sandro Botticelli, who a few years before had also had an (unsuccessful) accusation of sodomy hanging over him, had a brother who completely espoused Savonarola's cause. However, the painter himself would not and could not range himself totally on the side of the fanatical preacher— that would endanger his "core brand," the sensuous depiction of naked goddesses and other beautiful women.[10]

Savonarola's increasing influence among the more educated citizens resulted from a power vacuum. Lorenzo de' Medici, who had long been suffering from gout, had died in 1492 at the age of only forty-three. His son Piero succeeded him but had a hard time of it. The wealthy families in the city were merely waiting for the young man to suffer some misfortune; they had long been troubled by the supremacy claimed by the Medici. Unfortunately, Piero reacted to this with arrogance and also made political mistakes. The king of France had taken it into his head to conquer Naples. Piero de' Medici refused his support. In late 1494, when he realized that he had drawn the short straw, as the soldiers would be marching through Tuscany, he immediately ceded important Florentine territories to France in order to appease the king. This caused his own government to turn against him, and, together with a good many of the citizens, it drove him out of the city.[11]

The French did indeed march into Florence, but did not cause havoc like elsewhere, and after two weeks they continued on their way south. The Florentines attributed this to the good influence of Savonarola on the occupying troops. After that, the city became a true republic, and in the Grand Council shop owners and artisans worked alongside the wealthy families to determine its political destiny. However, in the background and without any official position, Savonarola exercised his influence for more than three years, until this became too much for Pope Alexander VI, who suffered constant criticism from Savonarola, and for a number

of Florentines who missed the old careless ways, the hedonism, and the appreciation of art of the Medici age. The mood changed—more and more citizens distanced themselves from Savonarola and avoided his sermons until he was finally imprisoned as a heretic by the government, tortured, and burned at the stake on May 23, 1498, along with his closest followers.[12]

While his fellow countrymen were still indulging in extremism, Leonardo was becoming more of a rationalist and humanist. His piety had nothing to do with orders and obedience, self-denial and blind faith. On the contrary, he believed that God had created man in his own image and therefore given him a unique body and mind.[13] As can be seen from both his paintings and his writings, Leonardo imagined a religion that was committed to freedom of thought. The ecstasies experienced by his figures result from their understanding of the world.

During the years of Savonarola mania, Leonardo created a new definition of Christian art. Once again, it was Il Moro who gave him the opportunity. He had now achieved his desire to become the duke of Milan. The legitimate bearer of the title, Ludovico's young nephew Gian Galeazzo Sforza, had first been sidelined by Il Moro, then deported to a fortress in Pavia, and finally, or so it was rumored in Milan, killed on his orders on October 21, 1494. Ludovico did not go to any great trouble to deny this rumor; he preferred to occupy himself with his posthumous reputation. Leonardo's equestrian statue would never come to anything; the artist found the task difficult, and Ludovico had then without further ado given the bronze intended for it to his father-in-law, Ercole I d'Este, to use for cannonballs. In addition, Ludovico no longer wanted to honor his ancestors but wished to set up a memorial to himself instead.

Leonardo could help him with this, but it would be better to have him paint something, because that was what he was good at. Ludovico wanted to have his tomb erected in the Dominican monastery of Santa Maria delle Grazie in Milan, and building work was already in progress. In order to attract attention outside the local area, the place needed to achieve greater artistic importance. What was lacking was high-status modern painting, so Leonardo was to decorate the refectory, where Il Moro regularly dined. The subject was obvious: the Last Supper (Plate 19).[14]

This was a wonderful opportunity for Leonardo to provide evidence of what could be achieved by his new art of movement. It could show expressions

of emotion and bring body and soul together in harmony. He did not think of lining the disciples up neatly behind the laid table. First of all he threw himself into extensive character studies. He strolled through the city with his note block at his belt, in search of strong facial expressions and expressive gestures. He spoke to various people, cracking a joke in order to see how the listener's facial muscles moved when he laughed, or observing how a person who has just been told something astonishing opened his eyes wide. He was intrigued by how a man jammed his fingers together and started a conversation, how one person whispered something in another's ear, or how a person leaned forward when listening in order not to miss anything. Leonardo became the chronicler of interactions.[15]

Now he was no longer concerned only with the individual, but also with interactions between people. The scene of the Last Supper is an archetypal image of a community, and—when Jesus says, "Verily, I say unto you, that one of you shall betray me"—of what happens when an atrocious suspicion spreads through a group.[16]

This was the dramatic moment that Leonardo chose, and he made his figures puzzle over which of them will be the betrayer, instead of providing them with the answer that it is Judas, as other artists had done. In Leonardo's painting, Judas sits on the same side of the table as all the others, between the attractive, androgynous John with his long hair and the dumbfounded Peter on Jesus' right. The only evidence of his crime is the purse he clutches on the table.

As usual, it took some time. On some days Leonardo slaved away on the scaffolding in the refectory without eating or drinking from morning until late evening. On other days he added just one or two brushstrokes and went home. Or he did not appear at all for months, until the monks finally complained to Ludovico that the painter really should work just as hard as the monks.[17]

As recounted by an acquaintance of Leonardo's, Ludovico summoned his artist to his presence.[18] It was not the first time Leonardo had idled away at a commission. "What is the meaning of what the monks have told me?" asked the enraged duke. Il Moro believed that his court artist had lied to him. The monks had said that Leonardo had not appeared at the monastery for over a year, but the artist averred that not a day had gone by when he had not spent at

least two hours on the work. "How can that be," insisted Ludovico, "if you do not go there?"

Leonardo could not help laughing. These monks and their prior understood nothing about art. He would get Ludovico on his side by explaining how much time he had spent on research for the *Last Supper*. Il Moro would then feel like an initiate, a connoisseur, and make fun of the monks. "Most illustrious lord," Leonardo began, "I have only the head of Judas still to paint; he was the great traitor, as you know, and he deserves to be painted with a face that is appropriate to his despicable act." Waspishly and slightly offended, he added that "among those who complain about me" there would be enough types who would make a wonderful Judas for the painting. But he did not wish to reveal his many enemies, so every day for more than a year he had been visiting the Borghetto district "where common, low people live, mostly cunning scoundrels, just in order to see whether I could spot a face that was suitable for depicting this villain."

However, he had not yet found one. Not even the scoundrels from Borghetto were devious enough for the image of Judas. So what would happen if he could not find one? "Then I will use the face of the prior who is making these charges against me and it will suit perfectly." Ludovico laughed out loud. Leonardo had won him over with his spiteful tongue.

According to Leonardo's acquaintance, who liked to watch him when he was working in the refectory, the artist later found a man in the streets whom he could use for Judas. On the other hand, Vasari, who once again felt the need to outdo every spiteful remark, implied that in the end Leonardo had indeed depicted the prior of the monastery as Judas.[19]

However, the extensive rambles through the city were not the only reason why Leonardo took so long over the *Last Supper*. He needed to think about creating something entirely new. He decided to depict the disciples deep in animated discussion, instead of just humbly receiving the words of Jesus. His figures are not only surprised, angered, amazed, and shocked by the news of the betrayal, they are also engaged in a process of realization. Leonardo could not—in a Dominican monastery—have dissociated himself more clearly from the authoritarian, uncompromising behavior of Savonarola, who believed he was in possession of the sole truth.

Leonardo also wanted to use completely different techniques. He was not an experienced fresco painter; his master Verrocchio did not teach this craft. As both researcher and artist, Leonardo was bothered by the fact that a fresco must

dry for a whole day after being painted directly onto the wet plaster. Corrections of the kind that could be made to an oil painting on a wood panel were impossible. However, this did not suit Leonardo's way of working. He liked to think while he painted, to layer colors and shapes on top of one another, create and erase figures. For him, the better idea was always the enemy of the good. He therefore immediately changed technique. On a priming coat of size and chalk, he experimented with painting using various mixtures of tempera and also oils.

That was not very successful; the paints peeled off after only a few decades. It was not until the following century that the Venetian painter Sebastiano del Piombo, a follower and admirer of Leonardo, discovered a workable formula for an oil paint that would also adhere to stone and plaster.[20] However, Leonardo believed in his mixture. At this time he was not to know that during his lifetime it would already cause the paint to crumble and that the picture would slowly but surely become a ruin that would require restoration.

The completed *Last Supper* was admired and praised; travelers made detours in order to see it. That pleased Leonardo, as he liked to talk about his art. The painter "was very pleased when everyone who viewed his painting said straight out what he thought of it," as the nephew of the prior of the Dominican monastery later recalled.

The artist surrounded himself with philosophers, mathematicians, and architects. In line with his theme of a religion that could be argued over, he enjoyed debates and absorbed what he could learn from them. He became increasingly insistent on his own view of things and even picked quarrels. At the court of Milan, as throughout Italy, the tone was set by the literati. Their works were counted among the *artes liberales*, the liberal arts, whereas those of painters and sculptors belonged merely to the *artes mechanicae*, the practical arts. In order to dispute the poets' sovereignty of interpretation, Leonardo railed against the poets in his notes. They couldn't capture reality, but first had to dissect it sentence by sentence, instead of making it able to be experienced as a whole. Painting was much cleverer, because it could depict storms and landscapes, light and darkness, plants and animals, and, above all, beautiful women. Leonardo's portraits of women were so captivating that his clients fell in love with them and would not be parted from them because they appeared as natural, living creatures, only more perfect.[21]

Leonardo had good reason for his outburst. He must have felt misunderstood as a result of some expressions of opinion. For example, a writer by the name of Antonio Tebaldeo said of a portrait of another of Sforza's mistresses that Leonardo had deliberately given the figure no soul because the woman's soul belonged to Ludovico Sforza alone.[22] It was as if a court poet wanted to straighten something out a little in terms of power, as if it should not be permissible for Leonardo to do what he did in emancipating *belle donne* from their masters, looking for their mental energy, their autonomous being, and celebrating their urge for freedom—and more or less sidelining Il Moro, who was not always so attractive either inwardly or outwardly.[23]

The portrait of a young, dark-haired lady that Leonardo painted in Milan (Plate 18)[24] could be understood in this way. It is presumed to be of Lucrezia Crivelli—Beatrice d'Este's lady-in-waiting—with whom Il Moro carried on a relationship before and after his wife's death. Tebaldeo's poem might have been referring to this painting.

The woman stands chastely separated from the viewer behind a stone parapet reaching to just below her waist. She is dressed in a red gown, with the oversleeves tied on at the shoulders, as was fashionable at the time. None of the bows are untied, and no edges of her shift peep out above the neckline. Her brown hair is severely parted and gathered at the back of her neck by a scarf. The necklace wound several times around her neck is pretty but not expensive. If she wears any makeup at all, it is so discreet as to be unnoticeable. Everything conforms to the highest standards of respectability.

Except for that look. The way her deep, brown eyes seem to pierce the viewers and then slip past them. This gaze constantly follows people as they walk to and fro in front of the picture. This seems to be the evidence that the eyes of a woman are the windows of the soul, and, as Petrarch said, it is through them that Cupid sends the arrows that pierce a man's heart.[25]

In this portrait, Leonardo shows the eyes of his *bella* wider open than ever before. The woman's gaze is no longer enraptured, as in the case of Ginevra de' Benci (Plate 9), no longer looking to the side as with Cecilia Gallerani (Plate 17). This new gaze only just bypasses the viewer avoiding direct contact only by a whisker. The power of this gaze as it approaches ever closer is so strong that it takes a parapet, a demure dress, and several rows of necklace to protect the viewer from the risk to which he has just been subjected. He is recognized by this woman, without completely seeing through her himself. If she came any

closer to him, she would unbind her hair and the scarf, and climb over the parapet; it would be almost unbearable. Leonardo excelled all others in his mastery of the interplay of nearness and distance.

Leonardo was equally forceful in bearing witness to the principle of dialogue. The disciples in his *Last Supper* (Plate 19) are talking about their faith; he himself would discuss his art with anyone who was willing. This woman personifies painting's ability to speak. She has what Petrarch desired: *voce ed intellecto*, voice and intellect. The ability of the *bella donna* to see, understand, feel, and respond lies in her unique gaze.[26]

Women, his workshop, painting, nature, and research—these meant everything to Leonardo. He felt no loyalty toward his patron. This was made clear in 1499, when Milan was overtaken by the political turmoil in Italy. The French powers now remembered how dubious the rule of the Sforzas was, as they were a young dynasty of mercenaries rather than long-established nobility. King Louis XII laid claim to the dukedom and assembled his soldiers on the Italian border. When they marched on Milan, rioting broke out in the city. Deeply shocked, Ludovico fled on September 2.

Leonardo did not follow him. He had just gotten comfortably settled in. Not long before, Ludovico had given him a large garden with a vineyard and a house close to the Dominican monastery. Overjoyed, Leonardo measured out every inch of his new property. He was now an estate owner, like his grandfather in Vinci. And he had nothing to fear from foreign occupiers; they would also need an artist and engineer. No sooner had the French marched in than Leonardo made contact with the leaders of the forces. For safety's sake he encoded his notes by writing names and places backward. He was probably not completely certain that all the Sforza spies had left the city.[27]

The plan succeeded; the occupying French recognized their enemy's former court painter as an independent, universal artist. King Louis tried in vain to take the *Last Supper* away with him but was forced to realize that an entire wall could not easily be plundered, as it would break. Nobody would wish to commit that crime, as Vasari reported. However, the soldiers were less scrupulous with regard to the clay model for the planned equestrian monument in honor of Ludovico's father. They used it as a target for shooting practice, and it shattered as a result.[28]

The fact that Leonardo had generally distanced himself from Sforza propaganda and always kept to his own favorite subjects paid off. In the end he did not care who was actually in power, as long as that person met him on an equal footing, or preferably with respect. Leonardo was well aware that an exceptional talent like his was desirable in the struggle for cultural importance among the European and Italian powers.

In any event, Leonardo knew Ludovico too well to cherish any illusions about him. Il Moro would not suffer humiliation for long. In fact, after a few months away, he prepared to reconquer Milan, and the French withdrew. Leonardo's treachery did not escape Il Moro's notice once he had become reestablished in Milan. So Leonardo prepared his departure. Late in 1499 he eventually left the city where, over the course of almost eighteen years, he had achieved fame and gained new insights. It was also the city where he had lived and loved in peace, and probably laid his mother to rest five years previously, as suggested by an entry in the Milan register of deaths.[29]

For the time being, Leonardo left the vineyard in the care of Salaì's father, who was to move into the adjacent house and look after the estate. Salaì, now aged nineteen, was to accompany his master. Leonardo planned to learn as quickly as possible from a Parisian colleague how to apply dry paints and how to make paper that had been glued on look like a single sheet.

Then he packed two bags, put in bedclothes for the muleteer, and even remembered to take a brazier with him. He wrote a shopping list. He still needed tablecloths and napkins, headgear, shoes, four pairs of breeches, a suede jerkin, and other leather for sewing. He wanted to buy garlic from Piacenza and seeds for growing vegetables, flowers, and fruit. The boards of his painting scaffolding could be sold for cash. "Sell everything you cannot take with you," he ordered himself in a note. Then he transferred his money to his account in a bank in Florence. After all, this amounted to 600 florins, the equivalent of four and a half years' pay for a higher-ranking official in the Florentine Republic.[30]

Leonardo may have said goodbye in person to Cecilia Gallerani, with whom he had become friendly as a result of painting her portrait.[31] Possibly she gave Leonardo some good advice: Go to Mantua, the home of your greatest admirer, the marchioness and art collector Isabella d'Este. Since Cecilia had sent Isabella the portrait with the ermine (Plate 17) to look at, she had wanted only one thing: to have her portrait painted by Leonardo da Vinci.

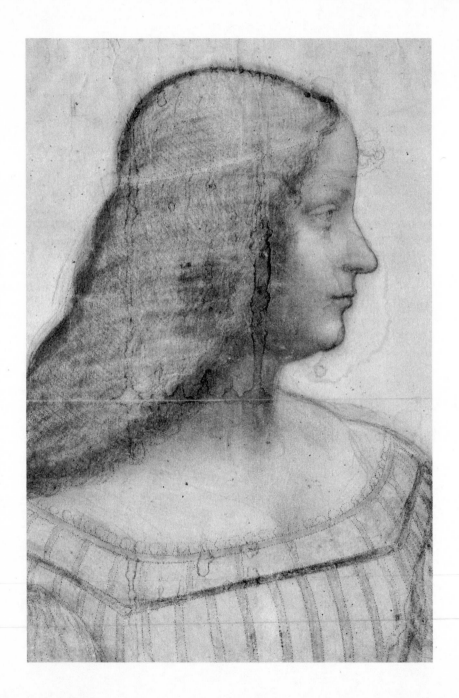

IX

POSE OR POETRY

LEONARDO AND SALAÌ probably greeted the new century in Mantua. To
the ears of those who did not believe the widespread fantasies about the end of
the world, 1500 sounded like the dawn of a bright future. The age of discovery
with its thirst for knowledge was about to unfold. The rediscovery of the ancient
world and research into nature and humankind were no longer the projects of
the few; they were the acknowledged spirit of the age. The world was expand-
ing and becoming more complex. It had been eight years since Columbus had
landed in America, but most Europeans were not yet aware of the revolutionary
consequences of this event. Certainly, on New Year's Eve 1499, no one would
have imagined that, a few decades later, the corrupt Church would become the
target of reformers and that Europe would face religious wars and a bloodbath
that would far exceed that of previous warfare between principalities.

Leonardo had every reason to look forward cheerfully to a future in
Mantua. Beguiled by princes, free to choose his projects and where to make his
home, at the age of forty-seven he was at a high point in his career. He wanted
to travel on to Venice and study the rivers in its hinterland. The Turks had
already crossed the Isonzo River in Venetian Friuli, and there was an ever-
present danger that their troops would penetrate even deeper into the interior.
Leonardo wanted to investigate on site how the river could be diverted or what
protective measures could be taken against invaders. It is not clear whether
he had been asked to do this by the Venetian Republic or its ally the king of

France, or whether no one had requested it. For whatever reason, the artist, who considered himself to be a talented engineer and an expert on water, felt duty bound to do so.[1]

In the meantime, the energetic and sensitive marchioness of Mantua could read his every wish in his face. Isabella had great plans for him, and she was well aware that she could not compel an artist of his stature to do anything. She must certainly have shown him her treasures—the collection of antiquities, the medallions and manuscripts, and the modern paintings. It seemed to her to be unfair that her dead sister Beatrice, the wife of the ostentatious Ludovico Sforza, had been much richer than she, although Beatrice had had less need of money. After all, it was Isabella who sent her agents all over the country to buy any works of arts that were good and admired.

Isabella was more cunning and better educated than her sister, and she had a more tolerant husband. Gianfrancesco II Gonzaga gave his wife, who was seven years his junior, free rein and appreciated her managerial qualities. When he was away traveling, she represented him and ran his affairs. She did everything she could in order to be perceived as an equal within the circle of northern Italian princes. Treatises began to appear in Mantua praising women in general, and especially Isabella d'Este for her political and intellectual abilities as well as for her beauty. Isabella's favorite occupations were hospitality and correspondence; she wrote and received thousands of letters during her lifetime. She also made translations from Latin, wrote the occasional poem, and was a keen musician, playing the lute, flute, and other instruments, as well as being a good singer.

Her favorite status symbol was her *studiolo*, her work and music room. Usually it was mainly men, especially male rulers, who owned such a retreat, and they made sure that their wives did not set foot there. Isabella wanted to outdo them all. For this she needed the best artists in the country to decorate the room according to her instructions. She was in her mid-twenties at the time, and she was in no doubt that Leonardo was just such a genius. However, before insisting—in vain—on participating herself in providing the *studiolo* with its own mythology, she requested something she desired even more ardently—a portrait from Leonardo's own hand.[2]

Isabella was familiar with Leonardo's portrait of Cecilia Gallerani (Plate 17), and on her visits to Milan she might well have seen the first version of the *Virgin of the Rocks* (Plate 15). She liked the delicate way he painted and his sensitive

approach to women.[3] She might have felt that she could be one of these women—the most beautiful, powerful, and intelligent of all. It seems as if she already suspected at the beginning of 1500 that her guest would one day create the most famous painting of a woman in history. And it seems that she wanted to be that woman: the Mona Lisa (Plate 28) of Mantua.

However, nothing was to come of it. Isabella did not only want her portrait to be painted in oils by the best artist of the age, she also wanted to beat the men at their own game in this field. She wanted Leonardo's picture to show her to everyone in the way she saw herself—as a cool, superior sovereign.[4] Inevitably, her models were men, in the pose adopted by rulers.

However, Leonardo was interested in rulers only when he could talk them into accepting his own fantastic bridge-building plans, or when they offered him interesting commissions. It is fairly obvious that he found them boring as subjects for his art, as he did not paint portraits of either Lorenzo de' Medici or Ludovico Sforza as far as we know. He detested having to express effusive thanks to people in authority, possibly because they were an unpleasant reminder of his unapproachable father. Where women were concerned, he was interested by the very opposite—their openness and a strength that was not due to any office, or marriage, or inheritance. He liked women for what they were. And even though, as he later averred, he had a high regard for Isabella, who admired him so much, he evidently shared her ideas to only a limited extent. And he certainly could not bear being told what he should do, even by a person with a considerable understanding of art.

However, Isabella had a tendency to do just that. She knew, of course, that she would have to involve Leonardo in finding a theme and in the composition, and she did not want to scare him off, but as a well-informed critic she was all too keen to pass judgment on art. Once she told a painter to his face that the layout of his figures was charming, but he had made a poor job of finishing them. Or she would tell an artist he should make an effort, because his work would end up being compared with the works of famous masters.[5]

Although Isabella did not treat Leonardo in that way, he had already survived a direct comparison of his portrait of Cecilia Gallerani (Plate 17) with a work by Giovanni Bellini in her castle. Isabella, however, was not such a natural and obliging model as Cecilia. After all, her aim was for her portraits

to convey a specific image. She used to send them to half of Italy as signs of favor and promotional gifts. One of the gratified ladies stated delightedly that she always took Isabella's portrait to dinner with her, placed it on a chair, and conversed with it.[6]

But this time the marchioness did not want a straightforward image of friendship that people could talk to; she wanted an official portrait painted by the best artist of her time. All the same, Isabella did not stick strictly to convention with Leonardo. This dictated that a woman of rank must look out of the picture to the left in full profile, as her portrait would always hang to the right of her husband, who set the tone. Of course, being subordinated in this way did not suit Isabella, and it certainly did not suit Leonardo, who had already done away with that idea in his portrait of Ginevra de' Benci.[7]

However, Isabella was not brave enough to put herself entirely in the hands of the master and allow him complete freedom to invent a new image of feminine power. Evidently she referred him to her portrait medallions, which showed her in profile looking to the right. Her mother had also had herself depicted in this way in a book illustration, in the pose of male rulers. With an eye to the future the eyes look to the front—controlling, but also very controlled. That is how Isabella wished to appear to the world.[8]

Leonardo did not argue with her. He accepted the format and made the best of it. After all, it was a matter of his favorite subject: the portrait of a beautiful woman. Although Isabella found it difficult to remain still for a long time, she posed for a large drawing. He promised to transfer it later to an oil painting in color. Maybe he already had a sense of foreboding at the time that he would not keep his word. Yet he created the large-format drawing in chalk and sanguine on paper with such care that it can stand alone (Plate 20).[9]

A young, plumpish woman has her pretty face—which the artist seems not to have idealized—and her gaze looking to the right. Her hair, which looks as if it had been glued together in the shape of a helmet, falls straight to the back of her bare neck, with not a single strand escaping. Her striped dress with its wide neckline is cut in the fashionable French style but does not look luxurious, and she wears no jewelry. A copy of the drawing that has remained undamaged—unlike the original—reveals what is really distinctive about her: Her large hands are placed one on top of the other, with her right forefinger pointing to a closed book in front of her (Ill. 26).[10] This woman is a mistress in several senses—of art and letters, of Mantua, and, from the controlled way in which she holds herself, of herself.

Isabella liked the work. She would have preferred Leonardo to remain in Mantua and paint her in oils immediately from this drawing. However, he wanted to investigate the course of the rivers in the Venetian hinterland, and he knew just how long the painting would take once he had begun working on it. As a sign of goodwill, Leonardo, Salaì, or another assistant copied the chalk drawing to use for a later painting and the new sketch was put in their luggage.[11]

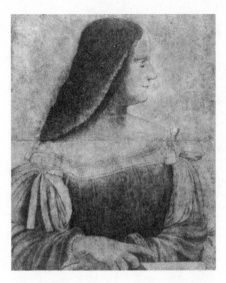

Illustration 26. Workshop of Leonardo, *Isabella d'Este with a Book*, Ashmolean Museum, Oxford

In February, or no later than the beginning of March 1500, Leonardo and his followers arrived in Venice. As an aesthete and as an engineer, Leonardo could not help but be interested by a city built in the water. Everything there appeared airier than in Milan, despite the 100,000 or so inhabitants. Anyone who could afford it had a boat to take them across the canals. Wealthy signori had their gondolas lined with Persian and Egyptian rugs and festooned with brocades and silks.

The Venetians also dressed their wives royally, buying them elegant gowns and very high platform shoes. As a result, the ladies always had difficulty in keeping their balance when strutting the few steps they had to take. Many bought hairpieces from the hawkers in the Piazza San Marco, which could be seen peeping out from under their headscarves. Others sat on the roof terraces in the middle of the day, so that the sun would bleach their long hair more quickly. A number of courtesans used cosmetics and dressed like noblewomen, and, like the established families of the city, were regular customers of the painters and booksellers.[12]

The Venetians were proud of their taste, their wealth, and their education— and of their political independence. Venice, which had never been conquered,

was an elective republic, in which the better families competed with one another. All noblemen of established family over the age of twenty-five had the right to vote in the Great Council. This was similar to Florence in some ways, but the political system was more stable. In Venice, no single family succeeded in determining the fate of the state over a long period, as the Medici did in Florence. Even a fanatical penitential preacher such as Savonarola would have had little chance in Venice. It was a city of traders, too pragmatic and too open to the world, where Muslims in turbans could be seen alongside Greek Orthodox Christians and Jewish traders (although at that time the Jews had to live in Mestre on the mainland), and, a few decades later, German Protestants also arrived there.[13]

Famous artists were doing good business in Venice. Art collecting started to become fashionable around 1500, so painters and sculptors were no longer dependent on official commissions, as they could also sell their images of the Madonna, portraits, and biblical and historical scenes on the private market. Many of their *case* (houses), as they described their palazzi with masterly understatement, looked like art galleries. Paintings on wood and canvas could be found in salons, dining rooms, and even bedrooms. Middle-class and poorer families treated themselves to less-expensive religious images. The Venetians had become addicted to painting.[14] Leonardo was in the right place.

Of course, the city's art connoisseurs had also had a literary education, and their curiosity encouraged the relatively new printing business. When Leonardo traveled through the cool mists along the Grand Canal in the spring of 1500, there were already 150 printers working in the city. One man stood out among them: Aldus Manutius, a humanist born south of Rome, who gathered the intellectuals of the city around him in his house in the San Polo district and also printed Greek books.

Aldus would soon publish the standard edition of Petrarch's *Canzoniere*. Working on the book, which would appear in 1501, was a young man whom Leonardo probably remembered. As a boy, Pietro Bembo had accompanied his father, the diplomat Bernardo Bembo, to Florence and seen him fall in love with the young poetess Ginevra de' Benci. Since then, Pietro, now aged twenty-nine, had traveled widely, studied many things, and also experienced his first secret love affair.[15]

Pietro was clearly obsessed with Leonardo's portrait of Ginevra in front of the juniper bushes (Plate 9). He also shared his father's passion for the poems

of Petrarch. Even more intensely than his father, he was preoccupied by the mental anguish of unrequited love. In 1500 he had already written parts of his *Asolani*. In this book, men and women at the court of Asolo near Treviso talk with unusual frankness about love and death, happiness and sadness, and the conflicts between erotic love and chastity, strong feelings and decency.[16] At first, Pietro postponed his own project in favor of the new edition of the *Canzoniere*. His father owned a piece of writing by Petrarch, and Pietro first wanted to bow down before the poet's great example.

Very possibly Pietro Bembo told Leonardo about this or gave him the first parts of the *Canzoniere* edition to read. Although the artist found ancient languages difficult, he enjoyed reading and read a great deal in Italian. He had included the *Canzoniere* in the list of books he drew up while still in Milan. And even though Leonardo himself normally wrote his notes in a much less florid style than that of the poet, whom he ridiculed for his emotionalism, he was willing to hear about the cult of Laura and all the discussion about love. After all, it concerned something that particularly interested him: the secret power of beautiful women, whom he thought of as the symbol of life and art.[17]

The other thing that interested Leonardo was painting in oils. The Venetian painters were masters of this skill. The wind and the damp, salty air of the lagoon prevented frescoes from adhering to the walls. Consequently, the artists there preferred wood panels, and soon canvas as well, and they achieved a brilliance in oil painting that had rarely been seen before. Conditions were perfect for this, as in Venice specialist *vendecolori*—paint dealers—offered pigments, resins, and dyes imported from all over the world. Artists could find ground lapis lazuli for making ultramarine blue, kermes red made from scale insects, and anything else their hearts desired.[18]

The Venetian painters particularly liked to experiment with flesh tones and went to great trouble to make the skin of their female figures glow as realistically as possible. The Venetians had an especially close relationship with Mary, who was said to have been involved in the founding of the city in AD 421. Images of the Virgin hung in virtually every house, as well as in churches and offices. Sometimes the Virgin was depicted concentrating on her child; at other times she was in the company of saints deep in prayer and angel musicians who had gathered together to worship.[19]

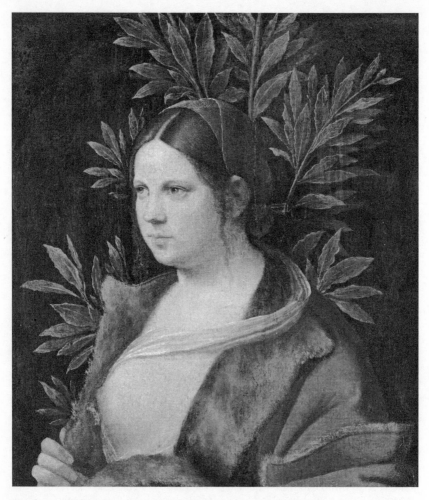

Illustration 27. Giorgione, *Laura*, Kunsthistorisches Museum, Vienna

So Leonardo was presented with hordes of wonderful images of women in the churches and houses. However, it is likely that he rarely saw portraits of contemporary women, as in Venice it was virtually only men who had their portraits painted. With the exception of the former queen of Cyprus Caterina Cornaro, who headed the court of Asolo on the mainland, there were no prominent women in Venice. The Venetians set great store by the fact that their offices, especially that of the doge, could not be inherited. That is why no portraits were painted of the wives of the office holders, since, if they had sons, the women could be seen as embodying the dynastic claims of their families, and such aspirations were not permitted.[20] So, in a city obsessed by love, the real women remained invisible—at least until Leonardo came to visit. The few weeks he spent in Venice in the spring of 1500 changed everything.

No evidence has survived of which fellow artists he met or where, whom he showed his portfolio or chest of drawings to, or how he explained the effect of his *sfumato*, his art of smooth transition. But over the next few years a new poetry found its way into painting in Venice. The splendid colors of Venetian painting met Leonardo's idea of a moving, animated, and autonomous art. Shortly after Leonardo's flying visit, Giovanni Bellini, then in his mid-sixties, and his young pupils Giorgione, Sebastiano Luciani (later known as Sebastiano del Piombo), and Titian were no longer content with pictures of the Virgin. They began to prove their mastery of the apparent reality of painting in seductive images of beautiful real women. Contemplation gave rise to sensuousness.[21]

Passionately, Giorgione turned to Leonardo's portrait of the poet Ginevra de' Benci (Plate 9). He interpreted the juniper in the background of the portrait as mockery of Petrarch's Laura mania, and in 1506 he placed his female model in front of a laurel bush, because *lauro*, laurel, hints at the name Laura (Ill. 27),[22] though Giorgione's *bella* is not an ethereal blonde like the lady worshipped by the poet. She is a well-formed, body-conscious brunette, indisputably painted from life, and even more forceful in appearance than Leonardo's earlier *belle donne*. It is no passive, chaste maiden who encounters the viewer, but rather a grown woman who has taken her fate into her own hands. She opens or closes her red, fur-trimmed nobleman's robe as she pleases over her naked bosom, which is delicately covered by a white shawl. She reveals herself to the viewer, but not completely. Without looking directly at him, she attracts him and then halts him an arm's length away. Her left arm, which is held across her body, creates a barrier at the front of the picture.

The picture gives the impression that someone was reading to Giorgione from Leonardo's treatise on painting, which he had scribbled down on paper in Milan. This talks about the superiority of painting over poetry, its physical presence and its seductive beauty. Like Leonardo, Giorgione also knew how to involve the viewer in a kind of relationship of unrequited love. The painting of both Leonardo and Giorgione is like Petrarch's Laura: very beautiful, approachable at first, but unattainable in the end.[23]

Giorgione and his friends were soon regular visitors in the salons of the city; they played the lute, recited poems, and argued with the young patricians about art and love. They met behind high windows overlooking the canals in societies known as the *compagnie della calza* (literally "stocking companies") and dreamed not of urban comfort but of the joys of a life in natural surroundings. They called this parallel world Arcadia. There shepherds played the flute in sylvan groves, and simple maidens were transformed into goddesses. People lived, loved, and died in Arcadia; it was the land of deep feelings that had little place in the everyday life of the merchant society based on financial success that knew only arranged marriages and prostitution and nothing about freely lived romantic love.[24]

Pietro Bembo was the intellectual leader of the young men who were addicted to love and art; he fed them with ancient and modern literature, from Virgil via Petrarch to their contemporary Jacopo Sannazaro. The Venetian artists listened and learned. They did not want to illustrate the poems but instead to create independent *poesie* in the spirit of Leonardo—atmospheric images of love that could stand alone, without always having to explain themselves.[25] So they invented new myths and painted naked goddesses who were women of their times. They painted portraits of grocers' daughters and other maidens who were not decked out in fine clothes and had hitherto not been considered worthy subjects for portraits. And they also turned to attractive, loving boys, once again quite in the spirit of Leonardo. These barely full-grown men were not cold-hearted heroes but sensitive beings with soft, dark curls, eyes filled with longing, loving hearts, and philanthropic minds.[26]

The more intensely the young, mostly unmarried Venetians focused on the concept of self-expression and self-discovery, the more determinedly they separated the realm of art from the material constraints of everyday political and business

life, the further they distanced themselves from the previous generation of people who commanded respect and acted pragmatically.[27] But even Leonardo, who was more than a quarter of a century older than Giorgione, only shared this unworldly sentimentality to a limited extent.

Leonardo's dreams may have been high-flown and ahead of their time, but they were within the bounds of reality. Instead of going into raptures over the pastoral life in the midst of urban Venice, he went off into the hinterland, probably in early March 1500, not in search of nymphs, the god Pan, and music-making shepherds, but to interview the people who lived by the Isonzo River. His intention was not to glorify the landscape of Friuli, but rather to understand it and make it subject to its people or, more precisely, the Christians of northern Italy. His rural romance consisted of plans for sluice gates and diversions, based on calculations of the waterpower and the mass of wood that the current carried with it. To his frustration, he established that embankments could not protect the Isonzo from Turkish attacks because they would not be able to withstand the floods. He sketched his onsite observations in a letter to the responsible authorities, which he may not have sent.[28] His ideas were probably not carried out.

In April 1500 Leonardo and his fellows received news from Milan. Ludovico Sforza's reconquest of the city had failed. Il Moro had attempted to flee to the north disguised as a servant but had been captured by the French.

Leonardo noted laconically that "The duke lost the state, his estate, and his freedom, and no work [intended] for him was completed by him."[29] The artist was probably referring mainly to the bronze horse that should have been made in honor of Ludovico's father. Leonardo never saw his former master again, as he eventually died in prison.

He bought a few more books from the Venetian dealers, learned about the new technique of copper etching, and sold, or probably gave away, a painting of the Virgin from his workshop, which was later seen by an eyewitness in the house of a Venetian collector. Then Leonardo and his assistants packed their bags again. On April 24, 1500, he withdrew money from his bank account in Florence. He had returned to his old home.[30]

What remained in Venice were Leonardo's notions of an independent art and a sovereign femininity that looked the world in the face.

A few years after Leonardo's departure, Isabella d'Este, who was still on the lookout for pictures for her *studiolo*, insisted that Giovanni Bellini should contribute to them. However, yet again, she was probably slightly too explicit in her wishes; at all events, she received a refusal, which was previously unheard of in the history of art. Bellini's response was conveyed by Pietro Bembo, who, despite being a writer himself, liked to make use of any trial of strength between poets and painters to advocate artistic freedom. According to Bembo, Bellini could paint only what matched his *fantasia*, because he was used to wandering at will in his pictures (*"di sempre vagare a sua voglia nelle pitture"*), in order to achieve the most original effects.[31]

Art was for artists, not for those who commissioned it, and a painter must wander at will in his imagination, as only then will his work be great and good. Giovanni Bellini and Pietro Bembo had learned from Leonardo.

Isabella, too, was capable of learning, although she still dreamed of a prestigious portrait of a female ruler from Leonardo's hand. Later, however, in the 1530s, even she allowed herself to be bewitched by the soft fabrics and furs, the merging colors, and the living incarnation of the proud, lovable female figures that entrance the male viewer without ever belonging to him. In the wake of Leonardo, these *belle donne* had become so beautiful, so independent and wise, that there was no longer any reason not to be one of them herself.

After Leonardo, femininity in art no longer meant self-abandonment and subordination; it became much more an expression of common humanity. Isabella, now a lady of around sixty, wanted a new portrait.

Giorgione had died of the plague in 1510 (Isabella immediately pounced on one painting he had left).[32] His friend Sebastiano del Piombo then moved to Rome, where he promoted the lyrical depiction of women. However, the Romans struggled with the notion of depicting self-assured seductresses in front of laurel trees.[33] In his old age, Giovanni Bellini, who had taught both of the above, adopted the poetical ideas of the Giorgionesque painters and was counted among their number when he died in his home city of Venice in 1516.

Only Titian remained in Venice. The last and most successful of the color revolutionaries, he added to Leonardo's art with a rapturous use of pigments and pastes. His multilayered paintings are a whole-body experience, stirring all the senses. With thick brushstrokes, Titian wiped the old Aristotelian anxieties about raw, allegedly feminine colors from the canvas. He must therefore be

considered as a painter of women, for whom the color and the feminine power of seduction of his painting were more important than abstract, seemingly masculine thinking and drawing.[34]

Isabella, the great art connoisseur, was able to appreciate such virtuosity. She asked Titian for a portrait and received one (Plate 21).[35] Nothing about this portrait looks lascivious; it shows a well-dressed lady in a turban and lynx fur, looking, rather seriously, directly out of the painting, without catching the eye of the viewer. The fabrics and the background are kept dark, allowing the rosy-cheeked, evenly proportioned face of the subject to shine out.

She could be Isabella's granddaughter; she is no more than twenty years old. The marchioness was represented in the picture by an adolescent model, probably a girl from the street. This meant that Isabella was spared the long hours of sitting for the portrait and, much to her delight, enabled her to come into the world as a youthful and respectable beauty.[36] Decades after Leonardo's first images of women, a determined, rosy-faced young lady succeeded in personifying strong leadership.

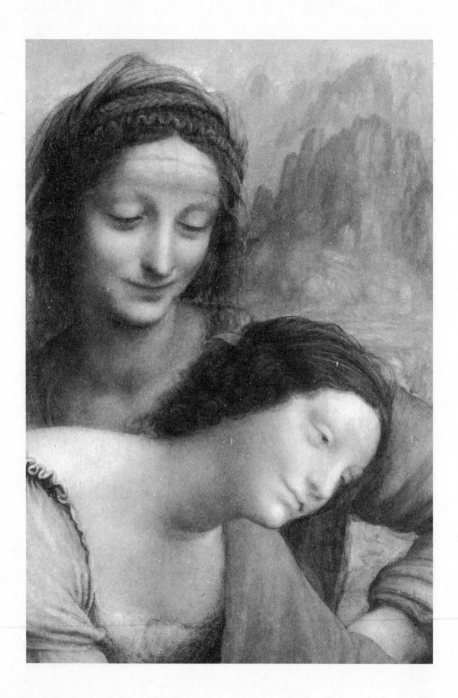

X

BIRTHS AND DEATHS

LEONARDO'S RETURN TO Florence must have felt like a triumph. He had left the city eighteen years before as an unrecognized artist; now he was one of the most famous men of his time. Under the protective cloak of the Virgin Mary, his female deity, he had set art in motion, had celebrated the freedom of women, and now understood nature better than anyone. He had become a painter of souls and an intellectual, a student of emotions and arguments, who had even turned the Last Supper into a humanist debating society (Plate 19). His boundless curiosity drove him to study waterfalls, blades of grass, and skulls. Nothing was too big or too small for someone who was both an engineer and a strolling observer. So many things distinguished this restless wanderer from his contemporaries, his pragmatic colleagues, his sedentary neighbors, the clergy submissive to Rome, and the merchants whose egos corresponded to the size of their bank accounts and the number of sons they had. Leonardo had earlier been sidelined because he was so different; now the Florentines were forced to recognize him as one of their great sons, even if the only reason was that kings and princes were begging for his favors and the republic was grateful that he was once again within their walls.

His arrival was simple. The Servite friars of the church of Santissima Annunziata immediately took him in, along with Salaì and his other assistants, and

paid for their keep. According to Vasari, they commissioned Leonardo to paint an altarpiece that was to have been painted by another artist.[1] Possibly they did this as a favor to Ser Piero, who acted as notary for the monastery. So once again Leonardo had his father to thank for a commission, but yet again Leonardo did not think of behaving well and working hard simply in order not to bring shame on the family. He owed nothing to his father or to the city. If he had a duty to fulfill it was to art, humanity, science, posterity, and himself. That was more than enough for one life.

What he started now, he did calmly and thoughtfully, as if there were no world outside, no clients, no deadlines, and no expectations from others. Previously he had worked painfully slowly and put everything off, sometimes with a bad conscience, whereas now it seemed as if he existed outside time and space, and could ponder for years, or even decades, over individual brushstrokes.

However, Isabella d'Este had not given up. She set her agents in Florence to spy on Leonardo, ensnare him, and force his hand. First of all, she needed a report from her father confessor, Fra Pietro da Novellara. The marchioness of Mantua wanted to know everything. Was "this Leonardo" painting again and, if so, what? How long would it take? After that, would he paint a picture for her *studiolo*, if he were allowed to decide the subject and timetable himself? And if not, would he at least paint one of the delicate Madonnas that were his specialty for her? And please could he send another copy of her portrait sketch (Plate 20), because her husband had given hers away.[2]

On April 3, 1501, Fra Pietro wrote to his "honorable mistress" to tell her what he had heard about the artist. "Leonardo's life is changeable and extremely unsettled, so it seems that he is living without any plan." He found regular daily working life hard. According to Fra Pietro da Novellara's reports, Leonardo's pupils painted portraits, and if they were lucky, the master himself would quickly lend a hand with them at the end. People were still waiting for works from his own hand. "All his effort goes into geometry; he has no patience at all for the brush."[3]

Leonardo had drawn only one cartoon sketch since his return to Florence.[4] It had not been completed, but much could be discerned from it. The subject is unusual: The adult Virgin Mary is seated on the lap of her mother, Saint Anne, while the infant Jesus plays with a lamb. Once again, Joseph is not present; Leonardo's little family still lacks a father figure. Fra Pietro had seen the drawing and could give Isabella an exact description of it. "It shows a Christ-child of

about one year old who, almost escaping from his mother's arms, catches a lamb and seems to be holding it tightly." His mother has half risen from Saint Anne's lap and is reaching out to her child in order to separate him from the lamb, which represents his Passion. Saint Anne is also rising from her seat; it looks as if she wants to dissuade her daughter."[5] The cleric considered what that might mean and came to the conclusion that, out of motherly love, Mary wanted to separate Jesus from the sacrificial lamb, in order to save him from dying on the cross, whereas her mother knew that this was not possible. Jesus must die to save humankind; the Passion must not be prevented.

What Fra Pietro had seen in Florence was part of a grand project that Leonardo would carry with him for more than fifteen years. He would long be haunted by the image of the child that wanted to get out into the world, even though it might cost him his life. Above all, he was attracted by the two women who had become, in his composition, a single, inseparable being with two heads, four arms, and a shared body. In Leonardo's cartoon, Saint Anne, the boy's grandmother, is not much older than the daughter sitting on her lap. Instead of observing events from the distance of a more mature age, she gives the female figures double the amount of motherliness and fruitfulness.

It seems as though Leonardo, now in his late forties, was reopening old wounds here in Tuscany and remembering his mother, Caterina, whose presence he was deprived of as a boy, and the women who took her place without ever being able to fill it—his grandmother and his first stepmother, Albiera, who may have cared for him but were never there for him as fully and completely as Mary was for Jesus. Two things remained in his mind: a longing for nourishing security, and a childish faith, now turning toward an almost religious belief in omnipresent, all-powerful mothers, whose images leave no room for anything else.[6]

Leonardo was so proud of his idea for the image of a double mother and child that he exhibited a cartoon with this motif. Vasari wrote that for two whole days a procession of men, women, and children streamed into the room where the "miraculous work" was displayed and marveled at it. Possibly they were simply pleased to have been invited. It was not customary to exhibit preparatory studies for paintings, and it was even more unusual to invite the public to an exhibition, rather than just a few select people.

Leonardo may have wanted to test the effect of his idea before going to the trouble of doing any more work on it. He produced several variations.[7] One

was the version with the lamb that Isabella's confessor knew. This cartoon has not survived, although another version exists, with Saint John as a boy instead of an animal (Plate 22). It is not clear whether this was created immediately after Leonardo's arrival in Florence, or whether he had drawn it in Milan and brought it with him.[8] Mary sits as if enthroned on her mother's lap; their bodies seem to merge together in a strange turning movement. Knowing, smiling, Saint Anne looks out with shadowed eyes into the brightly lit, finely modeled face of her daughter. The forefinger of the uncompleted outline of her left hand points heavenward—another oversize woman's hand, like the one in the portrait of Cecilia Gallerani (Plate 17).

However, in this early sketch, Mary does not look in the direction in which her mother is pointing but is absorbed in contemplation of her intensely concentrating son. Soft baby hair curls around his head as he blesses the somewhat older John, who is trustingly approaching him. It is slightly reminiscent of the *Virgin of the Rocks* (Plate 15); Leonardo remained true to his favorites, but this time he placed more emphasis on the mother–child relationship. John, representing believers, is not part of the inner circle of the closely grouped Holy Family. They are governed by a motherliness that is as unconditional as Mary's love but is also, like Saint Anne, aware of the higher divine purpose. In this version, too, the group appears to feel at home in a rocky landscape. There are hints of stones in the foreground and mountains in the background.

The drawing, which closely resembles a painting, is both complete and incomplete. The faces are so finely drawn that they seem to stand out in relief against the shapeless brownish background, and Leonardo's carefully thought-out lighting and the shadows on the clothing and bodies give the figures a physical presence like that of sculpture. However, the women's feet and Saint Anne's heavenward-pointing hand are only roughly indicated. Leonardo evidently lost interest at that point. This could have been because, as Isabella's confessor reported, he had come to prefer the more compact composition. While the four figures in the older cartoon are moving slightly away from one another, Fra Pietro was describing a version in which Saint Anne, the Virgin Mary, and the child Jesus are closely bound together.

Pietro da Novellara had evidently seen a preparatory study for Leonardo's great painting of the *Virgin and Child with Saint Anne* (Plate 23).[9] Perhaps Leonardo

was remembering his *Virgin of the Rocks* (Plate 15) when he began this painting, or maybe he was thinking of his long excursions in the mountains of northern Italy. What is certain, however, is that he at last wanted to unite all his roles in life; he no longer wanted to be either a painter or an investigator of nature, either an anatomist or a water engineer. He had something more ambitious in his sight: He wanted to portray the functioning of the world in art.[10]

The world as it was known in the Renaissance was old, but no older than as described in the Book of Genesis. Its age was counted in thousands of years, not in millions or billions. The conceivable time frame stretched from creation to the last judgment. How the earth had changed, how mountains were created, continents formed, and the waters divided, was not known for certain, and evolution, which was not readily compatible with the Bible, was utterly inconceivable. Apart from the lack of geological knowledge, there were no systematic classifications of flora and fauna.

Leonardo guessed at the gaps in the knowledge of his day, and they tormented him. He wanted to know for certain how things had come to be as they were. In his writings, he pondered on why some water was sweet and some salty, what caused the ebb and flow of the tides, how the Italian peninsula could have grown out of the Mediterranean, why the oceans did not seep away into the earth, and why the waters of the Great Flood had receded.[11]

The Great Flood confronted Leonardo with an almost insoluble problem: How did the fossilized seashells get into the Limestone Alps? As he said, peasants had shown him sacks full of them in Milan, and he had probably searched for fossils himself on his walks in the mountains. If the Flood had washed the shells so far up, he wondered why they did not appear everywhere, including on the mountain peaks, since the Flood had entirely covered the earth. Also, he wrote, mussels dig their way into the ground, so what washed them up so high and so far from the sea, and all in just the forty days of the Flood, since mussels move even more slowly than snails? He could not see how it all added up, but it seemed clear to him that the sea must once have filled the valleys of Italy.[12]

At the start of the new century, all Leonardo could do was spend long hours pondering such questions, and because he had no diving apparatus (even though he once drew one) and there were, regrettably, no documentary sources from the primeval world available to him, there was nothing else he could do but absorb the available knowledge and investigate it using what means he had—drawing and painting. Like many of his contemporaries,

Illustration 28. Leonardo da Vinci, *Study showing an explosion of a rock massif caused by a bursting water vein*, Chalk drawing, Royal Collection, Windsor

Leonardo believed that great veins of water originating from the ocean bed ran through the earth. In his notebooks, he rejected the idea that rivers could feed on rainwater and melting snow, on the grounds that there were also great rivers in Africa, where there was hardly any rain.[13]

In this model, the earth is comparable to the human body—it pulsates, breathes, and sweats. Leonardo's view was that the water that, according to the Bible, once covered the earth could not actually have flowed, as, in places where there was water everywhere, it would not have been able to move from the spot. He believed that on the seabed, it forced its way into the openings of the subterranean veins, where it was set in motion by the inner heat and breathing of the earth and was pushed back out on the other side of the earth. These veins also spewed out mud and stones with such force that mountains could build up in the ocean and protrude above the water. That was how first islands and then the continents were formed. The water bursting out of the veins then took possession of this landscape, scraping gorges and valleys into the mountainous massifs, and carrying the mud and stones away to build up landmasses and plains elsewhere. At some point, the earth would once again be completely covered with water, and, according to Leonardo, it was to be feared that, when the earth had been reshaped into a globe without elevated land, the water would cease to move in its veins.[14]

Leonardo could also imagine the world ending in another way: The veins of the earth might become blocked by the detritus carried down by the water, rather like the calcification of the veins of elderly people. The water would no longer be able to flow away and would either remain standing on the earth's surface or evaporate. There would no longer be water in the rivers, the earth would

dry out, and the air would also disappear. Once the earth had lost all its moisture, the barren soil would have no protection from the blazing heat of the sun. Leonardo prophesied: "Then all that would remain of its surface would be ashes and that will be the end of earthly nature."[15]

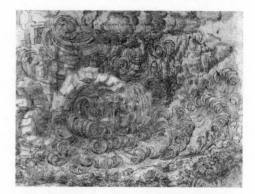

Illustration 29. Leonardo da Vinci, *Study showing an explosion of a rock massif caused by a bursting water vein and formation of waves in a lake due to falling boulders*, Royal Collection, Windsor

From all these deliberations Leonardo concluded that the power of nature must not be underestimated, and any painter or draftsman who reduced it to pretty background landscapes had no idea of, or even scorned, creation. However, he could not get the earth's turbulent history out of his head, and this compelled him to capture the primeval forces in his drawings. At some point he drew apocalyptic images of floods, burst water veins, masses of mud and stone flung out from openings in the ground, and falling lumps of rock (Ill. 28 and Ill. 29).[16] He had previously given his female figures ornamental ringlets, but now he began to use the motif of small, rolling circles in a different way. In his drawings, increasingly dangerous waves threaten to consume the world; woe to anyone devoured by them. Yet, thanks to Mother Earth, life flourishes between the creation of the world and its end. Trees spread out and plants thrive as if they would exist forever. Nature renews itself, year by year and person by person. In the first place it is women who ensure that it continues and that humanity can go on starting afresh with each birth. At the high point of the story of the world, when the continents were fully developed and the end of the world was foreseeable but still distant, Saint Anne gave birth to Mary and Mary bore Jesus. The world may grow old, but before that happens the Holy Family works to prevent it through rejuvenation.

That is the subject of Leonardo's *Virgin and Child with Saint Anne* (Plate 23).[17] In 1503 an acquaintance of Leonardo, Agostino Vespucci, noted in the margin of his edition of Cicero that Leonardo was working on a picture of Saint Anne, the mother of the Virgin Mary, and that he had painted her head first of all.[18] This was probably already a reference to the large painting *Virgin and Child with Saint Anne*, the composition of which had been described by Isabella's father confessor. This work was exceptionally important to Leonardo, and he kept the six-foot-tall poplar wood panel with him until the end of his life.

As in the older *Burlington House Cartoon* (Plate 22), the young Mary is comfortably seated sidesaddle across her mother's broad thighs, while the latter smiles in mild acquiescence. From the age point of view, they look more like sisters than mother and daughter. Mary is turned toward her son, who stands naked between her legs, which are swathed in her blue mantle. Jesus is occupied with the lamb, which he is both caressing and maltreating. He has used his small, sturdy body to force the animal to the ground and is half sitting on it, holding it in a headlock with his short legs, and twisting its head back. Mary gently reprimands the boy, pulling him toward her to make him release the lamb, either because she does not wish to watch Jesus being linked to his future Passion through the symbolic animal, or because she does not approve of his boisterous behavior, in which the suffering of the lamb already heralds Jesus' Passion. Whichever is the case, the boy looks up at his mother. The trio's looks and gestures describe an oval motion; it is an up and down of human interaction, and the heads of the three generations create a diagonal reaching up toward heaven.

At the very top is the head of the grandmother, Saint Anne, which was evidently completed at an early stage. Her face is slightly in shadow, with the mountain peaks in the background shining above her. In this painting, Leonardo implemented what he had experimented with in the *Annunciation* (Plate 6) and the *Madonna of the Carnation* (Plate 1). He also noted in his writings how distant mountains appear azure, and how they seem to merge into the haze of the sky.[19]

However, in this painting he was concerned with more than optical phenomena. An event in the history of the development of the earth is taking place in this picturesque, artificial landscape. It is not only the sky and the light that bathe the setting in pale blue; the ravines are also filled with great quantities of water. According to Leonardo's theory of the earth's history, the water has not yet flowed away; although the continents have risen from the ocean in the form

of mountains, the sea has not yet subsided to the water level that was familiar in Renaissance times. This also explains the fossil shells in the mountains. There are a few small stones and possibly the remains of a few shells lying at Saint Anne's feet. The rocky middle ground on which the figures are seated consists of the reclaimed land that has been wrung from the water. And, against all probability, a tree and some bushes are growing in this barren area. Viewers experience the fortunate, fruitful phase in the history of the world and of salvation.

However, as in the *Virgin of the Rocks* (Plate 15), here too the abyss opens up. The tips of Saint Anne's toes are pointing downward, toward the cleft in the rocks that opens up at the group's feet. Leonardo's great child bearers cannot halt the catastrophic course of the world, but they wrench life, society, and youth away from it. Only those who, like Leonardo, understand the global context can truly appreciate their strength.

Leonardo's ideas were so grandiose that he found the trivialities of everyday life a burden. He handed smaller commissions over to Salaì and the other assistants, contenting himself with giving advice and adding the occasional brushstroke when he felt the urge. Fra Pietro da Novellara also mentioned that to Isabella d'Este, sounding as though he rather than she were the penitent. He was not to be successful in persuading Leonardo to grant Isabella's wish at last. Nevertheless, during Holy Week 1501, he did succeed in speaking to the master personally. Before this, Salaì had acted as go-between, as if the artist had been a great nobleman and Salaì one of his courtiers. Leonardo was still more preoccupied with scientific matters than with the painter's art, and he made it clear to Novellara that he had first to supply the king of France and his people with paintings before he could deal with Isabella's request. According to the cleric's letter to Mantua, Leonardo was currently working on a painting of the Madonna for the king's secretary. It showed Mary trying to spin yarn and the boy Jesus smiling as he tries to grasp his mother's spindle because it is shaped like a cross. Mary does not like this, and Novellara explained that, as in the composition with Saint Anne, she is disturbed by the thought that the young Jesus is playing with his fate.[20]

This picture, if it was ever finished, has not survived, but the spindle motif (with slight differences from the information reported by Novellara) is known from two versions from Leonardo's workshop. The better of the two could be

Salaì's (Plate 24).[21] Jesus is leaning on Mary's spindle on the rocky layers of a cliff, which may have been created by the spouting of a waterfall as Leonardo might have imagined it. In the middle ground and background a river winds its way in front of a very pleasant, shimmering, bluish alpine landscape. One can imagine Leonardo telling Salaì about his unrelenting visions of the history of the earth and Salaì readily adopting the artistic ideas of his teacher and lover, but without being swept along by their apocalyptic dimension.

Isabella d'Este was not satisfied with the news from her confessor. She engaged additional agents in an attempt to get her portrait or any nice picture from Leonardo's hand. But even an ambassador from Mantua achieved nothing except the transparent excuse that Leonardo had begun to work for his mistress and he should not inquire any further. Another of Isabella's courtiers tried his luck; she now wished him to persuade "our friend" Leonardo at least to value a few antique vases that were on the market. Leonardo praised the wares effusively but set their value so unrealistically high that even the generous Isabella shrank from buying them.

Although Leonardo had to fall back on his bank savings, he could not bring himself to paint Isabella's ardently desired portrait, or anything else for her. Even her offer of letting him paint a picture of Christ, for which he could set his own price, did not tempt him. He agreed but took no action. One of Isabella's agents added with a sigh that, if there was a competition for the slowest painter, Leonardo would win it.[22]

Shortly before that, on April 15, 1502, Leonardo had reached the age of fifty. He obviously did not want to waste any more time on things that did not interest him sufficiently. He could not bear to spend much time in his workshop, among his half-finished paintings of women and the assistants who helped him and organized his life. Instead, he was seized by a desire for adventure and the thrill of once again trying his luck with powerful rulers. In the early summer of that year he packed his compasses and dividers, his sword, a leather jerkin, and his drawing tools and left Florence, possibly accompanied by Salaì and Zoroastro, his technical assistants.

Leonardo, of all people, entered the service of an enemy of the state in the role of engineer, although it is not certain whether he was a double agent or a turncoat. Leonardo's new master was Cesare Borgia, an illegitimate son

of the current pope, Alexander VI. Cesare claimed Romagna in northern Italy for himself and unnerved the entire country with his predatory campaigns and political murders. Florence had good reason to worry about being attacked by him, and even saw itself having to pay a kind of protection money. However, that did not avert the danger. In the summer of 1502 Cesare, who considered himself a second Caesar, first got the city authorities of Arezzo on his side and then occupied Urbino.

Leonardo arrived in Urbino at the end of July. From there he traveled on into the other territories that Cesare had already conquered. Cesare issued "our excellent and most beloved friend, the architect and engineer Leonardo Vinci" with a passport, enabling him to pass through all street barriers and visit all fortresses. According to the letter, the engineers in the area under his control had been instructed to discuss things with Leonardo, if they did not wish to risk Cesare's anger.[23]

Even taking account of the fact that in the early sixteenth century people were accustomed to death, disaster, and crime, and that most of them had seen executions and were familiar with the smell of corpses at the edges of the streets, the havoc created in the country by Cesare was more bestial than anything normally experienced by the people of the time. Leonardo must certainly have seen gruesome things during that summer.

However, he acted as though he were not traveling in the retinue of a butcher but on an educational journey. He described many harmless things in his notebooks. In Urbino he noticed a dovecote, in Pesaro he was struck by the library, in Cesana he attended a banquet and admired the hooks for hanging up grapes, and in Rimini he was impressed by the waterfalls. It seems as though, in his writings and thoughts, he wanted to rescue normality from the catastrophes of the war. If he was struck by the beauty of a tree, he noted how densely the branches had grown; if he saw a cart with wheels of different sizes, he mocked the backwardness of the province.[24]

Leonardo spent the fall in Imola, drew a few inaccurate plans of the city for his master, and probably traveled on to other occupied cities, studiously ignoring the way Cesare ordered rebels to be strangled, terrorized entire villages, and basked in the fame of his reign of terror. Leonardo, the universal artist, evidently found war easier in theory than in practice. The role of military engineer did not suit him. Deep down, the man who could feel sympathy for donkeys and trees was probably not as callous as he sometimes pretended to be.

In the following year, 1503, Leonardo left his post just in time before the pope died in August and his son Cesare lost his support. The new pope, Julius II, soon put Cesare in his place. Florence had nothing more to fear from the bloodthirsty Borgia, and Leonardo returned to his home city as though nothing had happened. For a short time he had to deal with everyday matters: He had to get his boots soled and a new robe made for himself, he owed somebody a tablecloth, and he urgently needed a new drawing book with white paper. He also wanted to buy a belt for his sword and a leather plastron, according to his list of things to be done.[25]

Yet Leonardo had still not had enough of the temptations of power, or else he was seeking further diversions from his lifelong occupation of painting. Because he was such a perfectionist, painting was too important for him to risk failure, and that was exactly why he ran away from it time and again.

Now he dreamed of going to Constantinople. That was where the sultan lived. Perhaps he was the enemy of Christendom against whose troops Leonardo had recently been active in Veneto. Even so, the man surely needed a bridge over the Bosporus, and, according to all reports, this would be a new wonder of the world, a gigantic task that only Leonardo would dare to tackle. So he wrote to the sultan offering him his workforce.[26] However, he did not receive a positive response.

That did not put an end to Leonardo's thirst for action. The next project he took on was serving the Republic of Florence not as an artist but as a hydraulic engineer. The idea was that, in order to drain the water away from hostile Pisa, it would be necessary to divert the Arno into a marshy area.[27] The effort was enormous, but nevertheless the government agreed to the project—which was a complete failure. In the end, the water flooded their own hinterland, farms were destroyed, and people died. After that, Leonardo could forget about his even greater plan to build a canal from Florence to the Mediterranean.

As a military engineer, Leonardo was a failure. Nor was he particularly good as an executive assistant to any kind of ruler; his urge for independence was too strong, and all forms of propaganda were too foreign to him. He was also well aware that, in the end, all the technical gadgets would pay less than his painting, which he considered to be the greatest of all the sciences. But this knowledge alone was not enough for him to escape the temptations

of distraction and overall responsibility. It took the intervention of another person to bring him back to the path of his artistic destiny—a competitor. This was a man almost half Leonardo's age, also a Florentine and a genius: Michelangelo Buonarroti.

Michelangelo saw the cartoon of Saint Anne, Mary, Jesus, and John the Baptist (Plate 22) in Florence and adopted the composition of one woman seated on another in a pen and ink drawing. He eyed Leonardo, who was twenty-three years his senior, with suspicion. The young sculptor was probably unnerved by the fact that Leonardo seemed so unlike him—elegant and articulate, a hedonist, who knew how to support his wordplay with a deeper meaning.

The playfulness that distinguished Leonardo despite all his self-torment was foreign to Michelangelo. The latter was driven by a pious gravity and, instead of Leonardo's aphorisms, puzzles, and explanations of the world, he later wrote perfectly formed poems about love that conveyed a puritanical Platonism. He had few friends but was sometimes infatuated with young men, though, unlike Leonardo, he preferred not to let them get too close to him. He was not particularly attractive to look at; his smocks were covered with marble dust, and, according to Vasari, he was so wrapped up in his work that he sometimes forgot to take off his dog-fur boots in the evening, and as a result, when he finally thought about it weeks later, his skin came off in shreds along with the boots. He was strong and thickset and, as a young man, had had his nose broken by a colleague with whom he had gotten into an argument.[28]

However, despite all his surliness and his deliberate moodiness, Michelangelo was a peace-loving man. His pious pacifism was striking in those war-loving times. He was more uncompromising than Leonardo, whose attitude to these matters was ambivalent, as he was constantly carried away by his curiosity and his fascination with machines.[29] Yet the pair had more in common than they admitted to. Both studied and valued human anatomy and autonomy; both appreciated antiquity. Both believed that man was the image of God, and that the artist was a second creator—the difference being that, in this context, Leonardo was thinking of painting and Michelangelo of sculpture. The humanism of both was undisturbed by political turmoil. Michelangelo's stubbornness would drive several popes to despair, although only one of them would dare to break off completely with the irreplaceable artist. And in the long run Leonardo's gods were not the potentates who squabbled over him, but the wind and the water, art and nature.

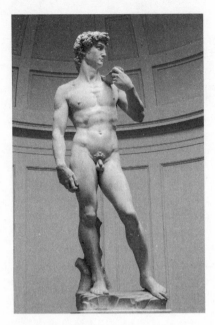

Illustration 30. Michelangelo, *David*,
Galleria dell'Accademia, Florence

The two artists should have liked each other and been grateful that there was another who was as determined, sensitive, and gifted as themselves, but they nevertheless regarded one another with envy.

Michelangelo had just returned from Rome to Florence, in order to support the free republic. Although the Medici had been good to him personally, he was now burning with impatience at the vision of a state without tyrants. The city of Florence needed him. It also needed a symbol, a statue that would represent freedom. Niccolò Machiavelli, a political official and military adviser to the republic, wanted the figure of a giant with fighting spirit to stand in the square in front of the city hall, the Palazzo Vecchio. In his mind's eye, he could see the soldiers recruited from the surrounding area assembling for roll call before an ostentatious stone muscle man.

In Florence, such a hero could only be the youthful David. The city identified with him more than any other figure, with the possible exception of another tyrant slayer, the biblical Judith (although a few members of the government considered that, as a woman, she could not be a military figurehead). So Michelangelo was to create a statue of David, as Donatello (Plate 8) and, after him, Verrocchio (Plate 3) had done—only larger. It was not an easy task, as the block of stone that Michelangelo was to use had been partly destroyed. He had to plan every stroke of the chisel precisely if he was to free his sixteen-foot-high youth from the marble unscathed.

The marble figure did indeed grow big and strong (Ill. 30), but Michelangelo refused to create propaganda, even in response to Machiavelli's call to arms. His David ponders over how he can defeat Goliath. His left hand holds the sling

loosely, while his right hand is already gathering strength for the victorious shot. The viewer must work out for himself what follows—the lethal shot. Michelangelo was not interested in the act of killing, and he had no intention of slaughtering Goliath simply in order to strike fear into the enemies of the republic. He was interested in David's inner strength.

Michelangelo may have been familiar with the writings of the philosopher Giovanni Pico della Mirandola, who had recently died in Florence. In his opinion, a person could become no better than an animal or emulate the divine: His fate was in his own hands.[30] The

Illustration 31. Leonardo da Vinci, *Drawing after Michelangelo's David* (detail), Royal Collection, Windsor

sculptor also emphasized the moment of decision. That was how his defender of the republic should be—a model of free will. His beautiful body in the antique style expresses not defeat and subjection but moral and intellectual superiority.

So much sovereignty and dignity in masculine beauty should have enchanted Leonardo, but it did not. Alongside Sandro Botticelli, now in his late fifties, and Verrocchio's successor, Lorenzo di Credi, and other notable artists, Leonardo sat on the committee that in 1504 advised the Florentine building authority on where the gigantic statue, the trademark of the new republic, should be erected. Enviously, Leonardo advocated the Loggia dei Lanzi next to the city hall. According to Leonardo, this position at the side would guarantee "that public ceremonies would not be disturbed."[31] There were already other works in the loggia; the statue of David would be one among many. However, Leonardo's vote did not prevail. The colossal statue was erected in a place of honor directly in front of the city hall.

Yet Leonardo, who was proud of having no models among living artists, sketched a David inspired by Michelangelo's statue (Ill. 31). At least on his sketch block, when no one was looking on, he could not conceal his admiration.

When in direct contact, however, both artists were in attack mode. Once, according to one of Leonardo's early biographers, a group of educated men were standing in one of the squares in the center of the city discussing the works of Dante. They could not agree on the interpretation of one of the lines and called in Leonardo. At that moment Michelangelo also happened to come around the corner. Leonardo said, "There's Michele Agnolo. He'll explain it to you." The sculptor suspected that he was about to be made a fool of and went on the offensive. Leonardo should please explain the Dante line himself. And had he not designed a bronze horse for Ludovico Sforza in Milan and then not created the sculpture? Perhaps he had been so ashamed that he had not mastered the sculptor's craft that he had preferred to leave it be. Then Michelangelo turned on his heel and walked away, leaving a blushing Leonardo. His fellow artist's attack had left him speechless. It was clear that he did not like to be reminded of his uncompleted projects.[32]

Above all, there were other uncompleted projects waiting at home in his workshop—his images of women. Of women Michelangelo was always a little shy, so much so that he preferred to have sturdy men in women's clothing model for his female figures, whereas Leonardo felt a kind of affinity with women, with their minds and with their physical presence. Half colored and half brought to life, they surrounded him in his workshop on wooden panels of all sizes. In order to fathom their secrets, he needed to have time for them, a great deal of time. The philosophical connections he sensed between Saint Anne, the Virgin Mary, and world history and the connections between his portraits of women, nature, and the art of painting in itself were not only new for him; they were also a provocation for his contemporaries, who were not used to such thoughtful painters. The influential writer on society Baldassare Castiglione would mock Leonardo in his 1528 *Book of the Courtier*: "Another, one of the world's finest leading painters, despises the art for which he has so rare a talent and has set himself to study philosophy; and in this he has strange notions and fanciful revelations that, if he tried to paint them, for all his skill he couldn't."[33]

Castiglione—and he was not the only one—did not understand that, for Leonardo, thinking and painting were not two different things. To bring them both together was the greatest challenge of his life. It attracted him, but continually made him aware of his own limitations. Once again, he fled from the challenge and left the beautiful women in his workshop to themselves. However, this time, he did not try his luck as an engineer; the battles that he sought took place only in art.

The head of the Florentine government, Piero Soderini, had the wicked idea of making the two star artists compete with each other, to decorate the holy of holies of the republic: the council chamber in the Palazzo Vecchio. Probably Soderini also knew that Leonardo would undoubtedly consider an open competition to be an unreasonable demand, so he set a trap for him. He invited the great master, the creator of the famous *Last Supper* (Plate 19) in Milan, to take on the most honorable task that the city had to offer. He was to decorate one wall of the council chamber of the Palazzo Vecchio with a fresco and thus leave his mark on the face of the republic for many years to come. The picture was to measure about sixty-two feet by twenty-six feet (19 × 8 meters). Leonardo had never painted anything so vast. He could not refuse. He signed a contract in which he committed himself not only to accept the commission but to complete it. The subject was prescribed: the Battle of Anghiari, in which the Florentines and their papal allies had defeated the Milanese forces in 1440.[34]

On October 24, 1503, Leonardo was handed the key to the Papal Hall in the monastery of Santa Maria Novella, the very hall in which Lorenzo de' Medici had once held a banquet for his admired Lucrezia.[35] Leonardo was to be allowed to set up his workshop there, and he and his assistants set up home in the adjacent accommodation wing. He soon felt at ease in these venerable surroundings.

However, shortly afterward, Soderini awarded another commission that Leonardo knew nothing about. In the same room of the city hall there was also to be a depiction of the Battle of Cascina, which the Florentines fought against the Pisans in 1364. This task went to Michelangelo, who set up his more modest workshop in the hospital of the Dyers' Guild.

Leonardo was now forced to make a move. He drew constantly, creating tormented faces of men in great danger and horses in mortal fear. Machiavelli and the state government wanted a heroic story. Among Leonardo's papers there is a surviving account of the historical Battle of Anghiari that Machiavelli had commissioned Agostino Vespucci to write for the artist—the same man who wrote comments on Leonardo's painting method in the margin of a copy of Cicero.[36]

However, Leonardo did not care about either instructions or historical details. His attitude toward war remained ambivalent. He called it "an extremely bestial madness" (*pazzia bestialissima*), yet he wanted to know everything about the kinetic energy released in a bloody battle.[37] His painting for the council chamber was to banish these contradictions and possibly help him to

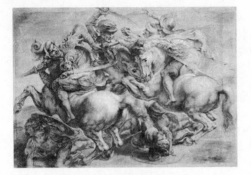

Illustration 32. Unknown artist or Peter Paul Rubens, Copy after Leonardo's *Battle of Anghiari*, Louvre, Paris

deal with the brutality that he had seen on his travels through the Borgia empire and had been unable to express in words. The painting was to be powerful, without glorifying the destructiveness of war. At the center would be the merciless struggle around a banner.

Leonardo sketched a furious tangle of warriors and horses, in which friend and foe, victor and conquered, were barely distinguishable. The main picture is preserved only in copies of the preparatory drawing; a late variant that is nevertheless true to the original is probably the work of Peter Paul Rubens (Ill. 32).[38] It shows a knot of horses with flaring nostrils and wild eyes and four laboring riders fighting tooth and nail, just in order to be able to ride off with the standard. The two warriors on the left are the leaders of the Milanese army; the two riders on the right are fighting for the Florentine side. All four are beside themselves, and the faces of the Milanese appear contorted with hatred. That is the only thing that makes them recognizable as enemies. In every other way, the carnage renders them all alike; the heroes and the villains are both courting danger. In these drawings, Leonardo succeeded for the first time in distancing himself from the warfare that had both attracted and tormented him for so long. It seems that he had at last determined his attitude.

Meanwhile, Michelangelo was pursuing his own path. He would not allow Soderini to exploit him either, but he avoided war scenes. He wanted to celebrate the beautiful body, rather than what was broken or destructive. Instead of a battle, he depicted the Florentine soldiers being surprised while bathing in the river by the news that the Pisan enemies were approaching. The motif has been preserved in a copy by one of his colleagues (Ill. 33).[39] This gave him the opportunity to depict a large number of naked or half-naked men from all

angles. They hurry out of the water, flexing their muscles, pulling on stockings and breeches in order to go off to fight. Their powerful bodies are formed in such detail that each one could be a sculpture. At the same time, the men do not relate to one another; each is busy with his own activities. Himself a loner, Michelangelo drew a group of beautiful individualists, whereas the social thinker

Illustration 33. Bastiano (known as Aristotele) da Sangallo, *Battle of Cascina*, Copy after Michelangelo, Holkham Hall, Earl of Leicester

Leonardo tried to fathom the meaning of warfare in the midst of the turmoil.

The city's artists stared at the sketches in amazement; Benvenuto Cellini, Raphael and others trained their eye by comparing the two works. However, the much-admired Michelangelo did not transfer his drawing to the wall of the council chamber. In February 1505, Pope Julius II summoned him to Rome, and he found this more attractive than the commission of the Florentine Republic.

Leonardo was probably not unhappy about his rival's departure. It meant that he would not be disturbed. He wanted to produce something special in the Palazzo Vecchio, not using tempera as was customary but, as Vasari reported, painting on the wall in oils. Zoroastro, his experienced technical assistant, helped him with mixing the paints. They seem to have banished the memory of how poorly Leonardo's innovative mixtures for the *Last Supper* (Plate 19) in Milan had adhered to the wall. The new experiment in Florence was a complete failure; the paints did not adhere to the plaster and ran. Leonardo was able to paint only a small part of the work on the wall, if any. He laid the blame on the dealer who, so he said, had sold him adulterated linseed oil.[40]

Frustrated, Leonardo lost interest. What was actually keeping him in this city? It was certainly not his family. His father, Ser Piero, died while he was working on the sketch for the battle scene. Soberly as always in personal matters,

Leonardo wrote a laconic comment on the death in his notebook; in between the everyday expenses, in July 1504 it says tersely, "Ser Piero da Vinci died on Wednesday at seven o'clock." In a second note Leonardo added that his father had left ten sons and two daughters.[41] Ser Piero had never been a father to him in the best sense of the word; above all, he had not been there for his first-born, after he had fathered so many legitimate descendants. Possibly Leonardo could only feel truly free now, after Ser Piero's death. This can be understood from a letter in which the artist congratulated one of his half brothers on the birth of his son. He then qualified his good wishes, joking bitterly that the boy would always be a keen enemy of his father and "do everything in his power to gain his freedom, which he will not have until your death."[42] So, in Leonardo's mind, a man can be master of his own fate only when his father can no longer influence him.

Ser Piero's death was of no financial help to his first son. Leonardo did not inherit; everything went to the legitimate descendants. His half brothers and half sisters had no thoughts of sharing in the following years, and his relationship with them became more distant again. Leonardo had lost the last remnants of his family. And three years later, when Leonardo's favorite uncle, Francesco, who had so much enjoyed playing with him as a boy in Vinci, died, the half brothers also claimed his inheritance, despite the fact that his will said otherwise. Hurt and angry, Leonardo fought for his share for a long time.[43]

After his father's death in 1504, it was time for Leonardo to return to more pleasant things—to the beautiful women and the free-flying birds of his imagination. He studied the flight of birds more intensively, imagined what it would be like to fly, and designed flying machines for people. And while he was still busy drawing the sketches for the *Battle of Anghiari*, in his workshop he drew a counterpart to the carnage—the naked Leda who, according to myth, was seduced by Zeus in the shape of a swan and then laid eggs that hatched into her children. When painting this subject, artists usually hinted at the sexual act between woman and bird, but Leonardo had little interest in this. He did not care if the swan was actually a man and the chief of the gods. He wanted to know what happened when human and bird entered into the kind of symbiosis that he had long been dreaming of. A surviving painting by a pupil or follower of Leonardo makes use of Leonardo's idea of a woman and a bird and children hatching from eggs against the background of a mountain landscape (Plate 25).[44]

In a pen drawing over black chalk, Leonardo takes these ideas further (Ill. 34).[45] The naked Leda is now kneeling, turning toward the viewer, amid rampant vegetation of the kind favored by Leonardo. Grass blades shoot upward; tussocks form eddies; everything is growing and thriving. Nature, and her representative, the woman and mother, celebrate the principle of fertility. The swan gently nibbles his beloved's ear. Beside the parents, the babies hatch from their eggshells, not in childbed but in the midst of the wilderness.

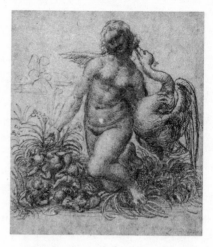

Illustration 34. Leonardo da Vinci, *Study for a Kneeling Leda*, Devonshire Collection, Chatsworth

This motif would also occupy Leonardo over a long period. He took the idea with him to French-occupied Milan, where he went with bag and baggage in 1506. The government of the city of Florence had granted him three months' leave from his duties in the council chamber. If he stayed away longer, he was threatened with a fine of 150 gold ducats.[46]

However, Leonardo would not submit to blackmail. Just as he knew how to shake off the begging, demanding Isabella d'Este, soon after arriving in Milan he staked everything on being able to use delaying tactics on the Florentines. King Louis XII and his governor in Milan were only too pleased to help him. First, the head of the Florentine government, Piero Soderini, received polite letters, full of admiration, from the French. Soderini was not to be appeased; he fumed about the harm done to the republic by Leonardo's dereliction of duty. Then the king himself unequivocally informed the Florentine ambassador that he was expecting Leonardo to enter his service immediately and that he would brook no contradiction. The ambassador inquired carefully what he was to paint. The reply he received was very vague: "a few small paintings of the Virgin and other things, depending on what comes onto my head."[47] So it was no longer a

matter of specific projects but knowing that this famous artist would be at hand, whatever it might cost.

Just as Isabella d'Este would now accept anything of Leonardo's, no longer only the uncompleted portrait she ardently yearned for, the king of France also granted his desired protégé maximum creative freedom. That was exactly what Leonardo wanted. In a slightly later letter to the French court, he indicated that he had one or two images of the Virgin in stock, should the need arise.[48] It was now the painter, not the sponsor, who decided what was to be seen and owned. Probably no artist before Leonardo could have worked with such self-determination as he did.

Leonardo made good use of this opportunity. Relieved of the burden of having to complete the irksome mural in Florence, and far from equally disagreeable family matters, he was enjoying his secure life in Milan. Free as a bird, he set to work. The only thing he was obliged to do was to complete the second version of the *Virgin of the Rocks* (Plate 16) together with his old assistant Ambrogio de Predis; the Milan Brotherhood of the Immaculate Conception had insisted on this in a court notification. However, by this time Leonardo had long since learned to delegate unloved works to assistants and to add only a few final brushstrokes—something he did not find difficult, as he was far less rigorous with the works of others than with paintings of his own that were close to his heart.

He occupied himself intensively with his nature studies, attempted to explain the phases of the moon, and further developed his thoughts about the regulation of the earth's waters. He also employed Francesco Melzi, a conscientious, good-looking young man from one of the best families. Melzi's task was to organize Leonardo's writings and take over some of his paperwork. This relieved the artist of a huge burden, as he was in danger of suffocating in the pile of his disordered notes. A later publication now seemed realistic and left Leonardo with his hands free for practical studies. He spent many hours dissecting bodies in a hospital and also haunted butchers' shops in order to investigate reproductive systems in the uterus of a pregnant cow. So much thinking about the world as a whole constantly led him back to feminine reproductive powers.

The ladies in the oil paintings waiting patiently in Leonardo's workshop were grateful. Now the artist could continue painting the *Virgin and Child with Saint Anne* (Plate 23), and it was probably at this point that he added the watery landscape in front of the mountains, thus introducing his conception of the history of the earth to the composition. He also made changes to the painting

of Leda, his beautiful, bird-loving woman, possibly with the aid of a female model in his workshop. It may have been around this time that he drew the head of Leda, remembering the basket weaving of the women of Vinci and giving his figure complicated braids, with untamable curls escaping from them, as dynamic as any of the waves and tussocks of grass in his art (Ill. 35).[49]

As well as the version with the swan, he evidently created yet another variant, in which Leda proudly presents her brood of children without the company of the divine bird. Leonardo's original has not survived, but one of his pupils, Giampietrino, painted the motif against the background of an airy mountain landscape, reminiscent of the *Virgin and Child with Saint Anne* (Plate 23). And, in fact, underneath the painting is the very composition that Giampietrino copied by learning from Leonardo and then overpainted with the figure of Leda (Plate 26).[50] For Leonardo, the world was feminine, and women were the world in smaller form.

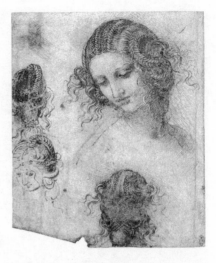

Illustration 35. Leonardo da Vinci, *Study for the Head of Leda*, Royal Collection, Windsor

XI

The Third Key Work:

THE UNIVERSAL WOMAN

THERE WERE MANY women in Leonardo's workshop in his later years, but one of them occupied him more than all the others. She had been his companion in life for fifteen years, a constant presence in the midst of relocations, political upheavals, illness, and old age. She became the main figure in his life and works, and he was more deeply devoted to her than to almost any other person. And, of course, when he was really moved by something, he fell silent. Despite being such a keen and versatile author, he was sometimes very quiet about his painting, because he knew that the prelingual sensuality of art could not be captured in words.[1]

His intense relationship with this woman consisted of fine brushstrokes, softly shadowed cheekbones, a delicate lock of hair touching her neckline, and much experimentation in the workshop in order to find out the right mixture of colors to give her a complexion that was not pale but had the warm color of living skin in the appropriate places.[2] The result was the most influential wood panel painting in Western art, honored and revered, celebrated profusely and interpreted in a greater variety of ways than almost any other picture, and constantly copied and parodied over the centuries—*La Gioconda*, often known as the *Mona Lisa* (Plate 28).[3]

The mystery surrounding this painting is connected with its unsatisfactory written record. Ginevra de' Benci, the poetess of Leonardo's youth, was a

historical person, and so was Cecilia Gallerani, the lady with the ermine. However, it is impossible to be completely certain who was the subject of Leonardo's portrait known as *Mona Lisa*, and whether it involved one person or more, because he worked on the painting for such a long time and in different places. The woman he painted was probably one specific person at the start— Lisa del Giocondo from Florence, who was then in her mid-twenties. However, in his eyes, the subject of the portrait soon became the universal woman, the great messenger conveying his personal philosophy. Leonardo once said that every artist paints himself, and although the *Mona Lisa* is certainly not a self-portrait, this *bella donna* is nevertheless the imaginary ideal being of his old age.[4]

The idea for the painting came to Leonardo in Florence on his return from Milan in 1500. It was the period when he was so busy with mathematics, hydraulics, and anatomy that he made the marchioness of Mantua, Isabella d'Este, wait for her portrait. He had simply lost interest in her, just as he had lost interest in the representation of power. Possibly his thoughts had returned wistfully to Ginevra (Plate 9) and Cecilia (Plate 17), his two young, self-assured models with whom he had had such a fruitful exchange of intellectual and human ideas. Perhaps he was looking for another woman with the same qualities: independent and charming, clever and beautiful, unconventional and ready to experiment, alert and lively, but just a little more mature than those two young ladies. However, that would not have been too easy. He could engage a prostitute as a model (as he may occasionally have done later on), but that would have been a business transaction, not a pleasurable dialogue. With any other women there would be a third party involved—the man who wanted her portrait—and he would probably have his own ideas and not allow Leonardo as much creative freedom as he had been given by the lovers Bernardo Bembo and Ludovico Sforza, who understood and appreciated art.

However, in Florence in 1503, Leonardo found a woman he wanted to paint. His father was probably helpful to him in this matter. Ser Piero, who was now caring for a whole host of children in his house in the Via Ghibellina near the church of Santa Croce, had built up an excellent network in the city through his legal practice. He had for decades been managing the legal affairs of the Servite monastery of Santissima Annunziata, where Leonardo and his men first found lodgings after their return to the city. A merchant by the name of

Francesco del Giocondo visited the monastery from time to time; he was linked to the monks through financial transactions and would later be buried there. At one point, when a dispute about land arose between Francesco's family and the monks, Ser Piero acted as mediator and reconciled the parties.[5]

It was probably from his father that Leonardo learned that Francesco and his wife, Lisa, née Gherardini, were intending to set up their new home in the central location of the Via della Stufa. Lisa del Giocondo would have been known as Mona Lisa—*Mona* or *Monna* followed by the forename being a usual form of address for married ladies in Florence. The couple had married eight years previously, after Francesco's first wife had died young, leaving him with a small son. Before her marriage, Lisa, who was born in 1479, had lived just around the corner from Leonardo's father, so Ser Piero must have known her since her childhood.[6]

Lisa came from a high-ranking family that had been in financial decline for some time. In order to arrange a good marriage for her, her father gave away one of his few remaining properties, a winery in Chianti. However, Francesco del Giocondo had also done well out of the negotiations for the marriage. He was a silk merchant, fourteen years older than Lisa, and over the course of the fifteenth century his family had prospered from the textile trade. They supplied the Medici and most of the other high-ranking Florentines with their finely woven silks. When Lorenzo de' Medici, who had always dressed in the height of fashion, died in 1492, he owed the del Giocondos a considerable amount of money. However, they had long been so successful in the international market that they could cope with this. Not even the fall of the Medici could cause them financial harm. At the time of his marriage to Lisa, Francesco owned large estates and villas, as well as shares in a number of textile workshops.[7]

When they moved into their new home in 1503, the couple already had a seven-year-old son, daughters aged four and three, and an infant boy. Another daughter had died. While they were small, Lisa's children were cared for by nurses, and the household also included a number of women whom Francesco had bought as slaves after they had been kidnapped in distant countries. He had so many of them baptized in Florence that he might have been suspected of trading in people as well as fabrics.[8]

Would such a cunning businessman as Francesco have appreciated Leonardo's sensitive, free-spirited painting of women? Maybe, or maybe not. No contract for a painting of Lisa del Giocondo has survived; possibly there never

was one.[9] If Francesco had paid for the painting, he would certainly have insisted on receiving the painting at some time. However, he never received it. Maybe he never commissioned a portrait, but only gave permission for Leonardo, the son of his business partner Ser Piero, to draw, and later paint, Lisa. Francesco could have met Leonardo previously in the neighborhood of Ser Piero's house, so Leonardo would not have come into the couple's lives as a stranger.

One of the few documents relating to Leonardo's *Mona Lisa* dates from October 1503. It concerns the marginal note of Machiavelli's employee Agostino Vespucci, which also mentions Leonardo's *Virgin and Child with Saint Anne* (Plate 23) and the *Battle of Anghiari* (Ill. 32).[10] While reading an early printed edition of Cicero's *Epistulae ad familiares* that had appeared in 1477, Vespucci was struck by the lines in which Cicero complains about the half-hearted support of some of the senators. Cicero rather acidly compares their hesitation to the painting method of the Greek artist Apelles, who had "skillfully painted the head and the upper part of the breast of his Venus but left the remaining parts of the body uncompleted."

The goddess of love, paintings of beautiful women, female heads—these were also Leonardo's key concerns in the area of reinventing art in pictures of clever, desirable women. An attentive reader, Vespucci must have thought of him immediately. That was why his marginal note on Leonardo was located at this place in the book. "Apelles, a painter. Leonardo da Vinci does the same in all his pictures, including the head of Lisa del Giocondo and the head of Anne, the mother of the Virgin." Then he also mentions Leonardo's project in the Palazzo Vecchio, where the artist was to paint the *Battle of Anghiari*, and dated his entry "1503, in October."[11]

According to this, in fall 1503, besides the *Virgin and Child with Saint Anne*, Leonardo was also working on a painting of Mona Lisa. He had started by concentrating on her head; her body and the background of the picture were clearly unfinished at that point. If, as is very likely, this was the version that is now in the Louvre, he had come to a remarkable decision: He painted the wife of a silk merchant on an unusually large poplar wood panel measuring 30 inches by 21 inches (77 × 53 cm). That is considerably larger than the portraits of Ginevra (Plate 9) and Cecilia (Plate 17) and is out of line with the Florentine portrait tradition.

What Leonardo found attractive in Lisa was not the rank of her family; he did not even give a prominent place in his picture to the fine collection of

colorful silk fabrics that Francesco traded in. In the twenty-four-year-old Mona Lisa, Leonardo saw a young, kind-hearted mother, and when he thought of mothers he was fundamentally thinking of the whole world.

The story of how Leonardo painted Lisa del Giocondo in Florence was still being told in the city long after Leonardo's death. For instance, Vasari heard it when he was working on his biographies of artists in the mid-sixteenth century. It is possible that he knew her when she was older, as she did not die until 1542, eight years before the first publication of the *Vite*. Her eldest son, a onetime neighbor of Vasari, and her daughter, who was a nun, could also have told him about the artist's meeting with their mother. Vasari did not see the actual painting, as Leonardo had taken it with him when he finally left Florence. However, he had an idea of the significance of this painting for the history of art, so he did what suited him—he embellished his story.[12]

In Vasari's version, Leonardo courted the silk merchant's wife like a queen. "While he was painting Mona Lisa, who was a very beautiful woman, he had musicians play and sing and jesters clown around in order to keep her in a good mood and drive away the melancholy that is often found in portraits. And in this painting of Leonardo's people saw a smile so charming that it appeared more divine than human and considered it miraculous because it appeared so lifelike."[13] He wrote that Leonardo worked on the painting for four years and even then it was still *imperfetto*—unfinished.

Leonardo did not hurry over the painting. The scene he imagined was set in a paneled loggia in front of an expansive landscape. He seated his figure on a semicircular wooden Tuscan armchair. She sits at ease, turning her upper body toward the viewer, echoing the turning movement of *Cecilia Gallerani* (Plate 17). Her left arm is leaning on the arm of the chair, with her other hand resting lightly on top of it.

Warm light falls on her décolleté, her forehead, and parts of her face. The source of the light is uncertain. She is dressed in fairly dark colors. Leonardo painted her clothing in layers. He painted the ornamental, embroidered, finely gathered edge of her bodice, even where it would later be covered by other fabrics. Her clothing looks unpretentious, but Leonardo expended a great deal of energy on giving the folds a natural look, and on the various layers of cloth that cozily embrace one another. He even paid attention to the tucks over the bosom.

Lastly he draped her in a transparent gauze overgown, which is stitched to the braiding of the neckline. This garment is rolled up over her left arm, so that the gauze lies over her shoulder like a toga. The transparent, generously draped fabric gives the figure extra volume, and the shimmering, airily floating material adds an even greater sense of movement to the effect already achieved by the way her body is turned.[14]

Leonardo devoted himself lovingly to her face. He wanted it to look natural and healthy, unbelievably beautiful, yet very real. He drew preparatory sketches on the poplar wood panel with a soft brush that left hardly any traces (except in small places around the eyes). This face is brought to life not by its outlines but by a balanced interplay of tones. Leonardo overpainted the shadows on the neck and cheeks in soft *sfumato*, so that, in the end, not a single brushstroke can be distinguished. He used a binder with a small proportion of pigment to apply wafer-thin layers of varnish that make the skin shimmer like silk.[15]

The woman looks at the viewer out of the corners of her dark eyes; her gaze is kindly, knowing, deep, and optimistic. The left corner of her mouth is slightly smiling, as befits her surname—*giocondo* means cheerful, bringing joy, or consoling.[16] Her skin looks fresh, partly because Leonardo added one or two grains of vermilion to her complexion to simulate the circulation of the blood. Her curly hair seems to be covered by a hood at the back of her head, as was proper for a respectable married woman, but a number of locks are hanging loose and falling over the bare skin covering her collarbones.[17]

"Leonardo had painted every detail here with the greatest subtlety," wrote Vasari, praising a portrait that he knew only from hearsay. "The eyes had the luster and watery sheen that are always seen in life, and around them one could see pale, rosy tints, and also the lashes, which cannot be painted without the greatest delicacy. The eyebrows could not look more natural, because of the way the hairs grow out of the flesh, denser in some places and sparser in others, and follow the direction of the pores of the skin. The nose with its beautiful rosy nostrils appeared completely natural. The mouth, whose open-ing and corners are linked by the red of the lips to the flesh-tints of the face, looked not like paint but like living flesh. Anyone gazing intently at the pit of the neck could have seen the pulse beating in it."[18] These details were not necessarily correct; it is uncertain how clearly such things as the finely painted eyebrows and lashes that have since disappeared were still visible even by the end of the sixteenth century.[19] Nevertheless, in this description Vasari sensed

Leonardo's perfectionism and his intention to make the painting pulsate with life.

The young Raphael also intuited the importance of this work, though without fully understanding Leonardo's intentions. An alert, lissome young man in his mid-twenties, Raphael had been living directly opposite the del Giocondo family in the Via della Stufa since 1504.[20] He had trained as an artist with Perugino and was now attempting to emulate both Leonardo and Michelangelo. Eagerly he trained his eye on every work by these two artists that he had the chance to see. Besides the sketches for the Florentine council chamber, these also included the *Mona Lisa*. As early as 1505, he instantly imitated its composition in his portrait of Maddalena Doni, the prosperous wife of the cloth merchant Agnolo Doni (Ill. 36).[21]

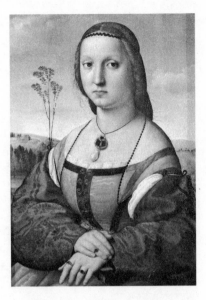

Illustration 36. Raphael, *Maddalena Doni*, Palazzo Pitti / Galleria Palatina, Florence

Raphael's lady is also leaning on her left forearm with her right hand placed on top of it, and she too is seated in front of a broad landscape with a blue sky. However, there the similarities end. The plump, harshly lit face of Maddalena Doni lacks the mellowness and ambiguity of Mona Lisa's countenance. Instead of Leonardo's seductive *sfumato* and wafer-thin varnishes, Raphael decided on severe outlines that accentuate his subject's full cheeks, widely spaced eyes, and long nose. He replaced the vibrant, energetic closeness to life of the *Mona Lisa* with a depiction of wealth. His Maddalena sits stiffly, with an unapproachable gaze but wearing colorful, expensive clothing and a great deal of jewelry. She represents the financial strength of her husband, Agnolo, whom the artist portrayed on a second panel that matched the portrait of his wife. The young artist thus observed the conventions for portraits of married couples, and made the extent of Leonardo's departure from them even clearer. Leonardo's *bella donna* needs no husband, no

necklaces or rings; she has no need to look distant in order to be taken seriously. She can appear to be looking at the viewer without becoming matronly.

Mona Lisa knows life; there is a soul living in her eyes, and anyone standing before her, not only her husband, may feel chosen and graced by her presence.

As Vasari mentioned, the *Mona Lisa* was still unfinished after Leonardo had worked on it for four years. He took the uncompleted picture with him to Milan, after his failure with the fresco painting in the Florentine council chamber. The *Mona Lisa* was in good company in his Milan workshop; the *Virgin and Child with Saint Anne* (Plate 23) and his Leda sketches were also to be found there. The del Giocondo family was far away. If Leonardo did any more work on the painting, he did it for himself. During this period he was investigating the anatomy of the smile.[22] He once again busied himself with studies of dead bodies, and hydraulics and the history of the earth were his constant preoccupations. In September 1508 he began a notebook, which he entitled "On the World and Its Waters" (*"Di mondo ed acque"*) and which within a few weeks was filled with his reflections and sketches.[23]

Leonardo brooded over the whole world, and the *Mona Lisa* watched him. It is possible that it was only now, or even considerably later, that he painted the background landscape—at least, Vasari, whose source was presumably the del Giocondos, mentioned nothing about mountains or waters. Evidence supporting the idea that Leonardo painted the landscape after the figure comes from a copy of the *Mona Lisa*, painted by his assistants, probably while Leonardo was working on his own version (Plate 27).[24] The painting also served the master as teaching material. One of his pupils—it is not known who or when—meticulously copied the loggia, the bases of the two columns at the sides of the picture, Lisa's wooden chair, her gown (though in brighter colors), and the attitude of her body. In contrast, the landscape resembles that of the *Mona Lisa* only vaguely; important details, such as the bridge at the back right, are missing. Either it had not yet been completed in the original when the copyist set to work, or he deliberately changed it, possibly because he did not understand this depiction of nature. He had not mastered the expression on the woman's face either; in the copy, Lisa's smiling sovereignty gives way to a straightforward, almost subservient gaze in the direction of the beholder.

Possibly what Leonardo was thinking of in the *Mona Lisa* was so new that he himself could not yet express it fully in words, and as a result, although his pupils could copy the artistic tools, they could not convey his philosophy.

This concerned the extent to which humans and their environment belong together. Mona Lisa sits enthroned against the background of a landscape that was well known as a motif from representations of rulers.[25] However, she does not rule over nature; she reacts to it. If things are going badly for the earth, this woman would be troubled. On the other hand, if everything is flowing smoothly, she is happy.

This can be seen from a glance at the landscape. It is strangely divided in two; the horizon on the right (as we view the painting) is noticeably higher than on the left. As a result, the woman appears to be higher above the left half. She is at eye level with some of the peaks of the blue, hazy mountains that frame a lake. We see this lake from above from a distant viewpoint, and so could she, if she were to turn around. The water is still. It lacks the energy and volume to reanimate the dried-out riverbed that winds downward from the height of the woman's neckline and bosom. With the exception of a few moist patches on the bottom, the river is dead, and even the rocks at its sides look as though they will soon erode away. The woman is turning away from this part of the landscape; she turns on her chair toward the front right, away from the dryness and stagnation at the back left. However, she cannot simply ignore the misery. The right half of her face (on the left in the picture as seen by the viewer) looks serious, almost tense. This corner of her mouth is not smiling. The knowledge that *Mona Lisa* carries within her is also an awareness of death and the end of the world.

However, that is not a reason to despair. In the right half of the picture the world is in order. The sun will probably rise over a well-filled mountain lake. Water flows along a riverbed, not rushing but steadily. It laps the cliffs along its banks, slides under a bridge, and flows out of the picture at the height of the woman's shoulder. This scenery is much closer to the figure than that on the left. The lake on the right is at the height of her ear, and she is seated in front of it, not above it. Visually, the bridge seems to extend the line of her overgown's back into the rocky landscape. Most importantly, the woman is looking to the right, and she is also smiling in this direction with the entire left half of her face. *Mona Lisa* is smiling at life.

This beautiful lady understands something about kinetic energy. Like Leonardo's figures of Saint Anne and the Virgin Mary, she is familiar with the

human ability to begin anew. As one who can bear children, she personifies precisely this quality. Through her knowledge of life and death she can mediate between the two very different background landscapes. Leonardo, who was always anxious about the world, sent humanity and himself a messenger of hope.

What is special about this painting is that it has as its subject not the Virgin Mary, a saint, or a goddess, but an ordinary woman, although this does not mean that she is nothing more than Lisa del Giocondo, the silk merchant's wife from Florence. She is a woman who stands for all women.

That is why Leonardo allowed himself all kinds of artistic freedom. When Lisa del Giocondo sat for him in Florence in 1503, she was probably not pregnant.[26] Nevertheless, Leonardo dressed her in an overgown of transparent gauze. In Florence, this kind of garment was worn by small children and pregnant women, as can be seen in Botticelli's portrait of Smeralda Brandini (Ill. 14).[27] Leonardo's gently rounded Mona Lisa, with her large, soft hands, seems to be pregnant, and that is another reason for her confidence.

Much of what Leonardo had long been reflecting on came together for him during his second stay in Milan. Conditions for being able to work in peace were good. Although the French court and its representatives in Milan did not always pay his salary on time, they did not swamp him with demands either. Thanks to privileges granted him by King Louis XII, such as rights of use for parts of the Milan canal system, Leonardo was financially secure. Salaì and some of his other assistants had now become so independent that they could meet the demand for pictures, and Francesco Melzi was diligently sorting Leonardo's writings, so that it no longer appeared impossible for them to be published one day. This left Leonardo with time to wander through the mountains and drop into the men's public baths on Saturday evenings.[28]

However, nothing lasted long in those years. Two great powers were contending for territorial supremacy in Italy—the Papal States and France. Pope Julius II was obsessed by the desire to drive the armies of Louis XII out of Italy; he had sworn not to shave again until this had been done. He was under great pressure to succeed, not least because his opponents within the Church were already planning to depose him. At Easter 1512 the French conquered the papal forces and their Spanish allies in an incredibly bloody battle at Ravenna, in which the governor of Milan, Gaston de Foix, died. The pope then tried his luck

with money. He succeeded in convincing an entire army from Switzerland that he was a better master than Louis XII, who liked to scrimp on pay. Together with their allies, in the summer of 1512, they drove the French troops out of northern Italy. That gave the Sforza family their chance. The sons of the former ruler of Milan, Ludovico Sforza, had never gotten over the loss of power. Supported by the Swiss, they reconquered the city in December 1512. The new duke was Massimiliano Sforza, Ludovico's legitimate son. His half brother Cesare remained loyally by his side. The son of Ludovico's mistress Cecilia Gallerani, whom Leonardo had once painted, was proud of his father's legacy.[29]

Meanwhile, Leonardo was staying in the country home of the family of his secretary Francesco Melzi. At first he observed the political change from a safe distance; after all, at the age of sixty, he had now lost another of his allies. At least he no longer had to struggle with Piero Soderini, for many years the head of the Florentine government, who had been urging him for so long to complete the *Battle of Anghiari* (Ill. 32) in the Palazzo Vecchio. In late August 1512 Lorenzo de' Medici's sons, Giovanni and Giuliano, had returned in triumph to their native city. As a cardinal, Giovanni had actively supported Pope Julius II in the war against the French. In return, he asked that the Spanish forces allied to the Papal States should drive out Soderini. After the Spanish had plundered the neighboring city of Prato, the mood in Florence changed. The Florentines welcomed the two brothers with shouts of *"palle palle,"* a reference to the balls on the Medici coat of arms. Many people hoped that their return would bring back the good old days they had enjoyed under Lorenzo de' Medici.[30]

Julius II was not to enjoy his success for long. He died on February 21, 1513. Shortly afterward, the conclave elected his successor. It was Giovanni de' Medici, who chose the name Leo X. Thus Florence, the city of merchants and artists, had indirectly become a power in Europe.

Giovanni's brother, Giuliano de' Medici (named after his murdered uncle), was less keen on politics. Still fashionably dressed, with regular features and a well-kept beard, his forte was spending a great deal of money on banquets, friends, racehorses, and hunting, and not least on art and literature. When he was still a small boy, his father, Lorenzo, had encouraged him to write poetry, and even though he had only modest success in this, more than any other Medici of his

generation, he felt he had an obligation to humanist culture. As a result, he handed over the business of governing Florence to a nephew and moved to Rome to live the good life in the Eternal City at the Vatican's expense.

During his exile from Florence, in 1496 Giuliano had spent some time at the court of Ludovico Sforza in Milan, when he may have made friends with Leonardo, who was a generation older. Both were interested in Petrarch, but, unlike Leonardo, Giuliano admired the dead poet unreservedly. He was a close acquaintance of the Venetian writer and publisher of Petrarch, Pietro Bembo.[31]

When Giuliano de' Medici established his court in Rome, he invited Leonardo to work for him there. The opportunity came at the perfect time for Leonardo. In September 1513 he packed his things and set off for Rome with Salaì, Francesco Melzi, three other assistants, and the painted ladies Mona Lisa, Anne, and Mary. Soon after their arrival, they moved into the Villa Belvedere, the pope's magnificent summer palace in the center of a large garden. A contemporary observed that Giuliano treated the artist "more like a brother than a friend."[32]

Leonardo probably met Giuliano's little son Ippolito in Rome. Giuliano fell in love quickly and frequently, but not usually for any length of time. His affair with Ippolito's mother, Pacifica Brandani, whom he had met during his exile at the court of Urbino, did not last long. When she became pregnant, it did not trouble him at first, as he thought another man was the father. In April 1511 Pacifica abandoned her newborn son anonymously in a church in Urbino. In the swaddling clothes she placed a rare coin from Ancona so that the child could later be identified if need be, if she should happen to be able to care for him after all. The boy was placed in the local orphanage, but he did not stay there long. One of Giuliano's agents soon appeared there and first took the child to foster parents, and then took the three of them to Rome. Pacifica, who probably died not long after the birth, must have spread the word before her death that Giuliano was the true father.[33]

The Medici family had a tradition of bringing up illegitimate sons, in case there were no legitimate sons or they suffered some accident. The mothers' names were often concealed, as they had no part to play in dynastic considerations. Little Ippolito saw things differently and continually asked about his mother. When Giuliano traveled to Turin in January 1515 to marry the sister of the duke of Savoy, the overjoyed boy told his uncle, Leo X, that his papa had gone to fetch his mama. "His Holiness nearly died laughing," reported one of

Giuliano's friends in a letter.[34] The adults knew that the aristocratic bride would not pretend that her illegitimate stepson was her biological son.

It can be assumed that the father was less amused by the child's pain. The passionate Giuliano loved and pampered the boy. When he was four, Ippolito already had a mule of his own and a number of servants at his command. After his return from the wedding, Giuliano decided to have himself painted and commissioned the papal court painter Raphael for the task.[35] There is no proof, but it is possible that he also asked his friend Leonardo for a portrait on this occasion. What he might have required was the imaginary portrait of an ideal mother and a beloved wife—not for himself, but for his little son, who wished for a mother.[36]

Such a painting—at whatever stage of completion—already existed in Leonardo's workshop in the Villa Belvedere: that of Mona Lisa.[37] The artist would later say that this picture had been intended for Giuliano.[38] The *Mona Lisa* embodied Leonardo's dream mother, his universal woman, comforter, beloved counterpart, and one of the most engaging creations of the Italian Renaissance. Whether and for whom Leonardo once again set his hand to the portrait in Rome is not known. Probably no further work was necessary, since Ippolito's real mother was dead, and Giuliano thought of her in terms of her function, rather than as a person. She was pregnant and had borne his son. Such an ideal mother could also have the features of Lisa del Giocondo.

Yet Ippolito was left with neither a picture nor a mother. Not long afterward, when he was just five years old, he also lost his father, who died of tuberculosis. Leonardo kept the *Mona Lisa* with him.

In the meantime, France was now ruled by the twenty-one-year-old Francis I, a self-confident aesthete. The previous year he had succeeded in driving the Sforzas out of Milan, so the city was once again in the possession of the French.

Giuliano's widow, Philiberta of Savoy, was the aunt of Francis I, so she may have spoken with her nephew about Leonardo's talents. Leonardo was offered a position for life, if he and his assistants would care to enter royal service in France for a fantastic salary. Francis I, a passionate admirer and lover of paintings of beautiful women, was evidently equally interested in both Leonardo's scientific works and his art.

Leonardo had had good experiences with the French, and he could expect little from the rather coarse Pope Leo X after Giuliano's death.[39] He did not hesitate to accept the king's invitation, especially as he was not in the best of health and needed a decent income. So the painting of the eternally youthful Mona

Lisa and her almost sixty-five-year-old master set off on a final journey together. In spring 1517 they moved into the sumptuous redbrick chateau of Clos Lucé near Amboise in the Loire valley.[40]

Here they received a visit on October 10, 1517. A friend of Giuliano de' Medici, the wealthy, art-loving Cardinal Luigi d'Aragona, was touring Europe with his secretary Antonio de Beatis and had made a stop in Amboise. De Beatis diligently kept a diary of everything they saw and experienced. They had already met King Francis I and his aunt Philiberta; now they wanted to view Leonardo's workshop.[41]

Leonardo was delighted to have guests with whom he could speak Italian. He was not very well; de Beatis reported that one of his hands was paralyzed. Leonardo might have suffered a stroke. He told them that he was therefore concentrating on teaching his assistants, no longer painting, but still drawing a lot.[42] His pupil from Milan (probably Francesco Melzi) was quick to learn.

Mentally, the old master was in top form. He explained his anatomical studies in detail to his guests and boasted that during his lifetime he had dissected more than thirty bodies, male and female, children, adults, and the very old. They also learned about his writings. Leonardo was proud of having written numerous volumes in Italian on water, machines, anatomy, and other subjects. He was hoping to publish them; after all—according to Leonardo—his texts made both useful and enjoyable reading.

Then Leonardo introduced the travelers to his faithful companions. He showed them his *Virgin and Child with Saint Anne* (Plate 23), the picture of a young John the Baptist (Plate 29), and lastly the painting of "a certain Florentine lady, painted from life at the request of the deceased Magnifico Giuliano de' Medici."[43] This appears to have been the *Mona Lisa*, which would later come into the possession of the royal house of France and end up in the Louvre in Paris. Cardinal Luigi d'Aragona and his scribe Antonio de Beatis are the only contemporaries whose account of experiencing Leonardo and his most beautiful woman together has come down to us. They felt that this painting, like the other two pictures, was "perfect."

The master's statement that he had painted the work at the request of Giuliano is Leonardo's only surviving personal testimony concerning the *Mona Lisa*. He did not mention Lisa del Giocondo in the fall of 1517; it seems that

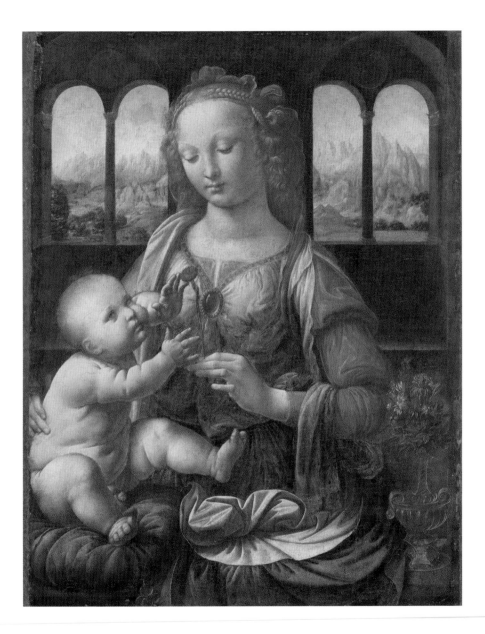

PLATE 1: Leonardo da Vinci, *Madonna of the Carnation*, Alte Pinakothek, Munich
(62 × 47.5 cm / 24.4 × 18.7 in)

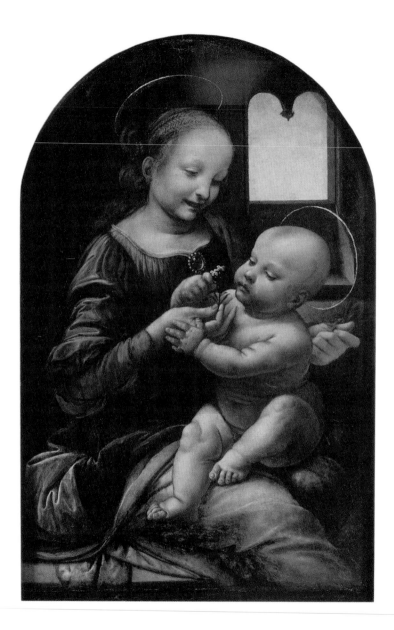

PLATE 2: Leonardo da Vinci, *Benois Madonna*, Hermitage, St. Petersburg
(49.5 × 31 cm / 19.5 × 12.2 in)

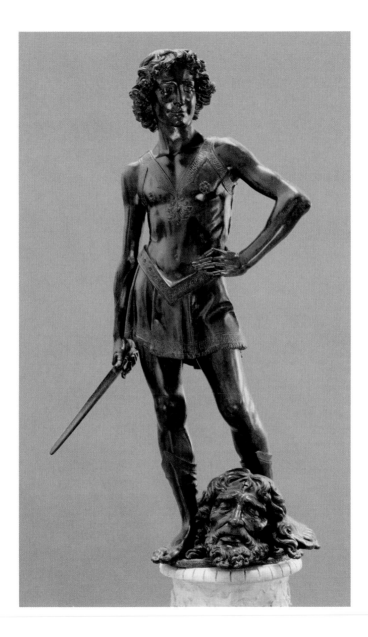

PLATE 3: Andrea del Verrocchio, *David*, Bargello, Florence (125 cm / 49 in)

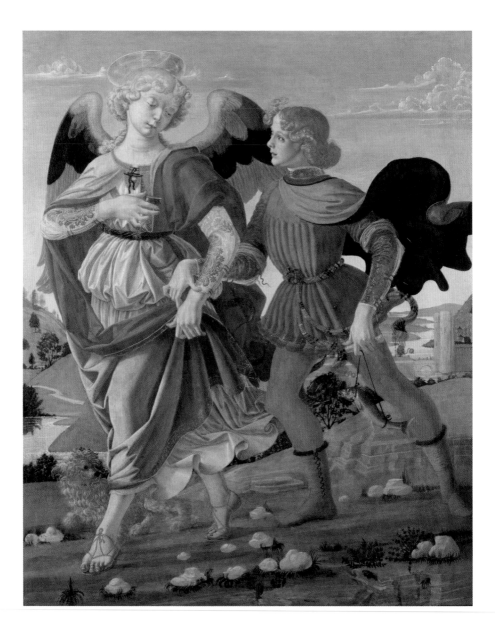

PLATE 4: Andrea del Verrocchio and Leonardo da Vinci, *Tobias und Raphael*, National Gallery, London (84.4 × 66.2 cm / 33.2 × 26 in)

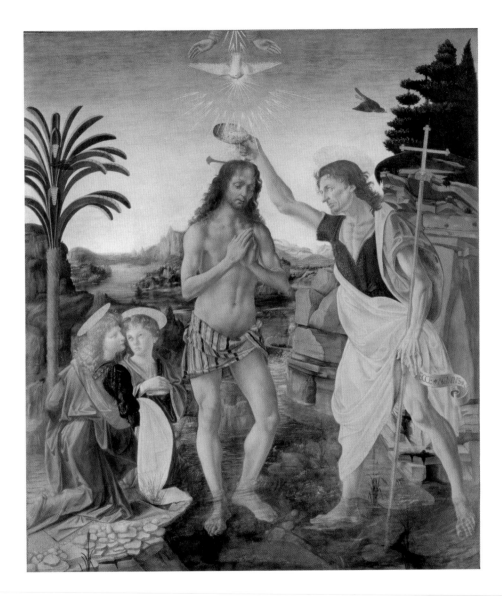

PLATE 5: Andrea del Verrocchio and Leonardo da Vinci, *Baptism of Christ*, Uffizi, Florence
(180 × 151.3 cm / 70.9 × 59.5 in)

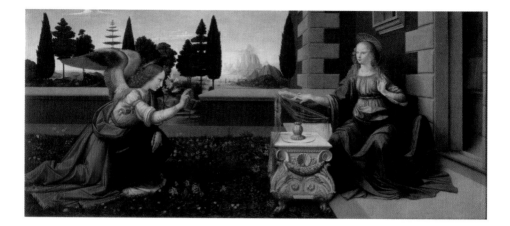

PLATE 6: Leonardo da Vinci, *Annunciation*, Uffizi, Florence
(100 × 221.5 cm / 39.4 × 87.2 in)

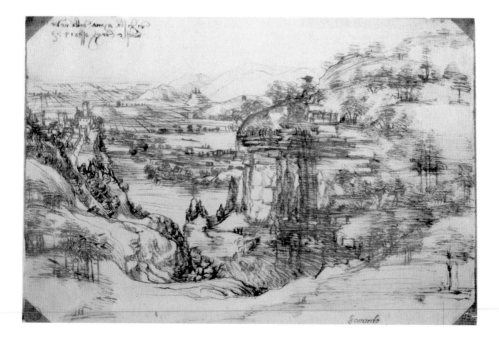

PLATE 7: Leonardo da Vinci, *Landscape Study*, Uffizi, Florence (19 × 28.5 cm / 7.5 × 11.2 in)

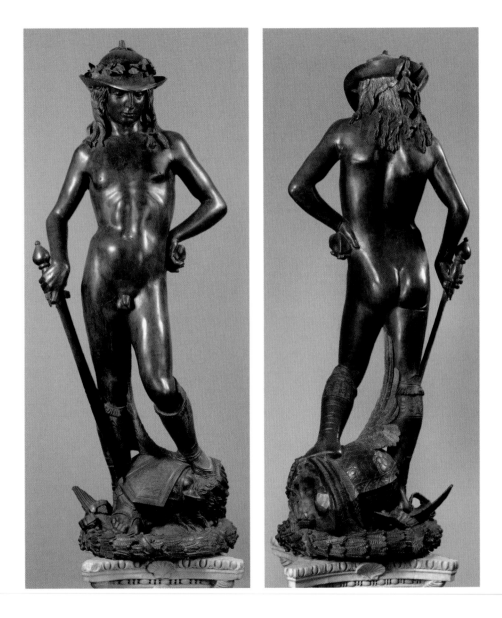

PLATE 8: Donatello, *David*, Bargello, Florence (158 cm / 62.2 in)

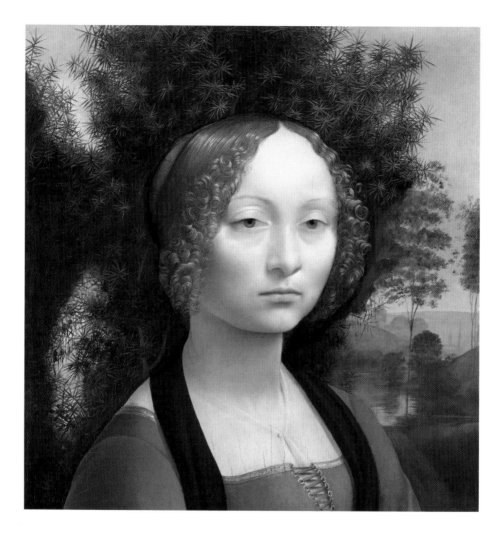

PLATE 9: Leonardo da Vinci, *Ginevra de' Benci*, National Gallery of Art, Washington, DC
(38.8 × 36.7 cm / 15.2 × 14.4 in)

PLATE 10: Leonardo da Vinci, *Ginevra de' Benci* (back), National Gallery of Art, Washington
(38.8 × 36.7 cm / 15.2 × 14.4 in)

PLATE 11: Andrea del Verrocchio, *Lady with a Bunch of Flowers*, Bargello, Florence
(60 × 48 × 25 cm / 23.6 × 18.9 × 9.8 in)

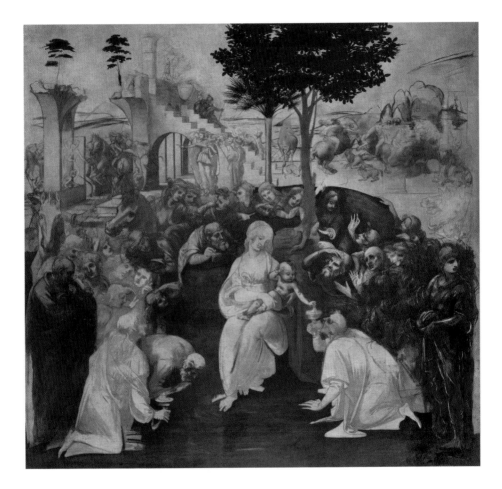

PLATE 12: Leonardo da Vinci, *Adoration of the Magi*, Uffizi, Florence
(243 × 246 cm / 95.6 × 96.8 in)

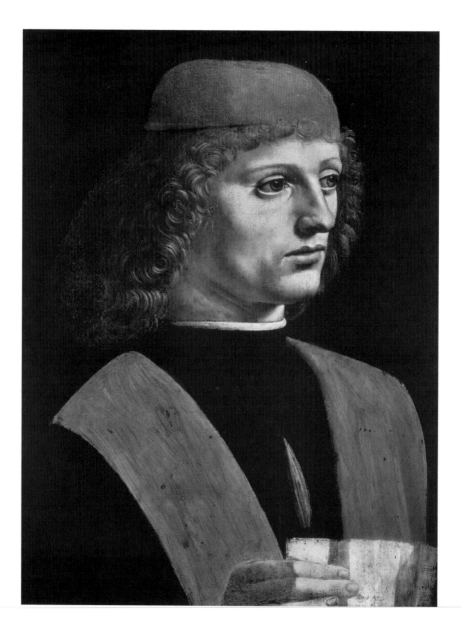

PLATE 13: Workshop of Leonardo da Vinci, *Portrait of a Musician*, Pinacoteca Ambrosiana, Milan (44.7 × 32 cm / 17.6 × 12.6 in)

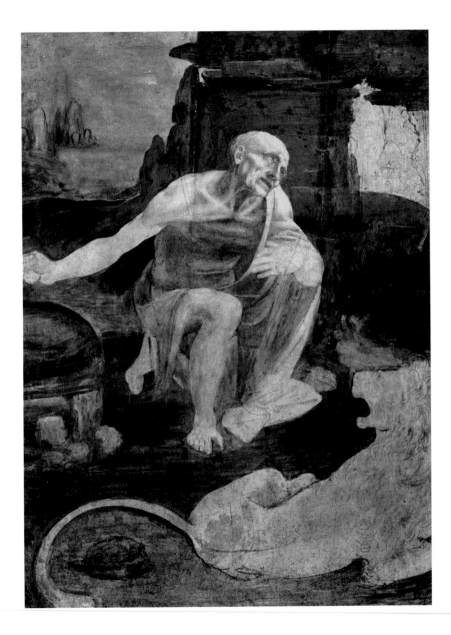

PLATE 14: Leonardo da Vinci, *Saint Jerome*, Pinacoteca Vaticana
(102 × 73.5 cm / 40.1 × 28.9 in)

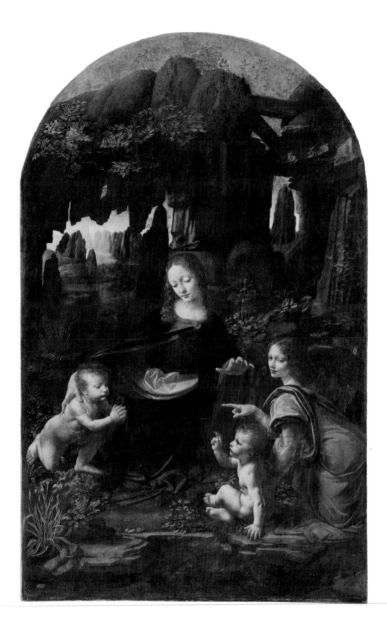

PLATE 15: Leonardo da Vinci, *Virgin of the Rocks*, Louvre, Paris
(197.3 × 120 cm / 77.7 × 47.2 in)

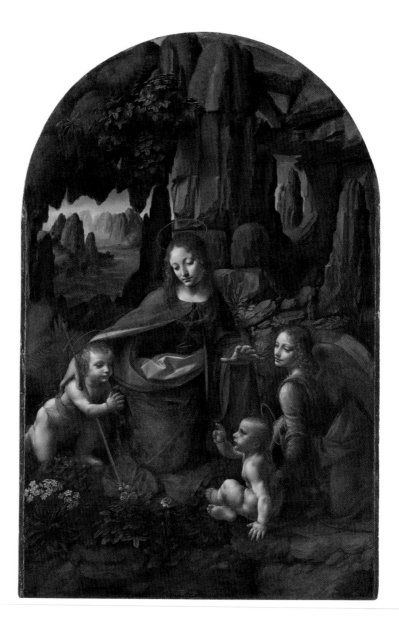

PLATE 16: Leonardo da Vinci and assistants, *Virgin of the Rocks*, National Gallery, London
(189.5 × 120 cm / 74.6 × 47.2 in)

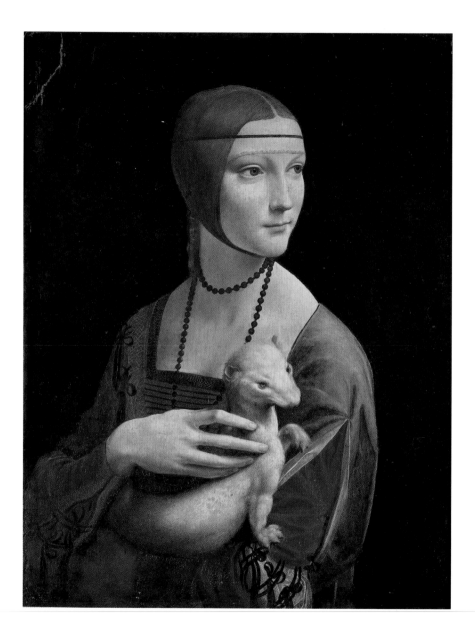

PLATE 17: Leonardo da Vinci, *Cecilia Gallerani*, National Museum, Krakow
(55 × 40.5 cm / 21.6 × 15.9 in)

she no longer had any importance for him at that point. Exactly what Giuliano de' Medici, the Cardinal's deceased friend, had to do with the picture remains unclear. Ippolito's mother, Pacifica Brandani, the most likely candidate for consideration among all Giuliano's loves, was not a Florentine lady. It is possible that Leonardo was not given precise information about the identity and origins of Ippolito's mother, as he was supposed to—and wanted to—portray her not as a person, but as an ideal woman.[44] As far as we know today, what remains insoluble is the contradiction between Agostino Vespucci's marginal note of 1503 mentioning Leonardo's portrait of Lisa del Giocondo, and Leonardo's own information of 1517, according to which this picture dates from his later patron Giuliano de' Medici.

It would be good to know what else he told the late visitors about the painting in his workshop. Did he talk about the landscape, or the relationship of this special woman (and all women) with nature? Did he confess why he had been carrying the painting around with him for at least fourteen years without ever handing it over to an interested party? Perhaps Leonardo was as unforthcoming in speech as he was in his writings where his feelings were concerned.

As Leonardo's health soon deteriorated further, Francis I had twice as much reason for concern.[45] He was attached to the old man who could explain the workings of the world to him. And he must have been afraid that he would never be able to call the *Mona Lisa* (Plate 28), the *Virgin and Child and Saint Anne* (Plate 23), the *Leda*, and the other great paintings from Leonardo's workshop his own. Evidently Leonardo had no intention of giving away his darlings, even so shortly before his death.

This roused Salaì's business sense. He was now in his late thirties, but he still lived up to his nickname of "little devil." While his colleague Francesco Melzi was taking care of Leonardo's intellectual achievements, painting for him, and generally always being there for him, Salaì was providing for his own future. He envisaged this as being in his home city of Milan, in the arms of a wealthy lady. He may have suspected that Leonardo was not planning to bequeath everything to him. Leonardo would bestow his drawings and writings on the clever, loyal Melzi, knowing how diligently he would care for his master's posthumous reputation. On the other hand, Salaì, whom Leonardo referred to in his will simply as "servant," would inherit the old vineyard in Milan, on which he had already built a house.[46] Salaì, however, wanted more. He wanted Leonardo's

beloved women, which were actually not to be sold, and any other masterpieces that were still to be found in the workshop.

Francis I wanted the same thing. In 1517 he gave Salaì some money. Possibly the king was trying to use bribery and an indirect invitation to betrayal in order to gain possession of the paintings he desired. In the following year, one of the royal treasurers did in fact draft a note, according to which Salaì was to be paid for a number of paintings that he had delivered. The sum mentioned was astonishingly high.[47] Either Salaì was dealing in a large number of works by fairly insignificant painters at this time, or he had sold Leonardo's few, very expensive masterpieces to the king without authorization.

But then the treasurer would have had to agree to the deal with Leonardo himself, since he was, after all, employed by the king. However, Leonardo was apparently not yet ready to sell the *Mona Lisa* (Plate 28). She was not to go before he did. Possibly he was still observing how his wafer-thin varnishes in the picture were slowly darkening and thus strengthening the intended effect of the dimly lit *sfumato*.[48] His body was aging and decaying, but the painting was alive.

It is not certain whether the deal, if it did indeed refer to Leonardo's paintings, took place during the artist's lifetime. Leonardo da Vinci died on May 2, 1519, and Salaì immediately left for Milan. Four years later he married a woman with a considerable dowry.[49]

Salaì's good fortune did not last long. He died in an accident in 1524. His death in his mid-forties was so unexpected that he did not leave a will. As a result, his sisters and his widow had plenty of reasons to argue. In 1525 they had an inventory drawn up. Among other pictures, the writer mentions the painting of a Saint Anne, the painting of a Leda—and a painting "named la *Ioconda*."[50] The price of 100 scudi for this one portrait was set as high as the average cost of an altarpiece by a famous master. Six years later, the heiresses were still arguing, particularly because, in the meantime, one of the sisters had pawned the painting. The painting "with the figure of the *Joconde*" then turned up again in an inventory.[51] It is not clear whether Salaì had taken Leonardo's originals with him to Milan, or only copies. At any rate, the *Mona Lisa* was now called *Gioconda*, the cheerful, comforting provider of joy. Salaì had probably heard this name from Leonardo and then used it himself. By this time no one looking at the picture still thought of Lisa Gherardini, married name del Giocondo.[52]

In 1550 Vasari was the first to recall the story of the model from Florence, and he reported that he knew that the *Mona Lisa* was now in Fontainebleau, therefore in the possession of the royal house of France.[53] So, at some point— either as early as 1518 or at some time after Salaì's death—Francis I had achieved his goal. And as the painting remained in French hands and finally reached the Louvre in Paris by way of Versailles in 1797, it is certain that the work with which Leonardo shared his workshop for so long is the *Mona Lisa*, alias *La Gioconda* (Plate 28).[54] The picture that reconciles people with a sometimes unrelenting nature and Leonardo with the world; the artwork that can smile and look at one like no other; Leonardo's dream picture of a beautiful, intelligent, and desirable woman, who seems to understand those who look at her better than they do themselves. *Mona Lisa*, the big sister of the pensive *Ginevra de' Benci* and the energetic *Cecilia Gallerani*, bears witness to Leonardo's alliance with women, his belief in the power of their minds and their independence.

XII

PAINTING FOR ETERNITY

BEFORE DEATH COMES passion. From 1513 Leonardo was once again enjoying life as an artist and researcher in the Eternal City. He was inspired by his communal life in the elegant Villa Belvedere with Francesco Melzi, Salaì, and his household goddesses Gioconda, Leda, Anne, and Mary. And, in turn, the group of artists around Leonardo inspired the other great painters of the age.

There was an exuberant atmosphere in Rome during those years; the angry outbursts of the Reformation in northern Europe had not yet reached the city. Michelangelo had unveiled his painted ceiling in the Sistine Chapel on All Saints' Day in 1512, and since then the Italians had been marveling at the celebration of peace and love created in the Vatican by the surly, melancholy Michelangelo while the country was still at war with the French. Michelangelo's account of biblical events, starting from the creation of the world, is framed by delicate naked youths and powerful, masculine-looking sybils. His full-bearded creator God divides the light from the darkness as dynamically as a painter separates his paints. Michelangelo, who had previously considered Leonardo to be arrogant, had been infected by the latter's pride in the profession they shared. Painters, the new creators, were now vying with God and showing human beings the opportunities awaiting them; they were born to be free.[1]

Anything that gave pleasure was allowed, not only what was deemed appropriate. The poet, erotomaniac, and profligate Giuliano de' Medici embodied and promoted this attitude to life. He seems to have encouraged Leonardo and

Illustration 37. Circle of Leonardo da Vinci, *Monna Vanna*, Musée Condé, Chantilly

his assistants to explore the boundaries of convention and morality. It was possibly at his request that the *Mona Lisa* (Plate 28) acquired a companion. Leonardo's assistants—and possibly the artist himself—conceived a second portrait of a woman in a loggia in the open air. Once again, a young woman with curly hair is seated on a wooden chair, set to one side in front of an open landscape, and with her right hand lying on her left forearm. However, this figure, later given the name of Monna Vanna, looks directly at her viewers, no longer out of the corners of her eyes. She smiles with her whole face, not just half of it—and she is nude.[2]

This was something completely new—a naked, individually recognizable woman, gazing at her viewers, as if she now wanted to attract them with her eyes as well; not a goddess or a nymph, but a woman of the time. It is not known who the model was. The motif has come down to us in several workshop versions and variations, but if Leonardo himself created such a painting it has been lost.[3] However, he would surely have had nothing against his beloved *Mona Lisa* acquiring a more permissive young sister. A carefully drawn chalk cartoon that was used as a preparatory study for some of the *Monna Vanna* paintings has survived (Ill. 37).[4] There is a similar painting that, while not reproducing the two-level details of the landscape of the *Mona Lisa*, repeats the other features of the composition of its great predecessor (Plate 31).[5]

With this bold attempt to combine the nude with the female portrait, Leonardo's circle even excelled their colleagues in Venice. Leonardo's visit to the city in 1500 had inspired the Venetians to paint sensuously reclining *belle donne* and scantily clad half-length figures. In their paintings Titian, Giorgione, and Sebastiano del Piombo played with closeness and distance, and with images of

beautiful but unattainable women who, like Giorgione's *Laura*, are beginning to undress but also withdrawing (Ill. 27).[6] By contrast, *Monna Vanna* does not hesitate. She reveals herself with no trace of humility, without holding her head at an angle or showing any other sign of bashfulness. She is utterly provocative. What she offers the viewer is not her submission but his. Whereas Leonardo once wanted his paintings of beautiful women to create an emotional link with the man outside the picture frame, *Monna Vanna* challenges the viewers' masculinity. Here the woman is no longer seductive; she is demanding.

The aggressive nudity of *Monna Vanna* made a considerable impression in Rome. Once again it was Raphael who adopted what he had seen in Leonardo's workshop or in the homes of his customers. This industrious artist from Urbino had come a long way since then. He was to decorate the popes' private chambers in the Vatican and was considered as a rival of Michelangelo and, although less inventive, a better portrait painter than the latter. He was helped in this by his feeling for color, which he had fine-tuned by studying Leonardo's oil paintings.

Like Leonardo, painting beautiful women appealed to Raphael; this was the very genre in which artists had demonstrated their skills since antiquity. In the Trastevere district of Rome, Raphael had decorated the villa of the banker Agostino Chigi with frescoes of erotic scenes. According to Vasari, he did so successfully only because his mistress watched him at work.[7] While Michelangelo believed he could be productive only if he did not give himself physically to anyone and Leonardo cohabited with his male friends without saying much about it, Raphael presented himself as a great seducer of women.[8] This was not particularly unusual in an age when courtiers attempted to outdo one another with love poems and the male elite nurtured their extramarital passions. In contrast to the age of Lorenzo de' Medici, in High Renaissance Rome there was no question of maintaining the appearance of sexual abstinence.

Raphael probably needed to add a touch of artistic exaggeration to his love affairs in order to make an impression professionally. In the daring composition of the *Monna Vanna*, he identified an opportunity to do so. After all, it was said that Alexander the Great had once commissioned Apelles to paint a nude portrait of his mistress Campaspe and found the painting so tender and affectionate that in the end he gave the woman to the artist. This legend may also have

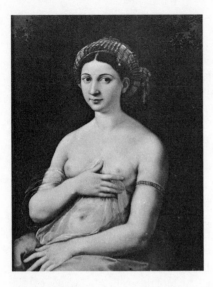

Illustration 38. Raphael, *Portrait of a Young Woman, Known as La Fornarina*, Galleria Nazionale d'Arte Antica, Rome

given Leonardo and his assistants the inspiration for the *Monna Vanna*, as the master liked to be compared with the ancient Greek painters.[9] Raphael would probably have enjoyed the story even more as, unlike Leonardo, he had a mistress. So he asked his beloved, who was probably a woman from a modest family, to pose for him (Ill. 38).[10] She tied a ribbon bearing Raphael's name around her arm, covered her lap with a shiny red cloth, and drew a transparent veil up over her belly to just under her bosom, leaving her breasts uncovered. Yet the finished painting is not frivolous, because her right hand is pointing to her heart; for her, it is a matter of love, not only of sex. Here there is no trace of the erotic duel to which the *Monna Vanna* challenges the viewer. Raphael's figure also looks directly at the viewer and reveals herself to him completely, but she approaches him as a partner, rather than a conqueror.

The extent to which Raphael had absorbed Leonardo's motifs, rather than his ideas, can be clearly seen from the background. His woman is seated in front of a tangle of dense, dark-green bushes, a mixture of laurels and quinces, the fruits of seduction and love. Raphael was once again alluding to Petrarch— whose admired Laura reminded him of *lauro*, laurel—as well as paying his respects to one of Leonardo's old portraits, *Ginevra de' Benci* (Plate 9), although in that case the subject is sitting in front of a juniper bush, rather than a laurel. Where Leonardo made a clear distinction between himself and the poet, the adaptable Raphael claimed a share of Petrarch's legacy.

This was also Raphael's response to the Venetian artists who sought to dispute his reputation as the best painter of women and master of color. In the villa of Agostino Chigi, Raphael met Sebastiano del Piombo, another of

Leonardo's followers in Rome. After Giorgione's death in 1510, Sebastiano had followed Chigi to Rome, together with a grocer's daughter who bore Chigi several children. She was probably the young woman in front of an evening landscape, one of Sebastiano's most sensuous portraits (Ill. 39).[11] Sebastiano's *bella donna* also has quinces in her basket, and in an earlier version she was seated in front of a laurel bush, which Sebastiano later overpainted, possibly at Chigi's request. This finely painted, subtly erotic portrait has little in common with the directness of *Monna Vanna*. Instead, Sebastiano drew inspiration from Leonardo's psychological portraits of women; the melancholy of *Ginevra de' Benci* (Plate 9), the dynamism of *Cecilia Gallerani*

Illustration 39. Sebastiano del Piombo, *Portrait of a Young Woman*, Gemäldegalerie, Berlin

(Plate 17), and the warmth and wisdom of *Mona Lisa* (Plate 28) are echoed in his portrait. In the 1530s Sebastiano would paint another famous portrait in the spirit of Leonardo—that of the aristocratic widow and later activist for the Catholic reform movement Giulia Gonzaga, which inspired undying love in the adult Ippolito de' Medici, the son of Giuliano.[12] Once again a young Medici celebrated a beautiful, intelligent woman in poems reminiscent of Petrarch, and once again an exceptionally gifted artist painted her portrait. Both could have seen the *Mona Lisa* in Leonardo's workshop, Sebastiano as a fellow painter from the north, and Ippolito as the motherless boy and son of Leonardo's patron Giuliano de' Medici.[13] The inspiration that Leonardo gave his contemporaries in Rome continued to take effect.

How emotionally charged the atmosphere surrounding Giuliano de' Medici was at the time when Leonardo was living in Rome with his assistants, lovers,

and female portraits can be seen from Baldassare Castiglione's *Book of the Courtier*, which was written between 1508 and 1516 but not published until 1528. Castiglione had the idea for the volume of dialogues on love, men, and women at the court of Urbino at the time when Giuliano was living in exile there and making advances to Pacifica Brandani, the future mother of his son Ippolito. Giuliano was one of the protagonists of the book; another was his friend Pietro Bembo, the poet and publisher of Petrarch who, as a boy in Florence, had looked on as his father Bernardo admired the young poetess Ginevra de' Benci and Leonardo painted her (Plate 9).

In the book, Giuliano de' Medici makes a long, ardent speech at the court of Urbino in defense of women. He is incensed by his opponent in the discussion, who considers women to be inferior and a mistake of nature, although, since humankind would then die out, nature must have had something in mind when creating women. Giuliano considers women to be at least as virtuous, sensible, and decisive as men, and he would prefer to hand over the affairs of state, the conduct of wars, and everything else to them. However, his task in the circle of debate at the court of Urbino is to define what makes a good palace lady. In his opinion, she should be discreet, but also quick-witted, entertaining, and ready to exchange erotic allusions, without ever becoming coarse. Her beauty should be accompanied by mental brilliance, as, although women might be weaker than men in terms of muscle power, they were not inferior in intellectual virtuosity. The court lady should know as much about painting, literature, and music as a courtier, and be fond of dancing and joking.[14]

Much of this reads as if Leonardo had put the words into Giuliano's mouth. He too disagreed with the prevalent disparagement of women and could not look on their beauty without seeing their intelligence. And, like Giuliano, Leonardo did not consider women to be an unfortunate mistake, but rather an ingenious invention on the part of Mother Nature. In Castiglione's book, Giuliano finds what he wants, the encouragement of the ladies present. One of them jokes that it was not by chance that the Italian word for virtue is feminine, whereas the word for mistake is masculine.[15] The women who listened to him at the court of Urbino were not lacking in self-confidence. They were aware of the disparagement of women but had not unconditionally internalized it.

Nor had Pietro Bembo, another supporter of women in the humanist circle. His personal experiences in Venice as a young man in love had been sorrowful.

He had learned what it meant to give way to one's feelings in a world of rigid norms. During his relationship—interwoven with poetry—with an aristocratic widow in Venice, he had reason to fear a murderous attack, so at night he disguised himself and climbed up a ladder into the window of his lady love.[16] In his will, her deceased husband had forbidden her to have any further romantic relationships, so male relatives kept guard over the widow's chastity. Bembo, the publisher of Petrarch, later embarked on a career in the Church, but before that he vigorously advocated a platonic ideal of love, and in *The Courtier* he defended this against Giuliano, who was untroubled by erotic questionings.

For Bembo, love meant the longing for beauty.[17] This is revealed through the way people look at and listen to one another. In *The Courtier* he advocates a mental and spiritual communion of man and woman. That would not endanger feminine virtue and would also allow married women to exchange views with men without any qualms of conscience. Above all, platonic association would avoid the pangs of love and thus also be of benefit to men. However, even Bembo could not entirely withstand the high intellectual and moral standards. He welcomed kissing with tongues; after all, the mouth was the "gate of words," so kissing was not so much a union of bodies as of souls.[18]

Castiglione's *Courtier* could not resolve the contradictions between desire and the ideals of virtue, or the hierarchy of the sexes and the exploration of one's own feelings. They were the contradictions of the times. The ideal courtier that Castiglione and the debaters of Urbino wished for was not an old soldier but an elegant and charming man who was sensitive, educated in the arts, and pleasant and amusing in company. He might, indeed must, be an Adonis and an aesthete. He should radiate *sprezzatura*, a certain natural effortlessness despite all the trouble he takes. The modern man was expected to exhibit these traditionally feminine qualities. Yet that too remains one of the contradictions of this period. If a man copied too much from women, he was ridiculed. For example, one of the participants in the discussions in Urbino in *The Courtier* criticized men who used cosmetics, plucked their eyebrows, curled their hair, and spoke mawkishly, "since Nature has not in fact made them the ladies they want to seem and be, they should be treated not as honest women but as common whores and be driven out from all gentlemanly society, let alone the courts of great lords."[19]

If such talk reached the ears of the man-loving Leonardo, who always took great care with his appearance, he did not show his feelings about it in his late years in Rome—quite the opposite. He had nothing more to lose, and, together with his pupils, he now celebrated not only the beauty of women but the beauty of all sexes.

Illustration 40. Circle of Leonardo da Vinci, *Angelo Incarnato*, private collection

The finely sketched drawing (Ill. 40) has survived, but it is not clear what it represents.[20] Is it a delicate angel with long, curly hair and bowed head smiling impishly at the viewer out of shadowed eyes? Or is it a young woman revealing a round, naked breast? Or is it an alluring youth? After all, the figure has just pulled the transparent cloth up over its loins to reveal a large erect member. In the Villa Belvedere in Rome, Leonardo or an assistant created a hybrid between man and girl, and between the heavenly and the human.

Leonardo was not ashamed; instead, probably in Rome, he gave the *Angelo Incarnato*, the *Angel in the Flesh*, as the drawing later became known, a painted companion.

His *John the Baptist* (Plate 29) is a creature of light.[21] He emerges from black depths with rays of light from heaven striking his face and his naked upper body. Like the *Angelo Incarnato*, he looks at the viewer with bowed head. His long, shining curls fall loosely down to touch his bare skin. He wears a fur instead of a transparent veil, and his chest is covered by his right arm. His index finger points heavenward, like the angel and the earlier figure of Saint Anne (Plate 22), while his left hand points to his heart. This John the Baptist is not seductive for the sake of seduction; he shows his admirers the way to the salvation of their souls. He does not have the slightly fragile look of the

androgynous angel with its deeply shadowed eyes and slender waist. He may look sensitive, but he also appears resolute. No other surviving male portrait by Leonardo has such presence. And this figure of John the Baptist is a portrait. Whichever brown-haired youth with finely chiseled features modeled for it, this half-length figure in close-up has the look of a portrait, rather than a rapt saint.

In this painting, Leonardo finally emancipates men. His *John the Baptist* profits from what he achieved in his paintings of *belle donne*. John is in motion, as they are, revealing the stirrings of his soul in the way his body turns. He beguiles the viewer with his deep gaze and beautiful body, but even more through his obvious will. Like Leonardo's women, he is not an exhibit but an independent person, with whom the viewer must engage on an equal footing. Inspired by Leonardo's paintings of women, from 1500 on, the Venetian painters in Giorgione's circle also painted homoerotic male portraits.[22]

However, Leonardo's *John the Baptist* has greater self-assurance than the gentle youths from the north. He has a mission, and he communicates it directly. This mission is not bellicose; it needs no status symbols and does not intend to subjugate the world or women. *John the Baptist* points to heaven with one hand and to himself with the other. His youthful virility, his long index finger, and his austere smile are an expression of the origins of humankind. God created man in his own image, so man has a will and a power of his own, and he can be proud of his own nature, without having to represent anything else.

The impression that this is not a two-dimensional image but something that is truly alive is strengthened by the wafer-thin varnishes that Leonardo applied to it. The artist's previous experiments with painting technology had all ended in failure; his *Last Supper* (Plate 19) was peeling off the wall, and his great *Battle of Anghiari* (Ill. 32) had never reached the wall of the Florentine council chamber. However, he had not stopped experimenting with new mixtures of oil and pigments (it is possible that in Rome he once again met his former chemist, Zoroastro, who was now living there among the followers of a cleric with an interest in the natural sciences). When Leonardo, who was now over sixty, painted on wood panels at this time, such as the walnut panel of *John the Baptist*, the paints adhered much better than in such youthful works as the *Madonna of the Carnation* (Plate 1). Soft transitions, gentle shadows, and, above all, his delicate varnishes were important to him. These varnishes contained virtually no pigment, but they ensured the gentle merging of light and dark. The result is like

looking at a figure through glass or water; the figure does not force itself on the viewer but exists in its own three-dimensional world.

This *sfumato* technique sets Leonardo at the opposite extreme from Michelangelo, the celebrated painter of the Sistine Chapel. Where the younger artist painted solid outlines in tempera, the older man favored dimly lit ambivalence. Where Michelangelo's colorful palette shone out brightly, Leonardo became the master of darkness and warm light. Both artists eroticized religion, but Michelangelo mostly kept to nudes in the antique style, whereas, now more than ever, Leonardo understood sexuality as a primeval force of nature. In the mid-1510s the symbiosis of thoughtfulness and sensuality was not yet considered as sacrilege. It was only with the arrival of the Counter-Reformation later on in the century that artists were forced to clothe their images of saints decently and separate the private sphere from the sacred.

However, the group of artists in the Villa Belvedere was not affected by any such measures. Probably with the master's approval or at his request, another *John the Baptist* was created in Leonardo's workshop, this time in the form of a full-length figure (Plate 30).[23] The animal skin serves as a loincloth; apart from that he is naked. With his legs lasciviously crossed, he shows off his well-formed body, and his finger points toward the darkness of a wood a little way above him. He is surrounded by flourishing plants, a resting stag, and trees and rocks reaching up into the sky. Not only women, but also a man, can live in harmony with nature. The divine dwells in every leaf and in every root, and the task of this *John the Baptist* is to open the eyes of his viewers to the fertile beauties of nature.

After Leonardo's death, at a time of fierce arguments about the true faith and true art, this nature-loving, eroticized *John the Baptist* annoyed viewers. A critic wrote in 1625 that the figure had "neither decorum nor similitude." Someone converted the *John the Baptist* from Leonardo's workshop into a figure of Bacchus, making it appear less blasphemous.[24]

Vasari, who was born in 1511, was already wary of Leonardo. When he published the first edition of his *Vite* in 1550, the Council of Trent, which brought in the Catholic Counter-Reformation, had already met. The second edition of the *Vite* appeared in 1568, in the restrictive climate of aggressive Catholicism. Although Vasari recognized that, together with Michelangelo and Raphael, Leonardo was one of a trio of very great artists, he did not warm to the man whom he knew only from the stories he had heard. Vasari found that

Leonardo used the "strangest methods," and related the story of how Pope Leo X had once asked his brother Giuliano's employee for a painting. Instead of developing an idea and drawing preliminary sketches, Leonardo had gone into his laboratory and distilled oils and plants for the varnishes. The Holy Father had groaned, "Alas, this man will never do anything, because he begins by thinking of the end of the work, before the beginning."[25]

And that was not all. According to Vasari, as Leonardo walked around in Rome, he carried a paste of wax with him, which he shaped into animals, blew into them, and made them fly into the air. He glued wings on to a lizard and kept it as a pet, and he filled the intestines of a sheep with air until they filled a whole room, leaving scarcely enough air to breathe.[26]

Leonardo was certainly not such an eccentric dreamer as Vasari depicts him.[27] But in the years from 1513 to 1516 he had not yet been fully adopted by the Romans. He attracted attention with what he did and did not do. In 1515 an explorer reported to Giuliano de' Medici on the strange customs of the Indians that they ate nothing that had blood in it—"like our Leonardo da Vinci."[28]

Leonardo had too much respect for life to eat animals. He hated it when newly appointed assistants in Rome shot birds just as a pastime. Yet he was not afraid of death and continued to haunt hospital mortuaries in order to better understand how human bodies functioned by dissecting them. One of his collaborators, a German mirror maker, sensed an opportunity for extortion and blackened Leonardo's name by reporting him to the hospital management and the pope for unchristian activities. Leonardo wrote a letter to Giuliano de' Medici asking him to intervene, and the affair had no further consequences for the artist.[29]

As so often in his life, Leonardo remained an outsider in his old age. The prestigious commissions in Rome went to Raphael and Michelangelo, while Leonardo watched from the sidelines—and did whatever he wanted. That only worked successfully when Leonardo had a sponsor who did not get involved and accepted him as he was. When his patron Giuliano de' Medici died in March 1516, he saw no further prospects in Rome or in Italy as a whole, and emigrated to France—to Francis I, the next tolerant and financially strong benefactor.

In the small chateau of Clos Lucé near Amboise, the aging artist had everything he needed—peace and quiet, good food, beautiful scenery, and Francesco Melzi (Salaì occasionally commuted between Milan and Amboise).

And, most importantly, Leonardo had his books and pictures with him. The *Mona Lisa* (Plate 28), the *Virgin and Child with Saint Anne* (Plate 23), and *John the Baptist* (Plate 29) watched over him as he wrote and drew.[30] The fact that he was able to spend the last years of his life together with his most perfect creations was unusual. Although artists were now being given greater personal recognition than at the start of Leonardo's career half a century before, they were still regarded as providing a service, creating works of art for their masters rather than for their own satisfaction.

In the spring of 1519 Leonardo was seriously ill. Shortly after his sixty-seventh birthday he wrote his will, bestowing his intellectual property on Melzi and leaving Salaì some land. Sixty poor people were to carry candles at his funeral, for which they would be paid.[31]

Vasari imagined Leonardo in his last days as a man of inner conflict. "Finally, having grown old, he remained ill for many months, and, feeling himself near to death, asked to have himself diligently informed of the teaching of the Catholic faith, and of the good way, and holy Christian religion." In tears he confessed and repented and told King Francis I that he also regretted "not having worked at his art as he should have done."[32] All his life, Leonardo had spent a lot of time philosophizing about nature, studying plants, and observing the paths of heavenly bodies—pursuing his own mad ideas instead of working regularly. In the first edition of the *Vite* of 1550 Vasari even suggested that Leonardo's "cast of mind was so heretical that he did not adhere to any religion, thinking perhaps that it was better to be a philosopher than a Christian."[33]

Could Leonardo da Vinci, who devoted many years to painting the Madonna and the Christ child, Saint Anne and John the Baptist, possibly be considered a heretic? Vasari's opinions tell us little about Leonardo's spiritual attitude. They are evidence of the ideological radicalization that Italian society went through under the pressure of the Reformation and then the Counter-Reformation. Three decades after Leonardo's death on May 2, 1519, people no longer understood what the artist thought, wished, and knew. His deep respect for creation and for women, his belief in the regenerative powers of nature, and his confidence in self-assured individuals, whether male or female, may not survive forever or everywhere in the world, yet they will live forever in his works.

At some point in his old age, probably when he was already living in France, Leonardo placed a small sheet of paper in portrait format on the table in front of him and worked on it in dark chalk. A young woman appeared (Plate 34).[34] Her darkly hatched gown flutters in the breeze, and the slender lines of her body emerge from the thin fabric. Her hair is also windblown; possibly she is standing among the reeds in a river landscape. There are plants sprouting all around her. With wide-open eyes, she contemplates the old man who has created her, stretching her left arm out to the right. She definitely wants to show him something. This something is outside the picture, beyond art and life. Leonardo is heading into unknown territory. But the pointing finger of the woman seems to suggest: He has nothing to fear.

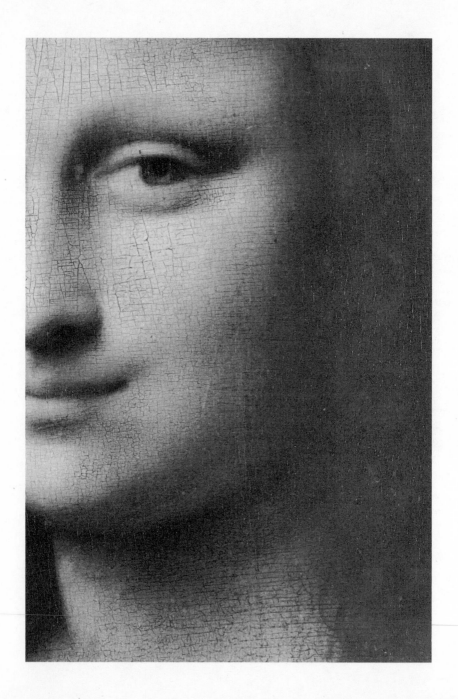

Epilogue

LEONARDO TODAY

EVERY PAINTER PAINTS himself, and every generation understands Leonardo in a new way. Male authors in the nineteenth century were in awe of the *Mona Lisa* and saw her as a femme fatale. In 1857 the writer and art critic Théophile Gautier wrote of her "sinuous, serpentine mouth" and how she gently mocked the viewer, making him feel "like a schoolboy in the presence of a duchess." His fellow critic Walter Pater wrote that *Mona Lisa*'s dangerous beauty was "expressive of what in the ways of a thousand years men had come to desire." She was a vampire who had "learned the secrets of the grave."[1] Leonardo's independent creations seemed like tempting and threatening harbingers of women's emancipation from family and financial dependence. Read in this way, *Mona Lisa* is not looking at us out of the past, but heralding an uncertain future, namely the social upheavals of the industrial age.

In 1919, to mark the four hundredth anniversary of Leonardo's death, Marcel Duchamp painted a moustache on a reproduction of the *Mona Lisa*. This ironic alienation brought the anxieties felt by the older generation about the battle of the sexes crashing down. Duchamp intuitively grasped Leonardo's more fluid understanding of the boundaries between the sexes, and even more he was targeting the pathos surrounding the reception of Leonardo's figures of women. Artists from the Surrealists to Andy Warhol have continued to grapple with Leonardo's position as an exceptional genius.

The way was open for new sociopolitical interpretations, and in the twentieth century women played almost no part in this. In the extensive Milan exhibition of 1939, the Italian fascists turned Leonardo into an ideal model of a virile, war-mongering man who would conquer the world through rationalism and technology. At the end of the twentieth century engineers were more in demand than fighters, and consequently Leonardo, the solitary visionary, was now said to have foreseen the inventions of the modern age and became the hero of both aircraft and computer technology.[2]

Both approaches—the demonization of Leonardo's *belle donne* and their subsequent eradication from discourse—misjudged the conciliatory nature of his art. With the dreaded destruction of the world before his eyes, the artist painted, as could be seen in this book, life. His great child bearers embodied the principle that human beings had the capacity to start afresh, and therefore their ability to design the world instead of destroying it. Leonardo's figures of self-assured women do not fight against nature; they are an inseparable part of it. And what they could do, the painter-creator Leonardo could also do—the man-loving man who could with so little effort empathize with all other organisms, hermaphrodites and angels, men, women, and children, birds, lambs, and plants. His investigative activity was not about winning and being defeated but rather about dialectical links between the painter and nature, women and art, and people and their talent for asking questions, instead of knowing everything already.

This way of looking at him is, like all others, dependent on the times. Leonardo's art and writings offer their interpreters a latitude that is meant to be exploited. His work is so important precisely because, although it can be explained by the Renaissance, it does not remain restricted to that era. His art is accessible to all generations; the universality of his works speaks to his contemporaries and to posterity. That is how he himself wanted it. He wrote that the notion that his beautiful paintings of women would endure much longer on the earth than their models in nature filled him with satisfaction.[3]

Just as Leonardo's paintings live on and change as a result of the darkening *sfumato* of the varnishes or cleaning by restorers, discussion of his work will never stagnate. Leonardo's oeuvre is as discursive as his *Last Supper* (Plate 19), and as interactive as the gaze of *La Belle Ferronnière* (Plate 18) and the angel in the *Virgin of the Rocks* (Plate 15). It functions in dialogue or not at all.

When there is no more argument about Leonardo, and no more grappling with his unusual ideas, the essence of his humanist legacy will be in danger. This happens occasionally at the beginning of the twenty-first century. Leonardo is no longer a painter of vampires or a virile military engineer, a heretic or a computer nerd, but only a very famous man. No new traits of character are attributed to him, only a succession of new art works that he seems to not be responsible for. Whoever painted the works that have in the meantime been claimed, offered, and sold as original Leonardos, it was hardly the creator of the *Madonna of the Carnation* (Plate 1), *Cecilia Gallerani* (Plate 17), or *John the Baptist* (Plate 29).

During his lifetime Leonardo avoided the demands of collectors; their desires remained pipe dreams, and instead he painted, drew, and investigated whatever he wanted and in whatever way he pleased. Interested buyers were mostly presented with items from his workshop. If they were lucky, he had added a few brushstrokes here and there, in order to instruct his pupils in his painting technique.

Some of the works that have been newly attributed to Leonardo da Vinci in recent years are variations of his well-known visual ideas or paintings from his workshop and followers. Other new arrivals in his oeuvre bear no relation to Leonardo's style and subjects. And all of them lack the immense and time-spanning power of imagery and thought that inhabits each one of the sixteen or so surviving paintings and cartoons from Leonardo's own hand.

In November 2017 Christie's auction house sold a painting of a figure of Christ, a *Salvator Mundi*, for the highest-ever auction price of $450.3 million (Plate 33). In 1958 the badly damaged work had been sold by their competitor Sotheby's for just £45, the equivalent of $72. Then it was sold as a picture from the circle of Leonardo's pupils, Giovanni Antonio Boltraffio, who had been employed in Leonardo's workshop in Milan in the 1490s. There seems to be no historical evidence for the assumption that Leonardo created the work. Two of his studies of clothing can only be vaguely associated with the painting. There are no Renaissance eyewitness reports of having seen on Leonardo's easel an image of the Savior balancing a glass ball in his hand, although word spread immediately in Florence and Milan about every one of his other inventions.[4]

The most striking feature of the debate about the *Salvator Mundi* is the questions that were not asked. How does the rather solemn *Salvator* relate to the discursive religiosity of the *Last Supper*? How should the frontal pose of the figure be interpreted, given Leonardo's desire to show the impulses of the spirit

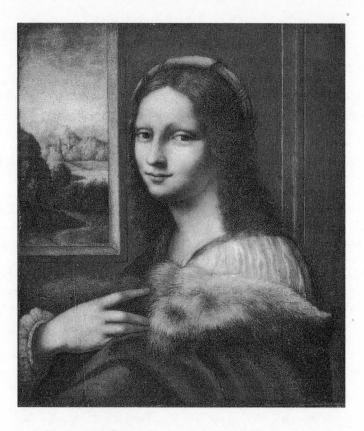

Illustration 41. School of Leonardo, *Portrait of a Woman after Sebastiano del Piombo*

through the movement of the body and the eyes? What does the glass ball tell us about Leonardo's image of the cosmos, and how does it fit into his ideas about the development of the world?

Increases in material value also have an impact on evaluations of the contents, resulting in changes in the overall impression of Leonardo's creations. This has particularly affected Leonardo's images of women. The paintings of women most recently attributed to him could not be further from his

requirement for pictures of attractive *belle donne* to seduce their viewers, involve them in an intimate dialogue, and provide them with a self-assured companion who is on an equal footing with them.

The one that corresponds most closely to this requirement is the portrait of a young woman in a fur-trimmed cloak, which can probably be attributed to the school of Leonardo (Ill. 41). She flirts rather shyly with the viewer, looking at him out of the corners of her eyes and pressing her mantle to her heart. All of this is an indirect reaction to Leonardo's painting of women. Apart from the head, the painter follows a portrait by Sebastiano del Piombo, which probably depicts Francesca Ordeaschi, the mistress of the banker Agostino Chigi (Ill. 39). This was Sebastiano's response to Leonardo's great portraits of noblemen's mistresses.[5]

In October 2013 amazing news appeared in Italian newspapers. Police officers specializing in art crime were mobilized to seize from a Swiss bank vault a national art treasure, which allegedly had been illegally taken from Italy.[6] Pictured with the article was a poorly executed painting modeled on Leonardo's drawing of the marchioness of Mantua, Isabella d'Este. At the time of the Counter-Reformation someone had painted a palm frond on it, to make the lady in the painting look like a saint (Ill. 42). In the opinion of an estimable expert on Leonardo, this work was the original portrait that was believed to have been lost. This would mean that Leonardo had not only sketched his portrait of Isabella d'Este (Plate 20), but also gone on to paint it, rather than keeping the noble lady waiting, as several of her agents reported.[7] And would the forthright Isabella, who desired nothing more ardently than a genuine work by Leonardo, really not have told anyone about it? Or could she have been embarrassed because the execution of this work could not compare with either the portrait of *Cecilia Gallerani* (Plate 17) or any other painting from Leonardo's own hand?

The attribution of the head of a girl known as the *Bella Principessa* (Plate 32)—which, to all appearances, might also originate from the nineteenth century—seems particularly disastrous. In 1998 the portrait was auctioned at Christie's for just $21,850. However, it has now been recognized by another well-known Leonardo expert as a portrait from Leonardo's hand of Ludovico Sforza's niece Bianca. Since then the work, which is now in private ownership, has been seen worldwide in exhibitions and promotional tours, and thus distorted Leonardo's great achievement—the invention of the psychological female portrait.[8]

Leonardo's original *Ginevra de' Benci* (Plate 9) turns toward the viewer and reacts to him emotionally, only to withdraw from him again. Thus, as a young

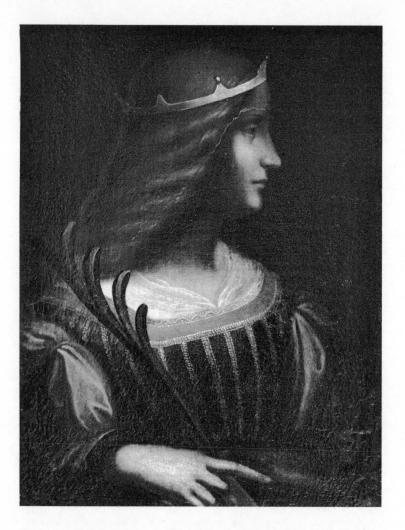

Illustration 42. Unknown artist, *Isabella d'Este with a Palm Frond*, private collection

man, Leonardo boldly broke with the convention that, for reasons of chastity, young Italian women should only be depicted in profile. He continued by giving women windblown hair, lithe bodies, deep eyes, powerful hands, and, in the case of the *Mona Lisa* (Plate 28), a half smile. Anyone who now attempts to foist off on the master a picture of an overdressed girl in full profile—and what is more, painted on parchment, which is extremely unusual—is ignorant of how radically Leonardo da Vinci had changed the view of women.

He saw the women of his day in a way they could not always see themselves—as free beings full of kinetic energy, as mothers and friends who were capable of loving, and as profound thinkers who knew about the powers of nature. In Leonardo's image of the world, female self-sacrifice is as rare as systematic depreciation. Together with his feminine models, he emancipated women in his own way, and then, at the end of his life, he also released men from their social constraints, by restoring sensitivity, love of nature, and seductive power to his figures of boys and young men.

The more his slim oeuvre is swollen by increasing numbers of dubious attributions, the more productive Leonardo da Vinci would have had to be five hundred years after his death, and the less remains of him, his aesthetic standards, and his special humanist view of the world. His art is in danger of turning into a matter of gross monetary value.

It is time to become better acquainted with the universal artist and to win back his paintings, drawings, and writings for a general social discussion of what is humanly possible and impossible. Leonardo can and must be the subject of dispute.

ACKNOWLEDGMENTS

I would like to thank the Kunsthistorisches Institut in Florence (Max-Planck-Institut) and the German study center in Venice (Centro Tedesco di Studi Veneziani) for research grants and the opportunity to present and discuss the results of this work. I wish to thank Dr. Bettina Keß, Susan Vahabzadeh, and Dr. Christine Walter for their critical reading. I would also like to thank all the employees in the archives, libraries, and museums I have consulted for their kind support.

Notes

Preface

1 See Chs. X and XX.

2 See Ch. V.

3 See Chs. V and VIII.

4 See Ch. VII.

5 See Ch. VII.

6 See Ch. X.

7 Quoted from Boris von Brauchitsch, *Leonardo da Vinci*, Berlin 2019, p. 951 (trans. from the German by Rae Walter, hereafter RW).

8 Cf. Martin Kemp, *Living with Leonardo: Fifty Years of Sanity and Insanity in the Art World and Beyond*, London 2018, p. 244.

I Childhood

1 The *Madonna of the Carnation* is in the Alte Pinakothek in Munich (inv. no. 7779).

2 Cf. Giorgio Vasari, *Leonardo da Vinci, Painter and Sculptor of Florence*, in *The Lives of the Painters, Sculptors and Architects*, trans. Gaston de Vere, intro. and notes David Ekserdjian, Everyman's Library, New York 1996 [hereafter *Leonardo*, trans. de Vere], vol. 1, p. 630; in the original: *Vita di Lionardo da Vinci. Pittore e scultore Fiorentino*, in *Le vite de' più eccellenti pittori, scultori e architettori nelle redazioni del 1550 e 1568* [hereafter *Vite*], vol. 4, ed. Rosanna Bettarini and Paola Barocchi, Florence 1976, pp. 14–38, at p. 23. See also David Alan Brown, *Leonardo da Vinci: Origins of a Genius*, New Haven and London

1998, p. 133. On the *Madonna of the Carnation*, see Cornelia Syre, Jan Schmidt, and Heike Stege (eds.), *Leonardo da Vinci. Die Madonna mit der Nelke*, Munich 2006, and Rona Goffen, "Mary's Motherhood according to Leonardo and Michelangelo," *Artibus et Historiae*, 20 (1999), pp. 35–69, at p. 40.

3 Cf. Giorgio Vasari, *Andrea Verrocchio, Painter, Sculptor and Architect of Florence*, in *Lives*, trans. de Vere, vol. 1, p. 552; original: *Vita di Andrea Verrocchio. Pittore, scultore et architetto Fiorentino*, in *Vite*, vol. 3, Florence 1971, pp. 532–45, at p. 539. Cf. also Brown, *Leonardo da Vinci*, p. 127.

4 Cf. Syre, Schmidt and Stege (eds.), *Leonardo da Vinci*, pp. 223f.; Andreas Schumacher, Annette Kranz, and Annette Hoyer (eds.), *Florentiner Malerei. Alte Pinakothek*, Berlin and Munich 2017, pp. 92ff. and 351ff. My thanks to Andreas Schumacher (Munich) and Cecilia Frosinini (Florence) for their helpful discussions regarding the problems of tempera and oil painting in fifteenth-century Florence.

5 Quoted from Leonardo da Vinci, *Sämtliche Gemälde und die Schriften zur Malerei*, ed. Andre Chastel, Munich 1990, p. 305 (trans. from the German by RW). In the original: "Come il buon pittore ha da dipingere due cose, l'uomo e la sua mente. Il bono pittore ha da dipingere due cose principali, cioè l'homo e il concetto della mente sua. Il primo è facile, il secondo difficile, perché si ha a figurare con gesti e movimento delle membra" (Leonardo da Vinci, *Trattato della Pittura* [1890], ed. Marco Tabarrini and Gaetano Milanesi, Rome 1989, no. 176, p. 73 [Codex Urbinas Latinus 1270]).

6 Leonardo da Vinci, *Study of a Young Woman with a Child*, pen and ink, London, British Museum, Department of Prints and Drawings (inv. no. 1913-6-17-1).

7 Translated by RW. In the original: "I putti piccoli con atti proti e storti, quado siedono, e nello star ritto atti timidi e pavrosi" (Jean Paul Richter [ed.], *The Notebooks of Leonardo da Vinci*, vol. 1, New York 1970, no. 583, p. 291 [Fragment, Codex Ashburnham, Paris, Bibliothèque de l'Institut de France, Ash. I. 18 a]).

8 Leonardo da Vinci, *Study of the Madonna and Child with a Cat*, pen and brown ink, London, British Museum, Department of Prints and Drawings (inv. no. 1856-6-21-1 r).

9 Cf. Kia Vahland, *Lorbeeren für Laura. Sebastiano del Piombos lyrische Bildnisse schöner Frauen*, Studi Reihe des Deutschen Studienzentrums Venedig, Berlin 2011, p. 183.

10 Cf. David Alan Brown (ed.), *Virtue and Beauty: Leonardo's Ginevra de' Benci and Renaissance Portraits of Women*, exh. cat., National Gallery of Art, Washington, DC, 2001, pp. 32 and 37.

11 On the *Madonna Litta*, see, e.g., the *Madonna Litta* by a pupil of Leonardo, Hermitage, St. Petersburg (inv. no. 249). Cf. Johannes Nathan and Frank Zöllner (eds.), *Leonardo da Vinci. Sämtliche Gemälde und Zeichnungen*, Cologne 2003, pp. 82ff. and 227.

12 Cf. Christiane Klapisch-Zuber, *Das Haus, der Name, der Brautschatz. Strategien und Rituale im gesellschaftlichen Leben der Renaissance*, Frankfurt am Main 1995, p. 94.

13 On breastfeeding, wet nurses, and raising children, cf. Klapisch-Zuber, *Das Haus, der Name, der Brautschatz*, pp. 94–119. See also: Sabine Seichter, *Erziehung an der Mutterbrust*, Weinheim 2014, pp. 42ff.; Wolfgang Kemp, *Die Räume der Maler. Zur Bilderzählung seit Giotto*, Munich 1996, pp. 47ff., 57ff., 68ff., and 74ff.; Goffen, "Mary's Motherhood," p. 40; Louis Haas, *The Renaissance Man and His Children: Childbirth and Early Childhood in Florence, 1300–1600*, New York 1998.

14 Cf. Klapisch-Zuber, *Das Haus, der Name, der Brautschatz*, p. 100.

15 Cf. Christoph Cluse, "Sklaverei im Mittelalter—der Mittelmeerraum. Eine kurze Einführung" (based on Jacques Heers, *Esclaves et domestiques au Moyen Âge dans le monde méditerranéen*, Paris 1981), in *Medieval Mediterranean Slavery: Comparative Studies on the Slave Trade in Muslim, Christian, and Jewish Societies (8th–15th Century)*, 2004, p. 12, available online at: http://med-slavery.uni-trier.de/minev/MedSlavery/publications/Einfuhrung.pdf (last accessed August 2018).

16 Cf. Giorgio Vasari, *Raffaello da Urbino, Painter and Architect*, in *Lives*, trans. de Vere, vol. 1, p. 711; '[. . .] e che più tosto ne' teneri anni aparasse in casa i costumi paterni che per le case de' villani e plebei uomini men gentili o rozzi costumi e creanze [. . .]' (Giorgio Vasari, *Vita di Raffaelo da Urbino. Pittore et architetto*, in *Vite*, vol. 4, Florence 1976, pp. 154–214, at pp. 156–7).

17 Cf. Giorgio Vasari, *Michelagnolo Buonarotti, Painter, Sculptor of Florence*, in *Lives*, trans. de Vere, vol. 2, p. 643; "[. . .] così come anche tirai dal latte della mia balia gli scarpegli e 'l mazzuolo con che io fo le figure [. . .]" (Giorgio Vasari, *Vita di Michelagnolo Buonarroti Fiorentino. Pittore, scultore et architetto*, in *Vite*, vol. 6, Florence 1987, pp. 2–41, at p. 5).

18 Leonardo developed the composition of the *Madonna of the Carnation* further in a playful way, especially in the painting known as the *Madonna Benois* after a later owner (now in the Hermitage in St. Petersburg, inv. no. 2773), a painting probably created in the 1470s. Cf. Nathan and Zöllner (eds.), *Leonardo da Vinci*, ibid., pp. 217 and 318ff.

19 For the reconstruction of Caterina's family history, cf. Martin Kemp and Giuseppe Pallanti, *Mona Lisa: The People and the Painting*, Oxford 2017, pp. 85ff. Evidence in favor of the fact that this woman by the name of Caterina Lippi was the Caterina whom Leonardo's grandfather Antonio named as the boy's mother is that after her marriage Caterina still kept in contact with the distant cousin who had been important to her in her childhood and with his children, and named one of her daughters after his wife. Cf. ibid., pp. 93ff. The notion that Caterina came from a good but impoverished family of small farmers is consistent with the 1540 statement by Leonardo's first biographer, the so-called Anonimo Gaddiano: "Era per madre nato di bon sangue" [His mother was of good family] (Anonimo Fiorentino, *Il Codice Magliabechiano*, cl. XVII 17, ed. Carl Frey, Berlin 1892, pp. 110–15, at p. 110).

20 Sigmund Freud discusses Leonardo's loss of his mother in a virtuoso study that is nonetheless questionable from the point of view of both history and art history, though he was not yet aware of the sources of information about Caterina. Cf. Sigmund Freud, *Leonardo da Vinci and a Memory of His Childhood* (1910), ed. James Strachey, trans. Alan Tyson (repr. edn.), New York 1989.

21 Evidence in favor of this is that Caterina is described as a Florentine in the Milan register of deaths and as supposedly sixty years old—which approximately matches his mother's real age of fifty-eight years. Cf. Kemp and Pallanti, *Mona Lisa*, pp. 98–9.

22 On illegitimate children in Florence, cf., fundamentally, Thomas Kuehn, *Illegitimacy in Renaissance Florence*, Michigan 2002, especially pp. 134ff.

23 Cf. Kemp and Pallanti, *Mona Lisa*, p. 84. See below, Ch. XI.

24 When Leonardo was eleven years old, Albiera gave birth to a half sister who died in the first month of her life. One year later Albiera died at the end of a second pregnancy. Cf. Kemp and Pallanti, *Mona Lisa*, p. 62.

25 "Ora i cani ànno si sottilissimo odorato che col naso sentono la uirtù rimasta in tali
feccie; e che sie uero, se le trova per le strade odorano, e se vi sentono dentro virtù di
carne o d'altro, essi le pigliano, e se nò, le lasciano; e per tornare al quesito dico, che
se conoscono il cane mediante tali odori essere ben pasciuto, essi lo riguardano, per-
chè stimano quello avere potete e ricco padrone [. . .]" (Jean Paul Richter [ed.], *The
Notebooks of Leonardo da Vinci*, vol. 2, New York 1970, no. 1330, p. 377 [Manuscript F,
Paris, Bibliothèque de l'Institut de France, F. 47 a]).

26 Cf. Kemp and Pallanti, *Mona Lisa*, p. 86.

27 Cf. Vasari, *Leonardo*, trans. de Vere, p. 626.

28 In the original: "So bene che per non essere io literato, che alcuno prosuntuoso gli
para ragionevolmente potermi biasimare coll'allegare jo essere homo sanza lettere"
(Richter [ed.], *The Notebooks of Leonardo da Vinci*, vol. 1, New York 1970, no. 10, p. 14
[Codex Atlanticus, Milan, Biblioteca Ambrosiana, C. A. 117 b]); "le mie cose essere
nate sotto la senplice e mera sperientia la quale è maestra vera" (ibid., no. 12, p. 15
[Codex Atlanticus, Milan, Biblioteca Ambrosiana, C. A. 117 b]); "Costoro vanno
sgonfiati e poposi, vestiti e ornati no delle loro ma delle altrui fatiche, e le mie a me
medesimo no conciedono e se me inventore disprezzeranno quato magiormente
loro non inventori [. . .] E' ànno da essere giudicati e non altrementi stimati li omini
inventori interpetri tralla natura e gli omini a comparatione de recitatori e trobetti
dell' altrui opere [. . .]" (ibid., no. 11, p. 15 [Codex Atlanticus, Milan, Biblioteca
Ambrosiana, C. A. 115a]); "farò come colui il quale per povertà givgnie l'ultimo
alla fiera [. . .] io questa disprezata" (ibid., no. 9, p. 13 [Codex Atlanticus, Milan,
Biblioteca Ambrosiana, C. A. 117 b]).

29 Quoted from Leonardo da Vinci, *Die Aphorismen, Rätsel und Prophezeiungen*, ed. Marianne
Schneider, Munich 2003, pp. 65 and 67 (Codex Atlanticus, Milan, Biblioteca
Ambrosiana, C. A. 944v and 945r) (trans. from the German by RW); Margot and
Rudolf Wittkower, *Künstler—Außenseiter der Gesellschaft*, Stuttgart 1989, pp. 92ff. (trans.
from the German by RW); cf. also: *La passione dell'anjama chaccja via la lussuria* (Jean
Paul Richter and Carlo Pedretti [eds.], *The Literary Works of Leonardo da Vinci*, vol. 2,
Berkeley and Los Angeles 1977, p. 113 [Codex Atlanticus, Milan, Biblioteca
Ambrosiana, C. A. 358 v-a]).

II Boyhood in the Country

1 For the essentials of the economy of Florence, see Richard A. Goldthwaite, *The Economy of Renaissance Florence*, Baltimore 2009.

2 On Florentine city life in the time of Leonardo, see Nicholas A. Eckstein, *The District of the Green Dragon*, Florence 1995. On artists' workshops in Florence, see Anabel Thomas, "The Workshop as the Space of Collaborative Artistic Production," in Robert J. Crum and John T. Paoletti (eds.), *Renaissance Florence: A Social History*, Cambridge and New York 2006, pp. 415–30.

3 Cf. Vasari, *Leonardo*, trans. de Vere, pp. 628–9; Vasari, *Vita di Lionardo da Vinci*, at pp. 19–22.

4 Cf. Vasari, *Leonardo*, trans. de Vere, p. 24. "Questa opera serve per quel che ella è fatta. Pigliatela dunque e portatela, ché questo è il fine che dell'opere s'aspetta," quoted from *Vita di Lionardo da Vinci*, pp. 19–22.

5 On Vasari's literary reinvention of the *Lives*, cf. Paul B. Barolsky, *Warum lächelt Mona Lisa? Vasari's Erfindungen*, Berlin 1996, and "Vasari and the Historical Imagination," *Word & Image*, 3 (1999), pp. 286–91; Svetlana Alpers, "Ekphrasis and Aesthetic Attitudes in Vasari's Lives," *Journal of the Warburg and Courtauld Institutes*, 23 (1960), pp. 190–215.

6 Verrocchio later placed the head of Goliath between David's feet; originally it was next to the boy's right leg. For essential information about the sculpture, now in the Bargello Museum in Florence (inv. no. Bargello n. 450, 45), see Beatrice Paolozzi Strozzi and Maria Grazia Vaccari (eds.), *Il Bronzo e l'oro. Il David del Verrocchio restaurato*, Florence et al. 2003, pp. 35–54, 55–60, and 61–80. On Leonardo as the model for the bronze, cf. Brown, *Leonardo da Vinci*, pp. 8ff.

7 The *Baptism of Christ* by Andrea del Verrocchio and Leonardo da Vinci is now in the Uffizi in Florence (inv. no. 1890 n. 8358).

8 The painting dating from around 1470 is in the National Gallery in London (inv. no. NG 781). Cf. also Brown, *Leonardo da Vinci*, pp. 47ff.

9 See Vasari, *Leonardo*, trans. de Vere, p. 627; Vasari, *Vita di Lionardo da Vinci*, at p. 18.

10 Cf. Richter (ed.), *The Notebooks of Leonardo da Vinci, vol. 2*, no. 1363, p. 414 (Codex Atlanticus, Milan, Biblioteca Ambrosiana, C. A. 658 a/199 v.). This was the starting point for Freud's study *Leonardo da Vinci and a Memory of His Childhood*; see also Alessandro Nova, "The Kite, Envy and a Memory of Leonardo da Vinci's Childhood," in Lars R. Jones and Louisa C. Matthew (eds.), *Coming About*, Cambridge, MA, 2001, pp. 381–6.

11 Translated by Richter (ed.), *The Notebooks of Leonardo da Vinci, vol. 1*, no. 662, p. 332 (Codex Forster III, London, Victoria and Albert Museum, formerly S. K. M. III. 48 a); in the original (ibid.): "Il dipintore disputa e gareggia colla natura." And translated by Richter (ed.), *The Notebooks of Leonardo da Vinci, vol. 1*, no. 652, p. 336 (Fragment, Codex Ashburnham, Paris, Bibliothèque de l'Institut de France, Ash. I 1 15 b); original (ibid.): "Se tu sprezzerai la pittura, la quale è sola imitatrice di tutte l'opere evidenti di natura, per certo tu sprezzerai una sottile invenzione, la quale con filosofica e sottile speculazione considera tutte le qualità delle forme: mare, siti, piante, animali, erbe, fiori, le quali sono cite d'onbra e lume. E veramente questa è scietia, e legittima figliuola di natura, perchè la pittura è partorita da essa natura; ma per dir piú corretto, diremo nipote di natura, perchè tutte le cose evidenti sono state partorite dalla natura, dalle quali cose è nata la pittura. Aduque rettamete la dimaderemo nipote di natura, parete di dio." On Leonardo's vegetarianism, see Ch. XII.

12 Cf. Mary D. Garrard: "Leonardo da Vinci: Female Portraits, Female Nature," in Norma Broude and Mary D. Garrard (eds.), *The Expanding Discourse: Feminism and Art History*, New York 1992, pp. 59–86.

13 Leonardo's *Annunciation* is in the Uffizi in Florence (inv. no. 1890 n. 1618). Cf., among others, Brown, *Leonardo da Vinci*, pp. 75ff.

14 For example, in the drawing of the *Flood* in the Royal Collection, Windsor (inv. no. RCIN 912.383). See also Ch. X.

15 Cf. Michael Baxandall, *Painting and Experience in Fifteenth-Century Italy*, Oxford 1972, pp. 51ff.

16 The *Annunciation* by Simone Martini and Lippo Memmi is in the Uffizi in Florence (inv. no. 1890 nn. 451, 452, 453).

17 Quoted from Brown (ed.), *Virtue and Beauty*, p. 17.

18 Quoted from Charles Nicholl (ed.), *Leonardo da Vinci: The Flights of the Mind*, London 2004, p. 85. In the original: "[C]ome io vidi a questi giorni un angelo che pareva nel suo annunziare che volesse cacciare la Nostra Donna dalla sua camera, con movimenti che dimostravano tanto d'ingiuria, quanto far si potesse a un vilissimo nimico. E la Nostra Donna parea che si volesse, come disperata, gettarsi giù da una finestra. Sicchè siati a memoria di non cadere in tali difetti" (da Vinci, *Trattato della Pittura*, no. 55, p. 37 [Codex Urbinas Latinus 1270]).

19 Cf. Natalie Tomas, "Did Women Have a Space?" in Crum and Paoletti (eds.), *Renaissance Florence*, pp. 311–30, at p. 313.

20 Cf. pp. 313 and 318; also Brown (ed.), *Virtue and Beauty*, p. 26.

21 Quoted (English translation: RW) from Leonardo, *Sämtliche Gemälde*, ed. Chastel, pp. 165–6; in the original: "La deità che ha la scienza del pittore fa che la mente del pittore si trasmuta in una similitudine di mente divina; imperocchè con libera potestà discorre alla generazione di diverse essenze di varî animali, piante, frutti, paesi, campagne, ruine di monti, luoghi paurosi e spaventevoli, che danno terrore ai loro risguardatori, ed ancora luoghi piacevoli, soavi e dilettevoli di fioriti prati con varî colori, piegati da soavi onde de' soavi moti de' venti [. . .]" (da Vinci, *Trattato della Pittura*, no. 65, p. 41 [Codex Urbinas Latinus 1270]).

22 In the original and in English translation: "Così accade a quelli che dalla vita soletaria cotenplativa vogliono venir abitare nelle città infra i popoli pieni d'infiniti mali" (Richter [ed.], *The Notebooks of Leonardo da Vinci, vol. 2*, no. 1272, p. 339 [Codex Atlanticus, Milan, Biblioteca Ambrosiana, C. A. 516 b]).

23 Cf. Alessandro Nova, "Addj 5 daghossto 1473: l'oggetto e le sue interpretazioni," in Fabio Frosini and Alessandro Nova (eds.), *Leonardo da Vinci on Nature: Knowledge and Representation*, Venice 2015, pp. 285–302.

24 In the original: "Che ti muove, o uomo, ad abbandonare le proprie tue abitazioni della città, e lasciare i parenti ed amici, ed andare in luoghi campestri per monti e valli, se non la naturale bellezza del mondo, la quale, se ben consideri, sol col senso del vedere fruisci? [. . .] Ma se il pittore ne' freddi e rigidi tempi dell'inverno ti pone innanzi i medesimi paesi dipinti, ed altri, ne' quali tu abbia ricevuto i tuoi piaceri, appresso a qualche fonte; tu possa rivedere te amante con la tua amata, ne' fioriti prati, sotto le dolci ombre delle verdeggianti piante, non riceverai tu altro piacere che ad udire tale effetto descritto dal poeta?" (da Vinci, *Trattato della Pittura*, no. 19, pp. 13ff. [Codex

Urbinas Latinus 1270]). See also Leonardo da Vinci, *Das Buch von der Malerei nach dem Codex Vaticanus (Urbinas) 1270, vol. 1*, ed. Heinrich Ludwig, Vienna 1882, p. 26; Martin J. Kemp, *Lezioni dell'Occhio*, Milan 2004, p. 164.

III A City of Images

1 Cf. Andreas Tönnesmann, *Die Kunst der Renaissance*, Munich 2007, pp. 25ff.; Kia Vahland, "Die dritte Dimension," *Geo Epoche Edition*, 3 (2011), pp. 26–37.

2 Cf. Erwin Panofsky, *Perspective as Symbolic Form*, New York 1991.

3 Cf. Tönnesmann, *Die Kunst der Renaissance*, pp. 18ff.

4 Quoted from Giannozzo Manetti, *Über die Würde und Erhabenheit des Menschen*, ed. August Buck, Hamburg 1990, p. 77 (translated from the German by RW).

5 "[. . .] quasi giudicato un'altro iddio," quoted from Hubert Janitschek (ed.), *Kleinere kunsttheoretische Schriften*, Vienna 1877, p. 91 (trans. RW). On Augustius, cf. Erwin Panofsky, "Artist, Scientist, Genius Notes on the 'Renaissance-Dämmerung,'" in *The Renaissance: Six Essays*, New York 1962, pp. 123–82, at p. 171.

6 Ch. VI.

7 Cf. Frank Büttner, *Giotto und die Ursprünge der neuzeitlichen Bildauffassung*, Darmstadt 2013, pp. 8 and 18–19.

8 Giotto's *Descent from the Cross* is in the Scrovegni Chapel in Padua.

9 Cf. Nicholas Mann, *Petrarch*, Oxford and New York 1984, pp. 46ff.

10 Cf. Daniela Bohde, *Haut, Fleisch und Farbe: Körperlichkeit und Materialität in den Gemälden Tizians*, Emsdetten and Berlin 2002, pp. 116ff.

11 Cf. Vahland, *Lorbeeren für Laura*, pp. 3ff. and 57.

12 Cf. Arnold Esch, "Über den Zusammenhang von Kunst und Wirtschaft in der italie-
nischen Renaissance—ein Forschungsbericht," *Zeitschrift für historische Forschung*, 8:2
(1981), pp. 179–222.

13 Cf. Giorgio Vasari, *Filippo Brunelleschi, Sculptor and Architect*, in *Lives*, trans. de Vere, vol. 1,
p. 327 and *Donato, Sculptor of Florence*, in *Lives*, trans. de Vere, vol. 1, p. 363; "Vita
di Filippo Brunelleschi. Scultore et architetto," in *Vite*, vol. 3, Florence 1971, pp.
136–98, at p. 141.

14 Donatello's *David* is now in the Bargello Museum in Florence (inv. no. Bargello
n. 95 B). Cf. also Ulrich Pfisterer, *Donatello und die Entdeckung der Stile 1430–1445*,
Munich 2002, p. 336.

15 Cf. Tönnesmann, *Die Kunst der Renaissance*, pp. 19ff.

16 Vasari described the opposition that Brunelleschi had to overcome in Florence. Cf.
Vasari, *Brunelleschi*, trans. de Vere, pp. 324–63; "Vita di Filippo Brunelleschi,"
pp. 136–80.

17 Cf. Vasari, *Brunelleschi*, trans. de Vere, p. 350; "Vita di Filippo Brunelleschi," p. 180.

18 For basic essentials on Lorenzo de' Medici, see Ingeborg Walter, *Der Prächtige. Lorenzo
de' Medici*, Munich 2003, pp. 66ff. Cf. also Richard C. Trexler, *Public Life in Renaissance
Florence*, New York 1980, pp. 220ff. and 394ff.

19 Cf. Volker Reinhardt, *Geschichte von Florenz*, Munich 2014, pp. 66ff.

20 This refers to Anonimo Gaddiano. Cf. Anonimo Fiorentino, *Il Codice Magliabechiano*,
p. 110.

21 The early biographer Anonimo Gaddiano describes Leonardo's taste in fashion thus:
"Era di bella persona, proportionata, gratiata et bello aspetto. Portaua un pitoccho
rosato, corto sino al ginocchio, che allora s'usauano I vestirj lunghj. Haueua fino
al mezzo in petto una bella capellaia et inanellata et ben composta" (Anonimo
Fiorentino, *Il Codice Magliabechiano*, p. 115). On Leonardo's penchant for rosewater
and lavender, cf. Leonardo da Vinci, *Tagebücher und Aufzeichnungen*, ed. Theodor
Lücke, Leipzig 1952, p. 912 (trans. by RW). Vasari also praised Leonardo's hand-
some appearance, Cf. Vasari, *Leonardo*, trans. de Vere, pp. 625 and 639; "Vita di
Lionardo da Vinci," pp. 15 and 37.

IV Games of Love

1 Cf. *Lucrezia Tornabuoni, Lettere*, ed. Patrizia Salvadoro, Florence 1993, pp. 62ff.

2 Cf. *Luigi Pulci, Opere minori*, ed. Paolo Orvieto, Milan 1986, p. 64. Cf. also Lucia Ricciardi, *"Col senno, col tesoro e colla lancia." Riti e giochi cavallereschi nella Firenze del Magnifico Lorenzo*, Florence 1992, pp. 166ff.

3 Cf. Aby Warburg, "Delle 'Imprese Amorose' nelle più antiche incisioni fiorentine" (1905), in *Die Erneuerung der Heidnischen Antike. Kulturwissenschaftliche Beiträge zur Geschichte der europäischen Renaissance, vol. 1* (Gesammelte Schriften, vol. 1.1), ed. Horst Bredekamp, Michael Diers, and Ulrich Pfisterer, Berlin 1998, pp. 77–87, at pp. 83–4.

4 Cf. Ingeborg Walter and Roberto Zapperi, *Das Bildnis der Geliebten*, Munich 2007, pp. 38–9.

5 Cf. Walter, *Der Prächtige*, p. 73.

6 On the eyewitness reports, cf. Ricciardi, *"Col senno, col tesoro e colla lancia,"* pp. 167ff.

7 Cf. Paola Ventrone (ed.), *Le Temps revient, 'l tempo si rinuova. Feste e spettacoli nella Firenze di Lorenzo il Magnifico*, Milan 1992, p. 183. Cf. Walter, *Der Prächtige*, pp. 89–90 and 306.

8 The list of Verrocchio's works that were not paid for by Lorenzo can be found in Paolozzi Strozzi and Vaccari (eds.), *Il Bronzo e l'oro*, p. 83.

9 Cf. Walter, *Der Prächtige*, p. 91.

10 Cf. Ricciardi, *"Col senno, col tesoro e colla lancia,"* p. 167.

11 Cf. Francesco Caglioti, "Donatello, i Medici e Gentile de' Becchi, un po' d'ordine intorno alla Giuditta (e al David) di Via Larga," *Prospettiva*, 80 (1995), pp. 15–58, at p. 42. Ulrich Pfisterer, *Donatello und die Entdeckung der Stile 1430–1445*, pp. 336ff.

12 Cf. Adrian W. B. Randolph, "Donatellos David. Politik und der homosoziale Blick," in Mechthild Fend and Marianne Koos (eds.), *Männlichkeit im Blick. Visuelle Inszenierungen in der Kunst seit der Frühen Neuzeit*, Cologne et al. 2004, pp. 35–52. Randolph describes the homosocial, not necessarily also homosexual, view in Florence as a constituent

of male society. Cf. also Adrian W. B. Randolph, *Engaging Symbols: Gender, Politics, and Public Art in Fifteenth-Century Florence*, New Haven and London 2002, pp. 139–92.

13 The inscription on the statue in the courtyard of the Medici reads: "Victor est quisquis patriam tuetur. / Frangit immanis Deus hostis iras. / En puer grandem domuit tiramnum. / Vincite, cives!" (quoted from Francesco Caglioti, *Donatello e i Medici, storia del David e della Giuditta*, vol. 2, Florence 2000, p. 397); English translation: "The victor is he who defends the country. God crushed the wrath of a huge enemy. Behold a boy has defeated a great tyrant. Conquer O Citizens" (quoted in Andrew Butterfield, *The Sculptures of Andrea del Verrocchio*, New Haven and London 1997, p. 30).

14 Cf. ibid., pp. 48–9.

15 Cf. Michael Rocke, *Homosexuality and Male Culture in Renaissance Florence*, New York et al. 1996, p. 155.

16 Cf. Randolph, *Donatello's David*, at p. 44.

17 Cf. Trexler, *Public Life in Renaissance Florence*, pp. 379ff.; Rocke, *Homosexuality and Male Culture in Renaissance Florence*, pp. 36ff.

18 Cf. Rocke, *Homosexuality and Male Culture in Renaissance Florence*, pp. 3ff. and 13.

19 E.g. Vasari's description of Leonardo's pupil Salaì: *Leonardo*, trans. de Vere, pp. 644–5; *Vita di Lionardo da Vinci*, pp. 28–9.

20 Cf. Rocke, *Homosexuality and Male Culture in Renaissance Florence*, pp. 4 and 237ff.

21 Cf. p. 198.

22 Cf. pp. 198–9.

23 This refers to the drawing *Angelo incarnato*, now in a private collection. Cf. Carlo Pedretti, *Leonardo da Vinci. The "Angel in the Flesh" and Salaì*, Florence 2009, pp. 66ff. and 78ff. See Ch. XII.

24 In the original: "Fid. Gli facesti forsi il gioco, che tanto ameno I fiorentini, di dretto? Leo. E quante volte! Considera che egli era uno bellissimo giovane, e massimo ne'

quindici anni. Fid. Non hai vergogna a dir questo? Leo. Come vergogna? Non è cosa di maggior lode, appresso a virtuosi, di questo, a che egli si sia il vero te lo dimostrerò con bonissime ragioni. [. . .] sappi che l'amore masculino è opera sollamente di virtù che, congiugendo insieme gli uomini, con diverse affezioni di amicizia, acciò che da una età tenera vengano nella virile piú fortificati amici.; oltre di ciò l'amore masculino fu precetto laudabile di animo filosofico [. . .]" (Gian Paolo Lomazzo, "Il libro dei sogni," in *Scritti d'arte*, vol. 1, ed. Roberto Paolo Ciardi, Florence 1973, p. 104) (translated by RW).

25 "L'amore fa venire de questi caprizzi," Lomazzo, "Il libro dei sogni," pp. 19–20 (translated by RW).

26 The fantasy of sex change is not unusual in the literature of the Early Renaissance. For instance, in the fourteenth century the poet Antonio Pucci—whose works Leonardo may have known—tells the story of a maiden who was transformed into a man with the help of the Archangel Gabriel. Cf. Pedretti, *Leonardo da Vinci*, p. 68.

27 Rocke gives the source from the State Archive of Florence: "Ufficiali di notte e conservatori dei monastery," 18 (2), 46v. Cf. Rocke, *Homosexuality and Male Culture in Renaissance Florence*, p. 298.

28 Cf. Rocke, *Homosexuality and Male Culture in Renaissance Florence*, p. 298.

29 Cf. Charles Nicholl, *Leonardo da Vinci: The Flights of the Mind*, London 2005 (pbk edn.), pp. 114–16 and 131–2.

30 Translation proposed by Nicholl, ibid., p. 121 (the handwriting is almost illegible). In Italian the sentence following Nicholl's transcription therefore would read: "Quando io feci Domeneddio putto, voi mi metteste in prigione, ora s'io lo fo grande, voi mi farete peggio." It is also conceivable that here Leonardo is relating the time when he himself was young ("essendo putto") and "you put me in prison" to his adult self, which is now threatened by something worse ("Quado io feci bene, essendo putto, voi mi mettesti in prigione, ora s'io lo fo grade, voi mi farete peggio"); in this form quoted from Richter (ed.), *The Notebooks of Leonardo da Vinci, vol. 2*, no. 1364, p. 414 (Codex Atlanticus, Milan, Biblioteca Ambrosiana, C. A. 248.a/737.a). For the various possible readings, see also Nino Smiraglia Scognamiglio, *Ricerche e documenti sulla giovinezza di Leonardo da Vinci*, Naples 1900, p. 49.

31 Cf. Vasari, *Leonardo*, trans. de Vere, p. 627; *Vita di Lionardo da Vinci*, at p. 18.

32 Cf. Rocke, *Homosexuality and Male Culture in Renaissance Florence*, p. 40. For a model of the sexual organs in the Renaissance, according to which the vagina was thought of as an inward-turned penis, cf. Thomas Lacqueur, *Auf den Leib geschrieben*, Munich 1996, pp. 117ff.

33 Cf. Brown (ed.), *Virtue and Beauty*, p. 27.

34 Drawings of the sexual act in vertical section, RCIN 919.096r and RCIN 919.097v (Ill. 8), Royal Collection, Windsor; and drawing of the muscle mechanism of the apertures of the body, RCIN 919.095r, ibid.

35 Cf. Nicholl, *Leonardo da Vinci*, pp. 438–43.

36 Cf. da Vinci, *Tagebücher und Aufzeichnungen*, p. 32; in the original, "Latto del coito ellj mebri acquello adoperatj son dj tanta bruttura chesseno fussj le belleze de uoltj/ ellj ornametj dellj opratj ella (s)frenata djspositione la natura perderebbe la spetie vmana." English translation: Richter and Pedretti [eds.], *The Literary Works of Leonardo da Vinci*, vol. 2, p. 112 [RCIN 919.009r, Royal Collection, Windsor].

37 This is written on a sheet of anatomical drawings dating from c.1506–8 in the Schlossmuseum Weimar (inv. no. KK 6287r, Klassik Stiftung Weimar, Graphische Sammlungen). Translation quoted from Nicholl, *Leonardo da Vinci*, p. 27. In the original: "Lomo che vsa il choito cho chotetione e djsagio fa figlioli ira chudj e cqujsstionevoli. Esse il choito si fara co grade amore e gradesiderio delle parti allora il figliolo fia dj grade intelletto esspirituoso e vivacie e amorevole" (Richter and Pedretti [eds.], *The Literary Works of Leonardo da Vinci, vol. 2*, p. 110).

38 Cf. Vahland, *Lorbeeren für Laura*, pp. 57ff. and 203.

39 On the tournament of 1475, cf. Giovanni Poggi, "La Giostra Medicea del 1475 e la 'Pallade' del Botticelli," *L'Arte*, 5 (1902), pp. 71–7; Ricciardi, 'Col senno, col tesoro e colla lancia,' pp. 174–86; Walter, *Der Prächtige*, pp. 131ff.

40 Here I have followed David Alan Brown, who considers that the sketch in the Uffizi is a design for the tournament of 1475, not 1469. Cf. Brown, *Leonardo da Vinci*, p. 124. The banner is mentioned in the list of the debts owed to Verrocchio by the Medici that was drawn up by Verrocchio's brother.

41 Cf. Brown, *Leonardo da Vinci*, pp. 127–8.

42 Cf. ibid., pp. 124ff.

43 Leonardo da Vinci's drawing *Star of Bethlehem* is in the Royal Collection in Windsor (inv. no. RCIN 912.424).

44 Cf. Elizabeth Cropper, "The Beauty of Women: Problems in the Rhetoric of Renaissance Portraiture," in Margaret W. Ferguson, Maureen Quilligan, and Nancy J. Vickers (eds.), *Rewriting the Renaissance: The Discourses of Sexual Difference in Early Modern Europe*, Chicago 1986, pp. 175–90.

45 Cf. Ricciardi, *"Col senno, col tesoro e colla lancia,"* p. 190.

46 Cf. ibid., pp. 177–8 and 179.

47 Cf. Andreas Schumacher (ed.), Botticelli, *Bildnis, Mythos, Andacht*, exh. cat. Städelmuseum Frankfurt am Main, 2009, pp. 35–6, 59–60, and 152ff.

48 Leonardo da Vinci, *Sämtliche Gemälde*, pp. 210ff.; Nicholl, *Leonardo da Vinci*, p. 85. See Ch. VI.

49 Sandro Botticelli's portrait of Simonetta is now in the Städelmuseum Frankfurt (inv. no. 93).

50 Cf. Ricciardi, *"Col senno, col tesoro e colla lancia,"* p. 180.

51 Cf. Schumacher (ed.), *Botticelli*, pp. 35 and 61.

52 Cf. Walter, *Der Prächtige*, p. 161.

V The First Key Work: Mountain Tigress

1 Translation quoted from Nicholl, *Leonardo da Vinci*, p. 110. In the original: "Chieggio merzede e sono alpestro tygre." Cf. Christiane Hessler, *Zum Paragone, Malerei, Skulptur und Dichtung in der Rangstreitkultur des Quattrocento*, Berlin 2014, p. 594.

2 Leonardo's painting of Ginevra de' Benci is in the National Gallery of Washington (inv. no. 1967.6.1.a).

3 This is evident from Leonardo da Vinci's Codex Atlanticus (Milan, Biblioteca Ambrosiana, C. A. 120 r.); cf. Hessler, *Zum Paragone*, p. 489.

4 The Medici's personal humanist, Marsilio Ficino, was given a valuable Plato codex by Amerigo de' Benci. Cf. Alessandro Cecchi, "New Light on Leonardo's Florentine Patrons," in Carmen Bambach (ed.), *Leonardo da Vinci: Master Draftsman, vol. 1*, New York 2003, pp. 121–39, in particular p. 129. On the Benci family, see Istituto della Enciclopedia Italiana (ed.), *Dizionario Biografico degli Italiani*, vol. 8, Rome 1966, p. 182 (on Ginevra's father Amerigo and her brother Giovanni), pp. 194ff. (on Ginevra's grandfather Giovanni di Amerigo), and pp. 193–4 (on Ginevra).

5 Cf. Mary D. Garrard, "Who Was Ginevra de' Benci? Leonardo's Portrait and Its Sitter Recontextualized," *Artibus et Historiae*, 53 (2006), pp. 23–56, in particular pp. 43–4, and 51; Saundra Lynn Weddle, "'Tis Better to Give than to Receive: Client–Patronage Exchange and Its Architectural Implications at Florentine Convents," in Peter Howard (ed.), *Studies on Florence and the Italian Renaissance in Honour of F. W. Kent*, Turnhout 2016, pp. 295–313.

6 Cf. Walter and Zapperi, *Das Bildnis der Geliebten*, p. 45.

7 Cf. Weddle, "'Tis Better to Give than to Receive," at pp. 298–9; see also Garrard, "Who Was Ginevra de' Benci?" at pp. 43–4 and 51. I do not accept Garrard's theory that Ginevra stayed in Le Murate from 1478 to 1480, i.e. before her husband's death, as it is based only on Lorenzo de' Medici's two poems that are said to refer to Ginevra, though this is dubious, as Hessler explains. The anecdotal tale that a Ginevra had played with the Medici heirs as a child and that it actually refers to Ginevra de' Benci is equally questionable. Cf. Hessler, *Zum Paragone*, pp. 481–2. On Le Murate convent, cf. Megan Holmes, "Giovanni Benci's Patronage of the Nunnery Le Murate," in Giovanni Ciapelli and Patricia Lee Rubin (eds.), *Art, Memory, and Family in Renaissance Florence*, Cambridge 2000, pp. 114–34. For a critique of Garrard theory that Ginevra had deliberately turned her back on the world and therefore withdrew into the convent, cf. Marco Faini, "Per Bernardo Bembo poeta. Un possibile scambio poetico con Ginevra de' Benci," in *Albertiana*, 19 (2016), pp. 147–61.

8 Cf. Giustina Niccolini, *The Chronicle of Le Murate*, ed. Saundra Lynn Weddle, Toronto 2011, pp. 81–2.

9 Cf. Brown (ed.), *Virtue and Beauty*, pp. 36–7. The guide to etiquette *Decor puellarum*, printed in Venice in 1471, instructs girls not to look even their parents, brothers over seven years old, or their father confessor in the eye. On the rules of eye contact in Renaissance books on manners, cf. Anne Christine Junkerman, *Bellissima Donna: An Interdisciplinary Study of Venetian Sensuous Half-Length Images of the Early Sixteenth Century*, Berkeley 1988.

10 One example of a female portrait in profile is Piero del Pollaiuolo's *Portrait of a Young Lady*, now in the Berlin Gemäldegalerie (inv. no. 1614). On representation in profile in bridal portraits of the Florentine Renaissance, cf. Patricia Simons, "Women in Frames: The Gaze, the Eye, the Profile in Renaissance Portraiture," in Broude and Garrard (eds.), *The Expanding Discourse*, pp. 39–57. Brown (ed.), *Virtue and Beauty* has a wealth of examples.

11 In 1472 in Florence a law on luxury was issued that limited the wearing of the dowry to a period of three years after the wedding. It was customary to immortalize the jewelry in the wedding picture; this also suggests that Leonardo could not have painted Ginevra's portrait on the occasion of her marriage to Luigi Niccolini. Cf. Adrian W. B. Randolph, "Performing the Bridal Body in Fifteenth-Century Florence," *Art History*, 2 (1998), pp. 182–97, at p. 189.

12 Cf. Hessler, *Zum Paragone*, p. 594; Carlo Carnesecchi, "Il ritratto Leonardesco di Ginevra Benci," *Rivista d'Arte*, 6 (1909), pp. 291–6; John Walker, "Ginevra de' Benci by Leonardo da Vinci," in *Report and Studies in the History of Art, National Gallery of Art*, Washington 1967, pp. 1–38; Brown, *Leonardo da Vinci*, p. 104. There is no surviving record of the musician's name.

13 Cf. Hessler, *Zum Paragone*, pp. 604ff. and 670 (trans. from the German by RW).

14 On January 20, 1530, Pietro Bembo wrote in a letter to Vittoria Colonna that she was more excellent by nature than one would think a member of the female sex was entitled to be. Paolo Giovio acknowledged the poetess's "virile ingegno" and "virile decus"—her manly genius and manly dignity. Cf. Sylvia Ferino-Pagden (ed.), *Vittoria Colonna. Dichterin und Muse Michelangelos*, exh. cat., Kunsthistorisches Museum Wien, Vienna 1997, p. 173. Michelangelo masculinized the poetess Vittoria Colonna, "A man in a woman, or rather a god, who speaks through her mouth" (trans. from the German by RW).—"Un uomo in una donna, anzi uno dio, per la sua bocca parla." Cf. Vahland, *Lorbeeren für Laura*, p. 157.

15 On the other hand, it was customary for women to write pious texts; cf. Brown (ed.), *Virtue and Beauty*, p. 37. On Sappho, cf. Hessler, *Zum Paragone*, pp. 605ff.

16 The portrait of a woman by Petrus Christus is now in the Berlin Gemäldegalerie. It is likely that in the 1460s he painted the portrait of a member of the English Talbot family. Cf. Brown, *Leonardo da Vinci*, pp. 110–11 and Brown (ed.), *Virtue and Beauty*, p. 70.

17 Quoted from Leonardo da Vinci, *Sämtliche Gemälde*, p. 138 (trans. from the German by RW). Concerning the eye, "O eccellentissimo sopra tutte le altre cose create da Dio! […] Questo è finestra dell'umano corpo, per la quale la sua via specula, e fruisce la bellezza del mondo; per questo l'anima si contenta dell'umana carcere, e senza questo essa umana carcere è suo tormento" (da Vinci, *Trattato della Pittura*, no. 24, p. 18 [Codex Urbinas Latinus 1270 15 v–16 r]).

18 Sandro Botticelli's portrait is in the Victoria and Albert Museum in London (inv. no. CAI.100). Cf. Brown (ed.), *Virtue and Beauty*, pp. 70–71, cat. no. 25.

19 The bust is in the Bargello Museum in Florence (inv. no. Bargello n. 1159). Cf. Brown (ed.), *Virtue and Beauty*, cat. no. 22; Jeanette Kohl, "Splendid Isolation. Verrocchios Mädchenbüsten—eine Betrachtung," in Barbara Mikuda-Hüttel, Richard Hüttel, and Jeannette Kohl (eds.), *Re-Visionen. Zur Aktualität der Kunstgeschichte*, Berlin 2002, pp. 49–76.

20 In the original: "Quella figura non sarà laudabile s'essa, il più che sarà possibile, non esprimerà coll' atto la passione dell' animo suo" (Da Vinci, *Trattato della Pittura*, no. 364, p. 124 [Codex Urbinas Latinus 1270]) (trans. by RW). See also Ch. VII.

21 Technical investigations have provided information on the working process; in particular x-ray and infrared images have revealed underlying drawing, painting, and pentimenti. Cf. Elizabeth Walmsley, "Leonardo's Portrait of Ginevra de' Benci: A Reading of the X-Radiographs and Infrared Reflectographs," in Michel Menu (ed.), *Leonardo da Vinci's Technical Practice: Paintings, Drawings and Influence*, Paris 2014, pp. 56–71; Brown, *Leonardo da Vinci*, pp. 113ff.

22 On pentimento, cf. Brown, *Leonardo da Vinci*, pp. 113ff.

23 Cf. Brown (ed.), *Virtue and Beauty*, p. 90.

24 Cf. Garrard, "Leonardo da Vinci," at p. 74.

25 Cf. Leonardo da Vinci, *Sämtliche Gemälde*, p. 147.

26 Cf. Daniel Arasse, *Leonardo da Vinci*, Cologne 2002, pp. 316–18; cf. Walmsley, "Leonardo's Portrait of Ginevra de' Benci," at pp. 68ff.

27 The study of a woman's hands is in the Royal Collection, Windsor, England (RCIN 912.558). Cf. Brown, *Leonardo da Vinci*, pp. 106ff.

28 I have followed the approach of Elizabeth Cropper, who discerns in Leonardo da Vinci´s portraits of women and their successors a Petrarchan idea of the relationship between picture and viewer, modeled on Petrarch´s ambivalent relationship to Laura, who as a character of his writings is portrayed intimately and yet remains unattainable. Cf. Cropper, "The Beauty of Women," at pp. 175–90.

29 Here Leonardo placed himself in tradition of satirical anti-Petrarchism. The words are to be found in the Codex Trivulziano (Milan, Castello Sforzesco, Tr. F 1 r): "Sel petrarcha amò si forte il lauro fu perché glie bon fralla salsicia e tor(do) i non posso di lor giance far tesauro." Cf. Luca Beltrami, *Il codice di Leonardo da Vinci nella Biblioteca Trivulzio*, Milan 1891, p. 8.

30 Cf. in the first place Jennifer Flechter, "Bernardo Bembo and Leonardo's Portrait of Ginevra de' Benci," *The Burlington Magazine*, 12 (1989), pp. 811–16.

31 The term "platonic love" goes back to Marsilio Ficino, and the Florentine circle of those years. Cf. Erwin Panofsky, *Problems in Titian: Mostly Iconographic*, New York 1969, p. 109.

32 Hans Memling's portrait of a man (now in the Royal Museum of Fine Arts in Antwerp, inv. no. 5) is probably of Bernardo Bembo. Cf. Caroline Elam, "Bernardo Bembo and Leonardo's Ginevra de' Benci. A Further Suggestion," in Guido Beltramini, Howard Burns, and Davide Gasparotto (eds.), *Pietro Bembo e le arti*, Vicenza 2013, pp. 407–20, at p. 411. For his biography, see Nella Giannetto, *Bernardo Bembo. Umanista e Politico Veneziano*, Florence 1985.

33 Cf. ibid., pp. 127–8.

34 In his letter of reply to Bernardo Bembo, the humanist and follower of Ficino, Giovanni Aurelio Augurelli, summarized Bembo's questions about the picture in this way. Cf. Ricciardi, *"Col senno, col tesoro e colla lancia,"* p. 182.

35 Giovanni Aurelio Augurelli replied to Bembo's questions about the banner motifs, "Multi multa ferunt, eadem sententia nulla est, Pulchrius est pictus istud imaginibus" (Hessler, *Zum Paragone*, pp. 345 and 1088 (trans. from the German by RW); see also Ricciardi, *"Col senno, col tesoro e colla lancia,"* p. 182).

36 Cf. Walter and Zapperi, *Das Bildnis der Geliebten*, p. 42.

37 On the concept of *sprezzatura*, see also Ch. XII.

38 Quoted from Hessler, *Zum Paragone*, p. 666 (trans. by RW).

39 Ibid., p. 667 (trans. by RW).

40 Ibid., p. 668 (trans. by RW).

41 Ibid., pp. 657–8.

42 Cf. Vahland, *Lorbeeren für Laura*, pp. 68ff.

43 Hessler, *Zum Paragone*, p. 670 (trans. by RW).

44 Ibid., p. 670 (trans. by RW).

45 Ibid., p. 659 (trans. by RW).

46 This concerns the Carte Strozziane in the Florentine State Archive, published by the Italianist Marco Faini. Cf. "Per Bernardo Bembo poeta."

47 "Che sanza te il piacer mi fia gran guerra." And, "Madonna se conforto / Da voi presto non viene / Mi troverrete morto / Et sarò fuor di pene" (ibid., p. 160).

48 "Io so ben ch' egl'è vero che tu m'onori / Cho' tuoi be' versi c'ònne gran piacere / Perché 'nostri son chasti e degni amori" (ibid., p. 161; trans. by RW).

49 "Per forza e per ragion convien ch'i t'ami" (ibid.; trans. by RW).

50 "Che bisogna, Signor, tanto lamento? / Io non n'ò già piacer del tuo gran male / Se tu se' in dolor, e io in tomento: / Sanza faticha mai su non si sale. / Amor nel petto mio non fia mai spento / Ma' l piangere e'l doler(e) poco ci vale. / Ch'a morte molte già ne son venute / Pensiamo addunque alla comun salute" (ibid.; trans. by RW).

51 Cf., among others, Patricia Simons, "Portraiture, Portrayal, and Idealization: Ambiguous Individualism in Representations of Renaissance Women," in Alison Brown (ed.), *Language and Images of Renaissance Italy*, Oxford 1995, pp. 263–311, at p. 310.

52 Francesco Petrarca [Petrarch], *Canzoniere* (ca. 1330–62), ed. Ernst-Jürgen Dreyer, Basel and Frankfurt am Main 1990, Sonnets 77 and 78, pp. 236 and 243.

53 This was also an obvious idea to him, because, years before, Lorenzo de' Medici had also commissioned the portrait—later lost—of his admired Lucrezia Donati from the workshop of the master Andrea del Verrocchio. In the list of claims drawn up by Verrocchio's brothers after his death in order to go to court to recover the debts owed to the artist by the Medici, an image on wood of the head of Lucretia de' Donati is also mentioned. This probably corresponds to a sonnet by Lorenzo de' Medici to Lucrezia, entitled "Sonnet, written in front of a small panel, on which a woman was depicted" (cf. Walter and Zapperi, *Das Bildnis der Geliebten*, pp. 39–40).

54 Cf. Garrard, "Who Was Ginevra de' Benci?," in particular pp. 28ff. and 37–8.

55 Cf. Brown, *Leonardo da Vinci*, pp. 117ff.

56 Bembo may have been inspired by the Greek poetess Sappho, whose works (or those that were ascribed to her at the time) he had read. The Roman poet Ovid quoted her in a letter supposedly written by her that surfaced in the early fifteenth century with the words "When you read my works I appeared *formosa* [beautiful] to you." Bernardo was aware of this letter and, probably mistakenly, believed it to be an original letter from Sappho. Leonardo may also have known the Ovid text, as his master Andrea del Verrocchio also owned a copy. One more thing that Ovid believed he knew was that Sappho had renounced jewels and worn a simple dress. No more adornment was necessary; her writings and her character made her beautiful. Leonardo's Ginevra does the same in her portrait. See (also for the quotations) Hessler, *Zum Paragone*, pp. 425, 427, 608ff and 613–14.

57 Da Vinci, *Sämtliche Gemälde*, pp. 144–5 (trans. from the German by RW); "composto bugiardo" and "composto finto" (idem, *Trattato della Pittura*, no. 28, p. 21 [Codex Urbinas Latinus 1270]).

58 Leonardo da Vinci, *Sämtliche Gemälde*, pp. 142ff. (trans. from the German by RW); "e fa esso poeta e similtudine di un bel volto, il quale ti si mostra a membro a membro, che così facendo non rimarresti mai satisfatto della sua bellezza, la quale solo consiste nella divina proporzionalità delle predette membra insieme composte, le quali solo in un tempo compongono essa divina armonia di esso congiunto di membra, che spesso tolgono la libertà posseduta a chi le vede" (idem, *Trattato della Pittura*, no. 28, p. 21 [Codex Urbinas Latinus 1270]). See also Claire J. Farago, *Leonardo da Vinci's Paragone: A Critical Interpretation with a New Edition of the Text in the Codex Urbinas*, Brill's Studies in Intellectual History 25, Leiden et al., 1992, no. 32, p. 248.

59 "Dammi cosa ch'io la possa vedere e toccare, e non che solamente la possa udire [. . .]" (da Vinci, *Trattato della Pittura*, no. 23, p. 17 [Codex Urbinas Latinus 1270]).

60 Leonardo da Vinci, *Sämtliche Gemälde*, pp. 144–5.

61 "E se il poeta dice di fare accendere gli uomini ad amare, che è cosa principale della specie di tutti gli animali, il pittore ha potenza di fare il medesimo, tanto più ch'egli mette innanzi all'amante la propria effigie della cosa amata, il quale spesso fa con quella, baciandola, e parlando con quella, quello che non farebbe con le medesime bellezze postegli innanzi dallo scrittore. E tanto più supera gl'ingegni degli uomini ad amare ed innamorarsi di pittura che non rappresenta alcuna donna viva" (da Vinci, *Trattato della Pittura*, no. 21, p. 16 [Codex Urbinas Latinus 1270]) (trans. from the German by RW).

62 Cf. Garrard, "Leonardo da Vinci," p. 60; Kia Vahland, "Der Kunstmensch als Maß der Dinge. Zur Utopie des idealen Körpers bei Leonardo da Vinci," in Kristine Hasselmann, Sandra Schmidt, and Cornelia Zumbusch (eds.), *Utopische Körper. Visionen künftiger Körper in Geschichte, Kunst und Gesellschaft*, Paderborn 2004, pp. 29–40.

63 Cf. Hessler, *Zum Paragone*, p. 488 ((trans. from the German by RW).

64 Anonimo Gaddiano considered the work to be so good that "it did not seem like a portrait but like Ginevra herself"—"Ritrasse in Firenze dal naturale la Ginevra d'Amerigho Benci, laquale tanto bene finì, che non il ritratto, ma la propria Ginevra pareua" (Anonimo Fiorentino, *Il Codice Magliabechiano*, at p. 111). Antonio Billi also

praised the realism of the work, and Giorgio Vasari called the portrait of Ginevra "beautiful." Cf. Vasari, *Leonardo*, trans. de Vere, pp. 635; *Vita di Lionardo da Vinci*, pp. 30–31.

65 Quoted from Brown (ed.), *Virtue and Beauty*, p. 26.

VI The Friend of Mary

1 Cf. Nathan and Zöllner (eds.), *Leonardo da Vinci*, p. 218; Brown, *Leonardo da Vinci*, p. 160.

2 Cf. Brown, *Leonardo da Vinci*, p. 154. Lorenzo di Credi's *Annunciation* predella is in the Louvre in Paris (inv. no. 1602 A [1265]). The bizarre argument over the attribution of Lorenzo di Credi's two predellas in the Louvre and in the Worcester Art Museum in Massachusetts (for the altarpiece from Pistoia) flared up in January 2018. Despite all the stylistic evidence to the contrary, Leonardo is still considered to be partly responsible for the work, especially by the Worcester Art Museum. Cf. Kia Vahland, "Heiliger da Vinci," *Süddeutsche Zeitung*, January 10, 2018, p. 9.

3 Cf. Brown, *Leonardo da Vinci*, pp. 147 and 151ff.

4 Cf. Brown, *Leonardo da Vinci*, p. 50; Eike Schmidt (ed.), *Il Cosmo Magico di Leonardo. L'Adorazione dei Magi restaurata*, exh. cat., Uffizi, Florence 2017, p. 29.

5 Cf. Vasari, *Leonardo*, trans. de Vere, p. 633; in the original: "e che il voler cercare sempre eccelenza sopra eccelenza e perfezzione sopra perfezzione ne fusse cagione [...]" (*Vita di Lionardo da Vinci*, p. 27). "Lionardo perche tanto penato[?]": Nicholl, *Leonardo da Vinci*, p. 154.

6 Cf. Brown, *Leonardo da Vinci*, p. 150; on Leonardo's postponing of work, see, e.g., Vasari, *Leonardo da Vinci*, trans. de Vere, pp. 627–8; *Vita di Lionardo da Vinci*, at pp. 25–6.

7 This can be seen from a report by Giovanbattista Giraldi and from Leonardo's notebooks. Cf. Vasari, *Leonardo*, trans. de Vere, pp. 630–1; *Vita di Lionardo da Vinci*, at p. 24.

8 Cf. Nicholl, *Leonardo da Vinci*, pp. 122, 126 and 127 (Codex Atlanticus, Milan, Biblioteca Ambrosiana, C. A. 1094 r and 394 r-b; 32 r and 9 r-b).

9 Cf. da Vinci, *Die Aphorismen, Rätsel und Prophezeiungen*, pp. 24–5, 95–6, 101, 104, and 122–3.

10 Leonardo da Vinci's drawings of a catapult and a war engine with sixteen crossbows are in the Biblioteca Ambrosiana in Milan (Codex Atlanticus, C. A. 182 a-r and 64 v-a; 182 b-r and 64 v-b).

11 Martin Warnke calls it Leonardo's "fantasies of power." Cf. idem, *Hofkünstler. Zur Vorgeschichte des modernen Künstlers*, Cologne 1996, p. 75. See also Ch. X.

12 Quoted from Nicholl, *Leonardo da Vinci*, p. 143. In the original: "In mezo di questa stanza è una gran tavola tutta piena di piegnatte, pignattine e coriguioli, còla, greta, pesce greca, cinabro, denti d'impiccati, radici e und base di zolfo lavorato al tornio; et sopra a la base è uno vaso di ambra gialla tutto votio, et dentro uno serpe con quatro gambe, il quale si mostra per miracolo" (Licia Brescia and Luca Tomio, "Tommasi di Giovanni Masini da Peretola detto Zoroastro. Documenti, fonti e ipotesi per la biografia del priscus magus allievo di Leonardo da Vinci," *Raccolta Vinciana* 28 [1999], pp. 63–77, at p. 70).

13 According to Vasari, Leonardo once fastened wings onto lizards using quicksilver. Cf. Vasari, *Leonardo*, trans. de Vere, p. 638; *Vita di Lionardo da Vinci*, at p. 34. See also Ch. XII.

14 Cf. da Vinci, *Tagebücher und Aufzeichnungen*, p. 662 (Codex Atlanticus, Milan, Biblioteca Ambrosiana, C. A. 346 r. a. / v. a.).

15 Quoted from Leonardo da Vinci, *Sämtliche Gemälde*, p. 165 (trans. from the German by RW). In the original: "Il pittore è padrone di tutte le cose che possono cadere in pensiero all'uomo, perciocchè s'egli ha desiderio di vedere bellezze che lo innamorino, egli è signore di generarle, e se vuol vedere cose mostruose che spaventino, o che sieno buffonesche e risibili, o veramente compassionevoli, ei n'è signore e creatore" (da Vinci, *Trattato della Pittura*, no. 9, p. 7 [Codex Urbinas Latinus 1270]).

16 Leonardo da Vinci's *Adoration of the Magi* is in the Uffizi in Florence (inv. no. 1890 n. 1594).

17 Cf. Schmidt (ed.), *Il Cosmo Magico di Leonardo*, pp. 27–8; Nathan and Zöllner (eds.), *Leonardo da Vinci*, pp. 49ff.

18 Cf. Schmidt (ed.), *Il Cosmo Magico di Leonardo*, p. 39. I would like to thank Roberto Bellucci and Cecilia Frosinini of the Opificio delle Pietre Dure in Florence for detailed consultations in connection with the restoration of the work, which was completed in 2017.

19 Cf. Schmidt (ed.), *Il Cosmo Magico di Leonardo*, pp. 35ff.

20 Cf. ibid., p. 27.

21 For the essentials, see Warnke, *Hofkünstler*.

22 Leonardo's possible letter of application in the original language can be found in Richter (ed.), *The Notebooks of Leonardo da Vinci, vol. 2*, no. 1340, pp. 395ff. (Codex Atlanticus, Milan, Biblioteca Ambrosiana, C. A. 382 a; 1182 a).

23 Giorgio Vasari and the biographer known as Anonimo Gaddiano who was active around 1540 maintain this, and the latter even states that Lorenzo de' Medici sent Leonardo with the lyre to the duke of Milan. Cf. Vasari, *Leonardo*, trans. de Vere, p. 631; *Vita di Lionardo da Vinci*, p. 24; Anonimo Fiorentino, *Il Codice Magliabechiano*, at p. 110.

24 The portrait of Leonardo and/or an assistant is in the Pinacoteca Ambrosiana in Milan (inv. no. 99). Cf. Luke Syson (ed.), *Leonardo da Vinci: Painter at the Court of Milan*, exh. cat., National Gallery, London 2011, pp. 24 and 97; on the reservations concerning attribution to Leonardo alone, cf. Nathan and Zöllner (eds.), *Leonardo da Vinci*, p. 225.

25 Cf. Vasari, *Leonardo*, trans. de Vere, p. 631, Syson (ed.), *Leonardo da Vinci*, p. 97 and cf. Giorgio Vasari, *Das Leben des Leonardo da Vinci*, ed. Alessandro Nova and Sabine Feser, Berlin 2006, p. 79.

26 Cf. Nathan and Zöllner (eds.), *Leonardo da Vinci*, p. 64.

27 Cf. Vasari, *Leonardo*, ed. Alessandro Nova and Sabine Feser, p. 79.

28 This refers to the *Virgin of the Rocks* in the Louvre in Paris (inv. no. 777).

29 "[. . .] e se tu dirai questa non esser virtù del pittore, ma propria virtù della cosa imitata, si risponderà che in questo caso la mente degli uomini può satisfare standosi

nel letto, e non andare, ne' luoghi faticosi e pericolosi, ne' pellegrinaggi, come al continuo far si vede. Ma se pure tali pellegrinaggi al continuo sono in essere, chi li muove senza necessità? Certo tu confesserai essere tale simulacro, il quale far non può tutte le scritture che figurar potessero in effigie e in virtù tale idea. Adunque pare ch'essa idea ami tal pittura, ed ami chi l'ama e riverisce, e si diletti di essere adorata più in quella che in altra figura di lei imitata [. . .]" (da Vinci, *Trattato della Pittura*, no. 4, p. 5, cf. also Syson [ed.], *Leonardo da Vinci*, p. 162 [Codex Urbinas Latinus 1270]).

30 Cf. Nathan and Zöllner (eds.), *Leonardo da Vinci*, pp. 77–8.

31 Cf. ibid., pp. 78 and 223.

32 Quoted and translated in Richter (ed.), *The Notebooks of Leonardo da Vinci, vol. 2*, no. 1339, p. 395: In Italian, ibid.: "e spesso piegandomi in qua e in là per vedere detro vi discernessi alcuna cosa, e questo vietatomi per la grande os.curità, che là entro era, e stato alquanto, subito s'alse in me due cose, paura e desiderio, paura per la minacciosa oscura spilonca, desiderò per vedere se là entro fusse alcuna miracolosa cosa" (Codex Arundel, London, British Library, Br. M. 155 a).

33 For the essentials of Leonardo's understanding of nature, cf. Alexander Perrig, "Leonardo, Die Anatomie der Erde," *Jahrbuch der Hamburger Kunstsammlungen*, 25 (1980), pp. 51–80.

34 Cf. ibid., p. 58; Nathan and Zöllner (eds.), *Leonardo da Vinci*, pp. 76–7.

35 Quoted and translated in Richter (ed.), *The Notebooks of Leonardo da Vinci, vol. 2*, no. 929, p. 179: "L'omo è detto da li antiqui mondo minore, e cierto la ditione d'esso nome è bene collocata, impero chè, siccome l'omo è composto di terra, acqua, aria e foco, questo corpo della terra è il simiglante. Se l'omo à in sé ossi, sostenitori e armadura della carne, il mondo à i sassi, sostenitori della terra; se l'omo à in sé il lago del sangue, dove crescie e discrescie il polmone nello alitare, il corpo della terra à il suo oceano mare, il quale ancora lui crescie e discrescie ogni sei ore per lo alitare del mondo. Se dal detto lago di sangue dirivano vene, che si vanno ramificando per lo corpo umano, similmente il mare oceano enpie il corpo della terra d'infinite vene d'acqua" (Manuscript A, Paris, Bibliothèque de l'Institut de France, A. 55 b).

36 Quoted from, Leonardo da Vinci, *Das Buch von der Malerei nach dem Codex Vaticanus (Urbinas) 1270*, vol. 1, no. 79, p. 68 (trans. from the German by RW). In the original:

"[. . .] come disse il nostro Botticella, che tale studio era vano, perchè col solo gettare di una spugna piena di diversi colori in un muro, essa lascia in esso muro una macchia, dove si vede un bel paese" (da Vinci, *Trattato della Pittura*, no. 57, p. 38 [Codex Urbinas Latinus 1270]).

37 Cf. Nathan and Zöllner (eds.), *Leonardo da Vinci*, p. 223.

38 These facts can be seen from a letter preserved in the Milan State Archive from the two artists to Ludovico Moro, printed in German translation in Marianne Schneider (ed.), *Leonardo da Vinci. Eine Biographie in Zeugnissen, Selbstzeugnissen, Dokumenten und Bildern*, Munich 2002, pp. 102–3.

39 How great a share Leonardo had in the panel is disputed, and also whether Ambrogio de Predis and/or another assistant was involved. The fact that the confraternity later waited for the final painting until Leonardo's return from Milan suggests that he was responsible for parts of it, yet, in view of the stylistic differences from the first version, it appears that he was not the only painter and that he had delegated large parts to others. Cf. Syson (ed.), *Leonardo da Vinci*, pp. 171–2; Nathan and Zöllner (eds.), *Leonardo da Vinci*, p. 229. Cf. Ch. X.

40 Cf. ibid., p. 229.

41 Leonardo da Vinci, *Tagebücher und Aufzeichnungen*, ed. Theodor Lücke, Leipzig 1952, pp. 84–5 (trans. from the German by RW).

42 Cf. Nathan and Zöllner (eds.), *Leonardo da Vinci*, pp. 400ff.

43 Leonardo's drawing of Vitruvian proportions is in Galleria d'Accademia in Venice (inv. no. 228).

44 See Nicholl, *Leonardo da Vinci*, pp. 202–3.

45 An ambassador by the name of Alamanni formulated Ludovico Sforza's doubts about Leonardo's skill in bronze casting in a letter to Lorenzo de' Medici, saying that Il Moro was not sure whether Leonardo would be able to bring the work to a successful conclusion. Cf. Nicholl, *Leonardo da Vinci*, p. 248.

VII The Second Key Work: Beauty and the Beast

1 Cf. Krystyna Moczulska, "The Most Graceful Gallerani and the Most Exquisite Galée in the Portrait of Leonardo da Vinci," *Folia Historiae Artium*, 1 (1995), pp. 55–86, at p. 83. For the basic essentials on weasel fashions and symbolism in Italy, cf. Jacqueline Marie Musacchio, "Weasels and Pregnancy in Renaissance Italy," *Renaissance Studies*, 15 (2001), pp. 172–87.

2 Cf. Syson (ed.), *Leonardo da Vinci*, p. 122; Moczulska, "The Most Graceful Gallerani," p. 83.

3 Leonardo's study of an ermine as a symbol of purity is in the Fitzwilliam Museum, Cambridge, UK (PD. 120-1961).

4 Cf. Garrard, "Leonardo da Vinci," p. 65.

5 On the history of the research on the panel in the Czartoryski Museum, Kraków, cf. Syson (ed.), *Leonardo da Vinci*, pp. 111ff. The Leonardo Research Project headed by Martin Kemp has carried out a technical examination of the work. Leonardo's fingerprints were found on the head of the ermine and of Cecilia. The background was originally lighter, and the ermine was smaller. Cf. www.universalleonardo.org (last accessed, September 2018).

6 Cf. Vahland, *Lorbeeren für Laura*, pp. 118–22.

7 Cf. Ingeborg Walter and Roberto Zapperi, *Das Bildnis der Geliebten*, Munich 2007, pp. 69ff.

8 Cf. Timothy McCall, "Traffic in Mistresses: Sexualised Bodies and Systems of Exchange in the Early Modern Court," in Allison Levy (ed.), *Sex Acts in Early Modern Italy: Practice, Performance, Perversion, Punishment*, Farnham 2010, pp. 125–36, in particular pp. 130ff.

9 Cf. Schneider (ed.), *Leonardo da Vinci: Eine Biographie in Zeugnissen, Selbstzeugnissen, Dokumenten und Bildern*, p. 89.

10 Cf. Walter and Zapperi, *Das Bildnis der Geliebten*, pp. 59–60.

11 "Malo mori quam foedari." The court poet Bernardo Bellincioni now called his master "Black Moor, white ermine," a play on words on the nickname Il Moro and his dark and light sides. Cf. Syson (ed.), *Leonardo da Vinci*, p. 111.

12 Cf. Syson (ed.), *Leonardo da Vinci*, p. 111.

13 For example, a birth platter by Masaccio (c. 1427, Gemäldegalerie der Staatlichen Museen zu Berlin, Preußischer Kulturbesitz, Id. no. 58C), cf. Musacchio, "Weasels and Pregnancy in Renaissance Italy," pp. 179ff. Among others, the Renaissance writers Marsilio Ficino and Benedetto Varchi assumed that the visual impressions received by a pregnant woman affected her baby. Cf. Jacqueline Marie Musacchio, "Imaginative Conceptions in Renaissance Italy," in Geraldine A. Johnson and Sara F. Matthews Grieco (eds.), *Picturing Women in Renaissance and Baroque Italy*, Cambridge 1997, pp. 42–60, at p. 48; Jacqueline Marie Musacchio, *The Art and Ritual of Childbirth in Renaissance Italy*, New Haven and London, 1999, p. 129.

14 "[. . .] quae quia mendaci parientem iuverat ore, ore parit nostrasque domos, ut et ante, frequentat." Translation from Ovid, *Metamorphoses*, trans. and ed. David Raeburn, London 2004, p. 355.

15 In *De generatione animalium* Aristotle contradicted the natural philosophers who had claimed that weasels give birth through the mouth. Cf. Aristotle, *De generatione animalium*, ed. Wilhelm von Moerbeke, Turnhout 2011, 6/756b; Maurizio Bettini, *Nascere. Storie di donne, donnole, madri ed eroi*, Turin 1998, pp. 153–4 and 172ff.; Moczulska, "The Most Graceful Gallerani," p. 82.

16 For Leonardo's use of Aristotle cf. Garrard, "Leonardo da Vinci," pp. 68–9.

17 Leonardo's conception of a nature that is creative and has female connotations also had philosophical precursors from Plato to Cicero. Cf. Garrard, "Leonardo da Vinci," pp. 68–9.

18 Cf. Garrard, "Leonardo da Vinci," pp. 69ff. and 83.

19 The same was true of the *Virgin of the Rocks* (Plate 15), in which the artist visualized the supposed system of subterranean veins of water and mountain lakes—the earth's circulatory system—before he found words to explain it. Cf. Nathan and Zöllner (eds.), *Leonardo da Vinci*, p. 77.

20 Cf. Elizabeth Cropper, "The Beauty of Women," pp. 175–90, in particular pp. 189 and 358. The topos of the woman who is dangerous because she is unattainable goes back mainly to Petrarch.

21 "Quella figura non sarà laudabile s' essa, il più che sarà possibile, non esprimerà coll' atto la passione dell' animo suo" (da Vinci, *Trattato della Pittura*, no. 364, p. 124 [Codex Urbinas Latinus 1270]). See also Ch. V.

22 See the sheet in the Royal Collection (RCIN 912.513, Windsor Castle, Royal Library); cf. Syson (ed.), *Leonardo da Vinci*, pp. 114ff. (cat. 13).

23 Leonardo da Vinci's study of a young woman is in the Biblioteca Reale in Turin (inv. no. 15.572 r.).

24 Leonardo da Vinci's study of Mary Magdalene is in the Courtauld Gallery, London (D.1978.PG80), cf. Syson (ed.), *Leonardo da Vinci*, pp. 108–9 (cat. 9).

25 Cf. Schneider (ed.), *Leonardo da Vinci: Eine Biographie in Zeugnissen, Selbstzeugnissen, Dokumenten und Bildern*, pp. 88–9; Garrard, "Leonardo da Vinci," p. 64.

26 Cf. Janice Shell and Grazioso Sironi, "Cecilia Gallerani, Leonardo's Lady with an Ermine," *Artibus et Historiae*, 25 (1992), pp. 47–66, at pp. 49–50.

27 Cf. Nicholl, *Leonardo da Vinci*, p. 227.

28 Cf. Walter and Zapperi, *Das Bildnis der Geliebten*, pp. 67ff.; Syson (ed.), *Leonardo da Vinci*, pp. 111 and 124.

29 Cf. Syson (ed.), *Leonardo da Vinci*, p. 111.

30 Translations from Nicholl, *Leonardo da Vinci*, p. 321. Original in full: "[. . .] più voluntiera lo mandaria quanto asimigliasse a me, e non creda già la S. V. che proceda per difecto del maestro che in vero credo non se truova allui un paro, ma solo è per esser fatto esso ritratto in una éta si imperfecta che io ho poi cambiata tutta quella effigie, talmente che vedere epso et me tutto insieme non è alchuno che lo giudica esser fatto per me" (Shell and Sironi, "Cecilia Gallerani," pp. 49–50).

31 Cf. Vahland, *Lorbeeren für Laura*, p. 121.

32 Leonardo da Vinci, *Sämtliche Gemälde*, p. 146 (trans. from the German by RW). "Quante pitture hanno conservato il simulacro di una divina bellezza di cui il tempo o morte in breve ha distrutto il naturale esempio, ed è restata più degna l'opera del pittore che della natura sua maestra!" (da Vinci, *Trattato della Pittura*, no. 26, p. 19 [Codex Urbinas Latinus 1270]).

33 Cf. Pietro Ghinzoni, "Lettera inedita di Bernardo Bellincioni," *Archivio storico Lombardo*, XVI (1889), pp. 417–18. Translation from Nicholl, *Leonardo da Vinci*, p. 228.

34 "Chi lei vedrà così, benchè sia tardo / Vederla viva, dirà: basti a noi / comprender or quel che è natura et arte" (Shell and Sironi, "Cecilia Gallerani," p. 49; trans. by RW).

35 ". . .con sua pittura / La fa che par che ascolti, e non favella" (ibid.).

36 "Se risponder savesse a' detti miei!"; for Petrarch's sonnets on paintings nos. 77 and 78 in the *Canzoniere*, cf. Petrarch, *Canzoniere*, pp. 236 and 243. Translation by RW.

VIII Belligerence and Sensuality

1 Cf. Schneider (ed.), *Leonardo da Vinci: Eine Biographie in Zeugnissen, Selbstzeugnissen, Dokumenten und Bildern*, pp. 93–4 and 98.

2 Ibid., pp. 93–4. Leonardo's note summing up Salaì translated by RW.

3 Cf. Nathan and Zöllner [eds.], *Leonardo da Vinci*, p. 135; in the original: "[. . .] e similmente ogni parte di bono e di tristo che aì in te, si dimostrerà in parte in nelle tue figure" (Richter [ed.], *The Notebooks of Leonardo da Vinci, vol. 1*, no. 586, p. 293 [Fragment, Codex Ashburnham, Paris, Bibliothèque de l'Institut de France, Ash. I. 8 b]).

4 Cf. Leonardo da Vinci, *Sämtliche Gemälde*, pp. 130 and 160 (trans. from the German by RW) (Manuscript L, Paris, Bibliothèque de l'Institut de France, L 94 r.; Codex Arundel, London, British Library, Ar. 229 v.).

5 Cf. Vasari, *Leonardo*, trans. de Vere, pp. 634–5; Lomazzo, "Il libro dei sogni," pp. 104–5. See above, Ch. IV.

6 Cf. Vasari, *Leonardo*, ed. Alessandro Nova and Sabine Feser, p. 100; Nicholl, *Leonardo da Vinci*, p. 276.

7 Leonardo da Vinci's *Saint Jerome* is in the Vatican Museums (inv. no. 40 337). The painting is often dated to the first Florentine period. I support the contrary argument of the 2011 Leonardo exhibition in the National Gallery, London, that dates the work to the period between 1488 and 1490 in Milan, on the grounds that Leonardo's male figures from this time reflect his growing interest in anatomy; in addition, the painting is on walnut wood, which is typical of Milan. Cf. Syson (ed.), *Leonardo da Vinci*, pp. 136–41.

8 Cf. Kenneth Clark, "The Drawings of Leonardo da Vinci in the Collection of Her Majesty the Queen at Windsor Castle," London 1968, no. 12.692 r., p. 174. Nicholl, *Leonardo da Vinci*, p. 163.

9 On Savonarola, cf. Lauro Martines, *Scourge and Fire: Savonarola in Renaissance Italy*, London 2007.

10 Here I support the argument of Ulrich Rehm, who refers to the documented differences between Sandro Botticelli and his brother Simone, thus contradicting Vasari's representation that Botticelli was an adherent of Savonarola. Cf. Ulrich Rehm, *Botticelli. Der Maler und die Medici*, Stuttgart 2009, pp. 207ff. and 215ff.; Schumacher (ed.), *Botticelli*, pp. 132ff.

11 Cf. Schumacher (ed.), *Botticelli*, pp. 124–5.

12 Cf. Reinhardt, *Geschichte von Florenz*, pp. 88ff.

13 In 1452 Giannozzo Manetti had already referred to the privilege enjoyed by humankind as a result of being made in the image of God, cf. idem, *Über die Würde und Erhabenheit des Menschen*, p. 32.

14 Leonardo da Vinci's *Last Supper* is still to be found in the church of Santa Maria delle Grazie in Milan.

15 Leonardo described in his notes a number of gestures and conversations that he noted in preparation for the *Last Supper*. And Giambattista Giraldi Centhio noted down the observations of his father, Cristoforo Giraldi, a historian who knew Leonardo well. Cf. Schneider (ed.), *Leonardo da Vinci: Eine Biographie in Zeugnissen, Selbstzeugnissen, Dokumenten und Bildern*, pp. 117–18.

16 Matthew 26:21.

17 Leonardo's enthusiastic work on the scaffolding was reported by Matteo Bandello, nephew of the prior and future monk who lived in the Dominican monastery. Giambattista Giraldi Centhio passed on the monks' grievances. Cf. Schneider (ed.), *Leonardo da Vinci: Eine Biographie in Zeugnissen, Selbstzeugnissen, Dokumenten und Bildern*, pp. 118–23.

18 This refers to the historian Cristoforo Giraldi, whose memories of his time with Leonardo were passed on by his son Giambattista Giraldi Centhio. The word-for-word quotations in the following come from this report. Quoted from Schneider (ed.), *Leonardo da Vinci: Eine Biographie in Zeugnissen, Selbstzeugnissen, Dokumenten und Bildern*, pp. 118–21 (trans. from the German by RW). In the original in Carlo Pedretti, *Documenti e memorie riguardanti Leonardo da Vinci a Bologna e in Emilia*, Bologna 1953, no. 1554, pp. 213ff., Vasari refers to the source in his life of Leonardo in order to emphasize how Leonardo spoke to Duke Ludovico Sforza as to an equal. Cf. Vasari, *Leonardo*, trans. de Vere, p. 632, and Vasari, *Leonardo*, ed. Alessandro Nova and Sabine Feser, pp. 29 and 85–6. *Vita di Lionardo da Vinci*, p. 26.

19 On Cristoforo Giraldi's statements, cf. Schneider (ed.), *Leonardo da Vinci: Eine Biographie in Zeugnissen, Selbstzeugnissen, Dokumenten und Bildern*, p. 121. Cf. Vasari, *Leonardo*, trans. de Vere, p. 632; *Vita di Lionardo da Vinci*, p. 26.

20 Cf. Claudia Bertling Biaggini, *Sebastiano del Piombo—Felix Pictor*, Hildesheim 2016, pp. 107ff.

21 See Ch. V.

22 Cf. Syson (ed.), *Leonardo da Vinci*, p. 124.

23 Cf. Garrard, "Leonardo da Vinci," pp. 65ff.

24 Leonardo da Vinci's portrait of a woman known as *La Belle Ferronnière* is in the Louvre (no. 778). It is evidently made from wood of the same tree as the panel on which the picture of Cecilia Gallerani is painted. Cf. Nathan and Zöllner (eds.), *Leonardo da Vinci*, p. 228.

25 Petrarch, "[. . .] quando i' fui preso, et non me ne guardai, / che i be' vostr' occhi, Donna, mi legaro" and "Io avrò sempre in odio la fenestra / onde Amor m'aventò già mille strali," Petrarch, *Canzoniere*, pp. 10–11 and 254. Cf. also Kemp and Pallanti, *Mona Lisa*, pp. 153ff.

26 Cf. Vahland, *Lorbeeren für Laura*, pp. 67ff.

27 Cf. Schneider (ed.), *Leonardo da Vinci: Eine Biographie in Zeugnissen, Selbstzeugnissen, Dokumenten und Bildern*, pp. 133 and 137–8.

28 Cf. Vasari, *Leonardo*, trans. de Vere, p. 633; *Vita di Lionardo da Vinci*, pp. 27–8.

29 "Caterina de Florentia" is listed in the register of deaths on July 26, 1494. This corresponds to Leonardo's list of Caterina's funeral costs. Cf. Martin Kemp and Giuseppe Pallanti, *Mona Lisa*, pp. 98–9.

30 Cf. Schneider (ed.), *Leonardo da Vinci: Eine Biographie in Zeugnissen, Selbstzeugnissen, Dokumenten und Bildern*, pp. 137–8; Nicholl, *Leonardo da Vinci*, p. 322.

31 Cf. Garrard, "Leonardo da Vinci," p. 65.

IX Pose or Poetry

1 Cf. Schneider (ed.), *Leonardo da Vinci: Eine Biographie in Zeugnissen, Selbstzeugnissen, Dokumenten und Bildern*, pp. 142ff.; Simonetta Rasponi (ed.), *Leonardo & Venice*, exh. cat., Palazzo Grassi, Venice, Milan 1992, pp. 25ff.

2 Cf. Francis Ames-Lewis, *Isabella and Leonardo: The Artistic Relationship between Isabella d'Este and Leonardo da Vinci, 1500–1506*, New Haven and London 2012, pp. 2ff., 7–8, 9–10, 11–12, 16, and 101ff.

3 On March 27, 1501, Isabella praised Leonardo in a letter for his sweet, sympathetic style that matched his nature. Cf. Ames-Lewis, *Isabella and Leonardo*, p. 117.

4 Cf. ibid., p. 141.

5 Cf. ibid., pp. 23, 28ff. and 236ff.

6 Cf. ibid., p. 108.

7 On portraits in profile, cf. Simons, "Women in Frames," pp. 39–57; Berthold
Hinz, "Studien zur Geschichte des Ehepaarbildnisses," *Marburger Jahrbuch für
Kunstwissenschaft*, 19 (1974), pp. 139–218; John Shearman, *Only Connect . . . Art and the
Spectator in the Italian Renaissance*, Washington, DC 1988.

8 Cf. Ames-Lewis, *Isabella and Leonardo*, pp. 5 and 106ff. See also Ch. V.

9 Cf. Ames-Lewis, *Isabella and Leonardo*, pp. 101 and 116. The first portrait sketch is prob-
ably the version in the Louvre, Paris (M.I.753), which is—despite the anatomical
inconsistency of the right arm—by far the most mature version of the much-copied
composition. Cf. Nathan and Zöllner (eds.), *Leonardo da Vinci*, p. 236.

10 The version of Isabella d'Este's portrait with the parapet and book is in the
Ashmolean Museum, Oxford.

11 It can be seen from the written sources that Isabella d'Este kept a drawing—probably
the first one—that her husband later gave away. One of her correspondents saw a
different version in Leonardo's workshop in Venice, as is shown in a letter of March
13, 1500. It is not certain whether this is the copy in Oxford. Cf. Ames-Lewis,
Isabella and Leonardo, pp. 101 and 116ff.

12 On the bleaching of hair, cf. Emil Schaeffer, *Die Frau in der venezianischen Malerei*, Munich
1899, p. 58; on hairpieces, cf. Junkerman, *Bellissima Donna*, p. 197; on courtesans, cf.
Patricia Fortini Brown, *Art and Life in Renaissance Venice*, New York 1997, pp. 157ff.;
Patricia Simons, "Portraiture, Portrayal, and Idealization," p. 296. A decree was issued
in 1543, lamenting the fact that courtesans dressed as elegantly as gentlewomen (*gentil-
donne*), so that they were indistinguishable from one another in the streets and churches
(cf. ibid.). Representations of courtesans in expensive clothes can be found in the later
engravings of Cesare Vecellio, cf. Rosita Levi Pisetzky, *Storia del Costume in Italia, vol. 3*,
Milan 1966, p. 64. An example of the inventory, including art, of a Venetian courtesan
can be found in Patricia Fortini Brown, *Private Lives in Renaissance Venice*, New Haven
and London 2004, p. 175.

13 Cf. Sylvia Ferino-Pagden and David Alan Brown (eds.), *Bellini, Giorgione, Tizian und die
Renaissance der venezianischen Malerei*, exh. cat., National Gallery, Washington, DC, and
Kunsthistorisches Museum, Vienna, Milan 2006, pp. 6–7.

14 Cf. Norbert Huse and Wolfgang Wolters, *Venedig. Die Kunst der Renaissance. Architektur, Skulptur, Malerei 1460–1590*, Munich 1996, pp. 226ff; Fortini Brown, *Private Lives in Renaissance Venice*, pp. 23ff.; cf. Ferino-Pagden and Brown (eds.), *Bellini, Giorgione, Tizian und die Renaissance der venezianischen Malerei*, p. 10.

15 Cf. Carol Kidwell, *Pietro Bembo: Lover, Linguist, Cardinal*, Montreal, London, and Ithaca 2004, pp. 6ff., 13ff., and 24.

16 Pietro Bembo, *Gli Asolani* (1505), ed. Giorgio Dilemmi, Florence 1991; Pietro Bembo, *Asolaner Gespräche. Dialog über die Liebe*, ed. Michael Rumpf, Heidelberg 1992.

17 The booklist from the 1490s can be found in Schneider (ed.), *Leonardo da Vinci: Eine Biographie in Zeugnissen, Selbstzeugnissen, Dokumenten und Bildern*, pp. 110ff. On Leonardo's mockery of Petrarch's *Canzoniere*, cf. Richter (ed.), *The Notebooks of Leonardo da Vinci*, vol. 2, no. 1332, p. 377; Beltrami, *Il codice di Leonardo da Vinci nella Biblioteca Trivulzio*, p. 8. See Ch. V.

18 Cf. Ferino-Pagden and Brown (eds.), *Bellini, Giorgione, Tizian und die Renaissance der venezianischen Malerei*, pp. 302–3.

19 Cf. Oskar Bätschmann, *Giovanni Bellini*, Munich 2008, pp. 56ff. and 76ff.; Bohde, *Haut, Fleisch und Farbe*, pp. 39ff.

20 Cf. Jaynie Anderson, *Giorgione: The Painter of "Poetic Brevity,"* Paris and New York 1997, pp. 135 and 193–4.

21 Cf. Vahland, *Lorbeeren für Laura*, pp. 32ff.

22 Giorgione's *Laura*, now in the Kunsthistorisches Museum, Vienna (inv. no. Gemäldegalerie 31), has the original date on the back and is signed with the words "1506 adj. primo zugno fo fatto questo de ma de maistro zorzi da chastel fr [. . .] cholega de maistro vizenzo chaena ad instanzia de misser giacomo" (Anderson, *Giorgione*, p. 299).

23 Cf. Vahland, *Lorbeeren für Laura*, pp. 74ff. See above, Ch. V.

24 Cf. Junkerman, *Bellissima Donna*, pp. 252ff.; Marianne Koos, *Bildnisse des Begehrens. Das lyrische Männerporträt in der venezianischen Malerei des frühen 16. Jahrhunderts—Giorgione, Tizian und ihr Umkreis*, Emsdetten and Berlin 2006, p. 358; Vahland, *Lorbeeren für Laura*, pp. 43ff.

25 The importance of poetry for painters in Venice in the early sixteenth century was explained in a letter by the artist Jacopo de' Barbari in 1501. It says that for his creations a painter must not only understand something of philosophy and music but also of poetry—"la poesia" is needed "per la inventione de la hopera." Here he was making a distinction between poetical and historical paintings for the first time. Quoted from Francis Ames-Lewis, *The Intellectual Life of the Early Renaissance Artist*, New Haven and London 2002, pp. 173 and 289.

26 For the essentials concerning the sensitive paintings of young men by the circle of Giorgione, see Koos, *Bildnisse des Begehrens*. On Leonardo's own images of men, see Ch. XII.

27 Cf. Koos, *Bildnisse des Begehrens*, pp. 346ff.

28 For the draft of the letter, see Schneider (ed.), *Leonardo da Vinci: Eine Biographie in Zeugnissen, Selbstzeugnissen, Dokumenten und Bildern*, pp. 142ff; in Italian, Rasponi (ed.), *Leonardo & Venice*, pp. 28ff. It is not clear whether the letter was addressed to the Venetian or the French government; however, as there is no response to be found in Venetian archives and Leonardo was already in contact with the French who had links with Venice at the time, it may be assumed that it was to a French addressee.

29 Schneider (ed.), *Leonardo da Vinci: Eine Biographie in Zeugnissen, Selbstzeugnissen, Dokumenten und Bildern*, p. 137. "Il duca perso lo stato e la roba e liertà, e nessuna sua opera si finì per lui" (Manuscript L, Paris, Bibliothèque de l'Institut de France, L o'). As mention is made of Ludovico Sforza's imprisonment, the note cannot have originated from late 1499, but must date from no earlier than April 1500.

30 Cf. Rasponi (ed.), *Leonardo & Venice*, pp. 23 and 34. For the extract from the accounts cf. Schneider (ed.), *Leonardo da Vinci: Eine Biographie in Zeugnissen, Selbstzeugnissen, Dokumenten und Bildern*, p. 145.

31 Quoted from Norbert Huse and Wolfgang Wolters, *Venedig*, p. 211.

32 Cf., among others Ames-Lewis, *Isabella and Leonardo*, p. 32.

33 The portrait of a young woman (Ill. 39), now in the Gemäldegalerie Berlin (inv. no. 259B), still shows traces of the underpainting, which shows that, in line with Giorgione, Sebastiano del Piombo seated the lady in front of a laurel bush in the first version. Cf. Vahland, *Lorbeeren für Laura*, pp. 59ff. and 83ff. See also Ch. XII.

34 Both Giorgio Vasari and Michelangelo systematically disparaged the Venetian paint-
ers, particularly Titian, as being "effeminate," because they considered that *colore*,
which had feminine connotations, was more important than *disegno*, design or idea,
which was understood to be masculine. Cf. Vahland, *Lorbeeren für Laura*, pp. 127ff.

35 Titian's portrait of *Isabella in Black* is in the Kunsthistorisches Museum, Vienna
(inv. no. 83). On this painting, cf. Sylvia Ferino-Pagden et al. (eds.), *"La prima
donna del mondo"—Isabella d'Este, Fürstin und Mäzenatin der Renaissance*, exh. cat.,
Kunsthistorisches Museum, Vienna 1994, pp. 111ff. In connection with Isabella's
lynx fur in Titian's portrait, in 2007 the museum presented an x-ray image that
revealed a fan under the fur. Cf. Sylvia Ferino-Pagden and Tiziano Vecellio (eds.),
Der späte Tizian und die Sinnlichkeit der Malerei, exh. cat., Kunsthistorisches Museum,
Vienna, and Gallerie dell'Accademia, Venice, Vienna 2007, pp. 133–4.

36 The work was created without sitting for the portrait on the model of another portrait
of Isabella d'Este. In 1536 she praised Titian's completed work, saying she had not
been so beautiful, even in her youth. Cf. Ferino-Pagden et al. (eds.), *"La prima donna
del mondo,"* p. 114.

X Births and Deaths

1 Cf. Vasari, *Leonardo*, trans. de Vere, pp. 635; *Vita di Lionardo da Vinci*, pp. 23 and 29;
Vasari, *Leonardo*, ed. Alessandro Nova and Sabine Feser, pp. 25 and 36. Some
details of this information are disputed. For instance, Leonardo could not, as Vasari
believed, have created a *Saint Anne* for the high altar of Santissima Annunziata, but
at most for the chapel of Saint Anne in that church. Cf. Nathan and Zöllner (eds.),
Leonardo da Vinci, p. 143.

2 Cf. Schneider (ed.), *Leonardo da Vinci: Eine Biographie in Zeugnissen, Selbstzeugnissen,
Dokumenten und Bildern*, pp. 145–6.

3 Quoted from ibid., pp. 146–7 (translation by RW). In the original: "Illustrissima et
excellentissima domina [. . .] per quanto mi occurre, la vita di Leonardo è varia et
indeterminata forte, sì che pare vivere a giornata. [. . .] Dà opera forte ad la geome-
tria, impacientissimo al pennello." Luca Beltrami (ed.), *Documenti e memorie riguardanti
la vita e le opere di Leonardo da Vinci in ordine cronologico*, Milan 1919, no. 107, pp. 65–6.

4 The history of Leonardo's sketches for this motif is complex, and the source material is ambiguous. The cartoon of an early version with the boy John the Baptist instead of a lamb has survived—the *Burlington House Cartoon* (Plate 22). However, in light of a reference made by Pietro da Novellara (see note 3 above), Leonardo must have produced at least one more cartoon with a subject similar to his painting *Virgin and Child with Saint Anne* (Plate 23) in the Louvre.

5 Quoted from Schneider (ed.), *Leonardo da Vinci: Eine Biographie in Zeugnissen, Selbstzeugnissen, Dokumenten und Bildern*, pp. 146–7 (translation by RW). In the original: "À facto solo, dopoi chè è ad Firenci, uno schizo in uno cartone, finge uno Christo bambino de età cerca uno anno che uscendo quasi de bracci ad la mamma, piglia uno agnello et pare che lo stringa. La mamma quasi levandose de grembo ad Santa Anna, piglia el bambino per spiccarlo da lo agnellino (animale immolatile) che significa la Passione. Santa Anna alquanto levandose da sedere, pare che voglia ritenere la figliola che non spicca el bambino da lo agnellino, che forsi vole figurare la Chiesa che non vorrebbe fussi impedita la passione di Christo" (Beltrami [ed.], *Documenti e memorie riguardanti la vita e le opere di Leonardo da Vinci in ordine cronologico*, no. 107, pp. 65–6).

6 Sigmund Freud discussed Leonardo's loss of his mother and understands the compositions featuring Saint Anne as referring directly to Leonardo's biological mother and his first stepmother. This narrow approach does not go far enough, partly because Freud was not yet familiar with the historical sources concerning Leonardo's childhood and his mother Caterina, and partly because of his oversimplified understanding of homosexuality, which he derived from Leonardo's early childhood, taking no account of historical changes in values and feelings. Cf. Sigmund Freud, *Eine Kindheitserinnerung des Leonardo da Vinci*, Frankfurt am Main 1995, pp. 82ff.

7 In his description, Vasari, who had not seen any of the cartoons himself, produced a mixture of the versions with and without the lamb, so that it is not clear which cartoon was exhibited—the lost cartoon with the lamb that was seen by Fra Pietro da Novellara, the *Burlington House Cartoon* with the boy John that is now in London (Plate 22), or a completely different one. Cf. Vasari, *Leonardo*, trans. de Vere, pp. 635, and Vasari, *Leonardo*, ed. Alessandro Nova and Sabine Feser, pp. 26 and 101ff.; *Vita di Lionardo da Vinci*, pp. 30–31. At this time Vasari was evidently writing from hearsay passed on to him from uncertain sources.

8 This is the *Burlington House Cartoon* in the National Gallery, London (inv. no. NG 6337). Zöllner argues that the cartoon with the looser figure grouping had already been produced around 1499 in Milan, possibly for King Louis XII of France, whose wife's name was Anne. Cf. Nathan and Zöllner (eds.), *Leonardo da Vinci*, pp. 234–5. The Leonardo exhibition at the National Gallery in London also dated it to the Milan period. Cf. Syson (ed.), *Leonardo da Vinci*, p. 290.

9 Leonardo da Vinci's painting of the *Virgin and Child with Saint Anne* is in the Louvre in Paris (inv. no. 776 [319]).

10 For basic information on Leonardo's understanding of the history of the earth and how this is reflected in his painting, especially in the *Virgin and Child with Saint Anne*, cf. Alexander Perrig, "Leonardo"; Frank Fehrenbach, *Licht und Wasser. Zur Dynamik naturphilosophischer Leitbilder im Werk Leonardo da Vincis*, Tübinger Studien zur Archäologie und Kunstgeschichte, ed. Klaus Schwager, Tübingen 1997; Françoise Barbe and Vincent Delieuvin (eds), *La Sainte Anne: l'ultime chef-d'œuvre de Léonard de Vinci*, exh. cat., Louvre, Paris 2012.

11 For the original, see Richter (ed.), *The Notebooks of Leonardo da Vinci, vol. 3*, no. 948, p. 190; no. 956, p. 192 and no. 986, p. 208 (Codex Leicester 17 v., 21 v., Codex Atlanticus 155 r.); Anna Maria Brizio (ed.), *Scritti scelti di Leonardo*, Turin 1952, p. 542 (Paris Manuscript G, 38 r.).; Giuseppina Fumagalli, *Leonardo "omo sanza lettere,"* Florence 1938, pp. 100 and 105 (Codex Arundel 168 v., Codex Leicester 10 v.). See also Leonardo da Vinci, *Das Wasserbuch. Schriften und Zeichnungen*, ed. Marianne Schneider, Munich 2011, pp. 57ff. and 65–6. See also above, Ch. VI.

12 Cf. da Vinci, *Das Wasserbuch*, pp. 57ff. For the original, see Richter (ed.), *The Notebooks of Leonardo da Vinci*, vol. 2, no. 986ff., pp. 208ff. (Codex Atlanticus 155 r., Codex Leicester 8 v., 9 r., 9 v.).

13 Cf. Perrig, "Leonardo," in particular p. 58.

14 Cf. ibid., in particular p. 60; da Vinci, *Das Wasserbuch*, p. 61; Fumagalli, *Leonardo "omo sanza lettere,"* p. 99.

15 Quoted from da Vinci, *Das Wasserbuch*, p. 66 (trans. from the German by RW); in the original, Fumagalli, *Leonardo "omo sanza lettere,"* p. 107 (Arundel Codex fol. 155 v.); see also Perrig, "Leonardo," in particular p. 60.

16 The series of Leonardo's deluge drawings is in the Royal Library: one showing an explosion of a rock massif caused by a bursting water vein (RCIN 912.387r) and the other an explosion of a rock massif caused by a bursting water vein and formation of waves in a lake caused by falling rock (RCIN 912.380r).

17 Cf. Perrig, "Leonardo," in particular pp. 68–9; Fehrenbach, *Licht und Wasser*, pp. 287–8.

18 Cf. Armin Schlechter (ed.), *"Die edel kunst der truckerey." Ausgewählte Inkunabeln der Universitätsbibliothek Heidelberg*, exh. cat., Schriften der Universitätsbibliothek Heidelberg, vol. 6, Heidelberg 2005, pp. 28–9; Veit Probst, *Zur Entstehungsgeschichte der Mona Lisa, Leonardo da Vinci trifft Niccolò Machiavelli und Agostino Vespucci*, Heidelberg 2008, p. 13. See also Ch. XI.

19 Cf. Nathan and Zöllner (ed.), *Leonardo da Vinci*, p. 183.

20 Cf. Schneider (ed.), *Leonardo da Vinci: Eine Biographie in Zeugnissen, Selbstzeugnissen, Dokumenten und Bildern*, p. 148; in the original: Beltrami (ed.), *Documenti e memorie riguardanti la vita e le opere di Leonardo da Vinci in ordine cronologico*, no. 107, pp. 65–6.

21 The *Madonna with the Spindle* attributed to Salaì is in a private collection in New York.

22 Manfredo de Manfredis reported Leonardo's empty promises to Isabella d'Este in late July 1501. Cf. Schneider (ed.), *Leonardo da Vinci: Eine Biographie in Zeugnissen, Selbstzeugnissen, Dokumenten und Bildern*, p. 149; in the original: Beltrami (ed.), *Documenti e memorie riguardanti la vita e le opere di Leonardo da Vinci in ordine cronologico*, no. 110, pp. 67f. On May 3, 1502, Isabella asked Francesco Malatesta to request her "friend" Leonardo to have the antiquities valued. In his reply of May 12, 1502, Malatesta reported Leonardo's valuation. Cf. Schneider (ed.), *Leonardo da Vinci: Eine Biographie in Zeugnissen, Selbstzeugnissen, Dokumenten und Bildern*, pp. 151–2; in the original: Beltrami (ed.), *Documenti e memorie riguardanti la vita e le opere di Leonardo da Vinci in ordine cronologico*, nos. 115 and 116, pp. 70–71. On March 4, 1503, Leonardo, who was short of money, had to withdraw 50 gold ducats from his account. Cf. Schneider (ed.), *Leonardo da Vinci: Eine Biographie in Zeugnissen, Selbstzeugnissen, Dokumenten und Bildern*, p. 159; in the original: Beltrami (ed.), *Documenti e memorie riguardanti la vita e le opere di Leonardo da Vinci in ordine cronologico*, no. 123, p. 78. On May 14, 1504, Isabella asked Leonardo for a painting of the young Christ, offering him whatever he might want for it. Isabella's confidant Angelo del Tovaglia told her on May 27, 1504, that

Leonardo had promised to paint the *Christ* for her, but warned her that the artist would win the prize for the slowest painter, even in competition with the similarly reluctant Perugino; cf. Schneider (ed.), *Leonardo da Vinci: Eine Biographie in Zeugnissen, Selbstzeugnissen, Dokumenten und Bildern*, pp. 183–4; Beltrami (ed.), *Documenti e memorie riguardanti la vita e le opere di Leonardo da Vinci in ordine cronologico*, nos. 142 and 143, pp. 90–91.

23 Quoted from Schneider (ed.), *Leonardo da Vinci: Eine Biographie in Zeugnissen, Selbstzeugnissen, Dokumenten und Bildern*, pp. 153–4 (trans. from the German by RW); in the original: Beltrami (ed.), *Documenti e memorie riguardanti la vita e le opere di Leonardo da Vinci in ordine cronologico*, no. 117, p. 72.

24 Cf. Schneider (ed.), *Leonardo da Vinci: Eine Biographie in Zeugnissen, Selbstzeugnissen, Dokumenten und Bildern*, pp. 154ff.

25 Cf. ibid., p. 160.

26 The Turkish translation of Leonardo's letter to Sultan Bayezid in the Istanbul Tate Archive is dated July 3, but it has not been possible to be certain whether this was 1502 or 1503, as assumed here. Leonardo's captioned sketches for the project match the letter. Cf. Schneider (ed.), *Leonardo da Vinci: Eine Biographie in Zeugnissen, Selbstzeugnissen, Dokumenten und Bildern*, p. 162; Nathan and Zöllner (eds.), *Leonardo da Vinci*, p. 152.

27 Cf. Schneider (ed.), *Leonardo da Vinci: Eine Biographie in Zeugnissen, Selbstzeugnissen, Dokumenten und Bildern*, pp. 170ff.; in the original: Beltrami (ed.), *Documenti e memorie riguardanti la vita e le opere di Leonardo da Vinci in ordine cronologico*, nos. 126 and 127, pp. 79–80.

28 Cf. Giorgio Vasari, *Das Leben des Michelangelo*, p. 213; *Vita di Michelagnolo Buonarroti Fiorentino*, p. 130.

29 Cf. Kia Vahland, *Michelangelo und Raffael. Rivalen im Rom der Renaissance*, Munich 2012, pp. 50–51.

30 Giovanni Pico della Mirandola, *De dignitate hominis. Rede über die Würde des Menschen*, ed. Gerd von der Gönna, Stuttgart 2009, pp. 8, 17–18, 25, and 31.

31 Quoted from Schneider (ed.), *Leonardo da Vinci: Eine Biographie in Zeugnissen, Selbstzeugnissen, Dokumenten und Bildern*, pp. 177–8; in the original: Beltrami (ed.), *Documenti e memorie riguardanti la vita e le opere di Leonardo da Vinci in ordine cronologico*, no. 135, pp. 83–4.

32 As reported by Anonimo Gaddiano, evidently on the basis of an eyewitness report; cf. Schneider (ed.), *Leonardo da Vinci: Eine Biographie in Zeugnissen, Selbstzeugnissen, Dokumenten und Bildern*, pp. 176–7, and Nicholl, *Leonardo da Vinci*, p. 379 (from which the translation of Leonardo's remark is taken); in the original: "Et passando ditto Lionardo insieme con Giouannj da Gauine da Santa Trinita dalla pancaccia dellj Spinj, doue era una ragunata d'houminj da bene, et doue si disputaua un passo di Dante, chiamero detto Lionardo, dicendogli, che dichiarassi loro quel passo. Et a caso spunto passo di qui Michele Agnolo, et chiamato da un di loro, rispose Lionardo, 'Miichele Agnolo ue lo dichiarera egli'. Di que parendo a Michelagnolo, l'hauessj detto per sbeffarlo, con ira gli rispose, 'Dichiarlo pur tu, che facestj un disegno di uno cauallo per gittarlo di bronzo et non lo potestj gittare et per vergogna lo lascisti stare'. Et detto questo, uolto loro le rene et ando uia; goue rimase Lionardo, che per le dette parole diuento rosso" (Anonimo Fiorentino, *Il Codice Magliabechiano*, cl. XVII 17, ed. Carl Frey, Berlin 1892, p. 115).

33 Quoted from Baldassare Castiglione, *The Book of the Courtier*, trans. and ed. George Bull, London 1976, p. 163; in the original: "Un altro de' primi pittori del mondo sprezza quell'arte dove è rarissimo ed èssi posto ad imparar filosofia, nella quale ha cosi strani concetti e nove chimere, che esso con tutta la sua pittura non sapria depingerle" (Baldassare Castiglione, *Il libro del Cortegiano* [Venice 1528], ed. Walter Barberis, Turin 1998, p. 176).

34 Cf. Schneider (ed.), *Leonardo da Vinci: Eine Biographie in Zeugnissen, Selbstzeugnissen, Dokumenten und Bildern*, pp. 173ff.

35 Cf. Beltrami (ed.), *Documenti e memorie riguardanti la vita e le opere di Leonardo da Vinci in ordine cronologico*, no. 130, p. 81.

36 Cf. Schneider (ed.), *Leonardo da Vinci: Eine Biographie in Zeugnissen, Selbstzeugnissen, Dokumenten und Bildern*, pp. 173–4 (Codex Atlanticus 202ra); Schlechter (ed.), "Die edel kunst der truckerey," pp. 28–9; Probst, *Zur Entstehungsgeschichte der Mona Lisa*, p. 13; see also Ch. XI.

37 Cf. Leonardo da Vinci, *Trattato della Pittura*, no. 173, p. 72 (Codex Urbinas Latinus 1270).

38 The copy, possibly drawn by Peter Paul Rubens after Leonardo's sketch for the *Battle of Anghiari*, is in the Louvre, Paris (inv. no. 20 271).

39 Aristotile da Sangallo's copy of the *Battle of Cascina* after Michelangelo's cartoon is in Holkham Hall, Norfolk, England (Estate of the Earl of Leicester).

40 On the poor adhesion of the paints, cf. Vasari, *Leonardo*, trans. de Vere, p. 637; *Vita di Lionardo da Vinci*, p. 33. Ten to twenty years after this fiasco, Antonio Billi gave an opinion about linseed oil; cf. Schneider (ed.), *Leonardo da Vinci: Eine Biographie in Zeugnissen, Selbstzeugnissen, Dokumenten und Bildern*, p. 199; in the original: Antonio Billi, *Il libro di Antonio Billi* (written around 1516–25), ed. Fabio Benedettucci, Anzio 1991, pp. 102–3. It is doubtful whether any traces of Leonardo da Vinci's work remained on the wall of the council chamber, as at the time he could have done no more than hang his cartoon there. Nevertheless, there are ongoing plans to spot-drill Giorgio Vasari's later fresco on the wall in search of Leonardo's *Battle of Anghiari*. This would be irresponsible from an art historical technical point of view; cf. Cecilia Frosinini, "Del cartone e della pittura nella vexata quaestio della battaglia di Anghiari," in Cristina Acidini and Marco Ciatti (eds.), *La Tavola Doria tra storia e mito*, Florence 2015, pp. 23–34.

41 Cf. Schneider (ed.), *Leonardo da Vinci: Eine Biographie in Zeugnissen, Selbstzeugnissen, Dokumenten und Bildern*, p. 185.

42 Quoted from ibid., p. 191 (trans. from the German by RW).

43 Cf. Nathan and Zöllner (eds.), *Leonardo da Vinci*, pp. 178 and 215ff.; Kemp and Pallanti, *Mona Lisa*, p. 84; Schneider (ed.), *Leonardo da Vinci: Eine Biographie in Zeugnissen, Selbstzeugnissen, Dokumenten und Bildern*, pp. 215ff.; Beltrami (ed.), *Documenti e memorie riguardanti la vita e le opere di Leonardo da Vinci in ordine cronologico*, nos. 189, 191, and 193, pp. 119ff. See Ch. X.

44 The painting of *Leda and the Swan* by one of Leonardo's successors is in the Uffizi, Florence (inv. no. 1890 [9953]). Leonardo also painted a *Leda*, which probably survived after his death but has since been lost. This is indicated both in the 1525 inventory of Salaì's estate and in a note by Giovanni Paolo Lomazzo from the late sixteenth century. Cf. Kemp and Pallanti, *Mona Lisa*, notably pp. 111 and 118.

45 Leonardo da Vinci's study of the *Kneeling Leda* is in the Devonshire Collection in Chatsworth House (inv. no. 717).

46 Cf. Schneider (ed.), *Leonardo da Vinci: Eine Biographie in Zeugnissen, Selbstzeugnissen, Dokumenten und Bildern*, pp. 202–3; Beltrami (ed.), *Documenti e memorie riguardanti la vita e le opere di Leonardo da Vinci in ordine cronologico*, no. 176, p. 110.

47 Quoted from Schneider (ed.), *Leonardo da Vinci: Eine Biographie in Zeugnissen, Selbstzeugnissen, Dokumenten und Bildern*, pp. 209–15, in particular p. 213; for the original documents, cf. Beltrami (ed.), *Documenti e memorie riguardanti la vita e le opere di Leonardo da Vinci in ordine cronologico*, nos. 177, 178, 179, 181, and 183, pp. 110ff.

48 Cf. Schneider (ed.), *Leonardo da Vinci: Eine Biographie in Zeugnissen, Selbstzeugnissen, Dokumenten und Bildern*, p. 221; Leonardo da Vinci, Codex Atlanticus, ed. Augusto Marinoni, Florence 2000 (C. A. 1027v [372va]).

49 Leonardo da Vinci's study of the *Head of Leda* is in the Royal Library at Windsor Castle (RCIN 912.516r).

50 Giampietrino's *Leda and Her Children* is in the Gemäldegalerie Alter Meister, Kassel (inv. no. 966). Cf. Nathan and Zöllner (eds.), *Leonardo da Vinci*, p. 188.

XI The Third Key Work: The Universal Woman

1 This is suggested by Leonardo's polemic against the "structures of lies" ("composto bugiardo") of the literati, which he contrasts with the "divine harmony" of painting, which can be understood by the senses at a glance. Cf. Leonardo da Vinci, *Sämtliche Gemälde*, pp. 142ff.; Leonardo da Vinci, *Trattato della Pittura*, no. 28, p. 21 (Codex Urbinas Latinus 1270); see also above, Ch. V.

2 Cf. Jean-Pierre Mohan, Michel Menu, and Bruno Mottin (eds.), *Im Herzen der Mona Lisa. Dekodierung eines Meisterwerks. Eine wissenschaftliche Expedition in die Werkstatt des Leonardo da Vinci*, Munich 2006, pp. 64 and 119.

3 Leonardo da Vinci's *Mona Lisa,* or *Gioconda,* is in the Louvre in Paris (inv. no. 779). For the history of the painting's reception, see, among others, George Boas, "The *Mona Lisa* in the History of Taste," *Journal of the History of Ideas,* 1 (1940), pp. 207–24, and André Chastel, *L'Illustre incomprise. Mona Lisa,* Paris 1988. For the essentials concerning the *Mona Lisa,* cf. Kemp and Pallanti, *Mona Lisa;* Roberto Zapperi, *Abschied von Mona Lisa. Das berühmteste Gemälde der Welt wird enträtselt,* Munich 2010; Mohan, Menu, and Mottin (eds.), *Im Herzen der Mona Lisa;* Frank Zöllner, *Leonardos Mona Lisa. Vom Porträt zur Ikone der freien Welt,* Berlin 2006; Fehrenbach, *Licht und Wasser;* Perrig, "Leonardo."

4 "[. . .] esimilmente ogni parte di bono e di tristo che ài in te, si dimostrerà in parte in nelle tue figure" (Richter [ed.], *The Notebooks of Leonardo da Vinci,* vol. 1, no. 586, p. 293 [Fragment, Codex Ashburnham, Paris, Bibliothèque de l'Institut de France, Ash. I. 8 b]); see also above, Ch. VIII.

5 Cf. Kemp and Pallanti, *Mona Lisa,* pp. 52 and 69ff.

6 Cf. ibid., pp. 17, 29, and 42.

7 Cf. ibid., pp. 14 and 23ff.

8 Cf. ibid., pp. 35–6.

9 At any rate, Vasari believed to know that Leonardo had received the contract to paint Lisa from Francesco del Giocondo, and Anonimo Gaddiano also mentions a portrait of "Piero Francesco del Giocondo," but not one of Mona Lisa. Apart from the man himself, this could also refer to the couple's son Piero, although he was still a child at the time in question. There is no further evidence to support either version. Cf. Vasari, *Leonardo,* p. 635; *Vita di Lionardo da Vinci,* p. 30. Anonimo Fiorentino, *Il Codice Magliabechiano,* cl. XVII 17, ed. Carl Frey, Berlin 1892, pp. 110–15, at p. 111.

10 See above, Ch. X.

11 The passage from Cicero in the original reads, "Nunc, ut Apelles Veneris caput et summa pectoris politissima arte perfecit, reliquam partem corporis incohatam reliquit, sic quidam homines in capite meo solum elaborarunt, reliquum corpus imperfectum ac rude reliquerunt" (Marcus Tullius Cicero, *Epistulae ad familiares,* Bologna 1477, p. 11a). In Agostino Vespucci's marginal note the original reads: "Apelles pictor. Ita Leonardus Vincius facit in omnibus suis picturis, ut enim caput Lise del

Giocondo et Anne matris virginis." Quoted from Probst, *Zur Entstehungsgeschichte der Mona Lisa*, pp. 12–13; see also Schlechter (ed.), "Die edel kunst der truckerey," pp. 28–9.

12 Cf. Kemp and Pallanti, *Mona Lisa*, pp. 54ff.; Barolsky, *Warum lächelt Mona Lisa?*, pp. 83ff.

13 Cf. Vasari, *Leonardo*, trans. de Vere, p. 636; "Usovvi ancora questa arte, che essendo mona Lisa bellissima, teneva mentre che la ritraeva chi sonasse o cantasse, e di continuo buffoni che la facessino stare allegra per levar via quel malinconico che suol dar spesso la pittura a' ritratti che si fanno [. . .]" (quoted from *Vita di Lionardo da Vinci*, p. 31).

14 The most recent technological investigation provides information on Leonardo's painting method and the materials he used. Cf. Mohan, Menu, and Mottin (eds.), *Im Herzen der Mona Lisa*, pp. 70 and 73–4.

15 Underdrawings on the panel are now barely traceable. Cf. ibid., p. 119.

16 Cf. Zapperi, *Abschied von Mona Lisa*, p. 113.

17 Cf. Kemp and Pallanti, *Mona Lisa*, pp. 64, 70ff., and 93.

18 Cf. Vasari, *Leonardo da Vinci*, trans. de Vere. pp. 635–6; "[. . .] avvegnaché gli occhi avevano que' lustri e quelle acquitrine che di continuo si veggono nel vivo, et intorno a essi erano tutti que' rossigni lividi e i peli, que non senza grandissima sottigliezza si possono fare; le ciglia, per avervi fatto il modo del nascere i peli nella carne, dove più folti e dove più radi, e girare secondo i pori della carne, non potevano essere più naturali; il naso, con tutte quelle aperture rossette e tenere, si vedeva essere vivo; la bocca con quella sua sfenditura, con le sue fini unite dal rosso della bocca con l'incarnazione del viso, che non colori ma carne pareva veramente; nella fontanella della gola, chi intentissimamente la guardava, vedeva battere i polsi [. . .]" (quoted from Vasari, *Vita di Lionardo da Vinci*, pp. 30–31).

19 According to the technological investigation, the eyelashes and eyebrows actually existed at one time; traces can still be made out in the undermost layers of the picture (and a few dots of the eyebrows in the upper layers), and also in one of the copies. It is not clear exactly when the now-invisible eyebrows and lashes disappeared; it probably happened during an earlier cleaning. Cf. Kemp and Pallanti, *Mona Lisa*, pp. 203 and 210.

20 Cf. Kemp and Pallanti, *Mona Lisa*, pp. 49–50.

21 Raphael's *Maddalena Doni* can be seen in the Galleria Palatina in Florence (inv. no. 1912.59).

22 Cf. Fehrenbach, *Licht und Wasser*, p. 281.

23 This concerns the Paris manuscript F, now in the Institut de France in Paris. The similarly scientific Codex Leicester with texts on such topics as geophysics and water (now in the Bill Gates Collection) was written during the first decade of the sixteenth century.

24 This copy of the *Mona Lisa* from Leonardo's workshop is in the Prado in Madrid (inv. no. P000504). The painting technologists could make only a few clear statements about the chronological order in which the parts of the *Mona Lisa* in the Louvre were painted. The even aging process of the panel suggests that not much time elapsed between the applications of paint. The veil overlies the landscape, so must have been painted later. Cf. Mohan, Menu and Mottin (eds.), *Im Herzen der Mona Lisa*, p. 70.

25 On the landscape in the *Mona Lisa*, cf. Perrig, "Leonardo," in particular pp. 62ff.; Fehrenbach, *Licht und Wasser*, pp. 276–83.

26 Lisa del Giocondo had already given birth to her son Andrea on December 12, 1502; her son Giocondo del Giocondo was not born until December 20, 1507. Cf. Kemp and Pallanti, *Mona Lisa*, p. 30.

27 Cf. Mohan, Menu, and Mottin (eds.), *Im Herzen der Mona Lisa*, p. 74.

28 Cf. Nicholl, *Leonardo da Vinci*, pp. 409, 433, and 446.

29 Cf. Zapperi, *Abschied von Mona Lisa*, pp. 56ff.; Nicholl, *Leonardo da Vinci*, p. 447.

30 Cf. Zapperi, *Abschied von Mona Lisa*, p. 58.

31 Cf. ibid., pp. 2–3.

32 Giuliano had treated Leonardo "[P]iu tosto da fratello che da compagno," according to the Florentine historian Benedetto Varchi. Cf. Carlo Pedretti, "'Li medici mi crearonno e destrussono," in *Achademia Leonardo Vinci* (ed.), Yearbook of the Armand Hammer Center for Leonardo Studies at UCLA, 6 (1993), pp. 173–84, at p. 182.

33 Cf. Zapperi, *Abschied von Mona Lisa*, pp. 44, 50, and 98. On the birth of Ippolito de' Medici and the entry in the register of the orphanage in Urbino, cf. Lothar Sickel, "Ippolito de' Medici und das Problem seiner Geburt," *Quellen und Forschungen aus italienischen Archiven und Bibliotheken*, 88 (2008), pp. 310–34.

34 Cf. Zapperi, *Abschied von Mona Lisa*, p. 99. For the letters concerning Ippolito from Bernardo Dovizi da Bibbiena to Giuliano, cf. Giuseppe Lorenzo Moncallero (ed.), *Epistolario di Bernardo Dovizi da Bibbiena*, vol. 2 (1513–29), Florence 1965, pp. 43 and 47.

35 Cf. Zapperi, *Abschied von Mona Lisa*, pp. 82, 98, and 105.

36 This is the theory of Roberto Zapperi proposed in his *Abschied von Mona Lisa*.

37 Zapperi believes that the *Mona Lisa* was dedicated to Ippolito de' Medici as an image of ideal motherhood (*Abschied von Mona Lisa*, pp. 97ff., 85ff., and 105ff.). He bases this on Alexander Perrig and Carlo Pedretti's research on the *Mona Lisa* (Perrig, "Leonardo" and Carlo Pedretti [ed.], *Studi Vinciani. Documenti, Analisi e inediti_leonardeschi*, Geneva 1957, pp. 132–41). This is contradicted by, among others, Frank Zöllner (Nathan and Zöllner [eds.], *Leonardo da Vinci*, pp. 240–1).

38 It is highly likely that a statement of Leonardo's in October 1517 to Antonio de Beatis refers to the *Mona Lisa* that is now in the Louvre. See below.

39 Cf. Zapperi, *Abschied von Mona Lisa*, p. 96.

40 The first news of the artist from France is a note of Leonardo's dating from Ascension Day, May 1517. Cf. Schneider (ed.), *Leonardo da Vinci. Eine Biographie in Zeugnissen, Selbstzeugnissen, Dokumenten und Bildern*, p. 262.

41 For de Beatis's report, see Antonio de Beatis, *The Travel Journal*, ed. John Hale, London 1979, pp. 132–3; Beltrami (ed.), *Documenti e memorie riguardanti la vita e le opere di Leonardo da Vinci in ordine cronologico*, nos. 238–9, pp. 149–50; cf. Zapperi, *Abschied von Mona Lisa*, pp. 12ff.

42 De Beatis wrote about the paralyzed right hand that restricted Leonardo. As a mostly left-hander he could still draw but not paint large works, for which he needed to use both hands.

43 Cf. Schneider (ed.), *Leonardo da Vinci: Eine Biographie in Zeugnissen, Selbstzeugnissen, Dokumenten und Bildern*, p. 263; "uno di certa donna firentina, facto di naturale ad instantia del quondam Magnifico Iuliano de Medici [. . .]" (quoted from Beltrami [ed.], *Documenti e memorie riguardanti la vita e le opere di Leonardo da Vinci in ordine cronologico*, no. 238, pp. 149–50).

44 In other places, De Beatis used the wording that a portrait had been painted from nature or from life, without making clear whether the work referred to a living person or one who was long since dead. The statement that Leonardo painted the picture "from nature" therefore carries little weight. Cf. Zapperi, *Abschied von Mona Lisa*, pp. 13ff.

45 Cf. Vasari, *Leonardo da Vinci*, trans. de Vere, p. 639; *Vita di Lionardo da Vinci*, p. 36.

46 Cf. Kemp and Pallanti, *Mona Lisa*, p. 110; Zapperi, *Abschied von Mona Lisa*, p. 112.

47 Cf. Bertrand Jestaz, "François 1er, Salaì et les tableaux de Léonard," *Revue de l'art*, 126 (1999), pp. 68–72; Zapperi, *Abschied von Mona Lisa*, pp. 110ff.; Kemp and Pallanti, *Mona Lisa*, p. 114.

48 Cf. Mohan, Menu, and Mottin (eds.), *Im Herzen der Mona Lisa*, p. 66.

49 Cf. Vasari, *Leonardo da Vinci*, trans. de Vere, p. 639; *Vita di Lionardo da Vinci*, p. 36; Kemp and Pallanti, *Mona Lisa*, p. 110.

50 Cf. Kemp and Pallanti, *Mona Lisa*, p. 111.

51 Cf. ibid., p. 113.

52 Zapperi points out that a married del Giocondo would not be called "Gioconda" in the usage of the times, because the feminine ending would be attached to the maiden name, not the husband's name. Cf. Zapperi, *Abschied von Mona Lisa*, pp. 113–4 and 129–30. However, Barolsky stresses the fact that Vasari—who (like Leonardo) enjoyed punning on names—would certainly have been attracted by the similar sound of del Giocondo and la Gioconda. Cf. Barolsky, *Warum lächelt Mona Lisa?*, pp. 83ff.

53 Cf. Vasari, *Leonardo da Vinci*, trans. de Vere, p. 635; *Vita di Lionardo da Vinci*, p. 30. The works was seen as early as 1542 in the Appartements des bains (the royal baths) in Fontainebleau (cf. Vasari, *Leonardo*, ed. Alessandro Nova and Sabine Feser, p. 106).

54 Cf. Kemp and Pallanti, *Mona Lisa*, p. 122.

XII Painting for Eternity

1 Cf. Vahland, *Michelangelo und Raffael. Rivalen im Rom der Renaissance*, pp. 55ff.

2 On the various versions of the *Monna Vanna*, including the female figure before a floral background, cf. David Alan Brown and Konrad Oberhuber, "*Monna Vanna* and *Fornarina*: Leonardo and Raphael in Rome," in Sergio Bertelli, Gloria Ramakus, and Craig Hugh Smyth (eds.), *Essays Presented to Myron P. Gilmore*, Florence 1978, pp. 25–86. On the motif, see also Kemp and Pallanti, *Mona Lisa*, pp. 171ff.; Arasse, *Leonardo da Vinci*, pp. 465ff.

3 In Salaì's legacy in 1525 there is a female seminude; Leonardo may have had a part in this panel. Cf. Kemp and Pallanti, *Mona Lisa*, p. 111. Evidence in favor of the idea that versions of *Monna Vanna* were first created in Rome and not in France is the response to the motif in papal Rome; see below.

4 The cartoon of *Monna Vanna* from Leonardo da Vinci's circle is in the Musée Condé, Chantilly. According to Martin Kemp, there are lines on the woman's breast, cheeks, arm, and part of the background that were drawn by a lefthander. However, this is not sufficient proof of Leonardo's involvement in the cartoon. Cf. Kemp and Pallanti, *Mona Lisa*, pp. 172–3.

5 *Monna Vanna* from Leonardo da Vinci's circle is in the Hermitage in St. Petersburg (inv. no. 110).

6 See Ch. IX.

7 Cf. Vasari, *Raffaello da Urbino*, trans. de Vere, pp. 737–8; in the original: *Vita di Raffaelo da Urbino*, p. 200.

8 It was not until 1563 that Lomazzo had his Leonardo posthumously making a verbose confession on the subject of *l'amore masculino* in a fictitious dialogue. Cf. Gian Paolo Lomazzo, "Il libro dei sogni," in *Scritti d'arte*, vol. 1, ed. Roberto Paolo Ciardi, Florence 1973, p. 104. See also Ch. IV.

9 Cf. Brown and Oberhuber, "*Monna Vanna* and *Fornarina*," pp. 36–7 and 49. Agostino Vespucci had also compared Leonardo with Apelles in his marginal note on Cicero; see Chs. X and XI.

10 The portrait known as *La Fornarina*, attributed to Raphael and a follower, can be seen in the Galleria Nazionale d'Arte Antica in Rome (inv. no. 2333). It was evidently uncompleted at the time of Raphael's death on April 6, 1520, which might explain the later, clumsily painted face. The model may have been one of Raphael's lovers, whom Vasari names as his last, suggesting that she might have been responsible for his premature death. Cf. Vasari, *Raffaello da Urbino*, trans. de Vere, p. 745; Vasari, *Vita di Raffaelo da Urbino*, p. 210. On the subject of this painting, cf. Brown and Oberhuber, "*Monna Vanna* and *Fornarina*," pp. 37ff.; Rosanna Barbiellini Amidei, Alia Englen, and Lorenza Mochi Onori (eds.), *Raphael Urbinas. Il mito della Fornarina*, exh. cat., Milan 1983.

11 Sebastiano del Piombo's *Portrait of a Young Woman* is in the Gemäldegalerie, Berlin. On the subject of this painting, cf. Vahland, *Lorbeeren für Laura*, pp. 59–82. See also above, Ch. IX.

12 Cf. Vahland, *Lorbeeren für Laura*, pp. 103–44.

13 See Ch. XI.

14 Cf. Castiglione, *The Book of the Courtier*, pp. 200–1, 218ff., and 216; Castiglione: *Das Buch vom Hofmann*, ed. Fritz Baumgart, München 1986, S.81, S.86ff. u.S.97ff. In Castiglione's original: *Il libro del Cortegiano*, pp. 252, 256ff., and 270ff.

15 Cf. Castiglione, *The Book of the Courtier*, p. 201; Castiglione, *Das Buch vom Hofmann*, p. 81. In Castiglione's original: *Il libro del Cortegiano*, p. 252.

16 Cf. Kidwell, *Pietro Bembo*, pp. 24ff.; Vahland, *Lorbeeren für Laura*, p. 57.

17 Cf. Castiglione, *The Book of the Courtier*, pp. 325ff; Castiglione, *Das Buch vom Hofmann*, p. 124ff. In Castiglione's original, *Il libro del Cortegiano*, pp. 427ff.

18 Cf. Castiglione, *The Book of the Courtier*, p. 336; Castiglione, *Das Buch vom Hofmann*, p. 127. In the original: "per quella [la bocca, KV] si dà esito alle parole che sono interpreti dell'anima [. . .]" (Castiglione, *Il libro del Cortegiano*, p. 430).

19 Cf. Castiglione, *The Book of the Courtier*, p. 61; Castiglione, *Das Buch vom Hofmann*, p. 32. In the original: "Questi, poiché [la natura, KV] non gli ha fatti femine, dovrebbono non come bone femine esser estimati, ma, come publiche meretrici, non solamente delle corti de' gran signori, mal del consorzio degli omini nobili esser cacciati" (Castiglione, *Il libro del Cortegiano*, p. 49).

20 Attributed to Leonardo da Vinci or his workshop, "Angelo incarnato," Private collection. Cf. Pedretti, *Leonardo da Vinci*.

21 Leonardo da Vinci, *John the Baptist*, Louvre, Paris (inv. no. 775, MR 318). The dating to Leonardo's Roman period, 1513–16, is stylistically plausible, but not confirmed by any documents. Cf. Nathan and Zöllner (eds.), *Leonardo da Vinci*, p. 248.

22 For basic information on the sensuous masculinity of Venetian paintings, see Koos, *Bildnisse des Begehrens*; see also Ch. IX.

23 *John the Baptist with Attributes of Bacchus* from Leonardo's workshop is in the Louvre in Paris (inv. no. 780).

24 Cf. Nathan and Zöllner (eds.), *Leonardo da Vinci*, p. 202. The critic in 1625 was Cassiano dal Pozzi; cf. Giovanni Poggi, *Leonardo da Vinci. La Vita die Giorgio Vasari nuovamente commentata*, Florence 1919, p. 26.

25 Cf. Vasari, *Leonardo*, trans. de Vere, p. 638; "Oimè, costui non è per far nulla, dache comincia a pensare alla fine innanzi il principio dell'opera [. . .]" (idem, *Vita di Lionardo da Vinci*, p. 35).

26 Cf. Vasari, *Leonardo*, trans. de Vere, p. 638; *Vita di Lionardo da Vinci*, p. 34.

27 The drawing of the head of an old, embittered-looking man with long hair and a very long beard is in the Biblioteca Reale, Turin. Since the nineteenth century it has been seen as a self-portrait of Leonardo, encouraged by the strange image of the artist promulgated by Vasari. However, there is no proof that the drawing is from Leonardo's hand, or even contemporary with him. Nevertheless, it has been repeatedly referred to in descriptions of Leonardo as an old man, including by Nicholl, *Leonardo da Vinci*, pp. 492–3.

28 Cf. Luca Beltrami (ed.), *Documenti e memorie riguardanti la vita e le opere di Leonardo da Vinci in ordine cronologico*, Milan 1919, p. 145.

29 Cf. Richter (ed.), *The Notebooks of Leonardo da Vinci*, vol. 2, nos. 1351 and 1353, pp. 409–10.

30 Besides the *Mona Lisa* (Plate 28) and *Virgin and Child with Saint Anne* (Plate 23), in October 1517 Leonardo showed the Cardinal of Aragon and his secretary, Antonio de Beatis, his own painting of *John the Baptist*. Another *Baptist* also appeared in the inventory of Salaì's legacy. The work from Leonardo's workshop in France is evidently the one that is now in the Louvre (Plate 29). Cf. Kemp and Pallanti, *Mona Lisa*, pp. 106ff. See above Ch. XI.

31 Cf. Kemp and Pallanti, *Mona Lisa*, p. 110; Nicholl, *Leonardo da Vinci*, pp. 498–9.

32 Cf. Vasari, *Leonardo*, trans. de Vere, p. 639; "Finalmente venuto vecchio, stette molti mesi ammalato; e vedendosi vicino alla morte, si volse diligentemente informare de le cose catoliche e della via buona e santa religione cristiana, e poi con molti pianti, confesso e contrito, se bene e' non poteva reggersi in piedi, sostenendosi nelle braccia di suoi amici e servi, volse divotamente pigliare il santissimo Sacramento fuor del letto. Sopragiunseli il re che spesso et amorevolmente lo soleva visitare; per il che egli per riverenza rizzatosi a sedere sul letto, contando il mal suo e gli accidenti di quello mostrava tuttavia quanto avea offeso Dio e gli uomini del mondo, non avendo operato nell'arte come si conveniva [. . .]" (*Vita di Lionardo da Vinci*, p. 36).

33 "E tanti furono i suoi capricci, che filosofando de le cose naturali, attese a intendere la proprietà delle erbe, continuando et osservando il moto del cielo, il corso de la luna e gli andamenti del sole. Per il che fece ne l'animo un concetto sì eretico, che e' non si accostava a qualsivoglia religione, stimando per avventura assai più lo esser filosofo che cristiano [. . .]" (*Vita di Lionardo da Vinci*, p. 19) (trans. by RW). See also Vasari, *Leonardo*, ed. Alessandro Nova and Sabine Feser, pp. 22 and 64.

34 Leonardo da Vinci's *Woman Standing in a Landscape* is in the Royal Collection, Windsor (inv. no. RL 12.573r). The drawing could refer to Dante's figure of Matelda, whom the narrator of the *Divine Comedy* (*Purgatorio* XXVIII) meets in a flowering landscape. Cf. Kemp and Pallanti, *Mona Lisa*, pp. 46–7.

Epilogue: Leonardo Today

1 Cf. Kemp and Pallanti, *Mona Lisa*, pp. 128f.; Zöllner, *Leonardos Mona Lisa. Vom Porträt zur Ikone der freien Welt*, pp. 7f.

2 Cf. Palazzo dell'Arte, Milan (ed.), *Mostra di Leonardo da Vinci e delle invenzioni italiane*, exh. cat., Milan 1939; Kemp, *Living with Leonardo*, p. 244; see also the preface.

3 Cf. Leonardo da Vinci, *Sämtliche Gemälde*, p. 146. "Quante pitture hanno conservato il simulacro di una divina bellezza di cui il tempo o morte in breve ha distrutto il naturale esempio, ed è restata più degna l'opera del pittore che della natura sua maestra!" (da Vinci, *Trattato della Pittura*, no. 26, p. 19 [Codex Urbinas Latinus 1270]). See above, Ch. VII.

4 A consortium of dealers had the panel of the *Salvator Mundi* cleaned and restored, then an agent bought it in 2014 for a suspected $75–80 million in a private sale at Sotheby's. He passed the *Salvator* on to a Russian oligarch for $127.5 million. A buyer from the Arab world auctioned the panel at Christie's in November 2017 in a sale of contemporary art. The decisive moment for the career of the *Salvator Mundi* was its approval as a work by Leonardo by the National Gallery in London, which showed the work in its big exhibition on Leonardo's Milan years in 2011. Cf. Luke Syson (ed.), *Leonardo da Vinci: Painter at the Court of Milan*, exh. cat., National Gallery, London 2011, pp. 300ff.; Kia Vahland, "Meister, die vom Himmel fielen," *Süddeutsche Zeitung*, October 2, 2015, pp. 13–15; idem, "Trophäe für Oligarchen" and "Geldsegen," *Süddeutsche Zeitung*, November 17, 2017, pp. 4 and 11; Sybille Ebert-Schifferer, "Ruine für Millionen," *Süddeutsche Zeitung*, November 17, 2018, p. 4.

5 See Ch. IX and Ch. XII. The painting was evidently offered for sale in Russia as an original work by Leonardo. Cf. Kia Vahland, "Die Mona Lisa von Berlin und ihre Nachfolgerin," *Süddeutsche Zeitung*, September 13, 2018, p. 13.

6 Anon., "Il Leonardo mai visto in una collezione privata. Scoperto il ritratto fatto a Isabella d'Este," *Corriere della Sera*, October 11, 2013, p. 14. Attributed to Carlo Pedretti.

7 See Ch. IX.

8 Martin Kemp (and others) attributed the portrait to Leonardo. Cf. Peter Silverman, *La Principessa Perduta di Leonardo*, Milan 2012; Kemp, *Living with Leonardo*, pp. 136ff.

The art historian Cecilia Frosinini from the Opificio delle Pietre Dure in Florence said that her institute refused to carry out a technological examination of the work because no new findings for Leonardo research were to be expected. In her estimation it could also be a piece from the nineteenth century. Cf. Vahland, "Meister, die vom Himmel fielen," p. 14.

Manuscripts by Leonardo da Vinci

Codex Arundel, London, British Library

Codex Ashburnham I and II, Paris, Bibliothèque de l'Institut de France

Codex Atlanticus, Milan, Biblioteca Ambrosiana

Codex on the Flight of Birds, Turin, Biblioteca Reale

Codex Forster I–III, London, Victoria and Albert Museum

Codex Leicester, Seattle, Bill Gates Collection

Codices Madrid I and II, Madrid, Biblioteca Nacional

Codex Trivulziano, Milan, Castello Sforzesco

Codex Urbinas Latinus 1270, Vatican, Biblioteca Vaticana Manuskripte A–I, Paris, Bibliothèque de l'Institut de France

Bibliography

Achademia Leonardo Vinci (ed.), *Yearbook of the Armand Hammer Center for Leonardo Studies at University of California Los Angeles*, 6 (1993), pp. 173–84.

Acidini, Cristina, and Marco Ciatti (eds.), *La Tavola Doria tra storia e mito*, Florence 2015.

Alpers, Svetlana, "Ekphrasis and Aesthetic Attitudes in Vasari's Lives," *Journal of the Warburg and Courtauld Institutes*, 23 (1960), pp. 190–215.

Ames-Lewis, Francis, *Isabella and Leonardo: The Artistic Relationship between Isabella d'Este and Leonardo da Vinci, 1500–1506*, New Haven and London 2012.

———, *The Intellectual Life of the Early Renaissance Artist*, New Haven and London 2002.

Anderson, Jaynie, *Giorgione: The Painter of "Poetic Brevity,"* Paris and New York 1997.

Anonimo Fiorentino, *Il Codice Magliabechiano*, cl. XVII 17, ed. Carl Frey, Berlin 1892.

Appuhn-Radtke, Sibylle (ed.), *Freundschaft. Motive und Bedeutungen*, Munich 2006.

Arasse, Daniel, *Leonardo da Vinci*, Cologne 2002.

Aristoteles, *De generatione animalium*, ed. Wilhelm von Moerbeke, Turnhout 2011.

Bambach, Carmen (ed.), *Leonardo da Vinci: Master Draftsman*, New York 2003.

Barbe, Françoise, and Vincent Delieuvin (eds.), *La "Sainte Anne" ultime chef-d'œuvre de Léonard de Vinci*, exh. cat., Louvre, Paris 2012.

Barbiellini Amidei, Rosanna, Alia Englen, and Lorenza Mochi Onori (eds.), *Raphael Urbinas. Il mito della Fornarina*, exh. cat., Milan 1983.

Barocchi, Paola (ed.), *Scritti d'arte del Cinquecento*, Milan and Naples 1971.

Barolsky, Paul B., *Warum lächelt Mona Lisa? Vasaris Erfindungen*, Berlin 1996.

———, "Vasari and the Historical Imagination," *Word & Image*, 3 (1999), pp. 286–91.

Bätschmann, Oskar, *Giovanni Bellini*, Munich 2008.

Baxandall, Michael, *Painting and Experience in Fifteenth-Century Italy*, Oxford 1972.

de Beatis, Antonio, *The Travel Journal*, ed. John Hale, London 1979.

Beltrami, Luca, *Il codice di Leonardo da Vinci nella Biblioteca Trivulzio*, Milan 1891.

———— (ed.), *Documenti e memorie riguardanti la vita e le opere di Leonardo da Vinci in ordine cronologico*, Milan 1919.

Bembo, Pietro, *Gli Asolani* (1505), ed. Giorgio Dilemmi, Florence 1991.

————, *Asolaner Gespräche. Dialog über die Liebe*, ed. Michael Rumpf, Heidelberg 1992.

Bertling Biaggini, Claudia, *Sebastiano del Piombo—Felix Pictor*, Hildesheim 2016.

Bettini, Maurizio, *Nascere. Storie di donne, donnole, madri ed eroi*, Turin 1998.

Billi, Antonio, *Il libro di Antonio Billi* [about 1516–25], ed. Fabio Benedettucci, Anzio 1991.

Boas, George, "The *Mona Lisa* in the History of Taste," *Journal of the History of Ideas*, 1 (1940), pp. 207–24.

Bohde, Daniela, *Haut, Fleisch und Farbe—Körperlichkeit und Materialität in den Gemälden Tizians*, Emsdetten and Berlin 2002.

Brauchitsch, Boris von, *Leonardo da Vinci*, Berlin 2019.

Bredekamp, Horst, "Götterdämmerung des Neuplatonismus," *Kritische Berichte*, 14.4 (1986), pp. 39–48.

————, "Nature as Mother and Stepmother: The Personification of Natura in Art History," in *Changing Concepts of Nature at the Turn of the Millennium*, Pontificae Academiae Scientiarum Scripta Varia, Rome 2000, pp. 226–9.

Brescia, Licia, and Luca Tomio, "Tommaso di Giovanni Masini da Peretola detto Zoroastro. Documenti, fonti e ipotesi per la biografia del priscus magus allievo di Leonardo da Vinci," *Raccolta Vinciana*, 28 (1999), pp. 63–77.

Brizio, Anna Maria (ed.), *Scritti scelti di Leonardo*, Turin 1952.

Broude, Norma, and Mary D. Garrard (eds.), *The Expanding Discourse: Feminism and Art History*, New York 1992.

Brown, David Alan, *Leonardo da Vinci: Origins of a Genius*, New Haven and London 1998.

—— (ed.), *Virtue and Beauty: Leonardo's Ginevra de' Benci and Renaissance Portraits of Women*, exh. cat., National Gallery of Art Washington, Washington, DC, 2001.

——, and Konrad Oberhuber, "Monna Vanna and Fornarina, Leonardo and Raphael in Rome," in Sergio Bertelli, Gloria Ramakus, and Craig Hugh Smyth (eds.), *Essays Presented to Myron P. Gilmore*, Florence 1978, pp. 25–86.

Burke, Peter, *Die Geschicke des "Hofmann,"* Berlin 1996.

Butterfield, Andrew, *The Sculptures of Andrea del Verrocchio*, New Haven and London 1997.

Büttner, Frank, *Giotto und die Ursprünge der neuzeitlichen Bildauffassung*, Darmstadt 2013.

Caglioti, Francesco, *Donatello e i Medici, storia del David e della Giuditta*, vol. 2, Florence 2000.

——, "Donatello, i Medici e Gentile de' Becchi, un po' d'ordine intorno alla *Giuditta* (e al *David*) di Via Larga," *Prospettiva*, 80 (1995), pp. 15–58.

Carnesecchi, Carlo, "Il ritratto Leonardesco di Ginevra Benci," *Rivista d'Arte*, 6 (1909), pp. 291–6.

Castiglione, Baldassare, *Il libro del Cortegiano* [Venice 1528], ed. Walter Barberis, Turin 1998.

——, *The Book of the Courtier*, trans. and ed. George Bull, London 1976,

——, *Das Buch vom Hofmann*, ed. George Bull, Munich 1986.

Cecchi, Alessandro, "New Light on Leonardo's Florentine Patrons," in Carmen Bambach (ed.), *Leonardo da Vinci. Master Draftsman*, New York 2003, pp. 121–39.

Chastel, André, *L'illustre incomprise. Mona Lisa*, Paris 1988.

Clark, Kenneth, *Leonardo*, Harmondsworth 1988.

———, *The Drawings of Leonardo da Vinci in the Collection of Her Majesty the Queen at Windsor Castle*, London 1968.

Cluse, Christoph, "Sklaverei im Mittelalter—der Mittelmeerraum. Eine kurze Einführung, basierend auf Jacques Heers, Esclaves et domestiques au moyen âge dans le monde méditerranéen, Paris 1981," in *Medieval Mediterranean Slavery. Comparative Studies on the Slave Trade in Muslim, Christian, and Jewish Societies (8th–15th Century)*, 2004, available online at http://med-slavery.uni-trier.de:9080/minev/MedSlavery (last accessed August 2018).

Cropper, Elizabeth, "The Beauty of Women: Problems in the Rhetoric of Renaissance Portraiture," in Margaret W. Ferguson, Maureen Quilligan, and Nancy J. Vickers (eds.), *Rewriting the Renaissance: The Discourses of Sexual Difference in Early Modern Europe*, Chicago 1986, pp. 175–90.

———, "On Beautiful Women: Parmigianino, Petrarchismo, and the Vernacular Style," *The Art Bulletin*, 3 (1976), pp. 374–94.

Crum, Robert J., and John T. Paoletti (eds.), *Renaissance Florence: A Social History*, Cambridge and New York 2006.

da Vinci, Leonardo, *Das Wasserbuch. Schriften und Zeichnungen*, ed. Marianne Schneider, Munich 2011.

———, Codex Atlanticus, ed. Augusto Marinoni, Florence 2000.

———, *Sämtliche Gemälde und die Schriften zur Malerei*, ed. André Chastel, Munich 1990.

———, *The Literary Works of Leonardo da Vinci*, compiled and edited from the original manuscripts by Jean Paul Richter, commentary by Carlo Pedretti, 2 vols., Berkeley and Los Angeles 1977.

———, *The Notebooks of Leonardo da Vinci*, 2 vols., ed. Jean Paul Richter, New York 1970.

———, *Tagebücher und Aufzeichnungen*, ed. Theodor Lücke, Leipzig 1952.

————, *Trattato della Pittura*, ed. Marco Tabarrini and Gaetano Milanesi, Rome 1890 and 1989.

————, *Das Buch von der Malerei nach dem Codex Vaticanus (Urbinas) 1270*, vol. 1, ed. Heinrich Ludwig, Vienna 1882.

Ebert-Schifferer, Sybille, "Ruine für Millionen," *Süddeutsche Zeitung*, November 17, 2018, p. 4.

Eckstein, Nicholas A., *The District of the Green Dragon*, Florence 1995.

Elam, Caroline, "Bernardo Bembo and Leonardo's *Ginevra de' Benci*: A Further Suggestion," in Guido Beltramini, Howard Burns, and Davide Gasparotto (eds.), *Pietro Bembo e le arti*, Vicenza 2013, pp. 407–20.

Esch, Arnold, "Über den Zusammenhang von Kunst und Wirtschaft in der italienischen Renaissance—ein Forschungsbericht," *Zeitschrift für historische Forschung*, 8.2 (1981), pp. 179–222.

Faini, Marco, "Per Bernardo Bembo poeta. Un possibile scambio poetico con Ginevra de' Benci," *Zeitschrift Albertiana* XIX, 1 (2016), pp. 147–62.

Farago, Claire J., "How Leonardo da Vinci's Editors Organized His *Treatise on Painting* and How Leonardo Would Have Done It Differently," in Ferago (ed.), *Leonardo da Vinci: Selected Scholarship*, vol. 4, New York and London 1999, pp. 417–60.

————, *Leonardo da Vinci's Paragone: A Critical Interpretation with a New Edition of the Text in the Codex Urbinas*, Brill's Studies in Intellectual History 25, Leiden et al. 1992.

Fehrenbach, Frank, *Licht und Wasser. Zur Dynamik naturphilosophischer Leitbilder im Werk Leonardo da Vincis*, Tübinger Studien zur Archäologie und Kunstgeschichte, ed. Klaus Schwager, Tübingen 1997.

Fend, Mechthild, and Marianne Koos (eds.), *Männlichkeit im Blick. Visuelle Inszenierungen in der Kunst seit der Frühen Neuzeit*, Cologne et al. 2004.

Ferino-Pagden, Sylvia (ed.), *Der späte Tizian und die Sinnlichkeit der Malerei*, exh. cat., Kunsthistorisches Museum, Vienna and Gallerie dell'Accademia, Venice, Vienna 2007.

———— (ed.), *Vittoria Colonna. Dichterin und Muse Michelangelos*, exh. cat., Kunsthistorisches Museum Vienna, Vienna 1997.

————, and David Alan Brown (eds.), *Bellini, Giorgione, Tizian und die Renaissance der venezianischen Malerei*, exh. cat., National Gallery, Washington, DC, and Kunsthistorisches Museum, Vienna, Milan 2006.

————, et al. (eds.), *"La prima donna del mondo." Isabella d'Este, Fürstin und Mäzenatin der Renaissance*, exh. cat., Kunsthistorisches Museum, Vienna, 1994.

Firenzuola, Agnolo, *On the Beauty of Women* [1562], ed. Konrad Eisenbichler and Jacqueline Murray, Philadelphia 1992.

Flechter, Jennifer, "Bernardo Bembo and Leonardo's Portrait of Ginevra de' Benci," *Burlington Magazine*, 12 (1989), pp. 811–16.

Fortini Brown, Patricia, *Private Lives in Renaissance Venice*, New Haven and London 2004.

————, *Art and Life in Renaissance Venice*, New York 1997.

Freud, Sigmund, *Eine Kindheitserinnerung des Leonardo da Vinci*, Frankfurt am Main 1995. English: *Leonardo da Vinci and a Memory of His Childhood*, trans. Alan Tyson and ed. James Strachey, New York 1989.

Frosinini, Cecilia, "Del cartone e della pittura nella vexata quaestio della battaglia di Anghiari," in Cristina Acidini and Marco Ciatti (eds.), *La Tavola Doria tra storia e mito*, Florence 2015, pp. 23–34.

Fumagalli, Giuseppina, *Leonardo "omo sanza lettere,"* Florence 1938.

Garrard, Mary D., "Who Was Ginevra de' Benci? Leonardo's Portrait and Its Sitter Recontextualized," *Artibus et Historiae*, 53 (2006), pp. 23–56.

————, "Leonardo da Vinci: Female Portraits, Female Nature," in Gerrard and Norma Broude (eds.), *The Expanding Discourse: Feminism and Art History*, New York 1992, pp. 59–86.

Ghinzoni Pietro, "Lettera inedita di Bernardo Bellincioni," *Archivio storico Lombardo*, XVI (1889), pp. 417–18.

Goffen, Rona, "Mary's Motherhood According to Leonardo and Michelangelo," *Artibus et Historiae*, 20 (1999).

———, *Renaissance Rivals: Michelangelo, Leonardo, Raphael, Titian*, New Haven and London, 2002.

Goldthwaite, Richard A., *The Economy of Renaissance Florence*, Baltimore 2009.

Graf, Arturo, *Attraverso il Cinquecento. Petrarchismo ed Antipetrarchismo*, Turin 1926.

Haas, Louis, *The Renaissance Man and His Children: Childbirth and Early Childhood in Florence, 1300–1600*, New York 1998.

Hempfer, Klaus W., "Intertextualität, Systemreferenz und Strukturwandel, die Pluralisierung des erotischen Diskurses in der italienischen und französischen Renaissance-Lyrik (Ariosto, Bembo, Du Bellay, Ronsard)," in Michael Titzmann (ed.), *Modelle des literarischen Strukturwandels*, Tübingen 1991.

Hessler, Christiane, *Zum Paragone, Malerei, Skulptur und Dichtung in der Rangstreitkultur des Quattrocento*, Berlin 2014.

Hinz, Berthold, "Studien zur Geschichte des Ehepaarbildnisses," *Marburger Jahrbuch für Kunstwissenschaft*, 19 (1974), pp. 139–218.

Holmes, Megan, "Giovanni Benci's Patronage of the Nunnery Le Murate," in Giovanni Ciapelli and Patricia Lee Rubin (eds.), *Art, Memory, and Family in Renaissance Florence*, Cambridge 2000, pp. 114–34.

Huse, Norbert, and Wolfgang Wolters, *Venedig. Die Kunst der Renaissance. Architektur, Skulptur, Malerei 1460–1590*, Munich 1996.

Istituto della Enciclopedia Italiana (ed.), *Dizionario Biografico degli Italiani*, vol. 8, Rome 1966.

Janitschek, Hubert (ed.), *Kleinere kunsttheoretische Schriften*, Vienna 1877.

Jestaz, Bertrand, "François 1er, Salaì et les tableaux de Léonard," *Revue de l'art*, 126 (1999), pp. 68–72.

Junkerman, Anne Christine, *Bellissima Donna: An Interdisciplinary Study of Venetian Sensuous Half-Length Images of the Early Sixteenth Century*, Berkeley 1988.

Kemp, Martin J., *Living with Leonardo: Fifty Years of Sanity and Insanity in the Art World and Beyond*, London 2018.

———, *The Marvellous Works of Nature and Man*, Oxford 2006.

———, *Lezioni dell'Occhio*, Milan 2004.

———, and Giuseppe Pallanti, *Mona Lisa: The People and the Painting*, Oxford 2017.

Kemp, Wolfgang, *Die Räume der Maler. Zur Bilderzählung seit Giotto*, Munich 1996.

Kidwell, Carol, *Pietro Bembo: Lover, Linguist, Cardinal*, Montreal, London, and Ithaca 2004.

Klapisch-Zuber, Christiane, *Das Haus, der Name, der Brautschatz. Strategien und Rituale im gesellschaftlichen Leben der Renaissance*, Frankfurt am Main 1995.

Kohl, Jeanette, "Splendid Isolation. Verrocchios Mädchenbüsten—eine Betrachtung," in Barbara Mikuda-Hüttel, Richard Hüttel, and Jeannette Kohl (eds.), *Re-Visionen. Zur Aktualität der Kunstgeschichte*, Berlin 2002, pp. 49–76.

Koos, Marianne, *Bildnisse des Begehrens. Das lyrische Männerporträt in der venezianischen Malerei des frühen 16. Jahrhunderts—Giorgione, Tizian und ihr Umkreis*, Emsdetten and Berlin 2006.

Kuehn, Thomas, *Illegitimacy in Renaissance Florence*, Michigan 2002.

Lacqueur, Thomas, *Auf den Leib geschrieben*, Munich 1996.

Levi Pisetzky, Rosita, *Storia del Costume in Italia*, vol. 3, Milan 1966.

Levy, Allison (ed.), *Sex Acts in Early Modern Italy: Practice, Performance, Perversion, Punishment*, Farnham 2010.

Lomazzo, Gian Paolo, "Il libro dei sogni," in Lomazzo, *Scritti d'arte*, vol. 1, ed. Roberto Paolo Ciardi, Florence 1973.

Manetti, Giannozzo, *Über die Würde und Erhabenheit des Menschen*, ed. August Buck, Hamburg 1990.

Mann, Nicholas, *Petrarch*, Oxford and New York 1984.

Martines, Lauro, *Scourge and Fire: Savonarola in Renaissance Italy*, London 2007.

McCall, Timothy, "Traffic in Mistresses: Sexualised Bodies and Systems of Exchange in the Early Modern Court," in Allison Levy (ed.), *Sex Acts in Early Modern Italy: Practice, Performance, Perversion, Punishment*, Farnham 2010, pp. 125–36.

Moczulska, Krystyna, "The Most Graceful Gallerani and the Most Exquisite *Galée* in the Portrait of Leonardo da Vinci," *Folia Historiae Artium*, 1 (1995), pp. 55–86.

Mohan, Jean-Pierre, Michel Menu, and Bruno Mottin (eds.), *Im Herzen der Mona Lisa. Dekodierung eines Meisterwerks. Eine wissenschaftliche Expedition in die Werkstatt des Leonardo da Vinci*, Munich 2006.

Moncallero, Giuseppe Lorenzo (ed.), *Epistolario di Bernardo Dovizi da Bibbiena*, vol. 2 (1513–29), Florence 1965.

Musacchio, Jacqueline Marie, "Weasels and Pregnancy in Renaissance Italy," *Renaissance Studies*, 15 (2001), pp. 172–87.

———, *The Art and Ritual of Childbirth in Renaissance Italy*, New Haven and London 1999.

———, "Imaginative Conceptions in Renaissance Italy," in Geraldine A. Johnson and Sara F. Matthews Grieco (eds.), *Picturing Women in Renaissance and Baroque Italy*, Cambridge 1997, pp. 42–60.

Nathan, Johannes, and Frank Zöllner (eds.), *Leonardo da Vinci. Sämtliche Gemälde und Zeichnungen*, Cologne 2003.

Niccolini, Giustina, *The Chronicle of Le Murate*, ed. Saundra Lynn Weddle, Toronto 2011.

Nicholl, Charles, *Leonardo da Vinci: The Flights of the Mind*, pbk. edn., London 2005.

Nova, Alessandro, "Addj 5 daghossto 1473, l'oggetto e le sue interpretazioni," in
Fabio Frosini and Alessandro Nova (eds.), *Leonardo da Vinci on Nature: Knowledge and Representation*, Venice 2015.

———, "The Kite, Envy and a Memory of Leonardo da Vinci's Childhood," in Lars R. Jones and Louisa C. Matthew (eds.), *Coming About*, Cambridge, MA 2001.

Ovid, *Metamorphosen*, ed. Michael von Albrecht, Stuttgart 1994.

Palazzo dell'Arte Milano (ed.), *Mostra di Leonardo da Vinci e delle invenzioni italiane*, exh. cat., Milan 1939.

Panofsky, Erwin, *Perspective as Symbolic Form*, New York 1991.

———, *Problems in Titian: Mostly Iconographic*, New York 1969.

———, "Artist, Scientist, Genius, Notes on the 'Renaissance-Dämmerung,'" in Panofsky et al. (eds.), *The Renaissance: Six Essays*, New York 1962, pp. 123–82.

Paolozzi Strozzi, Beatrice, and Maria Grazia Vaccari (eds.), *Il Bronzo e l'oro. Il David del Verrocchio restaurato*, Florence et al. 2003.

Pater, Walter, *The Renaissance*, London 1873.

Pedretti, Carlo, *Leonardo da Vinci: The "Angel in the Flesh" and Salaì*, Florence 2009.

———, *Leonardo: A Study in Chronology and Style*, London 1973.

———, *Documenti e memorie riguardanti Leonardo da Vinci a Bologna e in Emilia*, Bologna 1953.

——— (ed.), *The Literary Works of Leonardo da Vinci*, compiled and edited from the original manuscripts by Jean Paul Richter, commentary by Carlo Pedretti, 2 vols., Berkeley and Los Angeles 1977.

——— (ed.), *Studi Vinciani. Documenti, analisi e inediti leonardeschi*, Geneva 1957.

Perrig, Alexander, "Leonardo, Die Anatomie der Erde," *Jahrbuch der Hamburger Kunstsammlungen*, 25 (1980), pp. 51–80.

Petrarca, Francesco [Petrarch], *Canzoniere* [c. 1330–62], ed. Ernst-Jürgen Dreyer, Basel and Frankfurt am Main 1990.

Pfisterer, Ulrich, "Freundschaftsbilder—Liebesbilder, zum visuellen Code männlicher Passionen in der Renaissance," in Sibylle Appuhn-Radtke (ed.), *Freundschaft. Motive und Bedeutungen*, Munich 2006, pp. 239–59.

———, *Donatello und die Entdeckung der Stile 1430–1445*, Munich 2002.

Pico della Mirandola, Giovanni, *De dignitate hominis. Rede über die Würde des Menschen*, ed. Gerd von der Gönna, Stuttgart 2009.

Poggi, Giovanni, *Leonardo da Vinci. La Vita die Giorgio Vasari nuovamente commentata*, Florence 1919.

———, "La Giostra Medicea del 1475 e la 'Pallade' del Botticelli," *L'Arte*, 5 (1902), pp. 71–7.

Probst, Veit, *Zur Entstehungsgeschichte der Mona Lisa, Leonardo da Vinci trifft Niccolò Machiavelli und Agostino Vespucci*, Heidelberg 2008.

Pulci, Luigi, *Opere minori*, ed. Paolo Orvieto, Milan 1986.

Randolph, Adrian W. B., "Donatellos David. Politik und der homosoziale Blick," in Mechthild Fend and Marianne Koos (eds.), *Männlichkeit im Blick. Visuelle Inszenierungen in der Kunst seit der Frühen Neuzeit*, Cologne et al. 2004, pp. 35–52.

———, *Engaging Symbols: Gender, Politics, and Public Art in Fifteenth-Century Florence*, New Haven et al. 2002.

———, "Performing the Bridal Body in Fifteenth-Century Florence," *Art History*, 2 (1998), pp. 182–97.

Rasponi, Simonetta (ed.), *Leonardo & Venice*, exh. cat., Palazzo Grassi, Venice, Milan 1992.

Rehm, Ulrich, *Botticelli. Der Maler und die Medici*, Stuttgart 2009.

Reinhardt, Volker, *Geschichte von Florence*, Munich 2014.

Ricciardi, Lucia, *"Col senno, col tesoro e colla Lancia." Riti e giochi cavallereschi nella Firenze del Magnifico Lorenzo*, Florence 1992.

Richter, Jean Paul (ed.), *The Notebooks of Leonardo da Vinci*, unabridged edition of the work first published in London in 1883, with the title "The Literary Works of Leonardo da Vinci," 2 vols., New York 1970.

———, and Carlo Pedretti (ed.), *The Literary Works of Leonardo da Vinci*, compiled and edited from the original manuscripts by Jean Paul Richter, commentary by Carlo Pedretti, 2 vols., Berkeley and Los Angeles 1977.

Rocke, Michael, *Homosexuality and Male Culture in Renaissance Florence*, New York et al. 1996.

Schaeffer, Emil, *Die Frau in der venezianischen Malerei*, Munich 1899.

Schlechter, Armin (ed.), *"Die edel kunst der truckerey." Ausgewählte Inkunabeln der Universitätsbibliothek Heidelberg*, exh. cat., Schriften der Universitätsbibliothek Heidelberg, vol. 6, Heidelberg 2005.

Schmidt, Eike (ed.), *Il Cosmo Magico di Leonardo. L'Adorazione dei Magi restaurata*, exh. cat., Uffizi, Florence 2017.

Schneider, Marianne (ed.), *Leonardo da Vinci. Die Aphorismen, Rätsel und Prophezeiungen*, Munich 2003.

——— (ed.), *Leonardo da Vinci. Eine Biographie in Zeugnissen, Selbstzeugnissen, Dokumenten und Bildern*, Munich 2002.

Schumacher, Andreas (ed.), *Botticelli. Bildnis, Mythos, Andacht*, exh. cat., Städelmuseum Frankfurt, Frankfurt am Main, 2009.

———, Annette Kranz, and Annette Hoyer (eds.), *Florentiner Malerei. Alte Pinakothek*, Berlin and Munich 2017.

Seichter, Sabine, *Erziehung an der Mutterbrust*, Weinheim 2014.

Shearman, John, *Only Connect . . . Art and the Spectator in the Italian Renaissance*, Washington, DC, 1988.

Shell, Janice, and Grazioso Sironi, "Cecilia Gallerani, Leonardo's Lady with an Ermine," *Artibus et Historiae*, 25 (1992), pp. 47–66.

Sickel, Lothar, "Ippolito de'Medici und das Problem seiner Geburt," *Quellen und Forschungen aus italienischen Archiven und Bibliotheken*, 88 (2008), pp. 310–34.

Silverman, Peter, *La Principessa Perduta di Leonardo*, Milan 2012.

Simons, Patricia, "Portraiture, Portrayal, and Idealization: Ambiguous Individualism in Representations of Renaissance Women," in Alison Brown (ed.), *Language and Images of Renaissance Italy*, Oxford 1995, pp. 263–11.

———, "Women in Frames: The Gaze, the Eye, the Profile in Renaissance Portraiture," in Norma Broude and Mary D. Garrard (eds.), *The Expanding Discourse: Feminism and Art History*, New York 1992, pp. 39–57.

Smiraglia Scognamiglio, Nino, *Ricerche e documenti sulla Giovinezza di Leonardo da Vinci*, Naples 1900.

Stierle, Karlheinz, *Francesco Petrarca. Ein Intellektueller im Europa des 14. Jahrhunderts*, Munich and Vienna 2003.

Syre, Cornelia, Jan Schmidt, and Heike Stege (eds.), *Leonardo da Vinci. Die Madonna mit der Nelke*, Munich 2006.

Syson, Luke (ed.), *Leonardo da Vinci: Painter at the Court of Milan*, exh. cat., National Gallery, London 2011.

Thomas, Anabel, "The Workshop as the Space of Collaborative Artistic Production," in Robert J. Crum and John T. Paoletti (eds.), *Renaissance Florence: A Social History*, Cambridge and New York 2006, pp. 415–30.

Tomas, Natalie, "Did Women Have a Space?," in Robert J. Crum and John T. Paoletti (eds.), *Renaissance Florence: A Social History*, Cambridge and New York 2006, pp. 311–30.

Tönnesmann, Andreas, *Die Kunst der Renaissance*, Munich 2007.

Tornabuoni, Lucrezia, *Lettere*, ed. Patrizia Salvadoro, Florence 1993.

Trexler, Richard C., *Public Life in Renaissance Florence*, New York 1980.

Vahland, Kia, "Meister, die vom Himmel fielen," *Süddeutsche Zeitung*, October 2, 2015, pp. 13–15.

———, *Michelangelo und Raffael. Rivalen im Rom der Renaissance*, Munich 2012.

———, *Lorbeeren für Laura. Sebastiano del Piombos lyrische Bildnisse schöner Frauen*, Studi Reihe des Deutschen Studienzentrums Venedig, Berlin 2011.

———, "Die dritte Dimension," in *Geo Epoche Edition*, 3 (2011), pp. 26–37.

———, "Der Kunstmensch als Maß der Dinge. Zur Utopie des idealen Körpers bei Leonardo da Vinci," in Kristine Hasselmann, Sandra Schmidt, and Cornelia Zumbusch (eds.), *Utopische Körper. Visionen künftiger Körper in Geschichte, Kunst und Gesellschaft*, Paderborn 2004, pp. 29–40.

Vasari, Giorgio, *Das Leben des Brunelleschi und des Alberti*, ed. Alessandro Nova et al., Berlin 2012.

———, *Das Leben des Verrocchio und der Gebrüder Pollaiuolo*, ed. Alessandro Nova and Katja Burzer, Berlin 2011.

———, *Das Leben des Michelangelo*, ed. Alessandro Nova and Caroline Gabbert, Berlin 2009.

———, *Das Leben des Leonardo da Vinci*, ed. Alessandro Nova and Sabine Feser, Berlin 2006.

———, *Das Leben des Raffael*, ed. Alessandro Nova and Hana Gründler, Berlin 2004.

———, *Andrea Verrocchio, Painter, Sculptor and Architect of Florence*, in *The Lives of the Painters, Sculptors and Architects*, trans. Gaston de Vere, intro. and notes David Ekserdjian, Everyman's Library, New York 1996, vol. 1, pp. 549–57.

———, *Filippo Brunelleschi, Sculptor and Architect*, in *The Lives of the Painters, Sculptors and Architects*, trans. Gaston de Vere, intro. and notes David Ekserdjian, Everyman's Library, New York 1996, vol. 1, pp. 324–63.

———, *Leon Battista Alberti, Architect of Florence*, in *The Lives of the Painters, Sculptors and Architects*, trans. Gaston de Vere, intro. and notes David Ekserdjian, Everyman's Library, New York 1996, vol. 1, pp. 414–19.

————, *Leonardo da Vinci, Painter and Sculptor of Florence*, in *The Lives of the Painters, Sculptors and Architects*, trans. Gaston de Vere, intro. and notes David Ekserdjian, Everyman's Library, New York 1996, vol. 1, pp. 625–40.

————, *Michelagnolo Buonarroti, Painter, Sculptor of Florence*, in *The Lives of the Painters, Sculptors and Architects*, trans. Gaston de Vere, intro. and notes David Ekserdjian, Everyman's Library, New York 1996, vol. 2, pp. 642–769.

————, *Raffaello da Urbino, Painter and Architect*, in *The Lives of the Painters, Sculptors and Architects*, trans. Gaston de Vere, intro. and notes David Ekserdjian, Everyman's Library, New York 1996, vol. 1, pp. 710–48.

————, "Vita di Michelagnolo Buonarroti, Fiorentino. Pittore, scultore et architetto," in Vasari, *Le vite de' più eccellenti pittori, scultori e architettori nelle redazioni del 1550 e 1568*, Testo a cura di Rosanna Bettarini. Commento secolare a cura di Paola Barocchi, vol. 6, Florence 1987, pp. 2–141.

————, "Vita di Lionardo da Vinci. Pittore e scultore Fiorentino," in Vasari, *Le vite de' più eccellenti pittori, scultori e architettori nelle redazioni del 1550 e 1568*, Testo a cura di Rosanna Bettarini. Commento secolare a cura di Paola Barocchi, vol. 4, Florence 1976, pp. 14–38.

————, "Vita di Raffaelo da Urbino. Pittore et architetto," in Vasari, *Le vite de' più eccellenti pittori, scultori e architettori nelle redazioni del 1550 e 1568*, vol. 4, Florence 1976, pp. 154–214.

————, "Vita di Andrea Verrocchio. Pittore, scultore et architetto Fiorentino," in Vasari, *Le vite de' più eccellenti pittori, scultori e architettori nelle redazioni del 1550 e 1568*, Testo a cura di Rosanna Bettarini. Commento secolare a cura di Paola Barocchi, vol. 3, Florence 1971, pp. 532–45.

————, "Vita di Filippo Brunelleschi. Scultore et architetto," in Vasari, *Le vite de' più eccellenti pittori, scultori e architettori nelle redazioni del 1550 e 1568*, vol. 3, Florence 1971, pp. 136–98.

Vecce, Carlo, *Leonardo*, Rome 1998.

Ventrone, Paola (ed.), *Le Temps revient, 'l tempo si rinuova. Feste e spettacoli nella Firenze di Lorenzo il Magnifico*, Milan 1992.

Walker, John, "Ginevra de' Benci by Leonardo da Vinci," in *Report and Studies in the History of Art*, National Gallery of Art, Washington, DC, 1967, pp. 1–38.

Walter, Ingeborg, *Der Prächtige. Lorenzo de' Medici*, Munich 2003.

———, and Roberto Zapperi, *Das Bildnis der Geliebten*, Munich 2007.

Walmsley, Elizabeth, "Leonardo's Portrait of *Ginevra de' Benci*: A Reading of the X-radiographs and Infrared Reflectographs," in Michel Menu (ed.), *Leonardo da Vinci's Technical Practice. Paintings, Drawings and Influence*, Paris 2014, pp. 56–71.

Warburg, Aby, "Delle 'Imprese Amorose' nelle più antiche incisioni fiorentine" [1905], in Warburg, *Die Erneuerung der Heidnischen Antike. Kulturwissenschaftliche Beiträge zur Geschichte der europäischen Renaissance*, vol. 1 (= *Gesammelte Schriften*, vol. 1.1), ed. Horst Bredekamp, Michael Diers, and Ulrich Pfisterer, Berlin 1998, pp. 77–87.

Warnke, Martin, *Hofkünstler. Zur Vorgeschichte des modernen Künstlers*, Cologne 1996.

Weddle, Saundra Lynn, "'Tis Better to Give than to Receive: Client-Patronage Exchange and Its Architectural Implications at Florentine Convents," in Peter Howard (ed.), *Studies on Florence and the Italian Renaissance in Honour of F. W. Kent*, Turnhout 2016, pp. 295–313.

Wittkower, Margot, and Rudolf, *Künstler—Außenseiter der Gesellschaft*, Stuttgart 1989.

Zapperi, Roberto, *Abschied von Mona Lisa. Das berühmteste Gemälde der Welt wird enträtselt*, Munich 2010.

———, and Ingeborg Walter, *Das Bildnis der Geliebten*, Munich 2007.

Zöllner, Frank, *Leonardos Mona Lisa. Vom Porträt zur Ikone der freien Welt*, Berlin 2006.

———, "Leonardo da Vinci's Portraits: Ginevra de' Benci, Cecilia Gallerani, La Belle Ferronière and Mona Lisa," in Sebastiana Dudzika and Tadeusza J. Żuchowskie (eds.), *Rafel i jego spadkobiercy. Portret klasyczny w sztuce nowozytnej Europy. Materialy sesji naukowej*, Torun 2003, pp. 157–83.

———, and Johannes Nathan (eds.), *Leonardo da Vinci. The Complete Paintings and Drawings*, Cologne 201.

———, and Johannes Nathan (eds.), *Leonardo da Vinci. Sämtliche Gemälde und Zeichnungen*, Cologne 2003.

Image Credits

akg-images Berlin: André Held: Illustration 5, Plate 31; Heritage Images: Illustration 25 (The Print Collector), Chapter IV, Illustrations 37, 40, 42, Plates 27, 32, 33 (Fine Art Images); Erich Lessing: Chapter IX, Illustrations 4, 7, 19, Plates 3, 11, 20, 21, 30; Mondadori Portfolio: Illustration 20 (Metis e Mida Informatica / Veneranda Biblioteca Ambrosiana), Illustration 24 (Sergio Anelli); The National Gallery: Plates 4, 16, 22; Rabatti & Domingie: Plates 5, 7; Eric Vandeville: Illustration 38

Alinari Archives, Florence: Illustration 6

bpk, Berlin: Bavarian State Painting Collections: Chapter I, Plate 1; Gemäldegalerie, SMB: Illustration 39 (Jörg P. Anders); Museum Hessen Kassel: Plate 26; RMN – Grand Palais: Chapter VI, Plate 15 (Angèle Dequier), Chapter VIII, Plate 18 (Christian Jean), Chapter XII, Plate 29 (Hervé Lewandowski), Chapter X, Plate 23 (René-Gabriel Ojéda), Chapter XI, Nachwort, Illustration 32, Plate 28 (Michel Urtado); Scala: Chapter II, III, Plates 6, 8, 19, 25 (Courtesy of the Ministry of Cultural Heritage and Activities), Chapter VII, Plates 13, 14, 17

Devonshire Collection, Chatsworth: Illustration 34

Hermitage Museum, St. Petersburg: Plate 2

mauritius images, Mittenwald: Illustrations 22, 41

National Gallery of Art, Washington: Vorwort, Plate 9, 10

Royal Collection Trust, London, © Her Majesty Queen Elizabeth II 2019: Chapter V, Illustrations 3, 8, 10, 16, 23, 28, 29, 31, 35, Plate 34

Index

Naples, Kingdom of, 36, 126
nature interest of Leonardo.
 See also water as interest of
 Leonardo
 ermine as symbol of
 pregnancy, 111–113
 functioning of world
 depicted by,
 152–157, *154, 155*
 furs and importance
 to wealthy class,
 107–109
 juniper in *Ginerva de'
 Benci,* 73–74, 80, 82,
 83, 140, 143, 194
 landscape in
 Annunciation, 31
 landscape in *Ginevra de'
 Benci,* 72–73
 landscape in *Mona Lisa,*
 180–182
 landscape in *Virgin of the
 Rocks,* 99–100
 Landscape Study
 (Leonardo), 30, P7
 Leonardo's early
 interest in, 18,
 25–26
 lion in *Saint Jerome,*
 123–125
 nature interest,
 overview, 2
 nature themes in *The
 Virgin and Child with
 Saint Anne,* 156–157,
 170–171
 themes of women in
 nature, overview,
 26–31
Neoplatonism, 63, 76, 97
Niccolini, Luigi, 66, 78,
 230n10
Novellara, Pietro da,
 150–152, 156–158

Officers of the Night
 (Florence), 52–59
On the Dignity of Man
 (Manetti), 35–36

"On the World and Its
 Waters" (Leonardo,
 notebook), 180
Opificio delle Pietre Dure,
 269n8
Orsini, Clarice, 47–49
Ovid, 112, 234n56

painting techniques and
 materials
 adhesion problems in
 frescoes, 129–130,
 167, 257n40
 central perspective,
 33–34, 39, 45
 colors used during
 Renaissance, 40–41,
 146–147
 Florentine painters'
 guild, 26
 leather used as canvas,
 39
 Leonardo's use of oils,
 10, 73, 115, 130, 141
 poetry and, 83, 131,
 250n25
 sfumato technique, 143,
 178, 179, 188, 200,
 206
 Verrocchio's use of
 tempera, 10, 25
 wood panels used by
 Leonardo, 69, 72,
 176, 199
Paolo de Leonardo de Vinci,
 57
Pater, Walter, 207
Petrarch
 Canzoniere, 38–39,
 140–141
 Canzoniere, Laura of,
 77–84, 111, 118,
 119, 232n28
 on eyes and love,
 131
 Raphael and, 194
 on unattainability/
 danger of a woman,
 243n20

on women's "voice and
 intellect," 2
Philiberta of Savoy, 185
Pico della Mirandola,
 Giovanni, 163
Piero da Vinci (Leonardo's
 father)
 Benci family and, 65
 brother of (Leonardo's
 uncle), 17, 168
 clients of, 150, 174, 176
 death of, 167–168
 Leonardo's birth and,
 4–5, 16–19, 168
 marriages and heirs
 of, 57
 parents of (Leonardo's
 grandparents), 15
 as son's agent, 92–94
 Vasari on Leonardo's
 shield presented to,
 23–24
 wife of (Leonardo's
 stepmother), 15, 17,
 217n24
Pierozzi, Antonino
 (archbishop of Florence),
 29
Piombo, Sebastiano Luciani
 del
 as Leonardo's student
 and friend, 143, 146
 nude women painted
 by, 192–193,
 194–195
 Portrait of a Woman
 (school of Leonardo,
 after Piombo), *208,*
 209
Plato, 35
platonic love, 51, 54, 77, 79,
 85, 110–111, 197
poetry. *See also* Petrarch
 de' Barbari on, 250n25
 of early Renaissance,
 overview, 38–39
 of Gallerani, 116
 Ginevra de' Benci and
 "wild tiger," 68–71

media used by, 10, 25
Medici's tournament of
1469 and, 49
painting techniques
of, 7, 8
*Sketch for a Tournament
Banner* (Verrocchio
and Leonardo), *60,*
60–61
in Venice, 94
Vespucci, Agostino, 165,
176, 187, 259–260n11
Vespucci, Simonetta.
See Simonetta Vespucci
(Botticelli)
Vinci (town)
Leonardo's childhood
in, 15–19
Leonardo's visits
to, during
apprenticeship,
30–31
name of, 18
*Virgin and Child with Saint
Anne, The* (Leonardo),
P23
on birth as creation,
2–3
documentation related
to, 176
in Leonardo's
possession at end of
life, 202
nature themes in,
156–157, 170–171
variations of, 252n4
Virgin of the Rocks (Leonardo),
97–105, 242n19, P15
Virgin of the Rocks (Leonardo
and assistants), 103–105,
170, P16
Vite (Vasari), 177, 200–202,
214n2, 215n3, 216nn16–
17, 223n13
Vitruvian Man (Leonardo)
drawing of, 104
illustration, *103*
study of head in, 124

twentieth-century
fascism and, 3–4
Vitruvius, 35

water as interest of
Leonardo
functioning of world
depicted by
Leonardo, 152–157,
154, 155
hydraulic engineering,
160
hydraulic engineering
by Leonardo, 160
"On the World and Its
Waters" (Leonardo,
notebook), 180
*Study showing an explosion
of a rock massif caused
by a bursting water vein
and formation of waves
in a lake due to falling
boulders,* 72, 155, *155*
*Study showing an explosion
of a rock massif caused
by a bursting water
vein* (Leonardo,
illustration 28), *154,*
155
water in *Virgin of the
Rocks* (Leonardo),
242n19
Woman Standing in a Landscape
(Leonardo), 203, P34
women of Renaissance.
See female image in
art; motherhood and
childbearing; women's
roles
women's roles. *See also*
motherhood and
childbearing
Book of the Courtier
(Castiglione) on,
196–197
Ficino on, 58
Isabella d'Este's power
and, 136

of Judith (biblical
figure), 162
rarity of women's
portraits, 143
Renaissance debate
about women as
sentient beings, 2,
12, 38

Zoroastro (Tommaso di
Giovanni Masini), 91–92,
96, 97, 104, 105, 121,
167, 199